ALSO BY
DANNY GREGORY:

HELLO WORLD

EVERYDAY MATTERS

CHANGE YOUR UNDERWEAR
TWICE A WEEK

THE Creative LiCense

GIVING YOURSELF PERMISSION
TO BE THE ARTIST YOU TRULY ARE

BY Danny GREGORY

HYPERION

NEW YORK

LIBRARY OF CONGRESS CATALOGING-IN-PUBLICATION DATA
GREGORY, DANNY
 THE CREATIVE LICENSE: GIVING YOURSELF PERMISSION TO BE THE ARTIST YOU TRULY ARE/ BY DANNY GREGORY.-- 1ST ED.
 P. CM.
 ISBN: 1-4013-0792-2
 1. DRAWING-STUDYING AND TEACHING. 2. CREATIVE ABILITY. I. TITLE.
 NC593.G74 2006
 741.2--DC22 2005050303
 ISBN-13: 978-1-4013-0792-9
HYPERION BOOKS ARE AVAILABLE FOR SPECIAL PROMOTIONS AND PREMIUMS.
FOR DETAILS CONTACT MICHAEL RENTAS, ASSISTANT DIRECTOR, INVENTORY OPERATIONS, HYPERION, 77 WEST 66TH STREET, 11TH FLOOR, NEW YORK, NEW YORK 10023, OR CALL 212-456-0133.

FIRST EDITION

10 9 8 7 6 5 4 3

DEDICATED TO
YOU, THE ARTIST

CONTENTS

I'M NOT SURE what the FUNCTION OF THESE Swiss cheeses could be. I also wonder how they were made and how they got here. They are each a DIFFERENT Shade of sea-battered CONCRETE and form JETTIES and then just stand around, here and THERE IN THE SAND. Jack's the only family member to have taken to the Sea on this vacation. He and His new pal, MARCO, were dragged behind a motor-launch on an INFLATED yellow banana boat while Patti and I looked on from the Shore. Then he went on a horse Ride which was fun but, MORE IMPORTANTLY, afterwards he got a FANTA. Today is PL's birthday which we are celebrating by lugging by the pool.

TOO MANY PEOPLE SEEM TO FEEL THEY ARE NOT AND CANNOT EVER BE CREATIVE.

THEY'D LOVE TO WRITE OR DRAW OR PAINT OR DANCE OR ACT OR PLAY MUSIC BUT ARE AFRAID TO EVEN TRY. SOME OF THEM ALSO WISH THEY COULD BE MORE CREATIVE PROFESSIONALLY, BUT HAVE TAKEN A CAREER PATH THAT MAKES THAT SEEM IMPOSSIBLE. OTHERS HAVE BEGUN TO DABBLE IN CREATIVE MATTERS BUT SOMEHOW FIND THEMSELVES BLOCKED OR LIMITED OR LOST, AND NEED HELP TO BREAK THROUGH.

THIS BOOK IS DESIGNED TO GIVE YOU — ALL OF YOU — SOMETHING YOU ACTUALLY ALREADY HAVE: PERMISSION TO BE INTENSELY, BRILLIANTLY, WONDERFULLY CREATIVE. EVEN THOUGH YOU PROBABLY DON'T BELIEVE IT AT THIS POINT, THIS GIFT IS SOMETHING THAT ONLY YOU CAN GIVE YOURSELF. IT'S NOT A MATTER OF GENETICS OR SOCIAL PERMISSION OR MONEY OR TALENT; IT'S JUST A MATTER OF WILL.

GETTING THERE REQUIRES SOME WORK. IT ALSO MEANS YOU ARE GOING TO HAVE TO LET GO OF SOME PRECONCEPTIONS AND TAKE A FEW RISKS. NONE OF THESE THINGS IS TERRIBLY SCARY, I PROMISE.

HERE'S HOW TO THINK ABOUT IT. IF YOU ARE AN ADULT, YOU ALMOST CERTAINLY KNOW HOW TO DRIVE A CAR. IT'S NOT A SKILL YOU WERE BORN WITH, BUT ONCE YOU LEARNED THE BASICS AND PRACTICED A BIT YOU WERE ABLE TO DO IT AT WILL. NOW YOU DO IT INTUITIVELY, FLUIDLY; AT LEAST WELL ENOUGH TO HAVE KEPT YOU ALIVE UP TO THIS POINT.

YOUR DRIVER'S ED STARTED WITH LEARNING SOME PRINCIPLES ON PAPER: THE RULES OF THE ROAD, HOW TO READ TRAFFIC SIGNS,

HOW TO PARK AND SO FORTH. THEN YOU TOOK A WRITTEN TEST TO SEE IF YOU HAD ABSORBED THIS INFORMATION. IF YOU PASSED, YOU WERE ALLOWED TO SIT BEHIND THE WHEEL FOR THE FIRST TIME WHILE YOUR INSTRUCTOR (OR IF YOU WERE UNLUCKY, YOUR DAD) SHOWED YOU THE ROPES.

SO FAR EVERYTHING YOU'D ABSORBED WAS INFORMATION AND FACTS. WHEN YOU STARTED THE ENGINE FOR THE FIRST TIME AND SHIFTED INTO GEAR, YOUR EDUCATION ENTERED A NEW DIMENSION. YOU HAD TO RELY LESS ON RATIONAL THOUGHT THAN ON INTUITION AND SENSATION TO MAKE THE SMALL COURSE CORRECTIONS NECESSARY FOR DRIVING. THIS PROCESS INVOLVED YOUR ENTIRE BODY. IT WAS LESS LIKE LEARNING TO READ OR DO YOUR

CCI GOLIATH.

MULTIPLICATION TABLES THAN LIKE WALKING OR RUNNING OR SWIMMING. YOUR BRAIN AND YOUR BODY LEARNED TOGETHER.

AT FIRST YOU OVERREACTED. YOU'D SLAM ON THE BRAKES TOO HARD, OVER-ACCELERATE, FIND IT IMPOSSIBLE TO PARALLEL PARK. WITHIN A FEW WEEKS OF PRACTICE, YOU SMOOTHED THE ROUGH SPOTS. BY THE TIME YOU TOOK YOUR ROAD TEST, YOU FELT PRETTY COMFORTABLE AT THE WHEEL AND THE CAR STARTED TO BECOME AN EXTENSION OF YOURSELF.

GETTING YOUR LICENSE DIDN'T MAKE YOU A GOOD DRIVER, HOWEVER. THAT WOULD TAKE YEARS, MAYBE DECADES. EVENTUALLY YOU AND YOUR CAR BECAME ONE. YOU COULD TALK ON THE PHONE, SIP COFFEE, AND LISTEN TO THE RADIO WHILE NEGOTIATING LANES ON THE HIGHWAY. NOW YOU CAN DRIVE WHEREVER YOU WANT, SAFELY AND COMFORTABLY. YOU CAN DRIVE MOST KINDS OF CARS ON MOST ROADS IN MOST CONDITIONS WITHOUT PANIC. YOU ARE A DRIVER.

LET'S COMPARE THIS PROCESS WITH YOUR CREATIVE EDUCATION. YOU PROBABLY NEVER STUDIED CREATIVITY IN SCHOOL. YOU NEVER LEARNED THE BASIC PRINCIPLES OF CREATIVITY. YOU NEVER WORKED CONSISTENTLY AT A CREATIVE DISCIPLINE UNTIL YOU MASTERED IT, PROBABLY BECAUSE THE INITIAL LEARNING CURVE WAS SO STEEP. WHEN YOU ENCOUNTERED AN OBSTACLE YOU

JACK SAID THIS WAS TOO HARD TO DRAW. GUESS WHAT, HE MIGHT HAVE BEEN RIGHT.

PROBABLY GAVE UP, BLAMING A LACK OF TALENT. MAYBE YOU BOUGHT BOOKS LIKE THIS ONE ON CREATIVITY OR MUSIC OR ART AND STARTED TO READ THEM, THEN FLIPPED AHEAD AND LOOKED AT THE EXAMPLES AND FELT OVERWHELMED AND STOPPED. PEOPLE AROUND YOU DIDN'T ENCOURAGE YOU TO BE CREATIVE. IF ANYTHING, THEY MAY HAVE MADE IT SEEM SELF-INDULGENT AND A WASTE OF TIME.

YOU NEVER HAD A CHANCE. NOW YOU DO.

THIS BOOK WILL GET YOU INTO THE DRIVER'S SEAT. WE'LL TALK ABOUT WHAT CREATIVITY IS, HOW TO STIMULATE IT, AND WHAT HAS BEEN BLOCKING YOURS — THE RULES OF THE ROAD. THEN WE'LL START YOUR ENGINE. STEP-BY-STEP, YOU WILL LEARN ONE PARTICULAR MEANS TO EXPRESS YOUR CREATIVITY. YOU'LL PRACTICE A BIT EACH DAY AND MARVEL AT YOUR PROGRESS.

THEN WE'LL HIT THE ROAD AND GIVE YOU DIFFERENT SORTS OF CHALLENGES TO STRETCH YOUR MIND AND BODY. SOON YOU WILL BE THINKING LIKE A CREATIVE PERSON, SEEING THE WORLD AS RICHLY AS ARTISTS DO. YOU WILL GIVE YOURSELF PERMISSION TO CREATE, YOUR OWN CREATIVE LICENSE.

FINALLY, I WILL STEP TO THE CURB AND YOU WILL HEAD OUT ON YOUR OWN LIFELONG JOURNEY, EXPLORING OTHER MEDIA AND CRAFTS AND FORMS, HAVING EXPERIENCES AND ADVENTURES THAT WILL TRANSCEND THE ROAD MAP.

11:50 WE SIT UNDER THE CANOPY OF A RUSSIAN CARPENTRY SHOP AND LOOK AT A GRAVEL YARD

fig 27: Cirsium arvense

WHaT IF WE tReAteD DRIVING LIKE WE treAt THE ArtS?

WE'D ASSUME THAT PEOPLE WERE EITHER BORN TO DRIVE OR NOT. WE'D WAIT AND SEE IF, AS CHILDREN, THEY STARTED DRIVING ON THEIR OWN, IF THEY HAD TALENT AND A CALLING. IF THEY DID, WE WOULD BE CAREFUL NOT TO INTERFERE WITH THEIR TALENT AND POSSIBLY SUPPRESS IT. WE WOULD MAKE SURE TO ENCOURAGE ONLY THOSE WHO SEEMED THEY'D BE ABLE TO DRIVE PROFESSIONALLY. WE'D PAY SOME OF THEM MILLIONS OF DOLLARS TO DRIVE AND LAVISH THEM WITH FAME; OTHERS WE WOULD REFUSE TO SUPPORT, ENCOURAGING THEM TO DO SOMETHING MORE USEFUL FOR SOCIETY. EVERYONE ELSE WOULD ASSUME THAT THEY WOULD NEVER BE ABLE TO DRIVE AND WOULD JUST STAND ON THE SIDEWALKS AND WATCH THE TRAFFIC.

AT LEAST THE OZONE LAYER WOULD BE IN BETTER SHAPE.

Make Like A Tree.

THIS SPRING WAS FULL OF CREATIVE ENERGY. IN MAY, I WATCHED THE TREES IN THE PARK TAP OUT BRANCH AFTER BRANCH OF LEAVES. OVER A SINGLE WEEKEND, MY VIEW WAS OBSCURED BY GREENERY WHERE BEFORE THERE HAD BEEN JUST COATRACKS OF BRANCHES.

PURE CREATIVITY IS ALL AROUND US. A WEED POKES THROUGH CRACKS IN THE PAVEMENT. BIRDS MAKE BEAUTIFUL NESTS. SO DO ANTS. BEEHIVES ARE ELEGANT AND INTELLIGENTLY DESIGNED. AND WHAT ABOUT THE COLORS AND SHAPES THAT FISH HAVE COME UP WITH TO PROTECT THEMSELVES? AND FLOWERS, AREN'T THEIR ADAPTATIONS, SO INFINITELY VARIED AND BREATHTAKING, CREATIVE?

THINK OF HOW A BRANCH BENDS, HOW NEW LEAVES ARRANGE THEMSELVES, HOW A TREE REACTS TO CIRCUMSTANCE, WATER, SUN, WIND, AND CALAMITY. THAT'S PURE CREATION WITH NO PAUSE FOR HARSH SELF-JUDGMENT. (YOU NEVER HEAR A PEAR TREE WHINE, "I'M NO GOOD AT FRUIT!")

IT'S IRONIC. WE SAY TREES ARE NOT "CREATIVE" WHEN THEY *DO* MAKE THINGS, WHILE WE ARE NOT "CREATIVE" WHEN WE *DON'T* MAKE THINGS. WELL, THAT'S JUST NOT VERY CREATIVE, IS IT?

INSTINCT, CONDITIONING, SELFISH GENE, DNA ... PLANTS DON'T CARE WHY THEY DO IT, WHY SHOULD WE?

CAN'T YOU BE AS CREATIVE AS A WEED?

AH, YOU SAY, THAT'S "GOD'S WORK." OKAY, SO LET'S SAY GOD IS PRESENT IN A LOWLY ANT CARVING UP A LEAF OR BORING A TUNNEL; IN A

This avocado made a good lunch. Now it's made this. →

WiNGED BeetLe

BUTTERFLY'S WINGS AS IT ADAPTS TO CHANGES IN AIR QUALITY; IN THE SUBTLE SHADING AND ALLURING FRAGRANCE OF A PEACH. BUT BECAUSE YOU ARE NOT "CREATIVE," GOD, IT SEEMS, IS NOT IN YOU. IS THAT TRUE? IS THAT WHY YOU CAN'T MAKE STUFF, CAN'T GET GOING, CAN'T DO A TEENY LITTLE DRAWING? OF COURSE NOT. WE ALL CONTAIN THE DIVINE, ARE ALL CONNECTED TO THE INFINITE SOURCE OF CREATIVE ENERGY. BUT UNLIKE THE REST OF CREATION, WE WORK AWFULLY HARD TO SUPPRESS IT.

BIRDS SING, WOLVES HOWL, CRICKETS CHIRP. BUT WHY? MONEY? FAME? RECORD CONTRACTS? ENDORSEMENTS? WHAT'S IT ALL FOR?

THEY DO IT BECAUSE THEY ARE ALIVE. THEY DO IT BECAUSE LIFE IS ABOUT MAKING THINGS. MAKING BABIES, NESTS, NEW CELLS, DINNER, DANDRUFF, EXCREMENT... OUR BODIES ARE ALWAYS TURNING ONE THING INTO ANOTHER, TRANSFORMING FOOD, AIR, AND WATER, INTO MOVEMENT, SWEAT, OFFSPRING, GAS. (EVEN WHEN YOUR BODY IS FINALLY DEAD, YOU WILL STILL BE CREATIVE AS YOU START TO NOURISH THE SOIL, BEETLES, CARRION BIRDS, AND FILL THE AIR WITH METHANE.)

IF YOU TRY TO SUPPRESS THAT URGE, YOU WILL STARVE, YOUR BOWELS WILL BECOME IMPACTED, YOUR JOINTS WILL FREEZE, YOU WILL DIE. AND, SIMILARLY, WHEN YOU SUPPRESS THE CREATIVE URGE IN YOUR MIND, YOU BECOME CRAMPED, CONSTIPATED, HOPELESS, AND SLOWLY YOU DIE. ALL THAT CREATIVE ENERGY, AN INEXTRICABLE PART OF YOU, WILL BE DIVERTED INTO SELF—

TORTURE, AND YOU WILL CREATE DOUBT AND ANXIETY AND HOSTILITY AND STRESS AND PARANOIA AND ANGER AND RESENTMENT.

IN THE END, YOU SEE, YOU CAN'T REALLY SUPPRESS YOUR CREATIVE URGE. AS JEFF GOLDBLUM SAYS IN *JURASSIC PARK*, NATURE WILL FIND A WAY.

DON'T TAKE IT LYING DOWN. OUR GOAL MUST BE TO CHANNEL THAT ENERGY IN A POSITIVE DIRECTION, TO CREATE HAPPINESS, APPRECIATION, CELEBRATION, AND JOY INSTEAD.

HOW? BY LIVING IN THE NOW — BY SEEING THE BEAUTY OF WHAT IS — BY CHOOSING TO MAKE SOMETHING SPECIAL OUT OF THE WAY YOU FOLD YOUR LAUNDRY, LETTER A SHOPPING LIST, CLEAN YOUR PLATE. CELEBRATE YOUR LIFE NOW, AS IT UNFOLDS. TURN AWAY FROM JUDGMENT AND NEGATIVE THEORIES ABOUT YOUR WORTH, YOUR POTENTIAL, AND YOUR DESTINY. SEE WHAT YOU ALREADY HAVE. CREATE CONNECTIONS AND CONVERSATIONS — MAKE FRIENDS. PUT A FRAME AROUND YOUR LUNCH. PUT A SPOTLIGHT IN YOUR TOOTHBRUSH. PUT A MEMORY ON A PEDESTAL. SEIZE EACH DAY AS IT DAWNS. AND MAKE MORE OF IT. SOON, LIKE THE TREES OUT MY WINDOW, YOU'LL FIND YOU CAN'T HELP IT.

"It is never too late to be what you might have been."
-George Eliot

EVERY DAY IS LOADED with CREATIVE POTENTIAL.

CREATIVITY IS NOT JUST THE DOMAIN OF BIRDS AND BEES. CREATIVITY IS NOT A MAGICAL TALENT THAT MUST BE IN YOU AT BIRTH. AND IT DOES NOT MAKE YOU WEIRD AND FREAKY.

HUMAN CREATIVITY IS EXPRESSED IN MANY, MANY WAYS. ARTISTS AND MUSICIANS AND ACTORS AND WRITERS ARE ALL, OBVIOUSLY, CREATIVE. SO ARE ADVERTISING PEOPLE AND FILMMAKERS AND FASHION DESIGNERS AND ENGINEERS. BUT CREATIVITY DOESN'T JUST APPLY TO "THE ARTS." CEOS, LAWYERS, POLITICIANS, ACCOUNTANTS, DENTISTS, AND BUS DRIVERS ARE CREATIVE, TOO.

AND SO ARE YOU. YOU JUST DON'T CALL IT THAT.

FOR INSTANCE, UNLESS YOU WEAR A UNIFORM OR HAVE AN OVERLY PROTECTIVE MOTHER, YOU BEGIN MOST DAYS WITH A CREATIVE ACT. YOU LOOK AT YOUR CLOSET, YOU THINK ABOUT HOW YOU FEEL, AND YOU DRESS YOURSELF. YOU DECIDE THAT ONE ITEM GOES WITH ANOTHER. YOU DECIDE THAT ONE SHIRT LOOKS MORE COMFORTABLE THAN ANOTHER. YOU PICK BROWN SHOES INSTEAD OF BLACK. YOU CREATE YOUR WARDROBE FOR THE DAY. NEXT, YOU ASSEMBLE YOUR BREAKFAST, AGAIN MAKING A HANDFUL OF SMALL DECISIONS THAT REFLECT HOW YOU FEEL. YOU MAKE DECISIONS ON THE WAY TO WORK, WHICH LANE TO TAKE, WHAT STATION TO LISTEN TO, WHERE TO PARK.

SKEPTICAL?

DO THESE REALLY NOT SEEM LIKE CREATIVE ACTS? IS THAT BECAUSE YOU DO THEM BY ROTE? IN OTHER WORDS, DID YOU DECIDE ONCE LONG AGO HOW TO DRESS AND WHAT TO EAT AND NOW YOU JUST GO THROUGH THE MOTIONS? DO YOU SLEEPWALK THROUGH YOUR MORNINGS UNTIL SOMEONE DEMANDS THAT YOU ENGAGE AND MAKE A DECISION? DOES SOMEONE HAVE TO CUT YOU OFF ON THE HIGHWAY AND FORCE YOU TO SLAM ON YOUR BRAKES AND DOUSE YOURSELF WITH ADRENALIN BEFORE YOU PAY ATTENTION TO THE ROAD? COULD BE.

BUT CAN YOU SEE THAT PERHAPS YOU HAVE DECIDED NOT TO DECIDE? HAVE YOU BECOME LIKE ONE OF HENRY FORD'S ASSEMBLY-LINE WORKERS, REPEATING THE SAME MOTIONS, STARING AT THE CONVEYOR BELT OF YOUR DAYS?

SO WHY ISN'T THAT A GOOD THING? WHY ISN'T IT PERFECTLY FINE TO BE ON AUTOPILOT, TO DO THE SAME THINGS THE SAME WAY SO YOUR BRAIN CAN THINK ABOUT OTHER THINGS, SO YOU CAN MAKE PLANS FOR THE EVENING WHILE YOU MECHANICALLY BUTTER YOUR TOAST, SO YOU CAN DAYDREAM ABOUT VACATION WHILE YOU DRIVE, LETTING THE BORING CHORES OF LIFE

"We must rediscover that reality from which we became separated as the formal knowledge we substitute for it grows in thickness and imperviousness – that reality which there is a grave danger we may die without having known, and which is simply our life."

– Marcel Proust

JUST HAPPEN TO YOU? WHAT'S WRONG WITH THAT?

WELL, WHY DON'T YOU TAKE A MINUTE AND CONSIDER THIS: AS YOU TOOL DOWN YOUR WELL-TRAMMELED ROAD,

ARE YOU DRIVING RIGHT PAST YOUR DREAM?

YO! ↑

WHAT HAPPENS WHEN YOU STIFLE Creativity?

THE ABILITY AND THE NEED TO BE CREATIVE ARE HARD-WIRED INTO ALL OF US. I SPEAK TO SO MANY PEOPLE WHO TELL ME THEY MAKE THINGS (DRAWINGS, SOUFFLÉS, JEWELRY, MOVIES, POP SONGS) BECAUSE THEY JUST HAVE TO. THEY CAN'T HELP IT. IT'S A BASIC URGE, AN IRREPRESSIBLE IMPULSE.

YET AN AWFUL LOT OF PEOPLE ARE ABLE TO SUPPRESS IT. THEY TRUDGE BACK AND FORTH IN A RUT, NEVER REINVENTING A SINGLE DAY. THEY JUMP TO CONCLUSIONS ABOUT THEMSELVES AND THEIR ABILITIES AND THEIR OBLIGATIONS THAT THEY THINK WILL HELP THEM AVOID CONFLICT. THEY MAKE CERTAIN CHOICES THAT THEY THINK WILL PREVENT OTHERS FROM BEING DISAPPOINTED, SHOCKED, OR ANGRY.

"Every day we slaughter our finest impulses. That is why we get a heartache when we read the lines written by the hand of a master and recognize them as our own, as the tender shoots which we stifled because we lacked the faith to believe in our own powers, our own criterion of truth and beauty. Every man, when he gets quiet, when he becomes desperately honest with himself, is capable of uttering profound truths." — Henry Miller

BUT DEEP INSIDE THEM, A LITTLE EMBER FLICKERS. THAT EMBER IS THEIR DREAM, THE THING THEY COULD REALLY LIKE TO DO, IF ONLY. IF ONLY THEY HAD THE TIME, THE TALENT, THE EDUCATION, THE TOOLS, THE MONEY, THE SUPPORT, THE FREEDOM. BUT BECAUSE THEY HAVE DECIDED LONG AGO THAT THEY CAN'T, THEY LOCK THAT LITTLE SPARK IN A BIG STEEL BOX, HOPING TO SUFFOCATE IT ONCE AND FOR ALL, AND THEN THEY RUSH ON WITH THEIR CHORES AND OBLIGATIONS. BUT THE EMBER WON'T GO OUT. INSTEAD IT HEATS UP THE STEEL BOX, AND THEY START TO FEEL THAT NEED AGAIN. IT GETS HOTTER AND THE FEELING TURNS TO PAIN. SO THEY REACH FOR AN ANESTHETIC.

OUR SOCIETY IS FULL OF ANESTHETICS — DRUGS, BOOZE, TELEVISION, MASS CULTURE, DESTRUCTIVE BEHAVIORS, ANGER, DEFENSIVENESS, SELFISHNESS — ALL ARE WAYS TO TAKE US AWAY FROM EXPERIENCING THE HERE AND NOW, FROM BEING IN TOUCH WITH OUR TRUE NATURE.

WHEN WE CONTINUE TO DENY WHO WE TRULY ARE AND SUPPRESS OUR ABILITY TO CREATE, WE BECOME CRIPPLED AND SHUT DOWN. OUR MINDS GROW NARROWER AS WE SHUT OUT ANYTHING UNEXPECTED THAT DOESN'T FIT WITH HOW WE'VE TOLD OURSELVES THE WORLD TRULY IS. WE GROW REMOTE FROM OTHERS, CATEGORIZING AND

STEREOTYPING THE PEOPLE WE MEET, THREATENED AND AFRAID, UNABLE TO SEE THEM CLEARLY AND FULLY. WE SPEED THROUGH LIFE, WANTING TO GET ON TO THE NEXT THING, UNABLE TO TAKE PLEASURE IN THE MOMENT. WE CHART LIFE ON A CHECKLIST, TICKING OFF EXPERIENCES AS IF THEY WERE CHORES, OVERLY COMMITTED TO OUR VIEWS AND UNABLE TO DEAL WITH THE UNEXPECTED. WE SEEM DISTRACTED AND SPACED OUT, UNABLE TO HEAR WHAT OUR FAMILY MEMBERS SAY TO US, ALWAYS PREOCCUPIED WITH SOME OTHER PLACE AND TIME.

IRONICALLY, OUR SOCIETY TENDS TO PORTRAY ARTISTS AS DREAMERS. BUT THOSE WHO SUPPRESS THEIR CREATIVITY ARE ACTUALLY THE ONES LIVING IN A DREAM. AN ARTIST IS SOMEONE WHO SEES AND FEELS REALITY VERY INTENSELY. CREATIVITY DOESN'T MEAN JUST MAKING THINGS UP OUT OF THIN AIR. IT MEANS SEEING AND FEELING THE WORLD SO VIVIDLY THAT YOU CAN PUT TOGETHER CONNECTIONS AND PATTERNS THAT HELP TO EXPLAIN REALITY. IT MEANS YOU SEE THE BEAUTY IN THE WORLD RATHER THAN TRYING TO HIDE FROM IT.

"An infant who has just learned to hold his head up has a frank and forthright way of gazing about him in bewilderment. He hasn't the faintest clue where he is and he aims to learn. In a couple of years, what he will have learned instead is how to fake it." - ANNIE DILLARD

ARMOR of @Sir James ScoDAMoRE

It's SCARY, isn't it?

INTRODUCTION - 11

GO WITH THE FLOW.

CREATIVITY is FUNDAMENTAL to all LIVING THINGS
↳ BUT ...
WE ARE ABLE to BLOCK OR miSCHANNEL it
into STRESS, JUDGMENT and MISERY
↳ WHICH ?

CAN TURN INTo a LiFE-Long, NEGATIVE haBIT
↳ WHICH ?

CORRUPTS OUR MINDS and FOSTERS
a BLEAK ViSION of REALITY
↳ SO ?

WE NEED to REORIENT OUR GAZE
IN a POSITIVE DIRECTION
↳ BY ?

SEEING tHE BEAUTY and VALUE of all WE HAVE
↳ BY ?

SEEING and RECORDING and ACKNOWLEDGING
the EViDENCE of OUR SENSES ─── CELEBRATING the EVERYDAY
what the BUDDHISTS call "the TEN THOUSAND THINGS"

What Creativity will DO For YOU:

I WANT TO HELP YOU RE-ENGAGE WITH YOUR LIFE AND YOUR DREAM.

I WANT TO SHOW YOU THAT IT IS POSSIBLE. THAT YOU CAN DO IT. THAT YOU CAN DRAW, AND WRITE, AND SING, AND LIVE MORE RICHLY, AND FIND AND BE THE REAL YOU.

THIS HAS NOTHING TO DO WITH HOW MUCH MONEY YOU HAVE OR HOW MUCH TIME. IT HAS NOTHING TO DO WITH WHAT YOU'VE DONE IN THE PAST OR WHAT PEOPLE TELL YOU THAT YOU CAN DO OR WITH HOW YOU MAKE A LIVING OR WHERE YOU LIVE OR ANY OF THAT.

YOU ALREADY HAVE ALL THE THINGS YOU WILL NEED: THIS BOOK (THOUGH YOU WON'T NEED IT FOR LONG). THAT EMBER INSIDE YOU (AND IT'S VERY POSSIBLE YOU DON'T EVEN FEEL ITS HEAT ANYMORE, DON'T UNDERSTAND IT, CAN'T IDENTIFY IT, THINK IT'S GONE COMPLETELY OUT). AND YOU HAVE TODAY.

THIS DAY IS FULL OF EXTRAORDINARY THINGS THAT YOU ARE MISSING. WONDERFUL SIGHTS, LIKE THE SUN ON YOUR COUNTERPANE, THE HAIRS ON YOUR CAT'S TAIL, THE CRACKS IN THE PAINT ON YOUR RADIATOR, THE LEAVES PILING UP AGAINST THE CURB. WONDERFUL SMELLS, WONDERFUL SOUNDS. WONDERFUL PEOPLE. WONDERFUL OPPORTUNITIES. TODAY IS WONDERFUL. BUT PERHAPS YOU HAVE LOST YOUR SENSE OF WONDER.

I'M NOT SAYING THIS BECAUSE I KNOW YOU. I'M SAYING THIS BECAUSE I KNOW ME. I HAVE SPENT TOO MUCH OF MY OWN LIFE WITH DIRTY GLASSES ON, WITH MY EARS STOPPED UP WITH COTTON AND PRECONCEPTIONS, WITH CLOGGED NOSTRILS AND A COATED TONGUE. FOR THE PAST FEW YEARS THOUGH, I HAVE WORKED TOWARD CLARITY BY DOING THE THINGS THAT I WILL TELL YOU ABOUT IN THIS BOOK.

AS I'VE BECOME CLEARER, MY LIFE HAS CHANGED. I HAVE BECOME HAPPIER. I HAVE DEEPENED MY APPRECIATION FOR WHAT I HAVE. I HAVE MET NEW PEOPLE AND STRENGTHENED THE CONNECTIONS WITH THE PEOPLE I KNOW. I HAVE SUBDUED MANY OF MY FEARS. I HAVE FOUND WORK THAT I LOVE. I HAVE HAD OPPORTUNITIES RAIN DOWN ON ME.

BUT I STILL HAVE MORE WORK TO DO, MORE WINDOWS IN MY SOUL TO WASH, MORE MUSIC TO HEAR, MORE HANDS TO SHAKE, MORE DRAWINGS TO MAKE.

THE ROAD I HAVE DRIVEN IS PROBABLY NOT THAT DIFFERENT FROM THE ONE YOU ARE ON. LET ME TELL YOU WHERE I HAVE BEEN SO FAR.

MY STORY (so far)

AT SIX, IT WAS UNIVERSAL. WE ALL DREW AND PAINTED, SANG AND SCULPTED. WE WERE ALL ARCHITECTS AND ACTORS, POTTERS AND DANCERS. IT WAS INNATE AND NATURAL.

I LIVED AROUND THE WORLD AS A CHILD, IN LAHORE AND LONDON, IN PITTSBURGH AND CANBERRA, STUDIED AT ST. JOHN'S AND ON A KIBBUTZ. I COULD QUICKLY FALL IN WITH ANY OTHER KID AND WE'D PRETEND TO BE MOUNTAIN CLIMB- ERS OR SCIENTISTS, WE COULD BUILD FORTS OUT OF SOFA CUSHIONS OR TURN A REFRIGERATOR BOX INTO A THEATER. I WROTE AND ILLUSTRATED BOOKS. IN A SCHOOL PLAY, I PLAYED A DOG THAT SAVED A FAMILY FROM THEIR BURNING HOUSE. I HAD AN ALTER EGO, ROGER WATFORD, AN ENGLISH LORD WHO SMOKED A PIPE AND CARRIED A SWORD. I MADE PIRATE MAPS, SOAKING THEM IN TEA FOR VERISIMILITUDE. I WORE MY HALLOWEEN COSTUME YEAR ROUND.

TWENTY YEARS LATER, I WORE TIES. I DREW ONLY WHEN DOODLING ON THE PHONE. I NEVER WENT TO GALLERIES OR MUSEUMS OR PLAYGROUNDS. I WATCHED GOLF ON TV.

I WAS NOT AN ARTIST ANYMORE.

I HAD VEERED OFF THE ROAD A FEW YEARS BEFORE. AT EIGHTEEN, I WROTE A COLLEGE APPLICATION ESSAY ON WHY I FELT THAT WRITING, RATHER THAN DRAWING, WAS THE MORE APPROPRIATE AND USEFUL MEDIUM OF EXPRESSION FOR ME. IT CAME DOWN TO A SIMPLE EQUATION. ARTISTS STARVED; WRIT- ING WAS USEFUL IN ALL ASPECTS OF BUSINESS.

PRINCETON HAD A PAINTING DEPARTMENT. I ASSUMED THAT ITS MEMBERS WERE LAZY, UNWILLING TO TAKE ON A PROPER MAJOR OR TO ATTEND A REAL ART SCHOOL. ARCHITECTURE STUDENTS WORKED NOTORIOUSLY LONG HOURS. FOOLS, AGAIN. AT BEST, I'D HEARD, THEY'D MAKE $30 GRAND A YEAR.

BY TWENTY-ONE, I'D BECOME CYNICAL, RIGID, AND UNIMAGINATIVE. I WAS READY TO GET TO WORK.

I HAD TALKED MYSELF OUT OF GOING TO ART SCHOOL BECAUSE

I BELIEVED THAT THE ONLY WAY TO MAKE A LIVING WOULD BE TO BE A "COMMERCIAL" ARTIST, WHICH SEEMED HORRIBLY COMPROMISED TO ME. BUT I DIDN'T HAVE ANY BETTER CAREER IDEAS. MY EXPERIENCE WORKING FOR A LOCAL PAPER HAD LED ME TO BELIEVE THAT JOURNALISTS WERE MERE OBSERVERS RATHER THAN PARTICIPANTS. IT SEEMED MY FRIENDS WHO WENT INTO INVESTMENT BANKING WERE TOTAL SELLOUTS. THREE MONTHS AFTER GRADUATION, I FELL INTO ADVERTISING. IT WAS A JOB, AND GOT ME OUT OF MY PARENTS' HOUSE. IN HARPER'S MAGAZINE, I READ AN ESSAY THAT CONCLUDED "CREATIVE PEOPLE IN ADVERTISING ARE ARTISTS... WITH NOTHING TO SAY." IT SEEMED APT. FOR THE NEXT TWENTY YEARS, IT WAS WHAT I DID.

THE ADVERTISING PROFESSION IS DIVIDED INTO "CREATIVES" (NOUN, RATHER THAN ADJECTIVE) AND ACCOUNT PEOPLE. CREATIVES ARE DIVIDED INTO ART DIRECTORS AND COPYWRITERS. I WAS THE LATTER, AND YET I DREW MORE AND BETTER THAN THE ART DIRECTORS I WORKED WITH. I HAD ENDLESS OPINIONS ABOUT THE VISUAL SIDE OF THE BUSINESS BUT I WAS ADAMANT THAT I WAS A COPYWRITER. I WOULD NOT BE JUDGED AS A VISUAL PERSON. I WAS NOT AN ARTIST.

DESPITE ALL THE MEETINGS I SAT THROUGH, ALL THE PRODUCT I MOVED, ALL THE CONCESSIONS AND COMPROMISES I MADE, THE URGE TO MAKE THINGS COULD NOT BE COMPLETELY QUASHED. FIRST OF ALL, I MADE ADS. I WORKED WITH PHOTOGRAPHERS AND DIRECTORS AND EDITORS AND COMPOSERS TO POLISH 30 SECONDS AT A TIME. WE ALL THREW OURSELVES MOST FERVENTLY INTO THESE PRODUCTIONS, BEING ADAMANT ABOUT THE TINIEST THINGS, THE SHADE OF BLUE OF A MODEL'S BLOUSE, THE PLACEMENT OF A COMMA. WE WOULD FALL ON OUR SWORDS ALL THE TIME, SO INTENT WERE WE TO ASSERT OUR CREATIVE WILL.

BUT MY INNER ARTIST PLAGUED ME LIKE HOMOSEXUALITY MUST PLAGUE THOSE STILL IN THE CLOSET. I WOULD JAM IT DOWN, INSISTING IT WAS IMPRACTICAL, THAT I WAS NOT GOOD ENOUGH, THAT IT WAS A HUGE WASTE OF TIME. BUT THAT CREATIVE URGE WOULD POP ITS HEAD OUT SOMEWHERE ELSE.

I WAS NOT "A PAINTER" (THOUGH I DID PAINT AT HOME, BALANCING HUGE CANVASES ON MY DINING ROOM CHAIRS BECAUSE I WOULD NOT COMMIT TO HAVING AN EASEL). I WAS NOT REALLY "A WRITER" EITHER, AND STOPPED WRITING THE FICTION I HAD PUMPED OUT IN SCHOOL.

WHEN I WAS TWENTY-THREE, I WROTE A PLAY AND SOME PRODUCERS STARTED TO RAISE MONEY TO PUT IT ON. WE DID A READING WITH KEVIN BACON IN THE LEAD. I DID NOTHING TO HELP. THE PRODUCTION GREW UNTIL THE PLANS WERE TO TRY TO STAGE IT OFF-BROADWAY AT THE HENRY MILLER THEATER, THEN ON BROADWAY ITSELF. I STOOD BY. EVENTUALLY THE PLANS GREW SO BIG, THEY COLLAPSED. I DID NOTHING TO REVIVE THE PLAY. I'M NOT SURE IF I STILL EVEN HAVE A COPY.

THREE DIFFERENT TIMES, I BOUGHT MYSELF

A KEYBOARD AND SET UP MUSIC LESSONS. EACH
TIME, I SABOTAGED MYSELF AFTER A WEEK,
MISSING PRACTICE AND LESSONS BECAUSE I WAS
SO BUSY AT WORK.

I DESIGNED AND BUILT THE FURNITURE FOR
OUR APARTMENT OUT OF BIRD'S-EYE MAPLE. BUT
THEN TOLD MYSELF WE SHOULD JUST REPLACE IT
CHEAPLY AT IKEA.

I GOT A CONTRACT TO WRITE A BOOK OF
HIGHLY SUBJECTIVE, FUNNY ESSAYS ABOUT NEW
YORK BARS. I WROTE 250 PAGES BUT THEN MY
EDITOR LEFT THE HOUSE. MY NEW EDITOR WANTED
TO MAKE CHANGES. I REFUSED. THE BOOK
FADED AWAY (BUT I HELD ON TO THE ADVANCE).

I WOULD COME HOME AND COOK, HAND-
GRINDING SPICES, ROLLING OUT RAVIOLIS,
SHOPPING FOR MONTHS FOR THE PERFECT
KNIFE, MAKING ELABORATE DISHES THAT
I WOULD EAT BY MYSELF, STANDING OVER
THE SINK. I WORKED HARD ON WHAT
I WORE, SCOURING VINTAGE STORES FOR
HAND-MADE SUITS, COLLECTING HUNDREDS
OF TIES, DRESSING AND RE-DRESSING
MYSELF TO GET THE LOOK JUST SO.

SOMEONE GAVE ME A HARMONICA AND I
KEPT IT IN THE SHOWER, WHERE I WOULD PLAY
IT TILL THE PIPES RAN COLD. WHENEVER SOMEONE
IN OUR FAMILY HAD A BIRTHDAY, I WOULD DE-
VELOP ELABORATE THEMES TO MY PRESENTS AND
PRINT MY OWN WRAPPING PAPER.

I SAW EVERY MOVIE THAT CAME OUT,
HUNDREDS A YEAR, TELLING MYSELF IT WAS
PART OF MY JOB AND TAX DEDUCTIBLE TO
BOOT. I WATCHED THEM INTENTLY, MEMORIZ-
ING CAMERA PLACEMENTS, NOTING EDITING
TECHNIQUES, THE NAMES OF KEY GRIPS.

I MADE MY GIRLFRIEND ELABORATE HAND-
MADE GIFTS. I WROTE AND ILLUSTRATED BOOKS
FOR HER, EVEN EPIC POEMS. I CONVINCED MY

BOSS TO LET ME HAVE A LASER PRINTER IN MY
OFFICE, AND THEN WORKED BEHIND CLOSED
DOORS TO PRINT MY BOOKS ON SPECIAL PAPERS,
TO MAKE SLIPCASES AND DESIGN MY OWN TYPE.
I WOULD FINESSE EACH PIECE OVER AND OVER,
READJUSTING THE KERNING, THE LEADING, TILL
IT WAS PERFECT. I WORKED FOR MONTHS ON
EACH ITEM, A SINGLE EDITION OF ONE BOOK. I
WAS DOING IT FOR LOVE. BUT I DIDN'T DEAL
WITH THE FACT THAT I WAS DOING IT BECAUSE
I HAD TO.

LONG BEFORE WE BECAME PARENTS, I
MADE INTENSE HOME MOVIES, COSTUMING PATTI
AND DRIVING HER TO INTERESTING LOCATIONS.
I DROVE HER IN A CAR I HAD BOUGHT SIMPLY
BECAUSE IT WAS BEAUTIFUL, A 1962 MERCURY
MONTEREY THAT WAS 18 FEET LONG AND
TWO-TONE: CORNFLOWER BLUE AND WHITE. IT
WAS COMPLETELY IMPRACTICAL, FAR TOO BIG
FOR MANHATTAN, AND I RARELY DROVE IT.
BUT I POLISHED IT AND REUPHOLSTERED IT, A
GLEAMING FEAST FOR THE EYE.

FADE-OUT.

ANOTHER DECADE PASSES. I AM MARRIED. I
HAVE GAINED A SON AND THIRTY POUNDS.

MY CAREER HAS CONTINUED TO CLIMB. I
AM AT THE TOP OF MY FIELD, RUNNING THE
CREATIVE DEPARTMENT OF AN AGENCY.

BUT I AM SUFFOCATING.

I AM UNDER ENORMOUS PRESSURE TO MAKE
OTHER PEOPLE PRODUCE CREATIVE IDEAS. MONEY IS
INEXTRICABLY WOUND UP IN EVERYTHING. ALL OUR
EFFORTS ARE JUDGED AND HARSHLY.

I SLOWLY COME TO REALIZE I HAVE BEEN
LEADING A FALSE LIFE FOR SO LONG THAT
I AM NOT WHO I AM PRETENDING TO BE. I
HAVE BEEN USING MY CREATIVE ABILITY PURELY
TO PROVIDE MONEY FOR MY FAMILY. THERE IS
NO JOY IN THE PROCESS. THE THINGS I MAKE

ARE COMPLETELY AT THE BEHEST OF OTHERS: I AM MAKING ADVERTISING CAMPAIGNS FOR INVESTMENT BANKS, FOR PEOPLE WHO SELL WEAPONS SYSTEMS, FOR CHEMICAL PRODUCERS AND MANAGEMENT CONSULTANTS. I AM MAKING MORE MONEY THAN I EVER HAVE AND YET I FEEL COMPLETELY BANKRUPT. NOTHING I DO IS FOR ME. I AM A BITTER INSOMNIAC. A FEW YEARS BEFORE, I HAD FOUND ONE OUTLET THAT MEANT A LOT TO ME. I HAD BEGUN AN ILLUSTRATED JOURNAL AND HAD BECOME QUITE GOOD AT DRAWING THE LITTLE THINGS I ENCOUNTERED EVERY DAY. I TOOK A CLASS IN BOOKBINDING AND LEARNED TO MAKE MY OWN JOURNALS. FOR A WHILE, IT WAS A GREAT ESCAPE. BUT THEN I'D STOPPED THAT, TOO. MY POSITION AS CREATIVE DIRECTOR MEANT THERE WAS NO TIME FOR SUCH THINGS, FOR THE FOLDEROL OF MAKING THINGS THAT DID NOT CONTRIBUTE TO THE AGENCY'S BOTTOM LINE. I LOCKED MY JOURNALS AWAY AND FOR FIVE YEARS I FOCUSED EXCLUSIVELY ON MY JOB, TWELVE HOURS A DAY. MY WIFE GREW DISTANT BUT I DIDN'T NOTICE. I HAD NO FRIENDS OUTSIDE OF WORK AND NO TIME FOR THEM IN ANY CASE. WHATEVER LITTLE BURBLINGS OF CREATIVITY I USED TO HAVE, THAT I HAD ONCE CHANNELED INTO COOK- ING AND FASHION AND GIFTS, WAS 100% CHANNELED INTO SERVICING CLIENTS.

THE CAMEL'S BACK FINALLY BROKE.

THROUGH MY JOB I STARTED TO MEET SOME OF THE TOP GRAPHIC DESIGNERS, PEOPLE LIKE STEFAN SAGMEISTER, WOODY PIRTLE, AND PAUL SAHRE, AND AS I TALKED TO THEM, I FOUND MYSELF ADMITTING HOW MUCH I HATED WHAT I DID, HOW LOST I FELT. I WAS SUP- POSED TO BE THEIR CLIENT BUT I TREATED THEM LIKE MENTORS. I SO ENVIED THEIR LIVES,

MAKING ALL SORTS OF THINGS FOR PEOPLE, WORKING ON THEIR OWN PROJECTS, COMMIT- TING THEMSELVES TO SOCIAL CHANGE, TURNING DOWN WORK IF THEY FELT IT WAS WRONG, LIVING ON A FIFTH OF WHAT I WAS MAKING AND SEEMING WELL-ROUNDED AND COMPLETE. FINALLY ONE OF THEM SUGGESTED I GET BACK TO MY JOURNALING. HESITANTLY, I DID.

I LET ART BACK IN THE DOOR AND SUD- DENLY THE WALLS STARTED TO CRACK. WITHIN A MONTH, I HAD A BOOK CONTRACT. A FEW MONTHS LATER, I HAD A SECOND, THIS ONE TO PUBLISH MY ILLUSTRATED JOURNALS. I WAS INVITED TO ILLUSTRATE BOOKS AND MAGAZINES. BEFORE LONG, I GOT A WONDERFUL AGENT. I MADE FRIENDS AROUND THE WORLD WHO PAINTED AND DREW AND COMPOSED MUSIC AND I SET OFF TO VISIT THEM. I WAS NO LONGER "IN MANAGEMENT" OR "CLIMBING THE LADDER."

INSTEAD, I WAS ME.

Some Wisdom from my Wife:

"I believe in the energy of art, and through the use of that energy the artist's ability to transform his or her life and, by example, the lives of others."
- Audrey Flack

They say that when someone is sick and dying, with a heightened awareness that their days are numbered and few, they develop a new appreciation of little things. Things intensify and become special and precious. That view out the window, that snowflake, that conversation, that kiss — each one could be your last.

The trick is to incorporate this perspective into your healthy — though challenging - life. Drawing does that; you pay attention in a way you normally wouldn't. Focus repels the distractions that muddle the experience. Every line, page, brick, unit of the thing you draw becomes essential. You're looking to catch each component in order to understand the construction of the object and therefore realize the beauty of its balance, the necessity of each small part. You look and examine that thing with love. You desire to recognize every part to capture it in your drawing. You can feel security about your subject and at peace with recognizing the value of every little thing and moment in your life.
- Patti Lynn Gregory

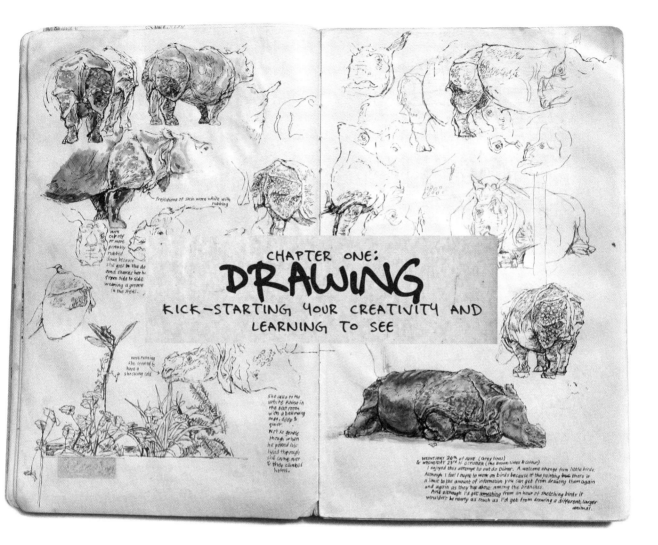

CHAPTER ONE:
DRAWING
KICK-STARTING YOUR CREATIVITY AND LEARNING TO SEE

WHILE MOST OF THE DRAWINGS IN THIS BOOK ARE MINE, MANY OF THE CHAPTERS START WITH PAGES FROM THE ILLUSTRATED JOURNALS OF ARTIST PALS OF MINE FROM AROUND THE WORLD. I HOPE YOU LEARN AS MUCH FROM THEM AS I DO.

From the journals of Richard Bell...

Hopefully, by now you are convinced, or at least open to the idea, that leading a more creative life is a good thing. But how? Where are you going to find the time and the ability and the resources to become more creative?

Let's review some of the steps to creativity.

You need to move away from pure left-brain thinking that is overly rational and literal and regimented, so you can form the sorts of free-form associations that are the richest benefit of creativity.

You need to stretch yourself beyond the habits that have forced your life into a rut. You need to see life anew and become more adventurous. You have to feel confident and safe in what you're doing but also comfortable moving into fresh and exciting new directions.

And you need to get into the habit of living and thinking and seeing in new ways on a regular, day-to-day basis.

We're going to start by developing one of your creative skills. It's a skill that you had when you were small but now almost certainly think you have lost. It's a skill that will immediately begin to stretch your mind, to transform how you see the world. It's a skill that takes minutes to learn but a lifetime to master.

looking uptown past the Toy district clock.

You Are going to Learn to DRAW.

YIKES! (gulp!)

TAKE A DEEP BREATH, HAVE A STIFF DRINK, SAY A QUICK PRAYER, WHATEVER, THEN LET'S GET DOWN TO IT.

LET'S START WORK IN SOME PRIVATE-ISH PLACE, WHERE IF YOU MAKE A MESS OR START SCREAMING AND RIPPING UP DRAWINGS NO ONE WILL BLUNDER IN AND START LAUGHING AT YOU.

NEXT, GET SOME PAPER. NOTHING FANCY, SOME BASIC COPIER PAPER, A NOTEBOOK, WHATEVER YOU WANT.

JUST MAKE SURE YOUR PAGES ARE A DECENT SIZE, AT LEAST 8" x 11", SO YOU CAN STRETCH OUT COMFORTABLY.

AND GET A BUNCH OF IT, DON'T BE MISERLY.

"I cannot tell you how happy I am to have taken up drawing again. I've been thinking of it, but I always considered the thing impossible and beyond my reach."
-Vincent Van Gogh in a letter to his brother

Next, get a PEN:

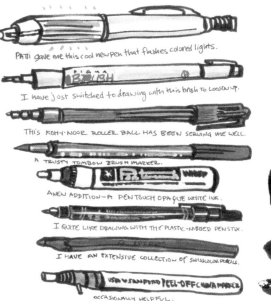

PATTI gave me this cool new pen that flashes colored lights.

I have just switched to drawing with this brush to loosen up.

THIS KOH-I-NOOR ROLLER BALL HAS BEEN SERVING ME WELL.

A TRUSTY TOMBOW BRUSH MARKER.

A NEW ADDITION—A PEN TOUCH OPAQUE WHITE INK.

I QUITE LIKE DRAWING WITH THE PLASTIC-NIBBED PENSTIX.

I HAVE AN EXTENSIVE COLLECTION OF SWISSCOLOR PENCILS.

OCCASIONALLY HELPFUL.

PENS

A BALLPOINT, A MARKER, WHATEVER FEELS GOOD. AT THIS POINT, BEST PROBABLY TO AVOID SOMETHING TOO THIN AND SCRATCHY OR TOO THICK AND BLOBBY. BUT IT'S YOUR CHOICE. DO NOT USE A PENCIL OR ERASE ANY OF YOUR LINES. IF YOU CHANGE YOUR MIND ABOUT A LINE AS YOU DRAW IT, SIMPLY DRAW A NEW ONE NEXT TO IT. NOW, FOR LAUGHS, LET'S MAKE A RECORD OF WHAT YOUR DRAWINGS LOOK LIKE BEFORE YOU'VE PRACTICED AT ALL. DRAW THE FOLLOWING:

"Do not fail, as you go on, to draw something every day, for no matter how little it is, it will be well worthwhile, and it will do you a world of good." — CENNINI

① DRAW a CHAIR.
② DRAW a MUG.
③ DRAW a TABLE.
④ DRAW a PERSON.

DO NOT ERASE ANY OF YOUR LINES.
DATE YOUR DRAWINGS.
DON'T READ AHEAD.
GO TO IT.

WHAT DO YOU THINK? WAS THAT FUN? WAS IT HARD? WERE YOU EMBARRASSED? WAS THERE ANYTHING THAT SURPRISED YOU?

DID YOU LOOK AT SOMETHING WHEN YOU DREW IT OR DID YOU JUST DRAW OUT OF YOUR HEAD?

WRITE DOWN YOUR THOUGHTS. YOU COULD DO THIS NEXT TO THE DRAWINGS OR ON A SEPARATE SHEET OF PAPER.

NOW PUT THOSE DRAWINGS SOMEWHERE WHERE YOU CAN LOOK AT THEM SOMETIME IN THE FUTURE. DO NOT RIP THEM UP OR SCRIBBLE OVER THEM. BELIEVE ME, YOU WILL BE VERY HAPPY TO HAVE THESE BABY PICTURES TO LOOK BACK ON WHEN YOU ARE DRAWING MORE CONFIDENTLY. AND I BET YOU WILL FIND SOME THINGS ABOUT THESE DRAWINGS THAT YOU WILL LIKE QUITE A BIT.

"When my daughter was about seven years old, she asked me one day what I did at work. I told her I worked at the college — that my job was to teach people how to draw. She stared at me, incredulous, and said, 'You mean they forget?'" — Howard Ikemoto

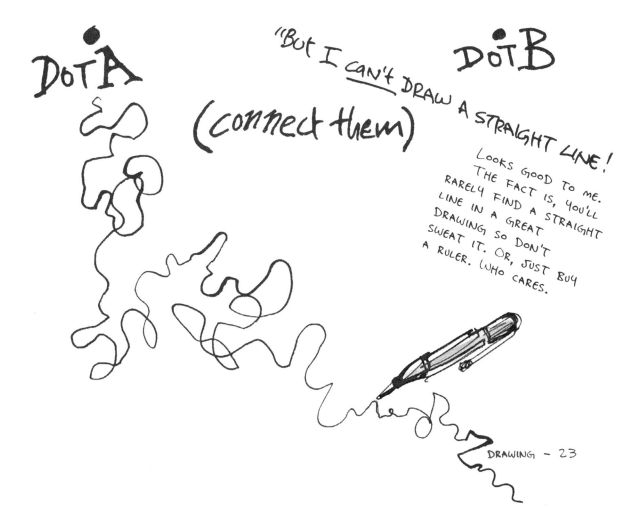

DOT A

"BUT I CAN'T DRAW A STRAIGHT LINE!

DOT B

(connect them)

LOOKS GOOD TO ME. THE FACT IS, YOU'LL RARELY FIND A STRAIGHT LINE IN A GREAT DRAWING SO DON'T SWEAT IT. OR, JUST BUY A RULER. WHO CARES.

DRAWING - 23

HERE'S THE BASIC IDEA:

LIKE MOST WORTHWHILE SKILLS, DRAWING CAN
BE BROKEN DOWN TO A HANDFUL OF BASIC LESSONS
WHICH YOU WILL GRASP QUICKLY
AND THEN TAKE THE REST OF
YOUR NATURAL LIFE TO MASTER.
TO SUSTAIN YOUR INTEREST, IT'S
IMPORTANT THAT YOU GET SOME
SATISFACTION FAIRLY EARLY ON, SO YOU CAN
ACTUALLY BELIEVE THAT WE ARE HEADING IN THE
RIGHT DIRECTION. WHILE IT IS UP TO YOU TO KEEP
PRACTICING, I BELIEVE THAT IN A FEW DAYS, MAYBE
A WEEK, YOU WILL HAVE THE BASIC TOOLS YOU NEED
TO MAKE DRAWING A REGULAR PART OF YOUR LIFE.
AND THAT'S WHEN THE ADVENTURE IS REALLY GOING
TO BEGIN.

SO HERE ARE SOME BASIC LESSONS, PULLED FROM
MY OWN EXPERIENCE OF LEARNING TO DRAW WHEN I
WAS IN MY MID-THIRTIES. YOU CAN COMPLETE MOST
OF THEM IN UNDER AN HOUR AT A GO. TOGETHER
THEY WILL PROVIDE YOU WITH THE CREATIVE
EQUIVALENT OF A LEARNER'S PERMIT. ONCE YOU'VE
GIVEN THEM A TRY, WE CAN GET ONTO THE HIGHWAY
AND START GOING PLACES. AND ULTIMATELY, YOU
WON'T NEED MY HAND RESTING NEXT TO YOURS ON
THE WHEEL. YOU CAN TAKE OFF ON YOUR OWN, TO
WHEREVER IT IS YOUR HEART AND SOUL WILL SEND YOU.

what is Drawing Exactly?

OBVIOUSLY IT'S YOUR HAND, HOLDING A PEN AND MAKING LINES ON PAPER. BUT HOW DOES YOUR HAND KNOW HOW TO DO THAT? IT'S NOT LIKE GOLF WHERE YOUR GRIP IS HUGELY IMPORTANT. PEOPLE HOLD PENS IN ALL SORTS OF WAYS.

IT'S NOT YOUR PEN ITSELF, THOUGH DIFFERENT PENS DO MAKE DIFFERENT SORTS OF MARKS. PICASSO COULD DRAW BEAUTIFULLY WITH A CRAYON, A BURNT STICK, OR HIS FINGER DIPPED IN PAINT.

THE MOST IMPORTANT PART OF DRAWING IS SEEING. (AND I'M NOT TALKING ABOUT YOUR EYESIGHT — MATISSE DREW BEAUTIFULLY WHEN HE WAS LEGALLY BLIND.)

YOU NEED TO SEE WHAT'S IN FRONT OF YOU IN A WAY YOU PROBABLY DON'T RIGHT NOW.

YOU NEED TO SLOW DOWN.

YOU NEED TO GET RID OF YOUR PRECONCEPTIONS ABOUT WHAT'S IN FRONT OF YOU.

HERE'S A GOOD EXAMPLE. ASK THE AVERAGE, NON-DRAWING PERSON TO DRAW A MUG AND THIS IS WHAT THEY'LL DO.

THEY'LL DRAW A ROUND OPENING. MAYBE THEY'LL RECOGNIZE THAT THEY ARE LOOKING AT THE MUG ON AN ANGLE AND WILL MAKE THAT CIRCULAR OPENING INTO AN OVAL OF SORTS. VERY NICE, THE TOP OF THE MUG LOOKS JUST LIKE THAT. THEN THEY'LL DRAW THE SIDES, STRAIGHT UP AND DOWN. THEY'LL ADD A HANDLE.

THE TEST OF WHETHER THEY ARE REALLY LOOKING COMES WHEN THEY DRAW THE BOTTOM. ALMOST EVERYONE WILL JUST DRAW A STRAIGHT LINE ACROSS. BUT LET'S REALLY LOOK AT A MUG ON A TABLE.

SEE IT? THE BOTTOM IS CURVED JUST LIKE THE TOP. SO YOU DRAW THAT SAME CURVED LINE.

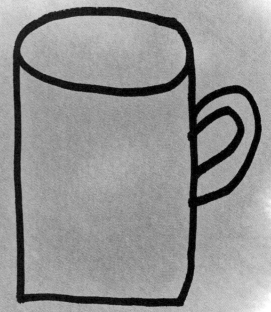

WHY? IT DOESN'T MATTER WHY. FORGET THE RULES, FORGET WHAT YOU'VE READ ABOUT PERSPECTIVE, JUST LOOK AT WHAT'S RIGHT IN FRONT OF YOU.

SO WHY DON'T MOST PEOPLE SEE THAT THE BOTTOM IS CURVED RIGHT OFF? BECAUSE THEY ARE THINKING, NOT SEEING.

THEY KNOW THE TABLE IS FLAT, THE BOTTOM OF THE MUG IS FLAT, AND THE WAY YOU DRAW SOMETHING FLAT IS WITH A STRAIGHT LINE.

YOUR (LEFT) BRAIN IS FAR MORE POWERFUL THAN YOUR EYEBALLS. IT HAS NO PROBLEM IGNORING THE DATA COMING IN AND TRANSFORMING IT INTO SOMETHING ELSE.

BUT THEN, WHEN YOU LOOK AT THE DRAWING OF THE MUG, SOMETHING SEEMS WRONG. YOUR EYES SAY, HUH, THIS LOOKS WEIRD. BUT YOUR BRAIN, SO SURE THAT IT'S RIGHT, CAN'T FIGURE OUT WHY AND CAN'T SEE WHAT HAPPENED. SO YOU GIVE UP.

HOW DO WE GET AROUND THIS? WE HAVE TO SHUT YOUR BRAIN OFF. OR AT LEAST THE PART OF YOUR BRAIN THAT IS SO STUCK ON RULES AND CORRECTNESS AND FLAT BOTTOMS.

YOU DON'T NEED A LOBOTOMY OR HEAVY ANESTHETICS. YOU JUST NEED TO BORE YOUR LEFT BRAIN BY SLOWING WAY, WAY DOWN.

Get a Mug. Put it on a table

"It is looking at things for a long time that ripens you and gives you a deeper understanding."
—Vincent van Gogh

NOW GET YOUR PEN AND PUT IT ON YOUR PAPER.

GET YOUR EYEBALLS AND REST THEIR GAZE ON THE UPPER LEFT-HAND SIDE OF THE MUG.

REALLY SLOWLY, MOVE YOUR EYE AROUND THAT UPPER BACK EDGE OF THE MUG'S RIM.

AND, JUST AS SLOWLY, TRACE THAT LINE ON THE PAPER. DON'T LOOK DOWN!

OH, NO!

JUST LOOK AT THE MUG AND LET YOUR PEN MOVE ACROSS THE PAPER REALLY SLOWLY. TAKE THIRTY SECONDS TO FOLLOW THAT CURVE ACROSS THE TOP. FEELS LIKE FOREVER, RIGHT? IT'S THE LENGTH OF A BEER COMMERCIAL. NOW SLIDE DOWN THE RIGHT SIDE, SLOWLY. NOW ACROSS THE TOP OF WHAT YOU CAN SEE OF THE HANDLE, ARCING AROUND IT AND DOWN THE UNDERSIDE OF THE HANDLE, THEN TO THE ANGLE WHERE THE HANDLE MEETS THE MUG, THEN SLOWLY DOWN THE REST OF THE SIDE OF THE MUG.

NOW LET'S BEGIN TO TRAVEL ACROSS THE BOTTOM OF THE MUG. CURVING SLOWLY, SLOWLY, TAKING THAT COMMERCIAL BREAK.

NOW YOU'VE REACHED THE OTHER SIDE AND ARE SLOWLY COMING UP THE LEFT SIDE TO WHERE YOU STARTED.

LOOK AT YOUR PAPER.

OH, NO! IT DOESN'T CONNECT!

OH, NO! IT DOESN'T REALLY LOOK LIKE A MUG!

ALL TRUE, BUT IT'S A GOOD RECORD OF WHAT YOU JUST SAW AND WHERE YOUR EYEBALLS ROLLED. WHY ISN'T IT PERFECT? BECAUSE YOUR EYES FIND IT REALLY HARD TO TRAVEL AT THE SAME CONSISTENT SPEED. THEY FLITTER ABOUT, DRAG THEIR FEET, THEN DART AHEAD, JUST LIKE A BRAND-NEW DRIVER JAMMING ON THE BRAKES, THEN HITTING THE GAS. YOUR TEMPO WAS PROBABLY BETTER WHEN YOU WENT DOWN THE RIGHT SIDE, AROUND THE HANDLE, BECAUSE THERE WERE LANDMARKS TO FOLLOW, BUT MAYBE YOUR CURVES AND ANGLES WERE OFF.

LET'S KEEP GOING. PUT YOUR PEN AND EYEBALLS BACK IN THAT UPPER LEFT-HAND CORNER AND NOW LET'S TRACE THE INNER MOUTH OF THE MUG. SLOWLY GO AROUND THE WHOLE ELLIPSE TILL YOU'RE BACK MORE OR LESS TO WHERE YOU STARTED.

AND NOW LET'S DO THE SAME WITH THE MUG'S HANDLE. LOOK AT YOUR PAPER. POSITION YOUR PEN ON THE TOP-MOST PART OF THE INSIDE OF THE HANDLE AND, MOVING CLOCKWISE, TRACE THAT SHAPE, DOWN AND THEN BACK UP.

SO WHAT DO YOU THINK OF THIS DRAWING? IT'S WEIRD, OFF-KILTER, MAYBE COMPLETELY UNIDENTIFIABLE AS A MUG. BUT IT'S A RECORD OF HOW YOU SAW, PROBABLY A FAIRLY ACCURATE ONE. YOUR HAND DID ITS JOB. SO DID YOUR PEN. IT'S YOUR EYEBALLS THAT NEED TRAINING, YOUR EYEBALLS AND WHATEVER IS CONNECTING THEM TO YOUR HAND.

PAUSE FOR SELF DIAGNOSTICS.

WHAT DO YOU REMEMBER ABOUT WHAT YOUR BRAIN WAS DOING DURING THIS EXPERIENCE? WAS IT YAMMERING A LOT AT FIRST? TELLING YOU "YOU CAN'T DRAW" OR "THIS IS TOO HARD" OR "THIS IS TOO EASY"? AT SOME POINT, AS YOU WENT REALLY SLOWLY, DID YOUR BRAIN SHUT UP? DID IT WANDER OFF AND START GNAWING ON SOME OTHER BONE? OR DID IT JUST ZONE OUT?

WHEN YOU WERE DONE, DID YOU FEEL RELAXED, REFRESHED, TRANQUIL? DID YOU LOSE ALL SENSE OF HOW MUCH TIME WAS PASSING? OR DID YOU OBSESS THE WHOLE TIME? (IF YOU DID, TRY THIS EXERCISE AGAIN AND TAKE TWICE AS LONG TO DO IT.)

"It is only by drawing often, drawing everything, drawing incessantly, that one fine day you discover to your surprise that you have rendered something in its true character."
— Camille Pissarro

CONGRATULATIONS!

You just managed to shut down your left brain (or at least distract it) so you could see more clearly.

When you do something really slowly and deliberately like tracing that mug's contour, your left brain struggles to maintain control but eventually gives up or wanders off. Your right **brain** has much less of a sense of time or rules or rigidity and will take you to that relaxed alpha state.

Can you see that all drawing from life is just an extension of what you just did? It's all about seeing and recording what you see. Seeing carefully, accurately, slowly, clearly. Then getting it down on paper.

Do you think "talent" has much to do with what you just did?

Or can you see that if you keep **drawing** that mug, you'll be more and more accurate in how you see and how you record?

Get yourself a BAGEL.

PREFERABLY ONE WITH SOME SORT OF STUFF ON TOP — SALT, GARLIC, SESAME SEEDS, ETC.

NO BAGELS? USE TOAST.

NO TOASTER? USE A SLICE OF BREAD.

NO BREAD? WELL THEN YOU CAN'T DRAW. SORRY. OH, OKAY, A DANISH, A CRUMB CAKE, ANYTHING THAT'S BAKED AND CRUMBLY WILL DO JUST FINE.

NOW GET A NEW PIECE OF PAPER AND YOUR PEN. PUT YOUR EYEBALLS AND PEN TIP ON THAT UPPER LEFT-HAND CORNER AND SLOOOOOOOWLY TRACE CLOCKWISE AROUND THE EDGE OF THAT BAGEL. IF YOU REALLY WANT YOUR LINE TO CONNECT UP WITH ITS ORIGIN, MIDWAY THROUGH YOU CAN GLANCE AT YOUR PAPER AND REASSURE YOURSELF THAT YOU ARE MORE OR LESS ON COURSE. IF NEED BE, CORRECT (DON'T ERASE!). TRY NOT TO DO THIS MORE THAN ONCE OR TWICE. OKAY, NOW THAT WE'RE BACK AT OUR POINT OF ORIGIN, LET'S START TO EXAMINE THE SURFACE OF THE BAGEL. IMAGINE THAT ALL THE TEENY SEEDS AND STRANDS OF GARLIC AND FLAKES AND BURN MARKS ARE A SERIES OF STEPPING-STONES THAT ARE GOING TO TAKE YOU ACROSS THE BAGEL FROM THE EDGE TO THE HOLE IN THE MIDDLE. DRAW THE

ONION BAGEL bought on BLEEKER STREET. CONSUMED ON WEST 3RD.

VERY FIRST BIT OR SEED CLOSEST TO THAT POINT OF ORIGIN. NOW DRAW THE ONE JUST BELOW IT. IT'S JUST A LITTLE SQUIGGLE BUT TRY TO DRAW IT ACCURATELY, TO REALLY SEE IT. KEEP GOING, WORKING YOUR WAY TOWARD THE HOLE. IF YOU'RE DRAWING TOAST OR SOMETHING ELSE, JUST WORK YOUR WAY DOWN FROM NOOK TO CRANNY.

Cream Cheese

DO NOT START PEPPERING YOUR DRAWING WITH RANDOM DOTS. THIS IS NOT A POLKA DOT COMPETITION. IMAGINE YOU ARE A MINIATURE ASTRONAUT WHO HAS JUST LANDED ON THE SURFACE OF THIS BAGEL AND YOU ARE MAPPING EACH SESAME SEED FOR FUTURE TEENY VISITORS. BE AS SPECIFIC AS YOU CAN ABOUT EACH LANDMARK. TRY TO SEE THE RELATIONSHIP BETWEEN ONE SEED OR STRAND AND THE NEXT. INCH YOUR WAY TOWARD THE CENTER, MAKING A LINE OF LITTLE SHAPES. WHEN YOU REACH THE LAST SPECK NEAR THE BAGEL'S HOLE, START TO TRACE THE CONTOUR OF THE HOLE, JUST AS YOU DID THE MUG'S HANDLE, UNTIL YOU GET BACK TO THE POINT OF ORIGIN. NOW KEEP GOING, DRAW MORE SEEDS, FILL IN MORE DETAILS. STOP WHEN YOU WANT TO. IF YOU HAVE THE INCLINATION AND TIME, MAP THE ENTIRE SURFACE OF THE BAGEL. THE POINT IS TO RECORD WHAT YOU SEE. A HALF-DRAWN BAGEL IS MERELY A RECORD OF A HALF-STUDIED BAGEL. NO PROBLEM WITH THAT.

STEP BACK.

WOW! THAT'S A GREAT DRAWING.

AND IT'S A DRAWING NOT OF "A" BAGEL BUT OF THIS VERY PARTICULAR ONE. NO OTHER BAGEL IN THE WORLD IS LIKE THIS ONE, AND YOU SAW IT INTIMATELY. YOU WOULD KNOW IT FROM ANY OTHER. IT IS BEAUTIFUL, ISN'T IT? IT'S A WORK OF ART.

Locks

let's Look back at your Mug.

CONSIDER THE SHAPE INSIDE THE HANDLE OF YOUR MUG. IT'S REALLY A DRAWING OF ... NOTHING. THAT SHAPE DEFINES SOMETHING THAT ISN'T A PHYSICAL OBJECT, IT'S THE EMPTY AIR THAT LIES WITHIN THE CONTOURS OF THE HANDLE. WE CALL THAT TRAPPED SHAPE "NEGATIVE SPACE." NEGATIVE SPACE IS ALL AROUND US AND IT'S FAIRLY EASY TO TRAIN YOURSELF TO DRAW IT.

HERE'S A DRAWING OF A HOUSE. BUT LOOK AT THE SPACE THAT SURROUNDS IT AND FILLS THE FRAME. IT'S A SHAPE, TOO — KIND OF A MOTH-EATEN "F" SHAPE. WHAT IF INSTEAD OF DRAWING THE HOUSE, YOU JUST DREW THE SKY BEHIND IT? THAT'S DOABLE, RIGHT?

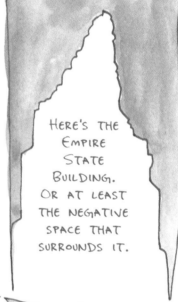

HERE'S THE EMPIRE STATE BUILDING. OR AT LEAST THE NEGATIVE SPACE THAT SURROUNDS IT.

A DOG.

HERE'S A CAR.

LOOK OUT THE NEAREST WINDOW AT THE SKY. CAN YOU SEE ITS SHAPE AROUND THE NEIGHBORS' ROOF AND TREES? TRY TRACING THAT LINE JUST WITH YOUR EYE, IGNORING THE FACT THAT YOU ARE JUMPING FROM ONE POSITIVE OBJECT TO ANOTHER. ACROSS THE ROOF, DOWN THE SIDE OF THE HOUSE, ACROSS THE TREETOPS... NOW TRY DRAWING THAT LINE ON PAPER.

Now take a dining room or desk chair, preferably one with an interesting mixture of long legs, slats, cross braces, arms, etc. Let's look at the negative space that lies between the parts of the chair, between the left legs and right under the seat.

Really pay attention to the lengths of each edge and the angle that takes it to the next line. Close one eye as you observe. This will flatten the chair from 3- to 2-D, just like it will be when it gets onto the page.

Next let's get those shapes on paper. Begin by drawing an imaginary frame around the chair, a box on your page. Now start arranging those shapes into that frame. Work your way across the chair.

Drawing one shape, then stepping to the next stone. Keep your eyes on the chair the vast majority of the time,

Negative Spaces.

But it will still be recognizable as a chair (even though it's actually a drawing of everything but).

Just glancing down at the page to make course corrections

It may come out a little wonky and lopsided

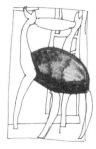

OVER THE NEXT DAY OR TWO, TRY OBSERVING AND DRAWING OTHER NEGATIVE SPACES.

- SPIN THE CHAIR AROUND OR THROW IT ON ITS BACK AND DRAW THE WHOLE NEW SET OF SPACES IT PRESENTS.

- THROW YOUR KEYS ONTO A TABLE AND DRAW THE TABLETOP AROUND THE KEYS.

- DRAW THE VIEW THROUGH A WINDOW, PANE BY PANE, INDICATING HOW THE WINDOW FRAME CARVES IT UP.

MaKing your ⟨Left Brain⟩ an ALLY.

EARLIER, WE DREW CONTOURS WITHOUT LOOKING AT THE PAGE IN ORDER TO STOP YOUR LEFT BRAIN FROM NAGGING YOU WITH DOUBTS, CRITIQUES, AND RIGIDITY WHEN YOU WERE TRAINING YOURSELF TO LET GO AND SEE WITHOUT PRECONCEPTION.

BY NOW YOU'VE TAKEN THE TIME TO PRACTICE MOVING YOUR EYES AND YOUR PEN SLOWLY AND IN UNISON WITHOUT BEING OVERLY CONCERNED ABOUT THE TRACES YOUR PEN LEAVES ON THE PAPER. AS YOU

SETTLED INTO THE ZONE AND THE REST OF THE WORLD FADED OUT, TIME SLOWED OR DISAPPEARED, YOUR MIND QUIETED, AND YOU HAD A PURE RIGHT-BRAIN EXPERIENCE. YOU CAN RECONNECT WITH IT AT ANY TIME, LIKE RIDING A BIKE.

NOW LET'S WORK ON MAKING YOUR DRAWING LOOK LESS OFF-KILTER AND OUT OF PROPORTION. TO DO SO, WE NEED TO GET YOUR LEFT BRAIN BACK IN HERE. WE NEED SOME HELP FROM OUR ANALYTIC FRIEND. IT CAN HELP US TO BETTER UNDERSTAND RELATIONSHIPS BETWEEN THE DIFFERENT SHAPES WE ARE DRAWING, TO JUDGE DISTANCES. IT TELLS US WHICH EXIT TO TAKE, WHEN TO TURN LEFT OR RIGHT, WHERE TO STOP AND BACK UP. OF COURSE, LIKE ANY GOOD NAVIGATOR, WE HAVE TO MAKE SURE IT KEEPS ITS MOUTH SHUT DURING THE LONG STRETCHES WHEN OUR RIGHT BRAIN IS PERFECTLY CAPABLE OF KEEPING US ON THE ROAD.

SUNDAY. NIGHT. ORANGES.

GRAB a CHAIR, and SOME PAPER and GO to THE BATHROOM.

OPEN THE MEDICINE CABINET, PLANT YOUR CHAIR, SIT DOWN, AND TAKE A GOOD LOOK. (IF YOU FEEL REALLY WEIRD DOING THIS, TRY IT SOMEWHERE ELSE, WITH A KITCHEN CABINET OR EVEN A BOOKSHELF.)

WOW, IT LOOKS LIKE A COMPLICATED MESS IN THERE, DOESN'T IT? LOTS OF JARS AND BOTTLES AND LABELS AND SHAPES... SO LET'S BREAK IT DOWN, STONE BY STONE, SEED BY SEED. THINK OF IT AS A BIG CROSSWORD PUZZLE AND TACKLE IT CLUE BY CLUE.

YOUR CABINET SHELVES ARE GOOD HORIZONTAL DIVIDERS OF THE INTERIOR SPACE OF THE CABINET, CARVING THE COMPLEXITY INTO A BUNCH OF SMALLER SHAPES WHILE THE BOTTLES AND JARS ON THE SHELVES DIVIDE IT UP LEFT TO RIGHT. TOGETHER THEY MAKE UP A LOOSE GRID. ALL WE NEED TO DO IS DRAW EACH OF THESE SMALLER SHAPES AND FIT THEM TOGETHER.

LET'S START BY DRAWING THE CONTOURS OF THE OBJECTS ON THE TOP SHELF. SET YOUR EYES ON THE LOWER LEFT HAND CORNER OF THE SIDE OF THE FIRST BOTTLE (OR BOOK, IF YOU'RE DRAWING YOUR BOOKSHELF) AND YOUR PEN ON THE LEFT HAND SIDE OF YOUR PAGE. MOVE YOUR EYES (AND YOUR PEN) UP THE SIDE, OVER THE CAP, DOWN THE OTHER SIDE AND ONTO THE NEXT OBJECT. IF THE NECK IS IRREGULAR, TAKE YOUR TIME. MOST BOTTLES ARE SYMMETRICAL, SO LOOK AND SEE HOW THE LUMPS AND CURVES ON ONE SIDE MATCH UP WITH THE OTHER.

IF YOU'RE GETTING LOST, LOOK BACK DOWN AT YOUR DRAWING TO CHECK YOUR PROGRESS, BUT DO SO JUST TEN TO TWENTY PERCENT OF THE TIME. YOUR

DRAWING SHOULD BE ONE SINGLE LINE ACROSS THE PAGE. DON'T FREAK OUT IF YOU RUN OFF THE PAGE — EITHER TAPE ON SOME MORE PAPER OR JUST DO A PARTIAL PORTRAIT OF THE CABINET.

WHEN YOU REACH THE RIGHT-MOST EDGE, SLIDE DOWN THE LAST BOTTLE AND DRAW THE UNDERSIDE OF THAT FIRST SHELF. DON'T JUST WHIP A STRAIGHT LINE ACROSS — OBSERVE AND MAKE SURE THAT'S REALLY WHAT THE UNDERSIDE OF THE SHELF IS LIKE.

START DRAWING THE NEXT SHELF DOWN. NOW WE'RE GOING TO USE THE VERTICAL LINES ON OUR IMAGINARY GRID TO MAKE SURE THAT WE LINE UP THE OBJECT ON EACH SHELF, CHECKING IT WITH ITS UPSTAIRS NEIGHBOR AS WE PROCEED.

LISTEN TO YOUR HELPFUL LEFT BRAIN AS IT SAYS THINGS LIKE "THE LEFT EDGE OF THAT BLUE BOTTLE SITS DIRECTLY UNDER THE RIGHT EDGE OF THE LABEL ON THE BOX DIRECTLY UNDER IT" OR "THE FRONT OF THE BRISTLES OF THE TOOTHBRUSH ARE JUST IN FRONT OF THE EDGE OF THE POINTED PART OF THE TWEEZERS BELOW." MAKE THE TINIEST OBSERVATIONS YOU CAN ABOUT THE PLACEMENT, ANGLE, HEIGHT, ETC. OF EACH OBJECT, RELATIVE TO ITS NEIGHBORS. AND DO IT SLOOOOOOOWLY.

KEEP GOING. DRAW THE CONTOURS OF EVERY OBJECT IN THE WHOLE CABINET. PRETTY AMAZING, ISN'T IT? YOU MANAGED TO CAPTURE ALL THOSE OBJECTS, JUST BY DRAWING THEM ONE BY ONE AND PLACING THEM RELATIVE TO EACH OTHER ON THE PAGE.

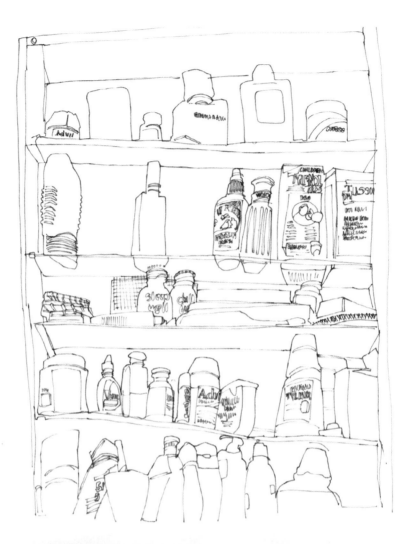

Let's Fill in Some Details. Pick one bottle. Go in and draw the shape of the label, figuring where exactly it fits within the contour. Next, connect the lines across the lid or the cap, making sure they arc across as you observe them. No need to fill in all the lettering and symbols, just draw the shapes that sit within the bottle's contour. If you're on a roll, fill in some more bottles. Don't feel compelled to do them all; a drawing can be very interesting if it leaves some details to the viewer's imagination.

HOW DO YOU FEEL?

EXHAUSTED? AMAZED? EXHILARATED? DEFEATED? Raring to DRAW the WORLD?

NEXT TO YOUR DRAWING, WRITE DOWN SOME OBSERVATIONS ABOUT THE PROCESS.

WHEN YOU FIRST LOOKED AT THE CLUTTER OF YOUR CABINET, IT WAS INTIMIDATING AND OVERWHELMING, BUT BY DRAWING ONE OBJECT, THEN THE NEXT, YOU WERE ABLE TO TACKLE GREAT COMPLEXITY. AND BY LOOKING AT THE LANDMARKS AROUND EACH SHAPE, BY USING YOUR ANALYTIC LEFT BRAIN TO TALK THROUGH THE RELATIONSHIPS, YOUR PROPORTIONS AND PLACEMENT WILL IMPROVE AND IMPROVE.

AGAIN, IT'S ALL ABOUT LOOKING CLOSELY, SEEING WHAT THINGS ARE REALLY MADE OF, HOW THEY RELATE TO ONE ANOTHER, GAUGING THEIR DIMENSIONS, AND NOT JUST RESORTING TO HOW YOU THINK THEY SHOULD LOOK.

EVERYTHING YOU WILL EVER WANT TO DRAW, FROM THE GRAND CANYON TO YOUR MOTHER'S FACE, IS MADE UP OF ELEMENTS AND RELATIONSHIPS. AS YOU SLOW DOWN AND LOOK CAREFULLY, YOU WILL SEE AND UNDERSTAND. DRAWING IS JUST A MATTER OF RECORDING THAT UNDERSTANDING ON PAPER.

DRAW MORE COMPLEX SUBJECTS.

OPEN YOUR CAR'S HOOD AND DRAW THE ENGINE.

DRAW A BICYCLE, ALL THE NEGATIVE SPACES BETWEEN THE SPOKES AND GEARS.

DRAW EACH LEAF ON A PLANT.

COPY A MAP OF THE USA, DRAWING STATE BY STATE.

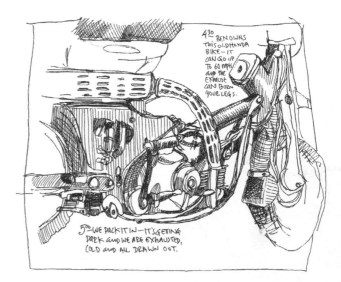

4³⁰ — BEN OWNS THIS OLD HONDA BIKE — IT CAN GO UP TO 60 MPH aND THE EXHAUST CAN BURN YOUR LEGS.

5³⁰ WE PACK IT IN — IT'S GETING DARK and WE ARE EXHAUSTED, COLD and ALL DRAWN OUT.

THUMBS UP.

SOMETIMES THE OBJECTS YOU DRAW AREN'T BROKEN UP BY LANDMARKS. INSTEAD OF TOOTHBRUSH BRISTLES OR SESAME SEEDS, YOU ARE FACED WITH A BROAD, UNBROKEN EXPANSE (WALL, SKY, CHEEK) OR BY TOO MANY TINY DETAILS (BRICKS, HAIRS, LEAVES, ETC.) AND YOU ARE UNABLE TO FIND A MEANINGFUL TOEHOLD. NOW WHAT?

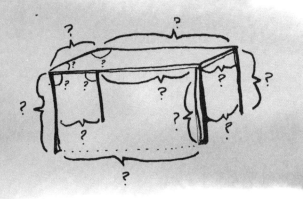

YOU KNOW THE CLICHÉD IMAGES OF THE ARTIST SQUINTING AT HIS OUTSTRETCHED THUMB? THIS IS ACTUALLY AN ENORMOUSLY VALUABLE TOOL, ONE I RELY ON QUITE OFTEN. USING YOUR THUMB OR YOUR PEN AS A YARDSTICK IS CALLED SIGHTING. ONCE YOU UNDERSTAND THE RELATIVE DISTANCE BETWEEN LANDMARKS YOU CAN TRANSFER THEM ONTO YOUR DRAWING.

LET'S DRAW YOUR DINING ROOM TABLE. SIT OFF TO THE SIDE AND STUDY IT. THERE ARE A FEW KEY OBSERVATIONS YOU ARE GOING TO HAVE TO MAKE:

THE HEIGHT OF THE LEGS IN PROPER PROPORTION TO THE WIDTH OF THE TABLETOP;

THE DIFFERENCE IN THE PERCEIVED LENGTHS OF THE FRONT AND BACK LEGS;

THE ANGLES OF THE CORNER OF THE TABLETOP.

HOLD OUT YOUR PEN AT ARM'S LENGTH AND LOOSELY LOCK YOUR ELBOW. CLOSE ONE EYE, LINE UP THE PEN WITH THE EDGE OF THE TABLE, AND MEASURE THE WIDTH OF THE TOP IN TERMS OF PEN LENGTHS, TURNING THE PEN OVER IN THE AIR IF NEED BE. LET'S SAY IT'S TWO PEN LENGTHS WIDE. NOW ROTATE YOUR PEN TILL IT'S VERTICAL AND MEASURE THE TABLE'S FRONT LEFT LEG.

MAKE SURE YOU KEEP YOUR BODY IN THE SAME POSITION AND YOUR PEN THE SAME LENGTH AWAY FROM YOUR EYE. LET'S SAY THE TABLE LEG IS ONE PEN LENGTH PLUS AN ADDITIONAL HALF A PEN CAP LENGTH.

NOW LAY YOUR PEN ON OR SLIGHTLY ABOVE YOUR PAPER AND MAKE A TINY DOT TO MARK THE WIDTH OF TWO PEN LENGTHS AND THE HEIGHT OF ONE PEN LENGTH PLUS HALF A CAP TO INDICATE THE TABLE LEG. NOW DO SOME MORE MEASUREMENTS: THE LENGTH OF THE BACK LEG, THE WIDTH OF THE NEGATIVE SPACE BETWEEN THE LEGS, ETC. IT IS ALWAYS HELPFUL TO FIGURE OUT WHERE THE VERTICAL AND HORIZONTAL MIDPOINTS OF YOUR SUBJECT ARE AND TO MAKE SURE THEY LINE UP WITH THE MIDDLE OF YOUR COMPOSITION, MEASURING SO THAT YOU NEVER AGAIN RUN OUT OF PAGE.

TO MEASURE ANGLES, USE YOUR FINGERS AS A PROTRACTOR. SIGHT THE ANGLE, SPREAD YOUR FINGERS TO MATCH, AND THEN HOLD THAT ANGLE AGAINST YOUR PAGE TO ACCURATELY REPRODUCE THE CORNERS OF THE TABLE.

GET CREATIVE: USE THE WIDTH OF YOUR PEN OR THE DISTANCE FROM THE TIP OF YOUR THUMBNAIL TO THE FRECKLE ON YOUR KNUCKLE. TEAR A THIN STRIP OF PAPER, MEASURE THE WIDTH, THEN FOLD IT IN HALF TO FIND THE MIDPOINT.

MY ADVICE: DON'T GET NUTS. WHILE IT'S GREAT TO HAVE SOME GUIDELINES TO KEEP YOU ON TRACK, THIS IS NOT A CONNECT-THE-DOTS EXERCISE OR A TECHNICAL ENGINEERING DRAWING. THE GOAL IS TO TRAIN YOUR BRAIN TO OBSERVE THE WORLD AROUND YOU MORE CLOSELY, NOT TO RENDER IT PHOTOGRAPHICALLY. DON'T GET HOOKED ON PERFECTION UNLESS YOU WANT TO BE A CARTOGRAPHER.

KEEP PRACTICING SIGHTING. MAKE IT A GAME. TRY IT EVEN WHEN YOU'RE NOT DRAWING. AS YOU WAIT IN TRAFFIC, MEASURE ONE CAR AHEAD OF YOU AGAINST A DISTANT ONE. MEASURE DISTANT BUILDINGS OR THE RELATIVE HEIGHTS OF PEOPLE ON A TRAIN PLATFORM. KEEP OBSERVING. AND KEEP DRAWING.

"I have painted by opening my eyes day and night on the perceptible world, and also by closing them from time to time that I might better see the vision blossom and submit itself to orderly arrangement."
— GEORGES ROUAULT

BEEP, BEEP! YOU'RE ON the ROAD!

THE EXERCISES YOU HAVE DONE SO FAR ARE LESS THAN EXHAUSTIVE BUT THEY COVER THE BASIC ELEMENTS OF LINE DRAWING:

CONTOURS: HOW TO FOLLOW THE EDGES OF THINGS CAREFULLY AND SLOWLY AND COPY THEM ONTO YOUR PAGE.

NEGATIVE SPACES: TO RECOGNIZE THE SPACES BETWEEN ELEMENTS AND TO FLATTEN THEM FROM 3- TO 2-D.

PROPORTIONS: TO GINGERLY RE-ADMIT YOUR LEFT BRAIN INTO THE PARTY AND START JUDGING AND GAUGING THE RELATIONSHIPS BETWEEN INDIVIDUAL LINES AND SHAPES AND ARRANGING THEM APPROPRIATELY ON THE PAGE.

IF YOU HAVE WORKED THROUGH THESE PRINCIPLES, PRACTICING THEM AND FIGURING OUT NEW WAYS TO APPLY THEM, CONGRATULATIONS, YOU HAVE YOUR CREATIVE LEARNER'S PERMIT.

YOU KNOW WHERE THE GAS, THE BRAKES, THE STEERING WHEEL AND THE TURN SIGNALS ARE POSITIONED. AND YOU HAVE A GENERAL SENSE OF THE RULES OF THE ROAD.

THERE'S STILL LOADS FOR YOU TO LEARN ABOUT DRAWING, THINGS THAT GO BEYOND THE SCOPE OF THIS BOOK. IT WOULD BE GREAT IF YOU WENT ON TO STUDY LIGHT AND SHADOW AND TO LEARN THE PRINCIPLES OF COLOR THEORY, AND I WILL BE TOUCHING ON MY OWN EXPERIENCE WITH THOSE SORTS OF THINGS LATER ON. BUT YOU COULD SPEND MANY YEARS HONING THE SKILLS YOU HAVE JUST PICKED UP. FOR NOW, USE THEM TO MAKE PERFECTLY SERVICEABLE OBSERVATIONS ABOUT YOUR DAILY LIFE, OBSERVATIONS THAT WILL AWAKEN YOUR CREATIVITY AND TRANSFORM YOUR APPRECIATION OF THE WORLD AROUND YOU. THAT'S WHAT YOU'RE REALLY HERE TO DO.

MEASURE

CONTOURS

PROPORTIONS

NEGATIVE SPACE

BE CONFIDENT

KEEP GOING

SLOW DOWN

FROM HERE ON OUT, I'M NOT GOING TO TALK MUCH MORE ABOUT THE MECHANICS OF DRAWING. INSTEAD I'M GOING (AGAIN) TO ENCOURAGE (AND HOPEFULLY INSPIRE) YOU TO JUST DRAW AND DRAW.

EACH DRAWING YOU DO WILL CHANGE YOU IN SOME WAY — SOME WILL GO SMOOTHLY AND WONDERFULLY AND YOU WILL WANT TO FRAME THEM AND HANG THEM IN YOUR LIVING ROOM. MANY OTHERS WILL FRUSTRATE AND DISGUST YOU AND END UP IN THE TRASH.

IT DOESN'T MATTER.

IT ALL COMES DOWN TO THE ONE MOST IMPORTANT LESSON I HAVE TO TEACH YOU ABOUT DRAWING ...

THERE ARE NO BAD DRAWINGS.

DRAWINGS ARE EXPERIENCES.
The MORE YOU DRAW, the MORE EXPERIENCED YOU'LL GET.

IN FACT, YOU'LL LEARN MORE FROM BAD OR UNPREDICTABLE OR WEIRD EXPERIENCES THAN FROM THOSE THAT GO EXACTLY AS YOU'D HOPED AND PLANNED. SO LET IT GO.

RELEASE YOUR EGO'S DESIRE FOR PERFECTION.

TAKE RISKS.

STRETCH.

GROW.

CREATE AS MUCH AS YOU CAN, WHENEVER YOU CAN.

YOU NOW HAVE TWO THINGS THAT CAN MAKE YOU HAPPY: YOU ARE FREE AND YOU ARE SAFE. YOU'VE GOT THE KEYS. YOU'RE ON THE ROAD. AND NO MATTER HOW BAD ANY ONE DRAWING MAY BE, IT WON'T ACTUALLY KILL YOU. NO TWISTED METAL, NO SHATTERED GLASS, JUST MAYBE A FEW DROPS OF INK AND SOME CRUMPLED PAPER. YOU'LL GET OVER IT. THE OPEN ROAD LIES AHEAD. NOW, LET'S HIT IT!

SEEING BREAD

DRAWING IS SEEING.
IF YOU CAN SEE, YOU CAN
DRAW. BUT CAN YOU SEE?

LET'S SEE.

LOOKING IS A LANGUAGE.
LOOK: A DOG, A TREE, A CAR,
A MAN. WE APPLY LABELS
TO THINGS IN ORDER TO
UNDERSTAND AND PROCESS
THEM. IN GENESIS, GOD HAS
ADAM NAME THE ANIMALS.
LABELS MAKE ABSTRACT
THINKING POSSIBLE. BUT
BECAUSE WE OVERDO IT,
LOOKING REPLACES SEEING AND
WE SOON STOP SEEING THINGS
FOR WHAT THEY TRULY ARE. WE
SAY "TREE" AND STOP SAYING
"ELM," STOP SAYING "THIRTY-
YEAR-OLD ELM, WITH SILVERY
BARK MISSING IN FIST-SIZED
CIRCLES ON THE EASTERN HALF
OF ITS TRUNK, 37-FOOT
8-INCH ELM WITH 37,437
LEAVES, SOME MUSTARD COLORED,
OTHERS SAP GREEN," AND WE
COMPLETELY MISS GOING TO THE
NEXT LEVEL, WHERE LANGUAGE
FAILS US ALTOGETHER, WHERE
THINGS ARE SO SPECIFIC THEY
CAN HAVE NO NAME, WHERE
THEY ARE ABSOLUTELY REAL.

THIS IS WHERE DRAWING
COMES FROM. YOU CAN LOOK
AT SOMETHING SLOWLY AND
CAREFULLY AND REFUSE TO SEE
IT FOR ANYTHING BUT WHAT IT
IS — AT THIS VERY MOMENT, IN
THIS LIGHT, FROM THIS ANGLE.
AS YOU BEGIN TO SEE, YOU
CEASE TO BE THE MANY THINGS
THAT LIMIT YOU. YOU DROP
JUDGMENTS, CULTURAL BIASES,
HISTORY, AND BAGGAGE. TIME
SLOWS, AND THEN DISAPPEARS.
ALL YOU FEEL IS THE PEN ON
THE PAPER, THE SLOW CUTTING
DRAG OF THE NIB AGAINST
THE GRAIN TILL EVEN THAT
SENSATION FADES AWAY, TOO.
YOU DON'T THINK ABOUT ART
OR WHAT PEOPLE WILL SAY OR
WHETHER YOU ARE INEPT OR
UGLY OR STUPID OR SELF-
INDULGENT. YOU STOP THINKING
ABOUT BILLS AND ACHES AND
GRIEVANCES AND CHORES. YOU,
YOUR PEN, YOUR PAPER, YOUR
SUBJECT, YOU JUST ARE.

YOU SINK DEEPER AND
DEEPER AS YOU SEE MORE AND
MORE. YOU DRAW THE EDGES
AND THEN THE TEXTURES,
THE SHADOWS, THE TEXTURES

14TH GREEN. 4:15 PM. SUNNY

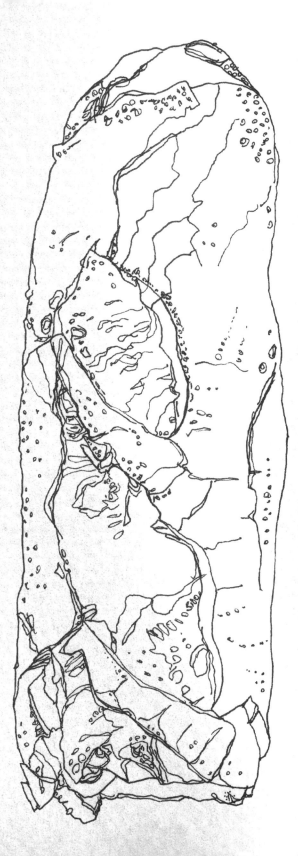

AND SHADOWS WITHIN TEXTURES AND SHADOWS. THE ORANGE, THE TREE, THE BODY YOU ARE DRAWING IS JUST A LANDSCAPE YOUR EYES TRAVERSE. YOUR LINE TAKES YOU THROUGH ADVENTURES AND SURPRISES, OVER HILL AND DOWN VALLEY, INTO LIGHT AND THROUGH SHADE. AND EVENTUALLY YOUR JOURNEY BRINGS YOU HOME AGAIN. YOU FEEL YOUR PEN THUD BACK AGAINST THE DOCK, THE DOORSTEP. THE WORLD SLOWLY CRANKS BACK UP AGAIN LIKE THE MERRY-GO-ROUND IT IS, AND YOU COME BACK TO ALL YOUR SENSES — SHARPENED, REFRESHED, RENEWED.

ON YOUR PAPER, THERE'S A MAP OF YOUR TRIP, A SOUVENIR, ONLY AS ACCURATE AS THE CLARITY OF YOUR VISION. KEEP IT IF YOU WANT, FRAME IT, SELL IT, BUT IT WON'T MATTER — EVERY TWIST AND TURN OF THE TRIP ITSELF WILL BE SEARED INTO YOUR MIND.

IF You'd like to LEARN More about DRAWING, check these out:

Drawing on the Right Side of the Brain by Betty Edwards

Drawing for Older Children and Teens by Mona Brookes

Drawing from Within: Unleashing Your Creative Potential by Nick Meglin

A Life in Hand: Creating the Illuminated Journal by Hannah Hinchman

Rendering in Pen and Ink by Arthur L. Guptill

Keys to Drawing by Bert Dodson

Draw: How to Master the Art by Jeffrey Camp

Drawing with an Open Mind by Ted Seth Jacobs

Drawing for Pleasure by Peter D. Johnston

The Elements of Drawing by John Ruskin

The Sketchbooks of Robert Crumb

The Zen of Seeing by Frederick Franck

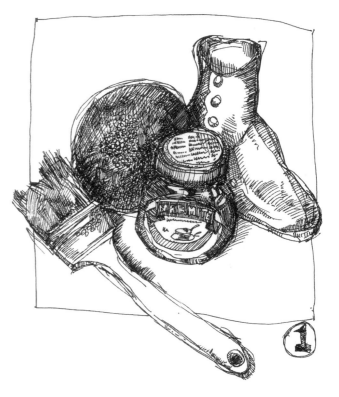

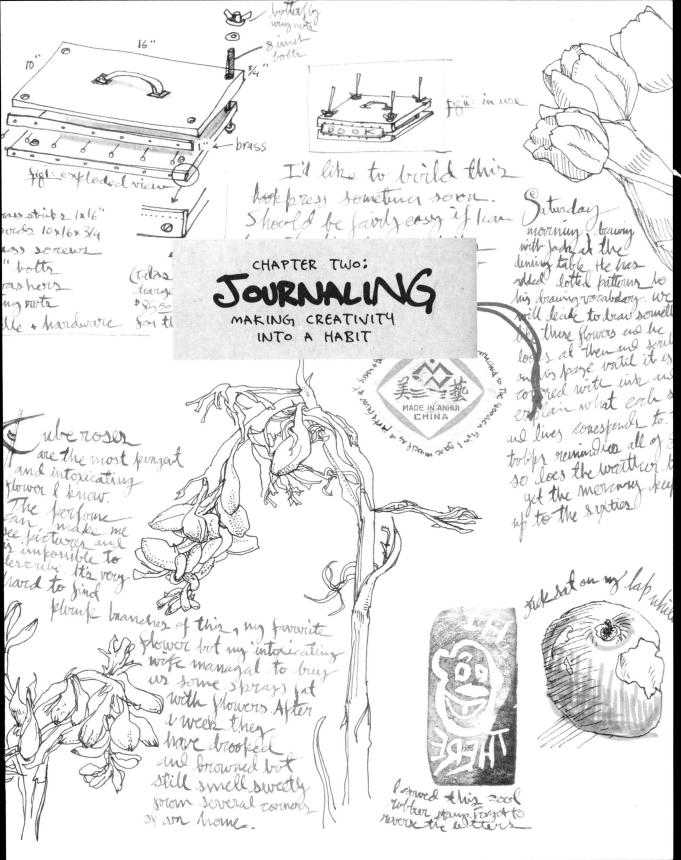

16"

10"

butterfly wing nuts

8 inch bolts

¾"

brass

fig i: exploded view

ass strib 2 1x16"
wds 10x16x¾
ass screws
" bolts
washers
ng nuts
le + hardware

(Telas
ararage
$85.50
for th

fig ii: in use

BOOK

I'd like to build this
book press sometime soon.
Should be fairly easy if I can

CHAPTER TWO:
JOURNALING
MAKING CREATIVITY
INTO A HABIT

美 一 艺
MADE IN ANHUI
CHINA

Saturday
morning drawing
with Jack at the
dining table. He has
added dotted patterns to
his drawing vocabulary. We
will learn to draw some
of these flowers and he
looks at them and scrib
on his page until it is
covered with ink and
explain what each s
and lines corresponds to.
tulips reminding all of
so does the weather b
yet the morning kee
up to the sixties.

Tuberoses
are the most pungent
and intoxicating
flower I know.
The perfume
can make me
see pictures and
is impossible to
describe. It's very
hard to find
plump branches of this, my favorite
flower but my intoxicating
wife managed to buy
us some sprays just
with flowers. After
a week they
have drooped
and browned but
still smell sweetly
from several corners
of our home.

Jack sat on my lap whi

I carved this cool
rubber stamp. Forgot to
reverse the letters.

NEXt...

Naturalist Richard Bell has been keeping illustrated journals since he was a kid.

oh, Yes, You caN!

OKAY, NOW YOU CAN DRAW. AND YOU CAN SEE MORE CLEARLY THAN YOU DID A FEW DAYS AGO, PROBABLY MORE CLEARLY THAN YOU HAVE SINCE YOU WERE IN THE CRIB. DRAWING PASSES FEELINGS TO AND FROM THE WORLD QUITE DIFFERENTLY THAN WRITING.

 IT EXPRESSES FEELINGS FAR MORE DIRECTLY AND DEEPLY THAN PHOTOGRAPHY. IT HELPS YOU PUT YOUR THOUGHTS IN ORDER, TO EXPRESS THEN FIGURE OUT WHAT YOU THINK AND FEEL. IT GIVES YOU A SENSE OF HARMONY, RELATIONSHIP, PROPORTION, AND ORDER.

 THE TRICK IS TO KEEP SEEING MORE AND MORE CLEARLY, EVERY DAY.

 LET'S DISCUSS YOUR FIRST VEHICLE OF CREATIVE EXPRESSION. YOU ARE GOING TO CREATE A BOOK (ACTUALLY A VERY LONG SERIES OF BOOKS) THAT WILL DOCUMENT WHAT YOU SEE — THE THINGS AND PEOPLE AND PLACES AND EVENTS THAT SURROUND YOU — IN DRAWINGS AND WORDS. AS OFTEN AS POSSIBLE (AND HOPEFULLY EVERY DAY), YOU WILL RECORD YOUR LIFE IN THIS BOOK. IT WILL KEEP YOU IN CONSTANT CONTACT WITH THE PRESENT. IT WILL PROVIDE

A READY, EASY, FUN WAY TO MAKE SURE YOU MAKE THINGS ON A REGULAR BASIS. IT WILL DEMONSTRATE TO YOU THAT YOU ARE CREATIVE AND PROVE THAT YOU ARE GETTING MORE SO ALL THE TIME.

THIS ILLUSTRATED JOURNAL WILL BE YOUR COMPANION, YOUR TEACHER, AND A RECORD OF YOUR AWAKENING. IT WILL BE A BEAUTIFUL THING AND WILL SHOW YOU HOW BEAUTIFUL THE WORLD IS AND HOW LUCKY YOU ARE TO BE IN IT.

THIS WILL BE A LONG AND VARIED JOURNEY AND THERE'S NO MAP. WHILE WE MAY ALL TRAVEL TOGETHER ALONG THE SAME HIGHWAYS FROM TIME TO TIME, YOU WILL HAVE TO MAKE YOUR OWN PATH. ALL I CAN DO IS GIVE YOU IDEAS AND SUGGEST INTERESTING DAY TRIPS. I WILL NOT CREATE THIS BOOK, THIS LIFE, FOR YOU; I CAN ONLY OCCASIONALLY HOLD YOUR HAND AS YOU CREATE IT. IN FACT, MORE OFTEN I WILL BE THROWING OBSTACLES IN YOUR WAY, NOT TO BE PERVERSE, BUT BECAUSE COMPLACENCY AND COMFORT ARE NOT TERRIBLY HELPFUL PASSENGERS FOR CREATIVE PEOPLE. WE NEED TO KEEP STIRRING OUR POTS. LUCKY FOR YOU, I HAVE A BIG ARSENAL OF WOODEN SPOONS.

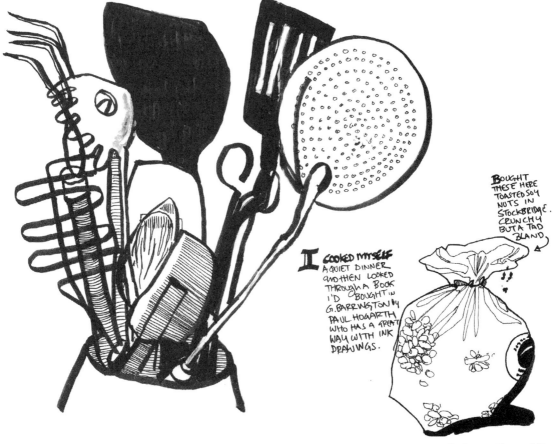

BOUGHT THESE HERE TOASTED SOY NUTS IN STOCKBRIDGE. CRUNCHY BUT A TAD BLAND.

I COOKED MYSELF A QUIET DINNER AND THEN LOOKED THROUGH A BOOK I'D BOUGHT IN G. BARRINGTON BY PAUL HOGARTH WHO HAS A GREAT WAY WITH INK DRAWINGS.

WHY JOURNAL?

ILLUSTRATED JOURNALING HAS A LOT TO OFFER AS A BEGINNING (AND A LIFELONG) CREATIVE ENDEAVOR. A JOURNAL IS:

COMPACT. PORTABLE.

WHO NEEDS A STUDIO? YOU CAN PUT A JOURNAL IN YOUR HIP POCKET.

INEXPEN$IVE.

I HAVE FRIENDS WHOSE JOURNALS ARE SIMPLY STACKS OF ORDINARY PAPER FOLDED IN HALF AND COVERED WITH DRAWINGS AND WRITINGS DONE WITH A FIFTY-CENT MARKER.

PERSONAL.

EVERY DAY YOU'LL BE MAKING ART THAT IS A REFLECTION OF YOUR UNIQUE PLACE ON THE PLANET. YOU'RE NOT FOLLOWING SOMEONE ELSE'S STEP-BY-STEP INSTRUCTION. YOU'RE EXPRESSING YOUR SELF.

USEFUL.

A MEMOIR, A SHOPPING LIST, A REPOSITORY FOR IDEAS THAT MIGHT GET LOST — YOUR JOURNAL WILL BECOME A VALUED COMPANION.

CUMULATIVE

SHORT BURSTS = LARGER WORK. MAKING A JOURNAL IS A SERIES OF SMALL STEPS. EACH CREATIVE. KEEP LIVING ONE PAGE AT A TIME, MOVING FORWARD THROUGH YOUR BOOK, EXPERIMENTING A LITTLE HERE AND THERE, ADVANCING, GETTING WILDER. IN JUST FIFTEEN MINUTES EACH DAY YOU WILL CHISEL AWAY A LITTLE BIT, ADD A FEW BRUSHSTROKES. SOON YOU'LL STEP BACK AND SEE YOU HAVE A COMPLEX WORK OF ART REPRESENTING MANY ACCUMULATED HOURS OF CREATIVE ENERGY.

FAMILIAR.

YOU'RE ALREADY AN EXPERT: EVEN IF YOU'VE NEVER DRAWN BEFORE, YOU'RE STARTING THIS PROJECT WITH A WEALTH OF KNOWLEDGE ABOUT ITS SUBJECT. IF YOU FEEL AT ALL INTIMIDATED, BE CONFIDENT IN YOUR OWN EXPERTISE ABOUT YOUR LIFE.

LEFT BRAIN. RIGHT BRAIN.

ILLUSTRATED JOURNALING INVOLVES DRAWING, DESIGN, WRITING, CALLIGRAPHY, INTROSPECTION, OBSERVATION, A BLEND OF INTUITION

OCEAN AVE, SANTA MONICA, ON A RATHER GREY AFTERNOON

AND ANALYSIS.

CREATIVE IDEAS MAY GERMINATE IN THE RIGHT BRAIN BUT THEY GET POLISHED AND PRODUCED WITH THE LEFT BRAIN'S HELP. AS STEVE JOBS, LEGENDARY CEO OF APPLE, SAID, "REAL ARTISTS SHIP."

A GATEWAY.

ONCE YOU GET HOOKED ON ILLUSTRATED JOURNALING, YOU WILL FIND YOURSELF BRANCHING OUT. YOU MAY WANT TO STUDY COLOR AND DO PAINTINGS IN YOUR JOURNAL. MY OWN JOURNAL WORK HAS PIQUED MY INTEREST IN CALLIGRAPHY, COLOR THEORY, WATER COLORING, ART HISTORY, PHOTOGRAPHY, BOOKBINDING, POETRY, AND EVEN PLAYING AND WRITING MUSIC.

AN ART FORM.

A RICHLY ILLUSTRATED JOURNAL, ITS PAGES FILLED WITH SOUVENIRS AND OBSERVATIONS, ITS COVER BATTERED BY EXPERIENCE, IS A BEAUTIFUL WORK OF ART, REFLECTING SO MUCH ABOUT ITS AUTHOR'S WORLD

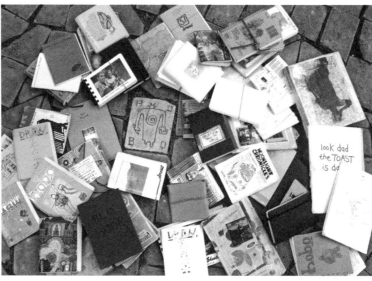

Dan Price publishes his illustrated journals in his 'zine, Moonlight Chronicles.

VIEW. EVEN IF YOU GO NO FURTHER, JOURNALING WILL MAKE YOU AN ARTIST.

A MEDICATION.

TAKING THE TIME EACH DAY TO SIT AND OBSERVE YOUR SURROUNDINGS, TO SUMMARIZE YOUR EXPERIENCES AND TO COUNT YOUR BLESSINGS, WILL ENRICH YOUR LIFE NO MATTER HOW BADLY YOU THINK YOU DRAW. DRAWING AND WRITING IN YOUR JOURNAL WILL RELIEVE YOUR STRESS, IMPROVE YOUR SENSE OF SELF-WORTH, AND GIVE YOUR DAYS FOCUS.

FORGIVING.

UNLIKE MARBLE SCULPTURE, MURAL-PAINTING, OR AXE-

JUGGLING, MISTAKES AND POOR DECISIONS ARE EASILY FORGIVEN BETWEEN THE COVERS OF A JOURNAL. DON'T BEAT YOURSELF UP IN PURSUIT OF PERFECTION. HATE A DRAWING? TURN THE PAGE. START AGAIN.

PRIVATE OR PUBLIC

DON'T WANT TO SHARE YOUR WORK WITH ANYONE? SLAM THE COVER, POP IT BACK IN YOUR BAG. IF YOU DON'T WANT YOUR EARLY EFFORTS SCRUTINIZED, JOURNALING IS PERFECT. AND IF YOU WANT TO SHOW OFF, YOU HAVE ALL YOUR WORK RIGHT THERE WITH YOU TO SHARE WITH THE EASILY IMPRESSED.

An illustrated journal can be lots of things: a scrapbook, a sketchbook, a travel journal, a memoir, a photo album. It can be as big as a table or it can fit in your hip pocket. It can be kept on 300 lb. imported watercolor paper, on the ruled pages of a grade school composition book, or on a sleek website.

But for now, let's start basic. Go to the art or office supply store and get yourself a bound journal. It could be a spiral-bound sketchbook or one of those black bound books with the pebbly covers. Just make sure it's big enough that you can put a couple of drawings on a page without feeling cramped, but not so big that you won't carry it around with you or so thick you'll be stuck filling it in forever. And make sure the paper is heavy enough so that your pen doesn't bleed immediately through the paper, but cheap enough that you won't hesitate if you want to give up, turn the page, and start a fresh drawing.

Keep using your pen. Don't chicken out on me now and start drawing with a pencil and erasing every second line. I'd hold off on the color for now, too; stick to black ink on white paper. You can always add some colored pencils or markers or watercolors once you feel more confident in your drawing. Let's keep it below the speed limit for now. I stuck with one type of black pen for my first year and then added a single additional warm grey marker. After a few months I got a cool grey marker and slowly, slowly worked my way through the tonal range. By year three, I was using a full range of colored pencils and markers and it took me another few years to get to watercolors. I've had a great time and learned a bunch at each step along the way.

Materials

"Beware of all enterprises that require new clothes."
– Henry David Thoreau

ONE fine day

YOU WAKE UP WITH THE EXCITING KNOWLEDGE THAT YOU'RE A BLANK JOURNAL OWNER. TAKE IT TO THE KITCHEN AND CRACK IT OPEN — BUT NOT TO THE FIRST PAGE. GO IN A FEW AND LEAVE SOME ROOM FOR A TITLE PAGE WITH THE DATE AND AN INSPIRING QUOTE (FEEL FREE TO COPY ONE DOWN FROM THE MARGINS OF THIS BOOK).

Now, draw your Breakfast.

TAKE NO MORE THAN FIVE MINUTES. BUT DO TAKE YOUR TIME. FIRST-THING-IN-THE-MORNING DRAWINGS CAN BE GREAT: YOUR MIND'S BLANK AND YOUR LEFT BRAIN IS STILL GROGGY.

THEN, NEXT TO YOUR DRAWING, WRITE A CAPTION. IT COULD BE SILLY, IT COULD BE LOFTY. WRITE ABOUT HOW YOU FEEL STARTING AN ILLUSTRATED JOURNAL OR HOW YOU FEEL ABOUT WHAT YOU'RE DRAWING OR WHAT YOU DREAMT LAST NIGHT OR HOW THE INSIDE OF YOUR MOUTH TASTES. TRY TO STAY PRESENT — THIS IS NO TIME TO RANT ABOUT YOUR BOSS OR YOUR MOTHER-IN-LAW — BUT FEEL FREE TO WRITE MOST ANYTHING YOU LIKE (EXCEPT "THIS DRAWING SUCKS").

Patti's Breakfast Remains Keeper telwarm

Next, eat your BREAKFast,

START YOUR DAY, HEAD OUT INTO THE WORLD, AND BRING YOUR JOURNAL. NOW, SEVERAL TIMES A DAY, PUT DOWN A SLOW DRAWING OF WHATEVER YOU ENCOUNTER. DON'T BEAT YOURSELF UP ABOUT IT; DRAW WHEN YOU HAVE DOWN TIME BUT BE CREATIVE IN SEARCHING FOR OPPORTUNITIES TO RECORD YOUR WORLD. TRY TO MAKE EACH PAGE A FRESH ADVENTURE.

Put your name and phone number on the inside front cover of your journal! Don't worry about strangers reading it and knowing your identity. If you lose it, you will be far more anxious about getting it back safely
— advice from a JOURNAL-LOSER

Living well through Bad Drawings.

WHEN SOME PEOPLE SEE AN ILLUSTRATED JOURNAL, THEY SAY, "WOW, THAT'S GREAT. I COULD NEVER DO THAT." WITH SOME COAXING, THEY MAY BE PERSUADED NONETHELESS TO GIVE IT A TRY. OTHERS SAY, "WOW, I'M GOING TO DO THAT." AND THEY START, TOO. AND QUITE A FEW SAY, "HUH, WHERE DO YOU FIND THE TIME?" THEN USE YOUR JOURNAL AS A COASTER.

IT'S COMPARATIVELY EASY TO START. TO BRING YOURSELF TO DRAW YOUR BREAKFAST ONCE OR YOUR COFFEE CUP ONCE AND TO KEEP IT UP FOR A COUPLE OF DAYS. IDEALLY THOSE FIRST FEW DAYS INFECT YOU WITH THE FEVER AND YOU'RE COMPELLED TO CARRY A LONG SERIES OF JOURNAL BOOKS AROUND WITH YOU FOR THE REST OF YOUR DAYS.

BUT MORE LIKELY, YOUR INITIAL ENTHUSIASM WILL WANE. YOU'LL FORGET TO DO IT ONE DAY, GIVE IN TO RESISTANCE THE NEXT, THEN FEEL LIKE YOU'VE BROKEN THE CHAIN, THE NARRATIVE IS LOST, A MONTH'S GONE BY, AND YOU DROP IT ALTOGETHER. WHY? OFTEN IT'S BECAUSE YOU ARE DISAPPOINTED WITH YOUR DRAWINGS. YOU MAY SAY YOU DON'T HAVE THE TIME, FORGOT YOUR BOOK, GREW BORED. BUT IT'S REALLY BECAUSE YOU AREN'T THAT IMPRESSED WITH

YOUR DRAWING SKILL. YOU HAVEN'T MADE SOMETHING THAT LOOKS LIKE ART.

I DON'T THINK THAT ILLUSTRATED JOURNALING IS REALLY ABOUT DOING GREAT DRAWINGS. YOU'RE NOT OUT TO MAKE SOMETHING THAT YOU COULD FRAME OR GIVE AS A CHRISTMAS PRESENT. I'M NOT REALLY INTO DOING THE SORT OF EXERCISES ON PERSPECTIVE AND TONE THAT YOU SEE IN MOST DRAWING BOOKS, EXERCISES THAT WILL MOVE YOUR SKILLS TO ANOTHER LEVEL ARTISTICALLY. NOT THAT YOU SHOULDN'T DO THEM IF THEY ARE FUN OR IF YOU HAVE SOME OTHER GOAL IN MIND, BUT I DON'T THINK THEY ARE ESSENTIAL FOR THE TRUE PURPOSE OF ILLUSTRATED JOURNALING.

THAT PURPOSE? TO CELEBRATE YOUR LIFE. NO MATTER HOW SMALL OR MUNDANE OR REDUNDANT, EACH DRAWING AND LITTLE ESSAY YOU WRITE TO COMMEMORATE AN EVENT OR AN OBJECT OR A PLACE MAKES IT ALL THE MORE SPECIAL. CELEBRATE YOUR HAIR-BRUSH AND IT WILL MAKE YOU APPRECIATE THE INTRICACY OF THE BRISTLES, THE MIRA-CLE OF YOUR LOST HAIR, THE BEAUTY OF YOU. SOUNDS SAPPY BUT IT'S IN THERE.

DRAW YOUR LUNCH AND IT WILL BE A VERY DIFFERENT EXPERIENCE FROM WOLFING DOWN ANOTHER TUNA ON RYE. IF YOU TAKE YOUR

KOMODO DRAGON
WAS CHILLIN' AND PEELIN' AS
HIS HIDE MOLTS.

TIME (AND WE'RE TALKING MAYBE FIFTEEN MINUTES HERE, FOLKS) AND REALLY STUDY THAT SANDWICH, THE NOOKS AND VALLEYS, THE CRINOLINE OF THE LETTUCE, THE TEXTURES OF THE TUNA, YOU WILL DO A DRAWING THAT RECOGNIZES THE PARTICULARITY OF THAT SANDWICH.

THAT'S THE POINT: TO RECORD THIS PARTICULAR MOMENT, THIS SANDWICH, NOT SOMETHING GENERIC. IF YOU APPROACH IT WITH THIS ATTITUDE, YOU WILL CREATE SOMETHING UNIQUE. REACHING THAT PLACE IS JUST A MATTER OF CONCENTRATION AND ATTENTION. A BRIEF MEDITATION AND YOU WILL HAVE A SOUVENIR TO JOG YOUR MEMORY BACK TO THAT MOMENT FOREVERMORE. IMAGINE IF YOU CAN KEEP DOING THAT, KEEP DROPPING THESE LITTLE GEMS IN YOUR DAY, RECOGNIZING THE INCREDIBLE GIFT YOU ARE GIVEN EACH MORNING UPON AWAKENING. YOU WILL BE A MILLIONAIRE.

THERE'S A DEMON IN YOUR MIND WHO WILL FIGHT THIS, WHO WILL TELL YOU YOUR LIFE IS UNWORTHY OF ACKNOWLEDGMENT, THAT TODAY SUCKS THROUGH AND THROUGH. IT WILL TELL YOU YOU HAVE NO TIME FOR THIS, THAT YOU ARE TOO HARRIED, TOO STRESSED, TOO UNDER THE WEATHER. WHICH BRINGS ME TO MARY BETH, WHO WROTE TO ME FROM NEBRASKA WHERE SHE JUST HAD EMERGENCY EYE SURGERY. FOR TWO WEEKS, SHE COULD ONLY SEE THE FLOOR. SHE WASN'T SIDELINED THOUGH— SHE DREW ALL OF HER VISITORS' FEET. SHE PULLED ART OUT OF THAT TRAGEDY, CELEBRATED HER VISITORS, CREATED A POSITIVE MEMORY THAT SHE WILL HAVE TO CHERISH LONG AFTER HER VISION IS BACK TO NORMAL. HER NIGHTMARE BECAME A LESSON.

I HAVE ENCOUNTERED MY OWN FAIR SHARE OF OBSTACLES IN LIFE. MY REGRET IS THAT I DIDN'T CELEBRATE ALL OF IT. I CAN'T SAY IT OFTEN ENOUGH: LIFE IS SHORT, ART IS LONG. GET THE HABIT.

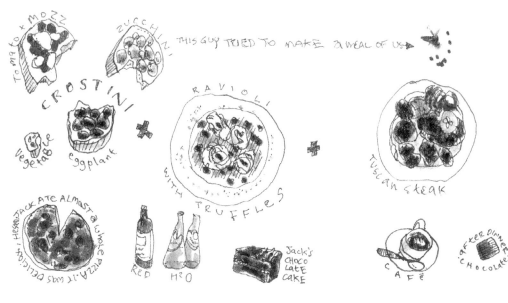

TOMATO + MOZZ

ZUCCHINI

CROSTINI

THIS GUY TRIED TO MAKE A MEAL OF US →

vegetable

eggplant

RAVIOLI WITH TRUFFLES

JACK ATE ALMOST A WHOLE PIZZA, IT WAS DELICIOUS, HERBS!

RED H²O

Jack's Chocolate Cake

TUSCAN steak

CAFÉ

after dinner CHOCOLATE

RISTORANTE CASALTA

TUSCAN HOGFEST

AS THE SUPERMARKET WAS CLOSED THIS AFTERNOON, WE DECIDED TO GO TO A LOCAL RESTAURANT FOR A LIGHT SUPPER. WE ALL DISPORTED OURSELVES LIKE SWINE, FEELING COMPELLED TO FOLLOW THE ITALIAN CUSTOM OF MULTIPLE COURSES,

The sun is beginning to go
down over Catharage.
The weather has been
tempermental all day
but now the wind has seized
And the air is still.
A slimmy character chatters at
me disturbing my most
tranquil momment at
Cathage. So I will close me
book And Join the
Others in the
Cafe.

splurge

BE BOLD, NOT PRECIOUS.
BE CREATIVE, PRODUCTIVE,
LAVISH, NOT HOARDING.
 YOU ARE HOLDING A STACK OF
PAPER, THIS BOOK. TREES WERE FELLED
TO MAKE IT. THEY SACRIFICED THEIR
LIVES TO BRING YOU THIS MESSAGE:

PLEASE *DO* WASTE ART MATERIALS.

 USE PAPER. EMPTY PAINT JARS. DEPLETE PENS. IF IT'S TEACHING YOU
STUFF, IT'S NOT BEING WASTED. DON'T SAVE YOUR SUPPLIES FOR A RAINY
DAY. BEAUTIFUL HANDMADE PAPER IS NO GOOD IN THE RAIN. PENS RUN IN
THE RAIN. PRECIOUS BOTTLES OF INK GET WASHED AWAY IN THE DOWNPOUR.
USE 'EM NOW, WHILE THE SUN IS SHINING! THERE'S LESS WASTED PAPER IN A
JOURNAL THAN IN THE NEWSPAPER YOU THROW AWAY EVERY SINGLE NIGHT.

IF THE PAPER IN YOUR BOOK SUCKS, LEAVE THE REST BLANK. START A NEW ONE THAT WILL KEEP YOU MOTIVATED. SWITCH BETWEEN ONE AND ANOTHER. I ONCE MADE MY WIFE A BEAUTIFUL BOOK. I BOUND TWO HUNDRED PAGES OF GOLD PAPER BETWEEN HAND-MARBLEIZED BOARDS. IT WAS SPECTACULAR AND SHE LOVED IT. SEVEN YEARS LATER, IT'S STILL BLANK AND GATHERING DUST. SHE WAS AFRAID TO USE IT. NOTHING SHE COULD THINK OF WARRANTED MARRING THOSE PRISTINE GOLD SHEETS. WHAT WAS I THINKING?

WHAT'S YOUR MEDIUM? BUY CHEAP. THEN WHEN YOU FIND WHAT YOU LIKE, GET BETTER STUFF. START WITH POSTER PAINTS, GEL PENS, GLUE STICKS, COPIER PAPER, ETC.

COMBINE MEDIA. WATERCOLORS WITH GOUACHE WITH MARKERS WITH PHOTOS WITH STICKERS WITH RUBBER STAMPS.

SPEND A LOT OF TIME IN ART SUPPLY STORES. ASK QUESTIONS. WATCH DEMONSTRATIONS. READ ARTISTS' MAGAZINES. ASK FRIENDS, SURF THE WEB. GET MESSY.

I SAID TO MY BOY, "I'VE BEEN LOOKING FOR YEARS BUT NEVER SAW A FOUR-LEAFED CLOVER." AND THEN I DID.

AND, AH, A MOMENT LATER, SO DID JACK.

RICHARD'S WATERCOLOR SET IS HOUSED IN A PLASTIC TUBE WITH A LOOP FOR HIS THUMB. HIS COLORS ARE DARK AND EARTHY; HE'S ADDED TO THE ORIGINAL SET. THEY LOOK BRIGHTER ON THE PAGE THAN IN THE BOX.

EPHEMERIZE. CARRY TAPE OR GLUE STICK AND STICK THE THINGS OF YOUR LIFE INTO YOUR JOURNAL. EPHEMERA LIKE DRIED FLOWERS & LEAVES, TICKETS, GUM WRAPPERS, POST-MARKS, STAMPS, CARTOONS, QUOTES, AND STICKERS CAN ADD A WONDERFUL TEXTURE TO YOUR WORK. COLLAGE IS A ME-DIUM LIKE ANY OTHER — WORK IT.

Managing Time

For one day, write down a list of every activity you do. Literally minute to minute, do an accounting of how you are spending your time. Wake up. Brush teeth. Shower. Dress. Feed kids and self, etc. Think about this list. Is there nowhere you could insert ten or fifteen minutes to draw? Is there no activity you could shorten, no TV show you could skip, that would give you the opportunity to start a fresh new perspective on life?

Is time your problem? Or fear? I find that people have time to write to me and tell me they don't have time to draw. Weird. In the time they write the note, they could have done a drawing or two.

Do one ten-minute drawing today. Just one. Then tomorrow, look at it. Do one more ten-minute drawing. Lock yourself in the bathroom if you have to. But draw.

There are 144 ten-minute increments in a day. You have 143 left.

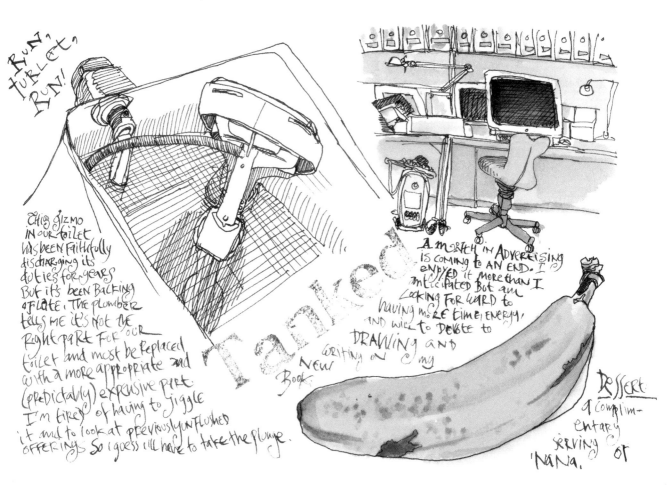

RUN, TOILET, RUN!

This gizmo in our toilet has been faithfully discharging its duties for years. But it's been backing aflote. The plumber tells me it's not the right part for our toilet and must be replaced with a more appropriate and (predictably) expensive part. I'm tired of having to jiggle it and to look at previously unflushed offerings. So I guess I'll have to take the plunge.

Tanked

A month in advertising is coming to an end. I enjoyed it more than I anticipated but am looking forward to having more time, energy, and will to devote to drawing and writing on my new book.

Dessert — a complimentary serving of 'Nana.

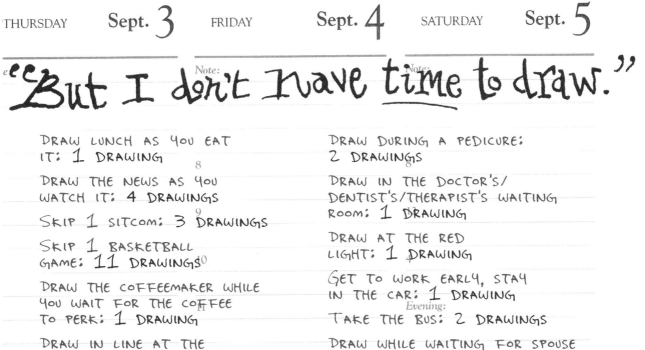

"But I don't have time to draw."

DRAW LUNCH AS YOU EAT IT: 1 DRAWING

DRAW THE NEWS AS YOU WATCH IT: 4 DRAWINGS

SKIP 1 SITCOM: 3 DRAWINGS

SKIP 1 BASKETBALL GAME: 11 DRAWINGS

DRAW THE COFFEEMAKER WHILE YOU WAIT FOR THE COFFEE TO PERK: 1 DRAWING

DRAW IN LINE AT THE SUPERMARKET: 1 DRAWING

STAY UP AN EXTRA 10 MINUTES: 1 DRAWING

GET UP 10 MINUTES EARLY: 1 DRAWING

DRAW DURING COMMERCIALS: 6 DRAWINGS PER HOUR

DRAW EVERY TIME YOU SMOKE A CIGARETTE: 1 DRAWING

DRAW EVERY TIME YOU SMOKE CRACK: 4 DRAWINGS

DRAW TILL THE WAITER BRINGS DESSERT: 1 DRAWING

DRAW IN THE TUB: 1-2 (WATERPROOF) DRAWINGS

DRAW ON THE PHONE: 2 DRAWINGS

DRAW THE MEETING: 4 DRAWINGS

DRAW DURING A PEDICURE: 2 DRAWINGS

DRAW IN THE DOCTOR'S/ DENTIST'S/THERAPIST'S WAITING ROOM: 1 DRAWING

DRAW AT THE RED LIGHT: 1 DRAWING

GET TO WORK EARLY, STAY IN THE CAR: 1 DRAWING

TAKE THE BUS: 2 DRAWINGS

DRAW WHILE WAITING FOR SPOUSE TO GET READY: 2 DRAWINGS

DRAW WHAT YOU'RE COOKING WHILE IT COOKS: 1 DRAWING

DRAW ON THE JOHN: 1 DRAWING

DRAW INSTEAD OF READING THIS BOOK: ? DRAWINGS

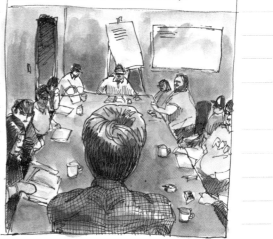

247 – 119 248 – 118

The good book

FOR YEARS, I KEPT DIARIES OF VARIOUS SORTS. I HAD BOOKS THAT I USED TO TAKE OUT AT 4 A.M. ON SLEEPLESS NIGHTS AND I'D FILL THEIR ABSORBENT PAGES WITH BUCKETLOADS OF SELF-PITY AND MISERY, RIPPING OTHER PEOPLE APART, LAYING OUT HYPOTHETICAL SCENARIOS, DUMPING LOADS OF ADRENALINE INTO MY SYSTEM AS I PONDERED NIGHTMARISH WHAT-IFS. I'D MOAN AND GROAN UNTIL I WAS SICK OF MYSELF AND THE NEXT MORNING I'D FEEL BETTER. THE CATHARSIS PROBABLY DIDN'T COME FROM PURGING. IT'S MORE THAT MOST THINGS TEND TO LOOK BLEAK AT 4 A.M. LIKE PICKED SCABS, THESE PREDAWN SESSIONS ACTUALLY MADE THE SITUATION WORSE, INFECTING MY MIND WITH THINGS I MIGHT NOT HAVE WORRIED ABOUT OTHERWISE, PEELING AWAY THE LINING OF MY STOMACH LIKE AN ONION.

IF I BOTHERED TO GO BACK TO THOSE BARELY LEGIBLE PAGES, I INVARIABLY FOUND THAT, LIKE THE MIND-BLOWING REVELATIONS THAT COME WITH ACID TRIPS AND BONG HITS, MOST OF MY PEREGRINATIONS WERE BANAL AND SELF-EVIDENT IN THE LIGHT OF MORNING.

STILL, I FELT THE NEED TO MAKE BOOKS AND TO FILL THEM WITH THE STUFF OF MY LIFE. EVENTUALLY I REALIZED THAT A JOURNAL'S TRUE PURPOSE WAS NOT TO REFLECT MY PAIN BUT TO BLUNT IT. THE FACT IS, I REALIZED IN MY LUCID MOMENTS, LIFE IS WONDERFUL. IT IS FULL OF EXTRAORDINARY THINGS AND PEOPLE AND MOMENTS BUT THE BLACK CLOUDS THAT SWIRL OVER MY INTERNAL LANDSCAPE WERE BLOCKING OUT THAT BEAUTY. MY JOURNAL COULD BECOME A PLACE OF CONTEMPLATION RATHER THAN CATHARSIS.

BY TAKING SOMETHING AROUND ME, ANYTHING AT ALL, AND STUDYING IT WITH A CLEAR EYE, I WOULD BE ABLE TO SEE THE WONDER IN IT. AND THE MORE THINGS I STUDIED, THE MORE I'D COME TO KNOW, DEEP DOWN IN MY CORE, THAT THESE WONDERS ARE ALL-PERVASIVE, THAT EVERYTHING IS CONNECTED, THAT THE WORLD IS GOOD AND WILL SUPPORT ME WHEN I STUMBLE. THE FOOD I EAT, THE SHIRT I WEAR, THE WOMAN I MARRIED, THE STORE THAT SELLS ME MY PAPER, THEY ARE ALL SOLID AND INTRICATE AND UNIQUE. THIS IS A CLICHÉ AND YET IT SEEMS TO BE A DIFFICULT THING TO KNOW. THAT'S WHY READING THESE WORDS FROM ME WILL ONLY GIVE YOU A HINT OF THAT TRUTH IF YOU DON'T YET

DRAW. IT'S WHY I NEED TO KEEP UP MY PRACTICE EVERY DAY, AND WHY, WHEN I ABANDON IT, THAT KNOWLEDGE TENDS TO SEEP AWAY, LEAVING ME ALONE, UNABLE TO SEE BEYOND THE BULWARK OF MY MIND ONCE AGAIN. SO, IRONICALLY, JOURNAL-MAKING ACTUALLY MAKES YOU LESS SELF-ABSORBED, MORE CONNECTED TO THE THINGS THAT FILL YOUR LIFE, MORE AWARE OF YOUR LOVED ONES, YOUR BLESSINGS, YOUR PURPOSE.

KEEPING A JOURNAL IS A WAY TO FOCUS YOUR LIFE, TO EXTRACT WHAT IS MEANINGFUL ABOUT EACH DAY, LIKE A RÉSUMÉ OR A CAMERA VIEWFINDER OR A NEWSPAPER HEADLINE. IN ADDITION, I BELIEVE THAT DRAWING LETS YOU TAKE THAT DEFINITION BEYOND THE VERBAL, SO IT DEEP-SOAKS INTO YOUR MIND AND TOUCHES YOU TO YOUR REPTILIAN CORE. MAKING PICTURES IS PRE-VERBAL SO IT BRINGS ENORMOUS CLARITY. WHEN YOU DRAW THE THING IN FRONT OF YOU, YOU ENTER DEEP

CONTEMPLATION, YOUR PEN LINE BECOMES YOUR MANTRA — NON-JUDGMENTAL, COMPLETELY PRESENT, TYING YOU TO EVERYTHING ELSE. TO GET THERE, YOU MUST GET RID OF YOUR FEAR AND JUDGMENT. YOU MUST STOP WORRYING ABOUT WHETHER OR NOT YOU CAN DRAW. OF COURSE YOU CAN, YOU WERE BORN WITH THE ABILITY.

TAKE SOLACE IN THE EXAMPLE OF VINCENT VAN GOGH. LOOK AT SOME OF HIS EARLY DRAWINGS — THEY ARE DREADFUL, AS IF HE WERE SKETCHING WITH A POTATO. BUT HOW FAR HE CAME, QUITE QUICKLY, AND WHAT ENORMOUS HEIGHTS HE REACHED. HE WAS SURROUNDED BY THE WORST

KINDS OF CRITICS, WAS A COMPLETE FAILURE AS WHAT WE NOW CALL AN "ARTIST," NEVER HAD A ONE-MAN SHOW OR APPEARED IN A GAP AD, AND YET HE PAINTED THINGS THAT MAKE ME CATCH MY BREATH.

JOURNAL-MAKING IS ABOUT BELIEVING IN YOURSELF, CELEBRATING YOUR LIFE, HAVING ADVENTURES, AND FEELING A PART OF (NOT APART FROM) THE UNIVERSE.

IT'S ALSO REAL FUN.

HOW WELL do WE KNOW what WE KNOW?

WHEN I WAS ELEVEN, I HAD A BIG BOOKCASE AT THE FOOT OF MY BED. AS I LAY IN BED, WAITING TO FALL ASLEEP, I WOULD STUDY THE BOOKS' SPINES IN THE SEMI-DARKNESS. I WOULD ASK MY MOTHER TO GO INTO MY ROOM, PICK A BOOK, AND MOVE IT TO ANOTHER SPOT. THE IMAGE OF THAT BOOKCASE WAS SO INGRAINED IN MY BRAIN THAT I WOULD BE ABLE TO IDENTIFY THE BOOK, WHERE IT HAD BEEN AND ITS NEW LOCATION. I HAD A HIGH-RES SCAN LODGED IN MY HEAD.

WHEN I STUDY SOMETHING INTENTLY IN ORDER TO DRAW IT, I FIND I GO THROUGH DIFFERENT INTERPRETATIONS OF THE OBJECT. AT FIRST IT SEEMS FAMILIAR ("SURE, I KNOW WHAT THAT IS. A BAGEL, A CAR, A BOOKSHELF, ETC.). THEN IT STARTS TO BECOME ALIEN AND WEIRD AS MY PRECONCEPTIONS ARE STYMIED BY COMPLEX DETAILS ("IS THAT REALLY HOW THAT GOES TOGETHER? WHAT ARE THOSE THINGS OVER THERE? WHAT DOES THAT LUMP DO? WHAT IS THIS OBJECT EXACTLY?"). FINALLY IT BECOMES VERY FAMILIAR, MORE FAMILIAR THAN MY MOTHER'S FACE OR EVEN MY OWN.

CONSIDER THIS: WE SAY, "I KNOW IT AS WELL AS THE BACK OF MY HAND." BUT HOW WELL DO YOU ACTUALLY KNOW THE BACK OF YOUR HAND? DRAW IT.

HOW WELL DO YOU KNOW IT NOW?

IT MAKES SENSE THAT THE WAY YOU EXPERIENCE SOMETHING IMPACTS THE WAY IN WHICH IT IS STORED IN YOUR MEMORY. SOMETHING YOU JUST BREEZE PAST, BARELY GLIMPSING, WILL PROBABLY NOT MAKE MUCH OF A DENT ON YOUR MEMORY BANK. IT'S THE EQUIVALENT OF A LOW-RESOLUTION DIGITAL IMAGE, ONE THAT DOESN'T TAKE UP MUCH ROOM ON YOUR HARD DRIVE BUT ALSO LACKS DETAIL AND CLARITY. ON THE OTHER HAND, IF YOU REALLY STUDY SOMETHING, SCRUTINIZE EVERY INCH OF IT, YOUR BRAIN STORES A MUCH MORE COMPLEX IMPRESSION. YOU CAN ACTUALLY ZOOM IN ON YOUR MEMORY AND SEE CRISP DETAILS.

"You should often amuse yourself when you take a walk for recreation, in watching and taking note of the attitudes and actions of men as they talk and dispute, or laugh or come to blows with one another... noting these down with rapid strokes, in a little pocket-book which you ought always to carry with you."
— Leonardo da Vinci

TRY this:

TALK TO NEW PEOPLE, TO TOTAL STRANGERS, ABOUT SOMETHING OF INTEREST TO THEM.

INTERVIEW PEOPLE FOR A STORY IN YOUR JOURNAL: HOMELESS FOLKS, FISHERMEN, NEIGHBORS, BUTCHERS, POLICE, KIDS, ELDERLY RELATIVES, DELIVERYMEN, DENTISTS, OR SANITATION WORKERS.

YOU'LL BE SURPRISED HOW EASY IT IS TO

FISHING in MANHATTAN

STRIPED BASS: Some weigh more than 40 pounds

BONITA arrive in late summer, skip museums, eat out a lot.

THANKS TO THE CLEAN WATER ACT, THERE ARE MORE THAN 250 SPECIES OF FISH IN OUR WATERS. MANHATTAN IS THE FINAL PORT OF GILL AS THEY FLOW OUT OF THE FRESH WATER RIVERS AND INTO THE SALTY OCEAN. SPORT FISHERMEN AND WOULD-BE DINERS SIT PATIENTLY IN WAIT.

DAVE is psyched. He reeled in a 25 pound bass just north of the foot of the George Washington Bridge.

EEL

LOCAL TACKLE STORE recommends Jigheads, Rubber Shads.

BLUEFISH don't mind crowded schools.

BY GRACIE MANSION, tackle includes Chicken, Tall Boys and a good radio.

CENTRAL PARK a haven for fresh-water fisherman. BASS, PICKEREL, BLUEGILLS, CARP, PERCH and CATFISH.

WEAKFISH: Sea trout that visit the city every spring.

FRANK fishes in rain or shine, skips work.

MY ONLY CATCH: a 17" Bass in the Boathouse Lake.

CHEN buys his bloodworms on Delancey Street.

CATCH AND RELEASE ZONE

SANDWORMS, OYSTERS, LORE bottom feeders.

WEST SIDE MARINAS

OFFICIALS recommend you eat no more than 1/2 pound of N.Y.C. river fish per week. HECTOR recommends you bake it in foil with onions and peppers.

OUCH! Look out for SAND SHARKS, STING RAYS and CRABS.

FLY FISHERMEN make dorky vests look FLY.

GRATE FISHING: seeing change in gum and spring.

CATCH LUNCH. Borrow gear and bait on the shores of Battery Park City.

DWAYNE claims the subway heats the river under the Brooklyn Bridge and fish love it.

ONCE THE CLOSING BELL RINGS, WALL STREET TRADERS GRAB RODS, CHARTER BOATS, AND SMOKE CIGARS.

FULTON FISH MARKET

POROY and BOB: He likes to drop his hook into the wake of departing Staten Island ferries.

BREAK DOWN BARRIERS, EVEN IN A FORBIDDING PLACE LIKE NEW YORK CITY. I AM A FAIRLY PRIVATE AND SHY PERSON AND YET I HAVE GONE UP TO TOTAL STRANGERS AND BROKEN THE ICE WITH A FEW WORDS AND CONSEQUENTLY HAD WONDERFUL, EYE-OPENING CONVERSATIONS I SHALL ALWAYS REMEMBER. OFTEN MY DRAWINGS WERE A GREAT WAY TO FIND COMMON GROUND. I'VE HEARD ABOUT UNUSUAL JOBS, WAYS OF LIVING AND GROWING UP, FAMILY ARRANGEMENTS, GRIPPING AUTOBIOGRAPHIES, IMMIGRANTS' STRUGGLES, AND LESSONS LIKE HOW TO KILL A BISON, HOW TO COOK A BASS, AND HOW TO HOP A FREIGHT TRAIN.

WHEN YOU DO THIS EXERCISE, PUT YOUR OWN EGO ASIDE. RESIST THE TEMPTATION TO TAKE OVER, TO PUT YOUR STORY ONSTAGE. EVERYONE LOVES TO TALK ABOUT THEMSELVES, SO LET THEM. GIVE THE GIFT OF ATTENTIVE SILENCE. BE GENEROUS AND YOU WILL GAIN SO MUCH FROM OTHERS.

CURTIS

HAS BEEN LIVING ON THE street for over a year. He tells me He can do any sort of work if he's just given some sort of instructions and left to do the job. He doesn't like it when people hover over him, monitoring. Despite this adaptability and independence, he's worked for just two weeks over the past 16 months. In fact he hasn't had a regular job for quite a while; he was in prison, serving thirteen of a twenty-year sentence. It's a little hard to understand his offense. According to Curtis, he invited the wrong people to a party in his apartment. When the police burst in, they found guns and narcotics,

which the culprits attributed to their host. The whole crew went to the big house, but Curtis, the allegedly innocent bystander, got a harsh sentence as well. His mother told him to let go of his anger, to have faith in the LORD. Then she died. His father passed too while their boy was behind bars. Curtis says he refuses to be angry but he seems full of RAGE. He reports to his parole officer every Monday and must continue to do so for the rest of his life. At each meeting, he contributes what cash he can towards the $4,000 fine he still owes the state. He pulls change out of his cup and hands it over. He's been given no assistance, no job placement, no help with housing. When he was released, the guard said, "See you in six months." Curtis says he's not going back, no matter what. He's always pursuing opportunities, out to Brooklyn after a job making deliveries, up to the Bronx to a car wash. No dice. Whenever he applies for a job, the last question is invariably 'Have you ever been convicted of a crime?' He lied once, then got fired for it. So he sits on Sixth Avenue with his cardboard sign and cup, a healthy 35 year old man with a thousand yard stare.

ONE DAY, I FOUND MYSELF ANGSTING ABOUT MONEY. I DECIDED THAT I SHOULD GO OUT AND TALK TO PEOPLE WHO HAD NONE. I APPROACHED HOMELESS PEOPLE IN MY NEIGHBORHOOD AND ASKED THEM TO SHARE THEIR STORIES WITH ME. AT FIRST IT WAS TERRIFYING, BREAKING THE BARRIER. BUT I SOON FOUND THAT IF YOU DON'T WANT ANYTHING FROM PEOPLE BUT THEIR STORY AND PERSPECTIVE, THEY ARE ENORMOUSLY FORTHCOMING AND TRUSTING. THEY'LL SOON FORGET TO WONDER WHY YOU'RE ASKING.

HOW CAN YOU GET A FRESH POV ON THE THINGS THAT SURROUND YOU, THE THINGS YOU THINK YOU KNOW SO WELL?

SOMETIMES LIFE WILL DO IT TO YOU. YOU OR SOMEONE YOU KNOW MAY SUFFER A CALAMITY (LOSING A JOB, DIVORCE, A TERRORIST ATTACK, DEATH OF A PARENT) OR YOU MAY DISCOVER YOU HAVE A TRANSFORMATIVE HEALTH CONDITION (MY WIFE'S PARAPLEGIA WAS MY WAKE-UP CALL; I KNOW PEOPLE WHO BEGAN JOURNALING WHEN THEY LEARNED THEY HAD MS OR CANCER) OR MAY MOVE TO A VERY DIFFERENT PLACE WHERE ALL IS UNFAMILIAR. BUT BARRING SOMETHING SO DISRUPTIVE FROM WITHOUT, HOW CAN YOU JOG YOUR OWN PERSPECTIVE SO YOU START TO SEE AFRESH? THIS IS THE MIRACLE OF CREATIVITY: SEEING LIFE MORE CLEARLY HELPS YOU DRAW BETTER ... AND VICE VERSA.

"Art is neither a profession nor a hobby. Art is a way of being." - Frederick Franck

Other Ways to Become Someone Else:

CHANGE PENS — TRY A HOT-PINK GEL PEN, F'R INSTANCE.

CHANGE SUBJECTS. DRAW SOMETHING YOU "WOULD (OR COULD) NEVER DRAW."

COPY A PICASSO, A REMBRANDT, A DEGAS.

BLAST BLACK SABBATH AND DRAW.

BLAST MOZART AND DRAW.

DRAW TEN TYPES OF CANDY.

DRAW STANDING UP.

DRAW IN A CROWD.

DRAW IN THE RAIN.

DRAW A NUDE SELF-PORTRAIT.

DRAW SOMEONE YOU HATE.

DRAW IN JAPANESE, IN FRENCH, IN SWAHILI.

DRAW IN YOUR OWN BLOOD.

Tom Pratt's journals record memories of the places he has traveled on business and pleasure.

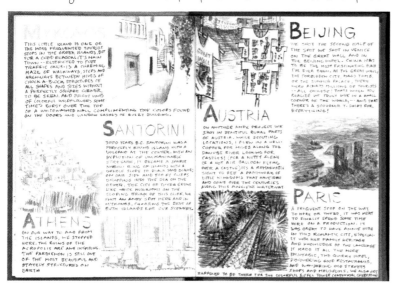

TRAVEL: WHILE YOU'RE AWAY, DRAW NON-STOP. DRAW FOOD, PACKAGES IN STORES, CARS, CLOTHES, HOUSES, TV SHOWS, MONEY, MOVIE THEATERS, BEGGARS, SALESMEN, McDONALDSES.

BECOME A TOURIST IN YOUR OWN HOMETOWN. BUY A GUIDEBOOK. SEE THE SIGHTS.

DRAW SOMETHING YOU REMEMBER FROM WHEN YOU WEREN'T YET FIVE YEARS OLD. UNDER TEN. UNDER FIFTEEN.

DRAW THE MAJOR PLAYERS IN YOUR LIFE. SPOUSE, PARENTS, NEIGHBORS, COLLEAGUES. DRAW THE MOST DISTINGUISHING THING YOU REMEMBER. WRITE ABOUT EVERY BOSS YOU'VE HAD SINCE HIGH SCHOOL (OR JUST TRY TO LIST THEIR NAMES).

DRAW EVERY PET YOU'VE EVER HAD.

DRAW YOUR FAVORITE FOOD. NOW ONE YOU HATE. NOW TRY IT. DOES IT TASTE BETTER AFTER YOU DRAW IT? IF NOT, EAT THE DRAWING. DRAW ANOTHER.

DON'T BE A PERFECTIONIST WITH YOUR JOURNAL. JOT DOWN PHONE NUMBERS. TAKE IT TO MEETINGS. WRITE DOWN GROCERY LISTS. DO LOUSY DRAWINGS. JUST WORK IN IT WHENEVER YOU CAN.

49.

This guy was in the gym with me on Monday, before I succumbed to my various ailments. There were only 3 of us exercising at the time and I studied and hypothesized about the other two quite extensively while cross-country skiing and listening to Al Franken on my iPod. The other guy was proudly running on the roadmill, deluged in sweat (the gym's an open-air hut and as humid as the rest of this tropical isle) who was eager and it seemed to me, quite creepily. The questioner wasn't wearing regular gym clothes but rather chinos, a polo shirt and brown street shoes — obvious toupee. It was and what seemed to me to be an unnaturally black and had a little bogish flip in the front and that tell-tale little duck's tail at the back where it met his real hair, what there was. He could periodically sit on the lat-pulldown machine and do a set and then stand next to me and my machine and carefully examine himself, his physique and his rug in the wall to wall mirror. Creepy, no? I've seen him alone a few times since then always in the same perfectly groomed hairpiece and Ross Perot ears. Suddenly, I decided to feel sorry for him and his lonely creepy self-deception (this happened as I drew his bony back) but then some

* The unnamed guy appeared at the pool later and removed his shoes, then slid sweatsocks + polo shirt and all into the pool. My, but so that's nice.

She* took off her face drape and left before I could draw her knees so I won't waste any more time thinking about her.

Woman joined him and I've had to start rewriting his story again—figuring he's just French or something.

ExPeriment with YOUR WRITING

FOR INSTANCE, TRY COMPOSING A CAREFULLY OBSERVED DESCRIPTION OF WHAT YOU HAVE DRAWN. IF YOU WANT, BE VERY CLINICAL. OR BE EVOCATIVE. OR EXPLAIN THE ASSOCIATIONS THESE OBSERVATIONS HAVE FOR YOU, WHAT THEY REMIND YOU OF, WHERE THEY LEAD YOUR MIND TO WANDER.

WRITE DOWN THE CONVERSATIONS YOU OVERHEAR AS YOU DRAW.

WRITE DOWN EVERY STRANGE TURN YOUR MIND TAKES AS YOU DRAW. DO IT AS IT HAPPENS, BREAKING FROM YOUR DRAWING TO WRITE NOTES IN THE MARGINS.

WRITE DOWN FIELD NOTES IN A TELE-GRAPHIC STYLE. NOTE DOWN COLORS, LIGHT, BEHAVIOR, BEING AS SPECIFIC AS YOU CAN. RECORD SMELLS AND SOUNDS, WHICH AREN'T EVIDENT IN THE PICTURE.

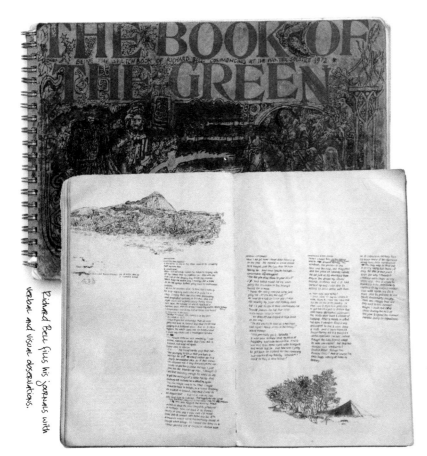

Richard Bell fils his journals with verbal and visual observations.

BEGIN YOUR JOURNAL BY THINKING ABOUT WHY YOU ARE DOING THIS. RENEW YOUR COMMITMENT. REGAIN YOUR BEARINGS. ON YOUR FIRST PAGE, WRITE A LITTLE BIT ABOUT WHAT YOU HOPE TO DO, WHAT YOU LIKE, WHAT SORTS OF EXPERIENCES YOU WANT TO RECORD, OBSERVE, LIVE.

TRY THIS: END YOUR VOLUME WITH SOME SORT OF SUMMARY ABOUT WHAT HAS GONE ON IN THE TIME YOU'VE FILLED THIS BOOK.

TRY this: DO SOME DRAWINGS FROM PICTURES IN THE PAPER. WRITE ABOUT CURRENT EVENTS. WHAT'S GOING ON IN THE WIDER WORLD? HOW DO YOU FEEL ABOUT IT?

TRY this: KEEP A PAGE IN YOUR JOURNAL TITLED "MOVIES TO SEE." OR "MUSIC TO BUY." "BOOKS TO READ." "PEOPLE TO WRITE." "DREAMS." "ADVENTURES TO HAVE." "DRAWINGS TO DO"...

And now the NEWS... MEDICAID, IRAQI ELECTIONS AND PUNDITS GALORE.

LAY DOWN A COAT OF
PAINT ON YOUR PAGE,
THEN DRAW ON TOP
OF THE COLOR. PASTE
DOWN A SHEET OF
NEWSPAPER AND DRAW
ON IT WITH A BRUSH.

I USED AN ITALIAN GROCERY RECEIPT AS THE BACKDROP
FOR THE TUSCAN FOOTHILLS.

AFTER
A night plagued by
mosquitoes, heat and
Jet lag, our spirits
are refreshed by the
clear sunlight on
the valley stretched
below.

DRAW ON
OTHER BACKGROUNDS

chicago/O'HARE:

BRACHIOSAURUS
altithorax LIVED IN
Utah 150,000,000 years ago
where he ate plants
and enjoyed the plains.
Now he looks over the
Starbucks by gate 38
and enjoys the planes.
Most people
don't seem
to see him.
Good place
to HIDE
a DINOSAUR.

TRY DRAWING ON
EPHEMERA — TAKEOUT
MENUS, ICE CREAM
CARTONS, PAGE
RIPPED FROM THE
PHONE BOOK.

IN THE MEN'S ROOM AT
O'HARE, I FOUND SOME
INTERESTING BROWN HAND
TOWELS AND DREW THE
DINOSAUR EVERYONE ELSE
IGNORES AS THEY TRUDGE
OFF TO THEIR GATES.

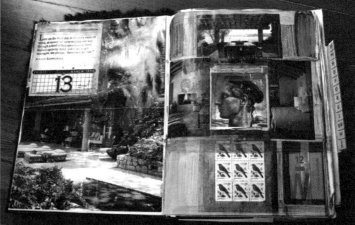

Andrea Scher's journals are rich with collage.

Make MAPS.

MAP YOUR TRIP TO AND FROM WORK.
MAP YOUR CHILDHOOD HOME.
MAP YOUR ELEMENTARY SCHOOL.
MAP ALL THE PLACES YOU'VE EVER TRAVELED.

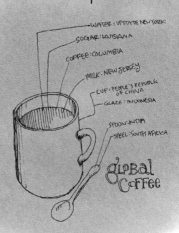

global coffee

WATER: UPSTATE NEW YORK
SUGAR: LOUISIANA
COFFEE: COLUMBIA
MILK: NEW JERSEY
CUP: PEOPLE'S REPUBLIC OF CHINA
GLAZE: INDONESIA
SPOON: INDIA
STEEL: SOUTH AFRICA

MAP THE ORIGINS OF THE FOOD YOU EAT.

DIAGRAM A TASK YOU DO EVERY DAY, STEP BY STEP.

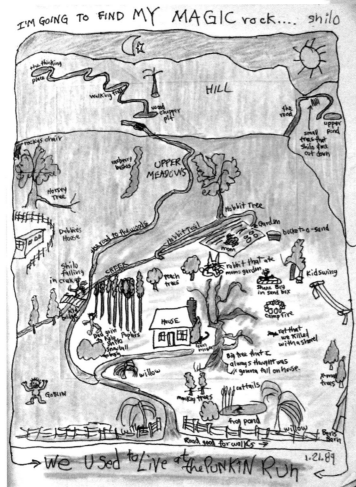

A nostalgic map from Dan Price's journals.

I'M GOING TO FIND MY MAGIC rock.... shilo

We used to Live at the PUNKIN RUN

SCHOOL

FRIDAY: taking my boy to School

UP THE AVENUE

ARCH

the PARK

HOME — WAIT FOR LIGHT

RECENTLY, I DREW A MAP OF MY GRANDPARENTS'
HOME IN LAHORE, PAKISTAN, A PLACE I'VE NOT
RE-VISITED IN THIRTY-FIVE YEARS.
IT WAS A BIT OF A STRUGGLE TO
FIGURE OUT WHERE ALL THE ROOMS
WENT (IT WAS A HUGE HOUSE AND A
MEDICAL CLINIC), AND THE EXERCISE
BROUGHT ALL SORTS OF MEMORIES
FLOODING BACK.
 THEN I CAME UPON A MAP OF
THEIR HOUSE I HAD DONE TWENTY
YEARS AGO. IT
WAS FASCINATING
TO SEE WHAT I
HAD REMEMBERED
AND WHAT I HAD
FORGOTTEN. I HAD
ENLARGED CERTAIN
SPACES, LEFT ROOMS OUT, AND SKIPPED
AN ENTIRE OUTBUILDING.

PEACOCK TOPIARY

terrace snapdragons VEGETABLE garden

PLAY FIELD

KITCHEN DINING ROOM BED ROOM SERVANT QUARTERS WELL SCIARY

LIVING RM Big hall OOMPJASA NIMOU and PRAPPA

ROSES CACTI COMPOST DIVE INTO LEAVES

LAWN LAB

T O P I A R Y YASH OFFICE

CARS SUBS CRAPPED

GARAGE

MY GRANDPARENTS' HOUSE and GARDEN, 1969

WEDNESDAY the FIRST HALF HOUR

7:30 DRESSED 7:01 alarm

7:04 BATHROOM
7:20 shower

7:06 JACK UP FROM BED

7:12 TOAST 7:10 KETTLE

MAKE EACH PAGE iN YOUR JOURNAL AN EXERCISE iN COMPOSITION

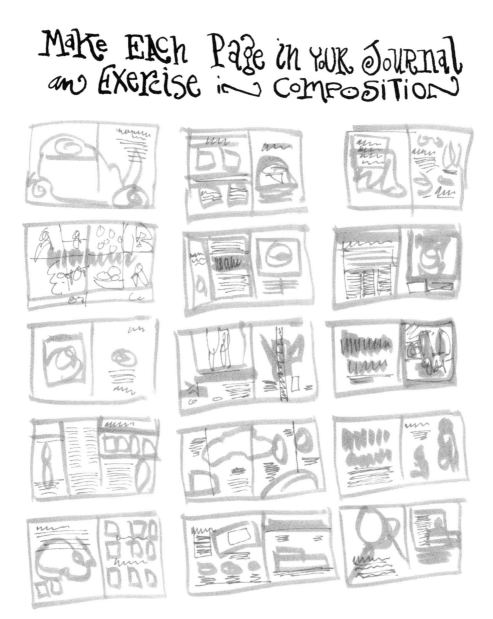

DESIGN HINGES ON AN IDEA — THINK WHAT YOU ARE TRYING TO SAY WITH THE PAGE AND MAKE ONE IMAGE OR WORD OR SENTENCE DOMINANT.

THINK ABOUT HOW ITEMS BALANCE ONE ANOTHER AND WHETHER YOU ARE CREATING A RHYTHM. IF THIS ADVICE SOUNDS ABSTRACT AND VAGUE TO

YOU, DON'T WORRY, JUST TRY TO THINK ABOUT YOUR LAYOUT. LOOK AT MAGAZINE LAYOUTS AND ADS. COPY THEM WITH YOUR OWN CONTENT.

REMEMBER: WRITING IS DRAWING.

THE **LETTERING** IN YOUR JOURNAL IS ANOTHER OPPORTUNITY TO CREATE. AFTER ALL, HANDWRITING REALLY IS JUST ANOTHER SORT OF DRAWING. HAVE FUN WITH YOUR CALLIGRAPHY AND EXPERIMENT WITH DIFFERENT LETTERING STYLES AND HOW THEY EXPRESS YOUR FEELINGS.

THINK ABOUT THE SHAPES OF YOUR PARAGRAPHS, TOO. THEY CAN BE FLUSH LEFT. LIKE THIS ONE.

OR THEY CAN BE CENTERED LIKE THIS ONE IS.

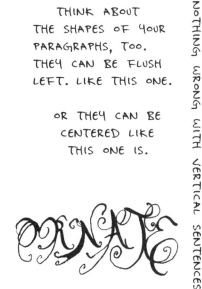

NOTHING WRONG WITH VERTICAL SENTENCES. OR UPSIDE-DOWN ONES NEITHER.

SERIFS

sans-serif.

Tall.

Round.

MECHANICAL

cursive.

CRUDE

Italics.

wiggly.

YOUR PARAGRAPHS, LIKE YOUR THOUGHTS, DON'T HAVE TO TRAVEL IN STRAIGHT LINES. YOUR WORDS AND YOUR

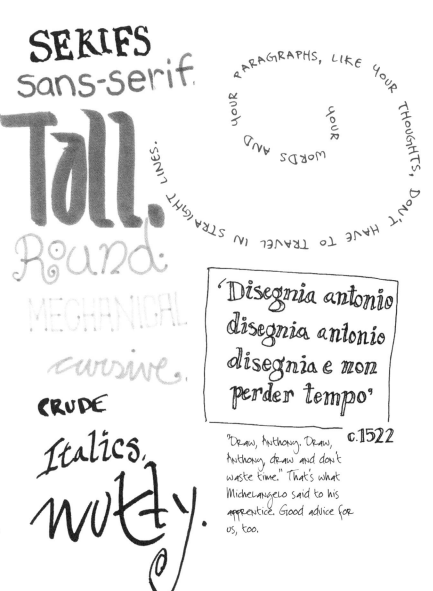

'Disegnia antonio disegnia antonio disegnia e non perder tempo'

c.1522

"Draw, Anthony. Draw, Anthony, draw and don't waste time." That's what Michelangelo said to his apprentice. Good advice for us, too.

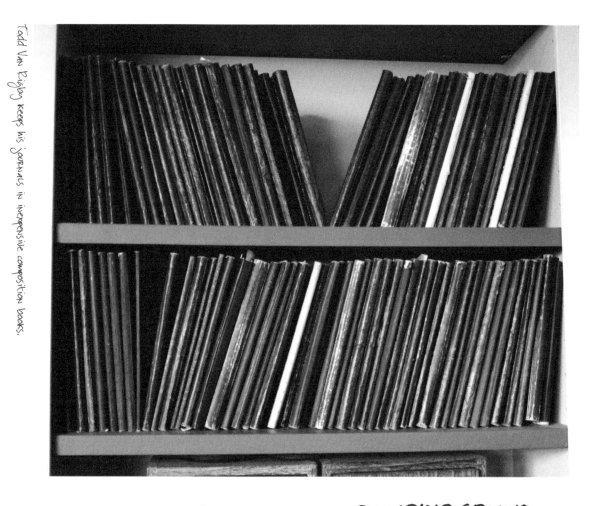

Todd Van Rigby keeps his journals in inexpensive composition books.

YOUR JOURNAL SHOULDN'T be a DUMPING GROUND, BUT a PLACE to CREATE, RECOGNIZE and CELEBRATE BEAUty and JOY, THAt WHICH IS IN aLL tHINGS. It SHOULD be a FRIEND you have a GReat time with, NOt a SHOULDeR you WHINE oN. COMMEMORAte the POSItIVE. ELIMINAte tHE NEGATIVE.

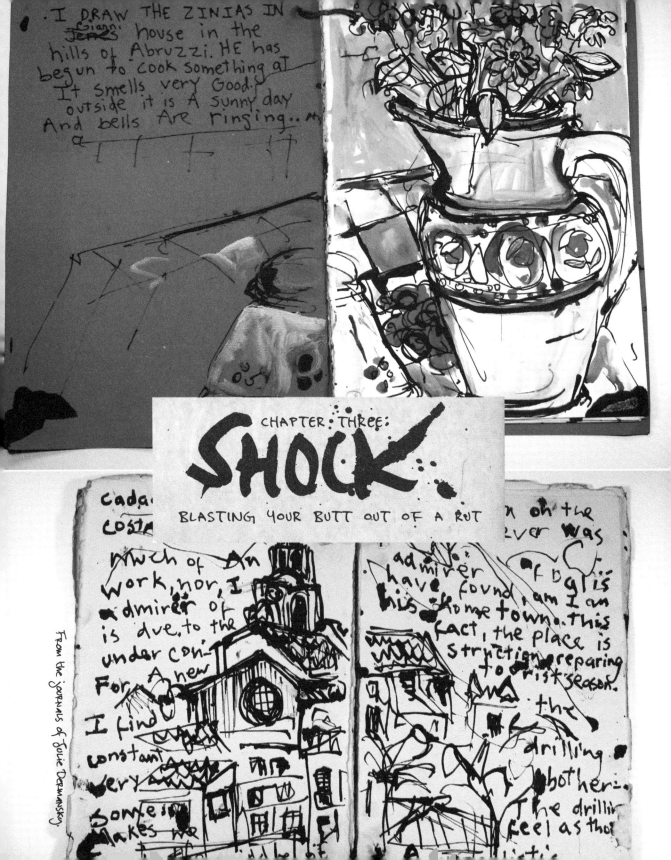

. I DRAW THE ZINIAS IN ~~Gianni~~ Jerry's house in the hills of Abruzzi. HE has begun to cook something &
It smells very Good.
outside it is A sunny day
And bells Are ringing..

CHAPTER THREE:
SHOCK
BLASTING YOUR BUTT OUT OF A RUT

From the journals of Josie Dermansky

cada...
costa...

much of An work, nor, I admirer of is due to the under con- For A new

I find constant very... some... Makes me

...oh the ...ver was

admirer have found his home town. this fact, the place is struction reparing to... risk season.

...the

drilling

bother... the drillin feel as tho'

Ideas and the END of the WORLD

In nature, we organisms have a tendency to seek balance. We want to adapt to our environment and develop the most efficient lifestyle based on the resources around us. You and your descendants change in order to find your niche. If there is an abundance of a certain hard nut, those with a large, hard-nut-cracking beak will survive. If the leaves are most plentiful at the top of the trees, those with longer necks will flourish. Once you reach this equilibrium, you won't have much incentive to continue changing. In fact, change could imperil your success as a species. As a result, evolution goes in spurts of change with long periods of stasis in between.

Our lives work the same way: most of us tend to seek a stable job, a stable community, a regular diet or form of exercise. We find a place we like to vacation and we go there every year and lie in the sun reading our favorite authors. We go to the same church, vote the same party line. We make friends with people who share our interests and we settle into regular social schedules with them.

We avoid disruption. We shun risk. Deep in our reptilian brains, we know that this is the key to survival. Herds only change grazing lands when the drought comes.

There are two results of this type of habitual existence: The first is that we are afraid of trying something new. We don't want to endure the discomfort of failure or the unknown. We prefer to limit suspense to Friday night at the movies. Better to not do at all than to do badly. We wouldn't want to stick out and possibly send ripples through the quiet watering hole. I'm not saying any of this derisively; it's a perfectly logical perspective, a perspective the vast majority of people in our society share. Far better to stick with the devil you know.

The second result is that we are completely unhinged when change does occur. And there is no question that it will occur, as sure as winter follows fall, as night follows day, as death follows the cradle.

When global events impact us at home after a long period of peace, for example, we have no real idea how to respond. When I was eleven and living in Israel, terrorist bombings were regular events. When my bus stop was blown up fifteen minutes before school let

OUT, THEY DIDN'T EVEN BOTHER REPORTING IT IN THE LOCAL PAPER. BUT IN AMERICA WE HAD A REAL SENSE OF APOCALYPTIC DOOM AFTER THE 9/11 ATTACKS. IT SEEMED LIKE EVERYTHING WAS GOING TO UNRAVEL AND OUR ENTIRE WAY OF LIFE WAS DONE. WE WERE LIKE HENS IN A COOP, COMPLETELY UNABLE TO INTERPRET ANY HOWL IN THE NIGHT. PERHAPS THAT'S WHY WE HAVE SO MANY PUNDITS, SO MANY PEOPLE WHO REASSURE US BY TELLING US WHAT IS TO COME. THE FACT THAT THEIR COLLECTIVE OPINIONS COVER EVERY POSSIBLE OUTCOME DOESN'T SHAKE OUR CONFIDENCE.

MY POINT IS NOT POLITICAL. WHAT I AM REALLY DISCUSSING HERE IS CREATIVITY. WE MUST UNDERSTAND THAT CREATIVITY IS BOTH ESSENTIAL TO SURVIVAL AND ANATHEMA, TOO. THAT'S WHY IT CAN BE SO HARD TO OVERCOME THE RESISTANCE WE HAVE TO OUR OWN CREATIVITY, WHY IT CAUSES US SUCH A DEEP SENSE OF FEAR AND DREAD. AND IT IS WHY ARTISTS ARE SO REVILED IN OUR FAT, CONTENTED WORLD. LOOK AT THE GOVERNMENT-SPONSORED ART OF THE WPA. LOOK AT THE CREATIVITY THAT SPRINGS UP DURING REVOLUTIONS. THINK OF THE WILD ARCHITECTURE THAT WAS PROPOSED TO REBUILD DOWNTOWN NEW YORK IN THE IMMEDIATE WAKE OF THE ATTACKS. WHILE THE DUST STILL LINGERED, WE WELCOMED A VISION OF A NEW WORLD, A COLLECTIVE RECOGNITION THAT OUR TIMES AND OUR LANDSCAPES WERE DIFFERENT. BUT ALL TOO QUICKLY, WE BECAME MORE CONSERVATIVE, MORE CALCIFIED, AND THE DESIGNS MORPHED BACK INTO THE PREDICTABLE, CORPORATIST VISIONS THAT SUITED A CALMING PUBLIC MOOD.

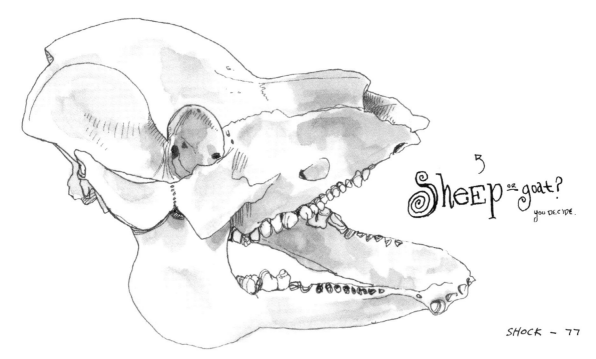

3

sheep or goat?

YOU DECIDE.

To be creative, you must be brave and allow yourself to take risks. You also must be a little crazy.

But have an appropriate degree of perspective. Reassure yourself that by doing a watercolor or throwing a pot you won't set off some chain reaction that destroys your entire universe. The whole reason you are feeling any sort of need to be creative is because you, as an organism, feel some need to adapt to changes in your environment. Your job may be too restrictive. Your relationship may be showing you new possibilities. Your daily paper may be reshuffling your deck. Your body may be changing. Or you may just be more sensitive than those around you, a canary in the coal mine, bellwether to changes that others don't yet sense.

Under all those conditions, creative change is no longer a risk — it's an imperative. Give yourself the chance to experiment and reconfigure your life. Start today. Before the volcano erupts or the meteor hits the earth, before you get run over by a bus, or your candidate loses, or your boss makes a cutback — before the changes erupt, and it's too late.

It's time to stop being a dinosaur and start figuring out how to become a bird.

"If I ever feel I am getting to the point where I'm playing it safe, I'll stop. That's all I can tell you about how I plan for the future." — Miles Davis

SHOCK YOUR SYSTEM

OPEN AN ART BOOK OR A MAGAZINE WITH ILLUSTRATIONS AND FIND A COMPLEX LINE DRAWING. OR USE ONE OF THE ONES I'VE DRAWN IN THIS BOOK. TURN IT UPSIDE DOWN. EXAMINE IT FROM TOP TO BOTTOM THEN SLOWLY COPY IT (UPSIDE DOWN!).

CHANGING YOUR POINT OF VIEW THIS WAY ELIMINATES A LOT OF THE PRECONCEPTIONS YOU HAVE ABOUT THE WAY THINGS LOOK. YOU CAN EXAMINE THE DRAWING FOR WHAT IT IS. ELIMINATING MEANING LIKE THIS IS A BASIC WAY TO SHOCK YOUR SYSTEM AND GIVE YOURSELF A FRESH PERSPECTIVE. IT ALSO GIVES YOU AN EXCUSE TO GIVE YOUR JUDGMENTAL LEFT BRAIN, YOUR INNER CRITIC. IT'S OKAY IF THE DRAWING SUCKS; AFTER ALL, YOU DREW IT UPSIDE DOWN.

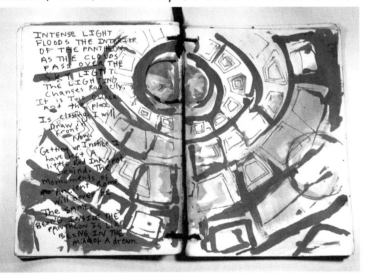

Julie Dermansky painted with the stopper of her ink bottle.

INTENSE LIGHT FLOODS THE INTERIOR OF THE PANTHEON AS THE CLOUDS PASS OVER THE SKYLIGHT. THE LIGHTING CHANGES RADICALLY. IT IS TWO O'CLOCK AND THE PLACE IS CLOSING. I WILL DRAW IT FROM NOW. GETTING UP INSIDE I HAVE LEFT (A LITTLE RED INK SPOT BEHIND. THE MONUMENTS OF ANCIENT ROME WILL NEVER BE THE SAME. BEING INSIDE THE PANTHEON IS LIKE BEING IN THE MIDDLE OF A DREAM.

DRAW WITH A FAT, JUICY BRUSH MARKER OR PAINTBRUSH. CHANGING YOUR MEDIUM LIKE THIS FORCES YOU TO SKIP OUT OF THE GROOVE, TO WRESTLE WITH A NEW ELEMENT THAT WILL TRANSFORM THE PROCESS OF DRAWING. WHENEVER YOU CHANGE FROM BUSINESS AS USUAL, YOU ARE GROWING.

TELL YOURSELF IT'S OKAY IF THE DRAWING SUCKS. AFTER ALL, YOU DREW IT WITH A BRUSH.

DRAW WITH YOUR LEFT HAND. SAME DEAL. SHAKING UP YOUR NEAT TOOLBOX, REJIGGERING YOUR SYNAPSES. PREPARING THEM FOR THE UNEXPECTED. IT'S OKAY IF THE DRAWING SUCKS, YOU DREW IT WITH YOUR LEFT HAND.

DRAW WITH A SHARPIE MARKER ON A PAPER TOWEL. IT'S OKAY IF IT SUCKS, YOU DREW IT ... BUT IT DOESN'T SUCK, RIGHT?

NO, YOU ARE GETTING USED TO SEEING YOUR DRAWING IN NEW WAYS. YOU ARE LEARNING TO APPRECIATE THE VALUE OF FRESHNESS, OF SURPRISE, OF UNDILUTED FEELING, OF HUMAN FRAILTY, OVER A SLAVISH CONCERN WITH ACCURACY. WELCOME TO THE ART WORLD.

More Shocks

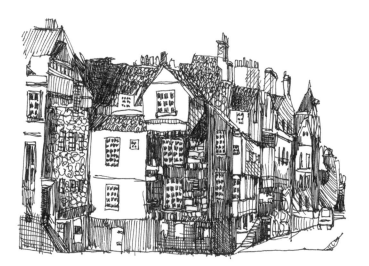

Notice light and dark. Look at shadows. See the way light transitions. Notice highlights and reflections. Try to figure out what's making them.

Do a drawing of something lit with a desk lamp or in later afternoon when the shadows are long. Draw only the shadows.

Look at a metallic object and draw the contours of every reflection. Indicate which are black, which are white, which are in between.

Draw distortions: hubcaps, toasters, etc.

Draw reflections: windows, puddles, etc.

How many ways can you draw shadows, reflections, textures, and midtones?

Experiment with cross-hatching — vertical, horizontal, thick, thin, overlaid, intersecting, parallel.

Stipple with dots, squares, dotted lines, hash marks.

Try drawing more details in the shadowed areas and leaving the highlights as plain paper.

DRAW A FORESHORTENED OBJECT
AND GET OVER YOUR PRECONCEP-
TIONS. DRAW SOMEONE LYING DOWN,
FEET TOWARD YOU. DRAW SOMEONE
SITTING DOWN FROM AN UPPER-
STORY WINDOW. FORGET THE RULES
AND SYSTEMS OF PERSPECTIVE.
JUST DRAW WHAT YOU SEE: A FAT
UPPER THIGH, A PEG-LIKE SHIN, A
HEAD BALANCED IN THE MIDDLE OF
A STOMACH, FINGERS THAT LOOK
LIKE DISCS. IGNORE THEIR MEAN-
INGS AND LABELS AND JUST DRAW
THEIR SHAPES, ONE AT A TIME.
YOUR LEFT BRAIN WILL KICK AND
SCREAM. WHEN YOU HAVE ASSEMBLED
ALL THE SHAPES, YOU WILL HAVE A
PERFECTLY FORESHORTENED IMAGE.

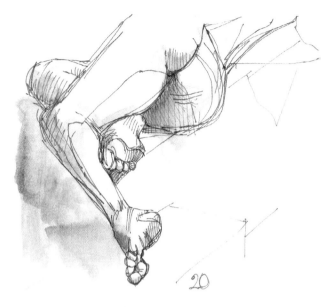

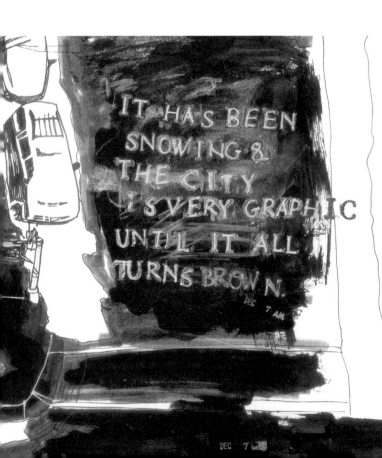

IT HAS BEEN
SNOWING &
THE CITY
IS VERY GRAPHIC
UNTIL IT ALL
TURNS BROWN.

CROP THE WORLD: GET
YOURSELF A VIEWFINDER,
A FRAME TO NARROW YOUR
VIEW. USE A PICTURE
MAT OR LOOK THROUGH
AN EMPTY BOX. CROP
LITTLE TEENY PARTS OF
YOUR ENVIRONMENT. DRAW
A SERIES OF THEM.

DRAW A VERY, VERY
COMPLICATED OBJECT: A
MACHINE, A ROOFSCAPE, A
CROWDED CLOSET, ETC.
DRAW WITHOUT LOOKING
WHILE WATCHING TV.
DRAW WITHOUT A PEN.

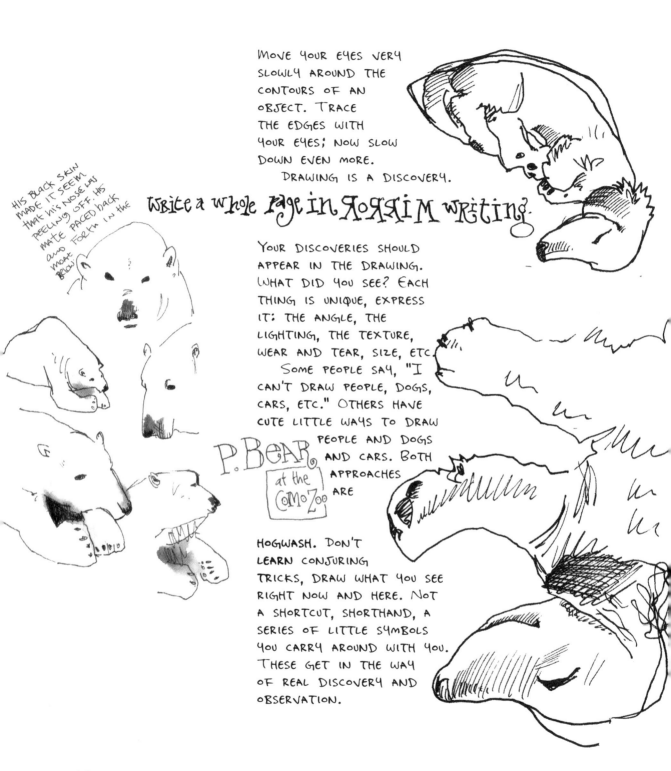

MOVE YOUR EYES VERY
SLOWLY AROUND THE
CONTOURS OF AN
OBJECT. TRACE
THE EDGES WITH
YOUR EYES; NOW SLOW
DOWN EVEN MORE.
 DRAWING IS A DISCOVERY.

HIS BLACK SKIN MADE IT SEEM THAT HIS NOSE WAS PEELING OFF. HIS MATE PACED BACK AND FORTH IN THE MOAT BELOW

WRITE a whole page in MIRROR writing

YOUR DISCOVERIES SHOULD
APPEAR IN THE DRAWING.
WHAT DID YOU SEE? EACH
THING IS UNIQUE, EXPRESS
IT: THE ANGLE, THE
LIGHTING, THE TEXTURE,
WEAR AND TEAR, SIZE, ETC.
 SOME PEOPLE SAY, "I
CAN'T DRAW PEOPLE, DOGS,
CARS, ETC." OTHERS HAVE
CUTE LITTLE WAYS TO DRAW
PEOPLE AND DOGS
AND CARS. BOTH
APPROACHES
ARE

P. BeAR
at the
ComoZoo

HOGWASH. DON'T
LEARN CONJURING
TRICKS, DRAW WHAT YOU SEE
RIGHT NOW AND HERE. NOT
A SHORTCUT, SHORTHAND, A
SERIES OF LITTLE SYMBOLS
YOU CARRY AROUND WITH YOU.
THESE GET IN THE WAY
OF REAL DISCOVERY AND
OBSERVATION.

Copy children's Drawings
BETTER YET, DRAW
WITH A CHILD. HAVE
THEM PICK THE
SUBJECT. YOU DRAW
ONE LINE. LET THEM
DRAW THE NEXT.
THEN YOUR TURN.
BACK AND FORTH
UNTIL YOU HAVE MADE
ART TOGETHER.

things you did before
you grew up

Why don't you
do them anymore?

Watch cartoons.
turn sofa cushions
into a fort. make up stories.
put cards in the play with children
spokes of your read with a
bike. flashlight
love animals. jump. laugh.
eat candy. skip. draw.
 cry.

central bank

Re-learning to Draw.

MY BOY, JACK, 10, HAS ALWAYS LOVED TO DRAW. HE DRAWS IN THE SYMBOLIC WAY KIDS DO, INVENTING CHARACTERS IN HIS MIND, DRAWING SCENES AND BATTLES AND MAPS AND WORLDS. RECENTLY, THOUGH, WE HAVE BEEN TALKING ABOUT DRAWING REALISTICALLY AND FROM NATURE.

WE BEGAN DOING EXERCISES FROM A GREAT BOOK BY MONA BROOKES, CALLED *DRAWING WITH CHILDREN.* THE BOOK'S METHOD IS EXTREMELY CLEAR AND SIMPLE AND WE'VE HAD A LOT OF FUN WORKING ON IT TOGETHER. IN THE VERY FIRST LESSON, HE DREW IN WAYS HE NEVER HAS BEFORE AND, AT THE END, ASKED ME WHEN WE COULD DO IT AGAIN.

WHEN CHILDREN DRAW, THEY ARE WORKING THINGS OUT, PLAYACTING, EXPLORING, AND LEARNING. THEY ARE PROBABLY BEING MORE LEFT BRAINED ABOUT IT THAN ADULT ARTISTS ARE, WORKING PRIMARILY WITH SYMBOLS THAT ARE NOT BASED ON OBSERVATION. OUR SOCIETY ASSUMES THAT THIS SORT OF PLAY SHOULD NOT BE INTERFERED WITH AS IT MAY SOMEHOW STUNT KIDS' IMAGINATIONS. INSTEAD, THERE'S ARISEN A MYTH THAT CHILDREN CAN'T OR OUGHTN'T BE TAUGHT TO DRAW. WHEN KIDS REACH TEN OR ELEVEN, THEY TAPER OFF WITH THIS SORT OF PLAY AND, FOR TOO MANY PEOPLE, THIS MARKS THE END OF THEIR DRAWING LIFE.

SOME KIDS PERSEVERE ON THEIR OWN, BUT AGAINST THE ODDS, BECAUSE THEY USUALLY HAVE INSUFFICIENT INSTRUCTION. IT'S ABSURD, LIKE GIVING A CLASS FULL OF CHILDREN ACCESS TO BOOKS BUT NOT TEACHING THEM TO READ. WE EXPECT KIDS MAGICALLY TO GO FROM DRAWING SYMBOLS TO SEEING CLEARLY ENOUGH AND HAVING THE PERSEVERANCE TO TRAIN THEMSELVES TO DRAW ACCURATELY. SOME WILL FIGURE IT OUT ON THEIR OWN, THE REST WILL JUST LOSE INTEREST. WE DON'T DO THAT WITH DRIVER'S ED, OR SWIMMING, OR MATHEMATICS, OR EVEN MUSIC.

THE TEACHING AND THE LEARNING AREN'T HARD. AT 10, JACK'S BRAIN IS A SPONGE AND THIS TECHNIQUE BREAKS SEEING AND RENDERING DOWN TO SUCH AN INTUITIVE, FUN EXERCISE THAT HE PICKS IT RIGHT UP. THE SYSTEM IS DESIGNED TO HELP ADULTS, TOO, AND PATTI HAS BEEN TALKING ABOUT STARTING SOON. I CAN'T WAIT.

IF YOU'VE BEEN PROCRASTINATING ABOUT LEARNING TO DRAW, TRY WORKING THROUGH THIS BOOK WITH A CHILD (EVEN TWO-YEAR-OLDS CAN DO THE EXERCISES). THE FUN IS CONTAGIOUS AND IT'LL LIGHT YOUR FUSE.

SHOCK - 85

MISTAKES

DON'T ERASE. "MISTAKES" ARE YOUR LESSONS. SEE YOUR DRAWING OBJECTIVELY. UNDERSTAND WHY YOU DREW WHAT YOU DID. DRAW A NEW LINE ON TOP WHERE YOU THINK IT "SHOULD" GO. DON'T TOSS OUT DRAWINGS THAT DIDN'T GO THE WAY YOU WANTED THEM TO, BUT ACKNOWLEDGE THAT THEY'RE JUST A RECORD OF A WAY OF SEEING — TOO HASTY, TOO CRAMPED, A REFLECTION NONETHELESS. WE'RE NOT MAKING PRETTY, PERFECT PICTURES. WE'RE MAKING A RECORD OF HOW WE SEE. TAKE A BREATHER AND THINK, OBSERVE, FEEL, AND THEN GO BACK TO IT OR START ANEW; THEN COMPARE. BE SINCERE. PERSONAL. THOUGHTFUL. HONEST. OPEN. DON'T WORRY ABOUT ACCURACY AND PERFECTION.

"If you're willing to fail interestingly, you tend to succeed interestingly."
— Edward Albee

FOCUS ON DRAWING BADLY

ASK YOURSELF: AM I DOING SOMETHING REALLY CRAPPY? WHAT MAKES IT SO? IS THERE NOTHING GOOD ABOUT IT? SURE? NOTHING? NOT ONE INTERESTING ANGLE OR UNUSUAL GLITCH? EXCELLENT! GREAT JOB! YOU DREW WHAT YOU SET OUT TO DRAW.

NOW DRAW SOMETHING GREAT. SAME WAY.

LONG AFTER THE SUBJECT OF YOUR DRAWING HAS MOVED AWAY, DRIED UP, BEEN REPLACED, EATEN, OR BURIED, YOU'LL NO LONGER KNOW HOW ACCURATE YOUR DRAWING WAS. BUT YOU'LL APPRECIATE ITS COMPOSITION, ITS ENERGY, MOOD, INTENT, THE RICHNESS OF ITS LIGHT AND TONE, THE MEMORY OF THE MOMENT.

CHERISH THE FIRST DRAWINGS YOU DO; IF YOU'VE NEVER DRAWN, OR NOT FOR AGES, THEY WILL COME TO MEAN A LOT TO YOU. YOU MAY LOOK BACK AT THEM WITH DERISION OR AFFECTION. THEY ARE THE FIRST CRACKS IN YOUR EGG, RELEASING YOU INTO YOUR NEW LIFE. BE GENTLE WITH THEM, WITH YOURSELF.

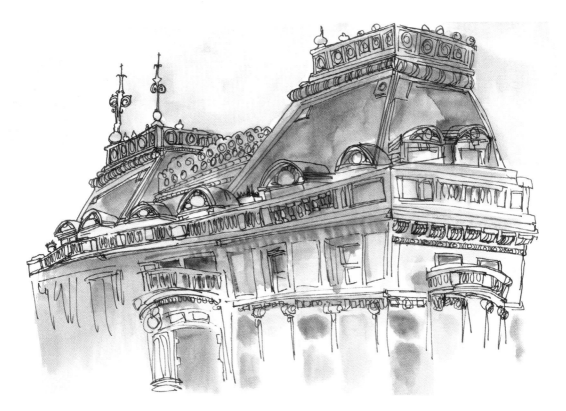

Be good to Yourself

DRAW THINGS THAT MAKE YOU GLAD. CATALOG YOUR BLESSINGS.

COMMIT A SPACE TO YOUR ART. A CORNER, A DESK, A SHELF, A TACKLE BOX, A SPACE THAT SAYS, "WHAT I MAKE MATTERS."

COLLECT THINGS TO DRAW. SCOUR FLEA MARKETS, THRIFT STORES, HARDWARE STORES, DUMPS. COLLECT OLD SAXOPHONES, EGGBEATERS, MANUAL TYPEWRITERS, BOX CAMERAS, TAXIDERMY, ARTIFICIAL LIMBS, HALF-MELTED BABY DOLL HEADS, OLD ENCYCLOPEDIAS AND YEARBOOKS, RUSTING PLIERS, CHIPPED BUSTS, DRESS FORMS, FARMING IMPLEMENTS, ETC.

ARRANGE THEM. DRAW THEM. REARRANGE THEM. DRAW THEM.

BUY YOURSELF THE BIGGEST BOX OF CRAYONS AVAILABLE.

REWARD YOURSELF WITH ART SUPPLIES. MEET A GOAL, BUY A PEN.

BUY TWO OF EVERYTHING. ONE GOOD, ONE EVERYDAY.

GO TO A TOY STORE. GO WILD.

Roz's Studio
She VERY NEATLY LABELS and FILES all HER art SUPPLIES and 3,000 RUBBER stamps.

DRAW ON SCRAP PAPER. COLLECT IT FOR THAT PURPOSE. CONSIDER IT PERMISSION TO LET GO, TO MAKE ANY SORT OF MESS YOU LIKE.

"To my distress and perhaps to my delight, I order things in accordance with my passions. What a sad thing for a painter who loves blondes but denies himself the pleasure of putting them in his picture because they don't go well with the basket of fruit! What a misery for a painter who detests apples to have to use them all the time because they harmonize with the tablecloth! I put in my pictures everything I like. So much the worse for the things — they have to get along with each other."
— Pablo Picasso

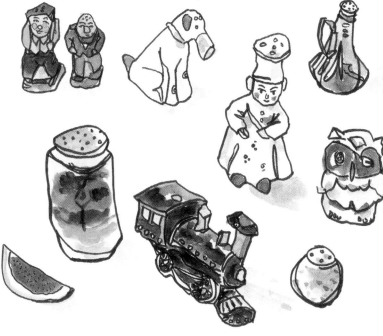

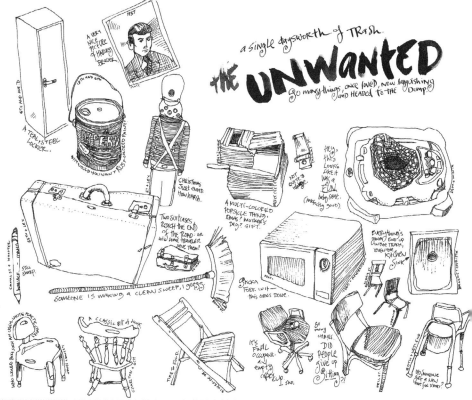

THE UNWANTED

So many things, once loved, now languishing and headed to the dump.

A TEAL STEEL LOCKER.

A VERY NICE PICTURE OF HARVEY BRADER.

WHO WOULD YOU WANT? RUST-COLORED PAINT.

CHRISTMAS SHEET-ENDED. HOW HARSH.

TWO SUITCASES REACH THE END OF THE ROAD: OR WHO WANTS TRAVELER SAVE THEM?

A MULTI-COLORED POPSICLE THING. XMAS? MOTHER'S DAY? GIFT.

HEY, THIS LOOKS LIKE IT WAS A FUN (perfectly good) baby seat.

SOMEONE IS MAKING A CLEAN SWEEP, I GUESS.

STICK A FORK IN IT— THIS OVEN'S DONE.

EVERYTHING'S GONNA END UP ON THE TRASH, EVEN THE KITCHEN SINK.

WHO LOOKED AWAY USUAL WHITE PLASTIC CHAIR

A CLASSIC BIT OF JUNK

SO MANY CHAIRS. DID PEOPLE GIVE UP SITTING?

IT'S FINAL OCCUPANT. AN EMPTY SEAT. SO I SAID.

DID SOMEONE GET A NEW ONE FOR XMAS?

Patti has gone to Los Angeles for a few days, leaving me with a blend 60's, plenty of time and not much to do but draw, a bowl of cherries, and a sore and tired heart. She'll be back on Tuesday, I hope.

SET AN APPOINTMENT TIME FOR DRAWING. REMEMBER THAT HALF AN HOUR THREE TIMES A WEEK IS BETTER THAN THREE HOURS ONCE A WEEK. EVEN TEN MINUTES EVERY DAY IS GREAT. JUST LIKE PHYSICAL EXERCISE, REGULAR SHORT SETS OF DRAWING ALLOW YOUR MENTAL AND PHYSICAL MUSCLES TO STRETCH AND GROW WITHOUT BOREDOM OR FATIGUE OR INJURY.

JOIN A CLASS, IDEALLY AT YOUR OWN LEVEL. IF YOU HATE IT AND WANT TO QUIT, COMMIT TO ANOTHER BEFORE YOU DO.

SHOW YOUR WORK. PUT IT UP ON THE FRIDGE OR IN YOUR OFFICE. REPLACE IT EVERY COUPLE OF DAYS.

BUY A CHEAP FRAME AND POP A DRAWING INTO IT. GIVE IT TO SOMEONE WHO WILL BE SURPRISED BY THE GIFT.

BE SPECIFIC.

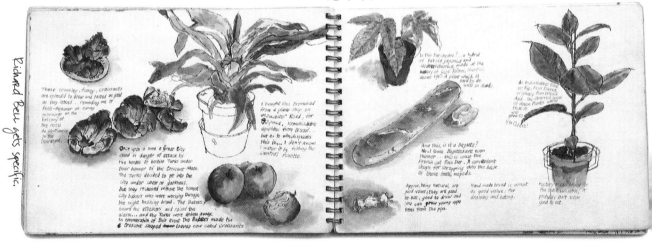

AVOID SKETCHY APPROXIMATIONS LIKE THIS: SOME PEOPLE RECOMMEND DOING A LITTLE PRELIMINARY COMPOSITIONAL THING FIRST. I'D RATHER SEE IT IN MY EYE. YOU ARE RECORDING WHAT YOU SEE, SO WHY BOTHER WITH A SKETCH? IT'S LIKE LOOKING THROUGH A DIRTY WINDOW BEFORE OPENING THE DOOR, IGNORING DETAILS IN ORDER TO CREATE A NICE PICTURE. GET RIGHT INTO IT AND BE SPECIFIC WITH WHAT YOU SEE AND DRAW. ONLY CHICKENS SCRATCH.

"The day is coming when a single carrot, freshly observed, will set off a revolution."
— Paul Cézanne

Richard Bell gets specific.

DRAW A PLANT OR AN OBJECT. WRITE CALL-OUTS NOTING ASPECTS OF THE OBJECT: WHAT IT SMELLS LIKE, WHAT ITS COLORS REMIND YOU OF, HOW ONE PART COMPARES WITH ANOTHER. MAKE YOUR OBSERVATIONS PARTICULAR TO THIS SPECIFIC SUBJECT. LOOK UP SOME NEW FACT ABOUT THE OBJECT: WHERE IT WAS MANUFACTURED, SOMETHING ABOUT ITS RAW MATERIAL, ITS LATIN NAME, ETC.

It's taken me far too long to get back into the swing of going to the gym again but this week I have forced myself back into the routine of being member #10806 at the gym again. I guess things fell apart when we went on vacation and though I did manage to go that one time in the Dominican Republic, we then all got sort of sick and the lazy, fat, inner me just kept on rolling with that excuse for a full month, surprisingly, I've not become overly bloated during this hiatus which I have, of course, attributed to some form of cancer rotting my innards and keeping my waistline in check. I seem to have developed sinus or pallet cancer now because when I get very thirsty (when I work at home I go for long stretches in which I kind of forget to hydrate at all) the roof of my mouth sort of hurts – no lumps yet but there may be blackened patches but I'm afraid to examine myself with a mouth mirror – anyway, I've returned with my iPod to the gym again – I even have a two-pack – must be all the hip-hop I'm listening to. And I am sweating like an old muscular bastard once again.

scott spencer

MEN in BLACK

On the plane, I started reading "a funny, dark and satirical novel" about a 40-something writer who achieves fame for the wrong reason, has all sorts of family problems + ultimately finds some sort of truth. When I finished it yesterday, I began reading "a funny, dark and satirical novel" about a 40-something realtor who is the ultimate conformist with an utterly empty soul.

SINCLAIR LEWIS
BABBIT

THERE ARE MANY DIFFERENT WAYS OF WRITING IN YOUR JOURNALS. YOU COULD MAKE SPARE LITTLE OBSERVATIONS ABOUT THE SCENE: "GREY, OVERCAST. DIRTY GYM CLOTHES DRYING SLOWLY. RUMPLED BED." OR YOU COULD BE MORE LAVISH, LESS STINGY WITH YOUR PROSE AND WRITE SOMETHING EVOCATIVE THAT THE PICTURE DOESN'T COMMUNICATE. OR WRITE ABOUT THE MEANING OF THE SCENE TO YOU: "WHY I AM BACK AT THE GYM AGAIN." OR WRITE DOWN THE TOTALLY OTHER THOUGHTS THAT FLASHED THROUGH YOUR MIND AS YOU DREW: "WHY I THINK WE SHOULD GO TO SPAIN THIS SUMMER..."

THE RHYTHM IS GONNA GET YOU.

I'VE ALWAYS ENJOYED DRAWING SERIES OF THINGS. IT'S SO INTERESTING TO SEE VARIATIONS ON A THEME, TO EXPLORE CONNECTIONS BETWEEN THINGS, AND TO EXPAND SPECIFICS INTO GENERALITIES AND VICE VERSA. I LEARN A LOT BY DOING DRAWINGS OF SIMILAR THINGS, GOING DEEPER INTO THE FAMILIAR AND SEEKING OUT VARIATION. THE SUBJECT ITSELF IS FAIRLY IRRELEVANT; THE PATTERNS AND CHANGES ARE WHAT INFORM.

SERIES ARE INTERESTING TO LOOK AT, TOO. THE EYES LIKE RHYTHM. AND REPETITION AND PATTERN ARE MADE MORE INTERESTING BY VARIATION. THIS IS THE BASIS OF MUSIC: THE BASS LINE AND THE DRUM KEEP YOUR FEET MOVING, SYNCING UP WITH THE NATURAL RHYTHM OF THE HEART WHILE THE MELODY ADDS THE VARIATION THAT KEEPS YOU FROM ZONING OUT.

IT'S ALSO INTERESTING TO REVISIT THEMES FROM YOUR OWN WORK OR THAT OF OTHER ARTISTS. MONET HAD HIS WATER LILIES, HAYSTACKS, CATHEDRALS, AND POPLARS. MOZART'S VARIATIONS ON HAYDN'S STRING QUARTETS IN TURN INSPIRED LUDWIG VAN. VAN GOGH PAINTED A SELF-PORTRAIT ALMOST EVERY MONTH IN PARIS. PICASSO PAINTED DOZENS OF VARIATIONS ON VELAZQUEZ'S *LAS MENINAS*, WARHOL DID SOUP CANS, JIM DINE BATHROBES, WAYNE THIEBAUD CAKES, DAMIEN HIRST

PILLS, JOHN FORD WESTERNS, AND THE MAGNETIC FIELDS WROTE *69 LOVE SONGS* ON ONE ALBUM. IT'S MORE THAN A SHTICK. IT'S HOW YOU GO DEEPER. LIFE ITSELF IS A VARIATION ON A THEME. THE SEASONS REPEAT LIKE MOVEMENTS. EACH FRESH DAY PROVIDES A CANVAS WHOSE DIMENSIONS STRETCH FROM DAWN TO DAWN. EACH DAY, THE CLOCK TICKS OUT THE SAME NUMBER OF BARS. DESPITE THIS CONSISTENCY, WE HAVE ENORMOUS FREEDOM TO PLAY EACH DAY AS WE WILL. WE CAN SEEM TO TRACE THE PREVIOUS DAY EXACTLY, FROM BED TO THE OFFICE TO LUNCH TO THE TRAIN HOME TO THE TV SET TO BED AGAIN. BUT OUR HAND ALWAYS HITCHES SOMEWHERE ALONG THE PATH, THROWING IN SOME MINOR VARIATION. THE ART IS IN NOTICING THESE CHORD CHANGES, ATTENDING TO LIFE CLOSELY ENOUGH TO RECOGNIZE ITS SHIFTS. THAT'S THE ART OF JOURNAL-KEEPING.

I FIND ENORMOUS POSITIVE REINFORCEMENT IN THESE LITTLE ADJUSTMENTS. THEY SHOW ME THAT WHAT HAS BEEN MAY NOT NECESSARILY CONTINUE TO BE—THE SKIES WILL CLEAR, THE MERCURY WILL RISE. AND YET I SEE THE CONSISTENCY, TOO, SO I AM NOT AS PANICKED BY CHAOS. THERE IS REASSURANCE IN THE SAMENESS AND HOPE IN THE CHANGES.

Remains of the Day

Jack's birthday and all the attending planning and chaos are over. I think he had a lot of fun.

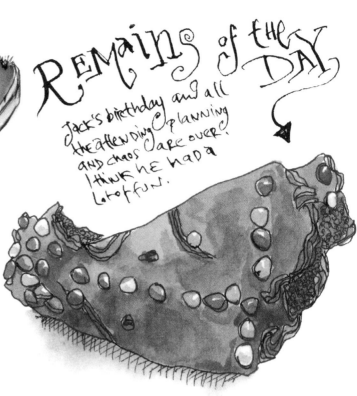

TAKE A WALK WITH YOUR EYES OPEN, A WALK JUST FOR SEEING. VISIT A NEW NEIGHBORHOOD, WALK THROUGH A PARK OR FOREST. ALONG THE WAY, COLLECT AN OBJECT THAT WILL BE INTERESTING TO DRAW AND WILL EVOKE YOUR JOURNEY. IT COULD BE A BRANCH, A LEAF, A FLATTENED SODA CAN, A CRUMPLED—UP FLYER, A CIGARETTE BUTT, A LOST GLOVE.

WHEN YOU GET HOME, DRAW YOUR OBJECT LARGE ON THE PAGE. THEN DRAW IT FROM ANOTHER ANGLE, MAYBE TWO. AROUND THE DRAWINGS, DESCRIBE YOUR WALK AND WHAT YOU DISCOVERED ALONG THE WAY. BE AS INTERESTING AND ENGAGING AND SPECIFIC AS YOU CAN IN YOUR DESCRIPTION. RECORD THE EVIDENCE OF AS MANY OF YOUR SENSES AS YOU CAN.

IN ONE CORNER, DRAW A MAP OF YOUR ROUTE, LABELING LANDMARKS — NOTE THE LOCATIONS OF THE THINGS YOU SAW, THE OBJECT YOU FOUND.

Live in your journal.
Live through your journal.

The squirrels don't seem to be in this nesting box but the evidence of their residence therein can be observed in the bite and scrape marks on the wooden entrance jamb. As you can tell by my vocabulary, I am distracted as I write this; someone's pomposity is gnawing on my ears like a squirrel.

THE FIRST DRAWING
OF THE DAY CAN FEEL LIKE
GETTING UP ON A SUNDAY
MORNING AFTER A LONG DAY
OF CHORING, A LONG NIGHT OF
POURING, OR A SHORT NIGHT OF
SNORING. RUSTY AS AN UNPAINTED
GATE, CRAMPED
AND OVERTHUNK.
WITH TIME, AND
CAFFEINE, AND
A FEW FALSE
STARTS, THE INK
BEGINS TO FLOW.

REMEMBER YOUR JOURNAL IS YOUR
COMPANION. FEEL FREE TO DOODLE ON
ITS PAGES, TO WRITE DOWN TO-DO
LISTS, BRILLIANT OR SILLY IDEAS, WHAT
HAVE YOU. JUST USE IT!

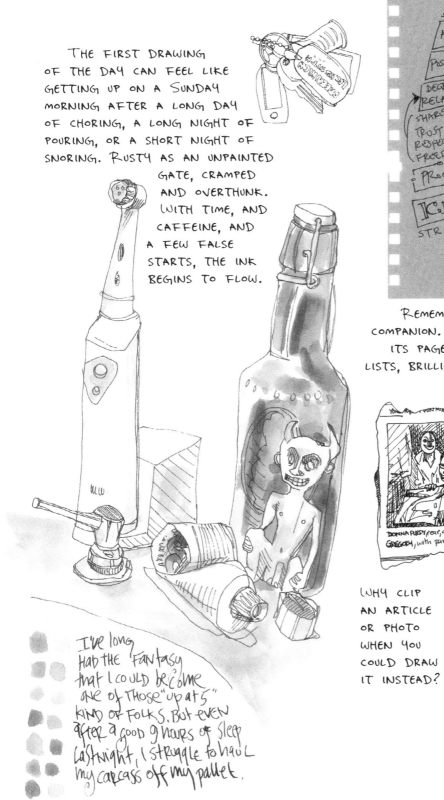

WHY CLIP
AN ARTICLE
OR PHOTO
WHEN YOU
COULD DRAW
IT INSTEAD?

I've long
had the fantasy
that I could become
one of those "up at 5"
kind of folks. But even
after a good 9 hours of sleep
last night, I struggle to haul
my carcass off my pallet.

Getting Nekkid

I HAVE BEEN DOING LIFE DRAWING AT A STUDIO A FEW BLOCKS FROM MY HOME. GENERALLY THE SESSIONS ARE OPEN AND YOU CAN DO WHAT YOU LIKE. SOME PEOPLE PAINT OR DRAW. ONE GUY DRAWS ENTIRELY ON HIS LAPTOP (AND FABULOUSLY, CREATING IMAGES THAT LOOKED BREATHTAKINGLY LIKE CHALK & PASTEL DRAWINGS). I JUST WENT TO A THREE-HOUR ANATOMY LESSON; WE STUDIED THE INNARDS OF THE BOTTOM OF THE FOOT. FASCINATING AND BAFFLING.

DRAWING THE HUMAN BODY IS HARD. TACKLING A NUDE IS THE HARDEST OF ALL. THE BODY HAS SO MANY UNFAMILIAR SHAPES AND ANGLES, ALL SYMBOLS DISTORTED BEYOND RECOGNITION (A LEG MAY LOOK LIKE A STICK OR A CIRCLE OR A FORESHORTENED TRIANGLE OR...) MAKING THE DEGREE OF DIFFICULTY QUITE NUMBINGLY HIGH.

IT'S NOT JUST THAT A BODY HAS SO MANY ANGLES AND CURVES. IT'S HOW LOADED IT IS WITH EXPECTATION AND MEANING. HUMANS KNOW THE HUMAN BODY INTUITIVELY AND YET NOT CONSCIOUSLY. WE ARE ABLE TO SPOT OUR SPECIES FROM AFAR, TO RECOGNIZE A FRIEND FROM ANOTHER AMONG THOUSANDS. HAVE YOU EVER SCANNED A HUGE CROWD, AT A FOOTBALL GAME OR IN A TRAIN STATION, AND BEEN ABLE TO FIND A FAMILIAR FACE — THOUGH ALL YOU HAVE TO GO ON ARE TINY DIFFERENCES, THE ANGLE OF A NOSE, THE MINUSCULE DIFFERENCE IN EYE SIZE OR THE RELATIONSHIP BETWEEN EAR AND CHEEKBONES?

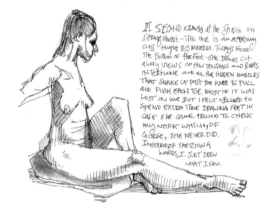

A SECOND CLASS AT THE STUDIO ON SPRING STREET — THIS ONE IS AN ANATOMY CLASS TAUGHT BY MINERVA. TODAY'S FOCUS THE BOTTOM OF THE FOOT — SHE DRAWS OUT AWRY VIEWS OF HOW TENDONS AND BONES INTERTWINE AND ALL THE HIDDEN MUSCLES THAT SNAKE UP PAST THE KNEE TO PULL AND PUSH EACH TOE. MOST OF IT WAS LOST ON ME BUT I FELT OBLIGED TO SPEND EXTRA TIME DRAWING FEET IN CASE SHE CAME AROUND TO CHECK MY WORK WHICH, OF COURSE, SHE NEVER DID. INSTEAD OF SKETCHING WARDS, I JUST DREW WHAT I SAW.

CUT A PERSON'S HAIR, GIVE THEM A BEARD, MAKEUP, A HAT, OR GLASSES AND, OFTEN, WE WILL STILL MANAGE TO PICK THEM OUT FROM ACROSS A CROWDED STADIUM. IT'S A LIFE-SAVING SKILL, FINDING YOUR MOTHER IN A HERD, AND YET IT'S A LOBSTER TRAP OF SORTS. WE CAN SPOT MOM AND YET WE PROBABLY CAN'T DESCRIBE HER ACCURATELY TO A POLICE OFFICER WITH AN INDENTIKIT. WE CAN'T RENDER IN WORDS THOSE FEATURES THAT WE CAN SO ACCURATELY IDENTIFY IN A SEA OF FACES.

WHEN DRAWING THE HUMAN BODY, UNCLOTHED — A SIGHT WE ACTUALLY BEHOLD QUITE RARELY IN THE FLESH (AND YET THINK ABOUT SEVERAL TIMES AN HOUR) — WE HAVE TO DITCH ALL OUR BAGGAGE AND TRY TO SEE CLEARLY WITHOUT JUDGMENT, BREAKING IT DOWN INTO COMPONENTS, LINES, SHADOWS, ANGLES, AND CURVES. AND YET THE INACCURACIES WE MIGHT GET AWAY WITH WHEN DRAWING AN APPLE OR A CAR OR A BUILDING ARE COMPLETELY UNACCEPTABLE WHEN DRAWING A PERSON.

THE TINIEST MISCALCULATION IN THE ANGLE OF A NOSE TURNS MARY INTO SUE OR POSSIBLY BOB. ON THE OTHER HAND, IF WE SLOW DOWN TOO MUCH, BECOME TOO ACCURATE, TOO CALCULATED, WE WILL NEVER CAPTURE MARY'S BALANCE AND WEIGHT. SHE WILL BECOME A TWO-DIMENSIONAL CUTOUT INSTEAD OF A BODY WITH MASS AND VOLUME. WE'LL LOSE THE SENSE OF THE BONE, MUSCLE, AND FAT THAT LIE BENEATH THE SKIN. AND MOST CHALLENGING OF ALL, WE WILL FAIL TO CAPTURE HER HUMANITY, HER PERSONALITY AND CHARACTER, HER SPARK OF LIFE. SHE WILL BE JUST A BODY, A SLAB OF FLESH, AN ANIMAL, A CADAVER, AND NOT MARY.

SEEING HUMANS IS EXTRAORDINARILY HARD BECAUSE IT REQUIRES THE USUAL COOL, CALM, OBJECTIVE SIGHT THAT LETS US DRAW STILL-LIFES AND LANDSCAPES AND YET A MUCH HEALTHIER DOLLOP OF SUBJECTIVITY. WE CAN READ ANATOMY BOOKS AND LEARN ALL THE TRICKS THAT MAKE JOINTS TURN AND PROPORTIONS ACCURATE, BUT WE WILL END UP WITH COMIC BOOK HEROES OR MANNEQUINS. TO BE DEGAS OR RODIN, WE MUST WORK AND WORK TO INTERNALIZE THESE PRINCIPLES SO THEY BECOME UNCONSCIOUS, SECOND NATURE, SO THAT WE CAN SUFFUSE THEM WITH FEELING

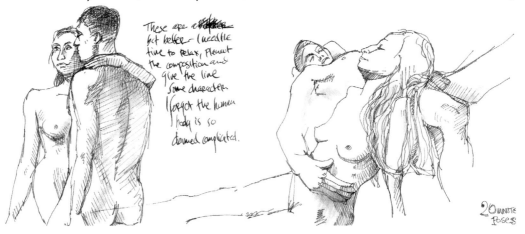

AND RESPONSE. THE ACTUAL PERSON BEFORE US IS NOT A FACELESS HULK BUT A LIVING BREATHING PERSON FOR WHOM WE CAN LUST OR FEEL PITY, LOVE, OR DISDAIN.

INVOKING THAT HUMAN FEELING IS AT THE CORE OF ALL SUCCESSFUL ART, EVEN WHEN IT'S NOT DEPICTING HUMAN ANATOMY. TO DRAW A PEACH OR A BEACH OR A LEECH, AND TO MAKE THE VIEWER FEEL SOMETHING REAL ABOUT IT, WE MUST TRANSCEND TECHNIQUE AND APPROACH THE TRUTH ABOUT HOW WE FEEL ABOUT PEACHES AND LEECHES, ABOUT THE WORLD, ABOUT OURSELVES — A TRUTH THAT IS SIMULTANEOUSLY INTENSELY PERSONAL AND COMPLETELY UNIVERSAL.

PRACTICE MAKES PERFECT. BY MASTERING TECHNIQUE, ANATOMY, LIGHT, COLOR, MATERIALS, WE PUSH THEM INTO THE BACKGROUND AND LET OURSELVES TAKE THE HELM — HONEST, OPEN, CARING, JUDGMENTAL, FLAWED, TRUE. DRAWING HUMANS IS INCREDIBLY HARD BECAUSE TO DO IT REALLY WELL, WE MUST LET OURSELVES BE A LITTLE NAKED, TOO.

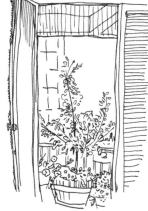

10,000 things to DRAW.

MAKE YOUR OWN LIST. HERE'S MINE.

- EVERY APPLIANCE IN OUR HOUSE
- EVERY PHONE IN OUR HOUSE
- EVERY CUP, MUG, VASE, AND LAMP
- MY CAR'S ENGINE
- MY HANDS, FEET, FACE, BODY
- ALL OF MY WIFE'S COSMETICS
- THE EXTERIOR OF EACH PLACE I BUY LUNCH
- EVERY PEN AND PENCIL IN MY DESK
- EVERY PRESENT I GOT ON MY LAST BIRTHDAY, CHRISTMAS
- THE PORTRAITS IN MY HIGH SCHOOL YEARBOOK
- EVERY CHAIR IN OUR HOUSE
- EVERY OUTLET AND ALL ITS PLUGS
- EVERYTHING THAT BELONGS TO OUR DOG: FOOD, TOYS, CLOTHES, BED, MEDICINE, ETC.
- ALL THE LIQUOR IN OUR CABINET
- ALL OF OUR SPORTS EQUIPMENT

- TEN PIECES OF BROKEN COOKIE
- TEN MANHOLE COVERS
- TEN HYDRANTS
- A PLATE OF SPAGHETTI
- EACH COMPONENT OF A SANDWICH, INDIVIDUALLY, THEN ASSEMBLED
- ALL OUR JEWELRY AND WATCHES
- EVERY HAT I OWN
- EVERY BILL AND COIN IN MY POCKET
- TEN THINGS FROM ANY CATALOG IN OUR MAILBOX
- THE LAUNDRY: CLOTHES, MACHINES, DETERGENT, ETC.
- THE VIEW OUT EACH WINDOW OF OUR HOME

- THE CONTENTS OF KITCHEN CABINET, FRIDGE, BEDSIDE TABLE, MEDICINE CABINET
- ALL MY SHOES, CLOTHES
- COVERS OF TEN FAVORITE CDS, BOOKS
- EVERY SIGNIFICANT FRONT DOOR OF EVERY PLACE I'VE LIVED OR WORKED
- EVERYTHING I EAT TODAY
- CONTENTS OF MY BAG, OF MY POCKETS
- EVERY TREE ON MY BLOCK, LABELED WITH ITS OFFICIAL LATIN NAME
- ALL THE CARS ON MY BLOCK
- CLUTTER ON MY DESK
- A MAP OF MY NEIGHBORHOOD
- PORTRAITS OF MY WIFE, SON, AND PETS ASLEEP

South from my bed.

CHAPTER FOUR:
SENSITIZATION
RE-CONNECTING WITH REALITY

From the journals of Prashant Miranda.

BODIES

EVERYWHERE

BODIES

"One night I went for a walk by the sea, along the empty shore.
"The deep blue sky was flecked with clouds of a blue deeper than the fundamental blue of intense cobalt, and others of a clearer blue, like the blue whiteness of the Milky Way. In the blue depths, the stars were sparkling, greenish, yellow, white, pink, more brilliant, more sparkling gem-like than at home — even in Paris: opals you might call them, emeralds, lapiz lazuli, rubies, sapphires.
"The sea was very deep ultramarine—the shore a sort of violet and faint russet as I saw it—some bushes, Prussian blue."

-Vincent van Gogh

Van Gogh

saw more in the dark than most people see in the light of day. He saw details, nuances, beauty in a single night sky. And he was able to describe what he saw to make it come alive for us, to describe it in words and, even more effectively, with paint. He shared his vision by explaining it in references we can all understand.

Creativity is about imagination and yet it's about reality, too. Seeing the world as it truly is, right now, observing carefully so you can respond to what IS — without that grounding in reality, flights of imagination are unconvincing. Thus the old saying: write what you know.

Your audience will always need a common launch pad. If you are completely detached, self-involved, no one will relate to or enjoy your work. They will be confused or disgusted. But the keener your sense of observation the more you will draw your audience in. The funniest stand-up comedians are the ones who tell the truth; the best actors embody their characters by nuanced observations that we recognize, too; musicians who write love songs without understanding emotion are hacks who produce only clichés.

The most interesting drawings are often of "damaged," aged, weather-beaten objects. Real faces complete with wrinkles, asymmetry, dings and dents. They seem alive because their owners are willing to embrace their experience. Perfection is just a cartoon. Botox erases life.

The same is true of how you draw. Beginners think there is some sort of ideal perfection toward which all artists strive, that ultimately all artists want to be able to capture reality with photographic accuracy. In truth, art is about the individual through whom vision is channeled. It reflects the peculiarities and idiosyncrasies of the mind that turn the observation into lines on paper.

No one is like you. Be yourself and you will be unique. Express that self, the unique place you occupy, the unique point of view from which you see, and your work will be unique.

People will want it. They will want you. Just be brave enough to *be* it, to have faith in it, and you will be rewarded.

But first, you must get down to the real you. You must scrape off the barnacles that cover you. You must open your senses so you can see clearly as yourself. You must get rid of all the preservatives and sweeteners and artificial coloring that are diluting you. You must distill your essence down to 100% unadulterated you.

Let's Do an EXPERiMeNT.

IT WILL MAKE YOU FEEL MORE IN CONTROL, MORE CLEAR, MORE IN TUNE, MORE CREATIVE, AND WILL HELP YOU RECLAIM A HUGE CHUNK OF YOUR LIFE. IT HAS TWO PARTS. FIRST WE'LL TRY TO CLEAR YOUR MIND OF ALL THE STUFF THE MODERN WORLD BOMBARDS YOU WITH. THEN WE'RE GOING TO FINE-TUNE YOUR RECEPTORS, ONE SENSE AT A TIME.

FIRST LET'S CLEAR SOME SPACE IN YOUR HEAD WITH A SHORT ELECTRON FAST.*

FOR TWO OR THREE DAYS, STOP WATCHING TELEVISION. STAY OFF THE INTERNET. IGNORE YOUR E-MAIL. TURN OFF THE RADIO. DON'T READ THE PAPER, MAGAZINES, OR BOOKS (EXCEPT THIS ONE, OF COURSE).

(IF YOU FEEL THIS WILL DERAIL YOUR JOB IN SOME MAJOR WAY, THEN BE JUDICIOUS. CUT BACK AS MUCH AS YOU CAN. BE CONSERVATIVE. THINK ABOUT EACH E-MAIL YOU WRITE. BE ONLINE AS LITTLE AS YOU CAN. EXPLAIN TO PEOPLE WHAT YOU ARE DOING IF YOU'D LIKE. YOU'LL BE SURPRISED HOW SUPPORTIVE THEY ARE. ONCE YOU LEAVE WORK, MAKE UP FOR LOST TIME BY BEING EVEN MORE ORTHODOX ABOUT THE FAST. BELIEVE ME, IF THERE'S SOME SORT OF BIG NEWS, YOU'LL HEAR ABOUT IT.)

WE ARE BOMBARDED WITH MORE INFO THAN ANY PAST GENERATION. TWENTY-FOUR-HOUR NEWS, BILLIONS OF WEB PAGES, THOUSANDS OF NEW PRODUCTS, 500 CABLE CHANNELS, HUNDREDS OF NEW MOVIES EACH YEAR, THOUSANDS OF DVDS, MOBILE PHONES ON OUR HIPS, E-MAILS FLOODING OUR PCS, NEWS OF SCANDALS, INTERNATIONAL INCIDENTS, AND LOADS OF MARKETING AND USELESS MIND-CANDY. OUR LIVES ARE REGULARLY ROCKED BY NEW HOMES, NEW JOBS, NEW ACQUAINTANCES, NEW RESPONSIBILITIES, ALL OF WHICH INCREASE OUR SENSE OF DISLOCATION, OVERWHELM OUR SENSES, AND DILUTE OUR SENSE OF SELF.

THINK ABOUT THIS AS YOU TRY TO DISENGAGE FROM THE INFO-TSUNAMI.

BE AWARE HOW MUCH MEDIA THERE IS:

*THIS IS A MODIFIED VERSION OF ONE OF THE MOST VALUABLE EXERCISES IN JULIA CAMERON'S MASTERPIECE, *THE ARTIST'S WAY*.

MESSAGES ON PEOPLE'S CLOTHING, ON BILLBOARDS, ON MILK CARTONS, AND ON TOOTHPASTE TUBES. LOOK AWAY. REMAIN IN THE PRESENT RATHER THAN ALLOWING THESE MESSAGES TO CATAPULT YOUR MIND TO SOME OTHER PLACE: A CARIBBEAN VACATION, A CAR SHOWROOM, A MOVIE SET.

No MATTER HOW SUCCESSFUL YOU ARE IN PRUNING YOUR LIFE OF ALL THIS INFORMATION, ONCE YOU START YOU WILL IMMEDIATELY FIND YOU HAVE A LOT MORE SPARE TIME. INSTEAD OF FLICKING ON THE TUBE WHEN YOU COME HOME, YOU WILL HAVE TIME. INSTEAD OF LISTENING TO TALK RADIO WHILE YOU DRIVE, YOU WILL HAVE TIME. INSTEAD OF READING THE PAPER ON THE TRAIN, YOU WILL HAVE TIME. INSTEAD OF DISTRACTING AND ANESTHETIZING YOURSELF, YOU WILL HAVE TIME.

Now, HOW WILL YOU FILL THAT TIME?

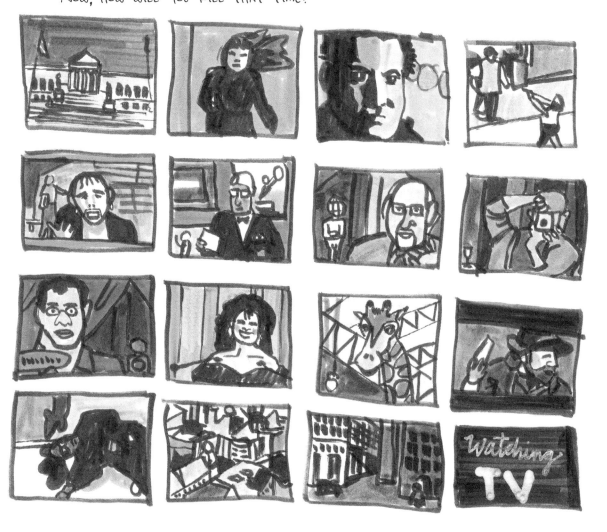

Tune in. Live more.

How aware are you? What colors did you wear yesterday? What color are your boss's eyes? Your spouse's toothbrush? Your car's upholstery?

How do you shop for lightbulbs? By price? Light quality? Wattage? Color? Or don't you care?

What was the last piece of music you heard? The first tune you heard this morning? Anywhere, including elevators or a neighbor's radio?

Describe the cover of this book in detail, without looking at it.

Do you ever re-adjust the settings on your TV? On your car radio? Have you ever used an equalizer?

Do you shop for sunglasses based only on their style? Or do you consider the color of the lenses?

When did you last choose silence?

What flower's smell do you love the most?

How many can you recognize? Can you recall any of them right now?

Do you own various perfumes or colognes?

Smell something offensive. Keep smelling it even when you'd rather not. What happens?

Do you talk, watch TV, read when you eat? How do you think that affects your taste?

Can you feel your body inside your shoes? Clothes? Underwear?

I've discovered that the first knuckle of my index fingers is the only hairless one on both my hands. It seems to be true of everyone's first knuckle. Am I the first to discover this? Can you be the first to discover something?

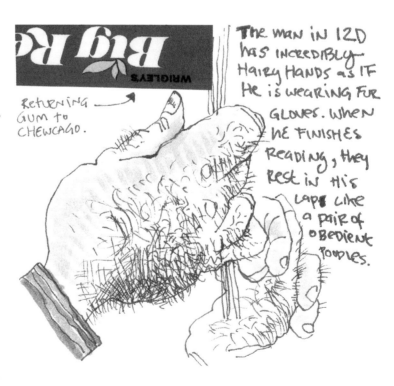

Returning gum to Chewcago.

The man in 12D has incredibly hairy hands as if he is wearing fur gloves. When he finishes reading, they rest in his lap like a pair of obedient poodles.

BE PRESENT.

PICK A LEAF. DRAW IT CAREFULLY FOR AS LONG AS YOU CAN. NOW HOLD THE LEAF. HOW DO YOU FEEL ABOUT IT? DO YOU FEEL A BOND, EVEN A ONE-NESS? WHAT WOULD SEEM APPROPRIATE TO DO WITH THE LEAF NOW? WHAT DOES THAT SAY ABOUT HOW YOU FEEL ABOUT YOURSELF?

DO YOU REMEMBER VIEWMASTERS AND HOW AMAZING EVERYTHING LOOKED THROUGH THEM? CLEAR, PERFECT LIGHTING; BRIGHT, UNAMBIGUOUS COLORS; ENDLESS DEPTH OF FIELD... WHAT IF YOU COULD SEE LIKE THAT ALL THE TIME? WELL, YOU CAN. THAT'S WHAT REALITY ACTUALLY LOOKS LIKE IF YOU CAN SEE THINGS AS THEY TRULY ARE.

"If we take eternity to mean not infinite temporal duration, but timelessness, the eternal life belongs to those who live in the present."
– Ludwig Wittgenstein

CAN YOU "SEE" THE SHAPE OF MOVEMENT IN NATURE? HOW RIVERS FLOW? HOW CLOUDS MOVE? HOW FIRES GROW? STUDY A NATURAL PROCESS OVER TIME: THE GROWTH OF A PLANT, A BIRD'S FLIGHT, HOW A LEAF FALLS, THE DEATH OF A BOUQUET, A DOG'S WALK.

QUINCY BELONGS to the NEIGHBOR of my guesthouse, BaL my Casa. He wandered in to visit with me this morning. A friendly Lug with the most extraordinary BREATH, He gets quite shifty and evasive when asked to pose for a drawing.

PUT THIS BOOK DOWN AND TRY TO BE IN THE HERE AND NOW, IN THIS PLACE. BREATHE IN AND OUT. OBSERVE BUT DON'T JUDGE OR FILTER. BE WITH ALL YOUR SENSES. BE.

I'M SERIOUS, PUT DOWN THE BOOK. BE.

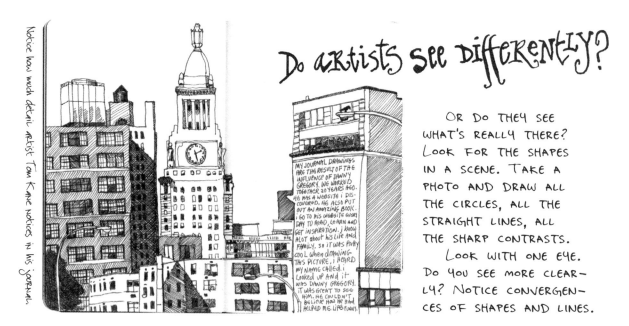

Do artists see Differently?

Notice how much detail artist Tom Kane notices in his journal.

MY JOURNAL DRAWINGS ARE THE RESULT OF THE INFLUENCE OF DANNY GREGORY. WE WORKED TOGETHER 20 YEARS AGO. HE HAS A WEBSITE I DISCOVERED. HE ALSO PUT OUT AN AMAZING BOOK. I GO TO HIS WEBSITE EVERY DAY TO READ, LEARN AND GET INSPIRATION. I KNOW ALOT about his Life AND FAMILY. SO IT WAS PRETTY COOL when drawing THIS PICTURE, I HEARD MY NAME CALLED. I Looked UP AND it WAS DANNY GREGORY. IT WAS GREAT TO SEE HIM. HE COULDN'T BELIEVE HOW HE HAD HELPED ME. LIFES FUNNY.

OR DO THEY SEE WHAT'S REALLY THERE? LOOK FOR THE SHAPES IN A SCENE. TAKE A PHOTO AND DRAW ALL THE CIRCLES, ALL THE STRAIGHT LINES, ALL THE SHARP CONTRASTS.

LOOK WITH ONE EYE. DO YOU SEE MORE CLEARLY? NOTICE CONVERGENCES OF SHAPES AND LINES.

NOTICE THINGS ON DIFFERENT PLANES. SEE HOW A LINE GOES BEHIND AN OBJECT AND WHERE IT EMERGES ON THE OTHER SIDE. NOTICE HOW INDIVIDUAL SHAPES CONVERGE TO FORM A LARGER SHAPE.

TRACE SHAPES IN A PHOTO. TRY COPYING THOSE SHAPES ON A SEPARATE PAGE.

DRAW ON A MIRROR WITH A GREASE PENCIL. (IT'LL COME RIGHT OFF WITH WINDEX.) TRACE THE OUTLINE OF YOUR REFLECTION. HOW BIG IS YOUR REFLECTION? WHY?

"These drawings were done for one reason only; to see before I die..." - Frederick Franck

The colors, the light, the vegetation, and the temperature remind me a lot of our visit to Florence. All the buildings in Jerusalem must be built from local stone, so the landscape is fairly uninterruptedly sandy; occasionally there are terra-cotta roofs for a spot of red and the olive and cypress trees add patches of dark green and black. The sky is always blue, at least during my current visit.

WHEN DRAWING NATURE YOU DISCOVER HOW BLAND AND UNIFORM ARE MAN'S CREATIONS. ONLY GOD CAN MAKE A TREE. WOULD YOU RATHER DRAW A PERSON OR THEIR CAR? A SKYSCRAPER OR A TREE? A COMPUTER OR AN APPLE?

Israeli Supermarkets

have certainly changed over the past decade when they were poorly lit and stocked; the merchandise seemed a bit suspect, underfresh or overfrozen; and generally Third World. Now the selection is almost as vast as my local Walgreen's. I don't understand why, with the few million Israeli customers, so many manufacturers have repackaged their brands especially for this market.

Just part of the inexorable march of globalism, I suppose.

HOW MUCH ART DO YOU SEE TODAY? BE AWARE OF PACKAGES, TEXTILE PATTERNS, STREET SIGNS...

Touch.

GET A MASSAGE, PARTICULARLY IF YOU'VE NEVER HAD ONE BEFORE. WHAT WENT THROUGH YOUR MIND? HOW DID YOUR BODY FEEL DURING AND IMMEDIATELY AFTER? HOW DID IT FEEL THE NEXT DAY? HOW DID YOU CHANGE YOUR FEELINGS ABOUT YOUR BODY, HOW IT IS CONSTRUCTED, HOW IT FEELS, HOW IT WORKS, WHAT IT ENDURES? WRITE AND DRAW A TRIBUTE TO THIS EXPERIENCE IN YOUR JOURNAL.

HAVE A PAL HAND YOU AN OBJECT WHEN YOUR EYES ARE CLOSED, SOMETHING YOU HAVEN'T SEEN. FEEL IT CAREFULLY ALL OVER. THEN HAVE THE FRIEND TAKE THE OBJECT AWAY. DRAW THE MEMORY. ADD NOTES AND LABEL ELEMENTS OF YOUR DRAWINGS.

"Beauty and grace are performed whether or not we will sense them. The least we can do is try to be there." – Annie Dillard

SMELL!

Not only are we surrounded by so many objects and products with fragrances, we are always masking and varying scents with others. Pine freshness, ocean breeze, lemony this and orangey that. Smells designed to confuse and dull our senses further. The more our sense of smell is overwhelmed and confused the more likely it is to shut down, to ignore new input. Eventually we stop relying on — or attending to — this vital sense.

The construction of our brain is such that smell is the most powerful and direct trigger of memory. How often have you smelled something which made you vividly aware of a memory from long ago? Your grandmother's pie, your father's soap, the family car, etc. Perfume is more than a sensual delight, it's a bookmark.

Let's give your nostrils a treat. Visit one or two of the following:
- Cheese store
- Florist
- Perfume counter
- Pet shop
- Lumberyard

Pick out individual smells.

Draw something in the store while focusing on the scents.

Take home a souvenir: a flower, a handful of sawdust, a cat toy. Draw it and see how it evokes the memory of the scent.

Today smell ten new things; carry three in your pocket.

Taste.

HERE'S ANOTHER VICTIM OF SPEED. DESPITE ALL OF OUR ENDLESS CHOICES SHIPPED FROM AROUND THE WORLD, IN SPITE OF CRAMMED SUPERMARKET AISLES AND EN-CYCLOPEDIC RESTAURANT MENUS, WE OPT FOR THE FAMILIAR — FOR OLD STANDBY RECIPES, FAST FOOD, AND ARTIFICIAL FLAVORS. WE EAT ON THE RUN OR WE MULTI-TASK AT THE DINNER TABLE SO FOOD BECOMES MERELY A ROUTINE WAY OF STILLING AN URGE OR A SUBLIMATION OF SOME OTHER NEED, RATHER THAN A FOCUSED AND MINDFUL PLEASURE. THIS WEEK, GIVE YOUR TASTE BUDS SOME NEW EXPERIENCES.

EAT SOMETHING YOU'VE NEVER HAD BEFORE. BETTER YET, COOK IT. PUT THE RECIPE AND A DRAWING OF THE FOOD IN YOUR JOURNAL.

TRY AN ETHNIC FOOD THAT'S NEW. LEARN ABOUT WHERE IT COMES FROM AND WHY THE PEOPLE THERE EAT AS THEY DO.

RE-VISIT FOOD YOU ATE AS A KID — SPAGHETTIOS, FROOT LOOPS, BAZOOKA, BABY FOOD — WHAT DOES THE TASTE TRIGGER? PROUST MANAGED TO SQUEEZE SEVEN VOLUMES OF RECOLLECTIONS OUT OF THE TASTE OF A SINGLE LITTLE COOKIE.

DO A "WINE TASTING" WITH FOUR DIFFERENT TYPES OF: ORANGE SODAS, BOT-TLED WATERS, TOOTHPASTES, JELLOS, ETC. DRAW THE PACKAGES. TRY TO DESCRIBE THE DIFFERENCE BETWEEN THE FLAVORS AS IF YOU WERE EVALUATING A FINE WINE.

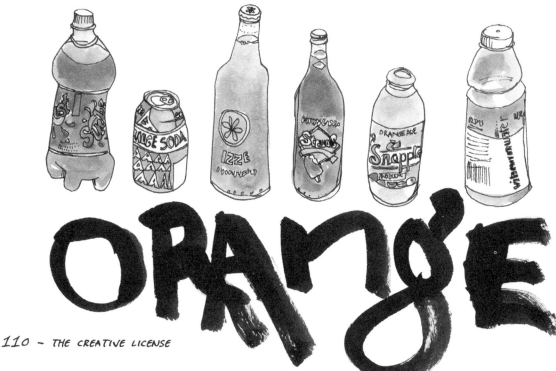

HEAR.

LIFE IS SO NOISY THESE DAYS. ALL DAY LONG, WE ARE BOMBARDED BY MUSIC, BY MACHINE NOISES, BY THE CHATTER OF OTHERS, BY TELEVISIONS IN THE BACKGROUND, BY RINGING, BUZZING, BEEPING TECHNOLOGY.

YET HOW OFTEN DO WE ACTUALLY STOP AND *LISTEN* TO THE WORLD? TRY IT NOW, EYES CLOSED. LISTEN TO DISTANT CHILDREN'S VOICES, TO LAWN SPRINKLERS, TO HUMMING AIR CONDITIONERS, BARKING DOGS, TO YOUR OWN HEARTBEAT. TAKE OFF YOUR HEADPHONES, TURN OFF THE TV, LOWER THE RADIO, AND LISTEN TO THIS MOMENT IN YOUR WORLD. CLOSE YOUR EYES. HEAR DEEPER. FURTHER. ISN'T IT AMAZING WHAT YOU'VE BEEN MISSING?

NOW LISTEN TO SOME MUSIC WHILE DOING NOTHING ELSE.

TRY LISTENING TO ALTERNATE RECORDINGS OF THE SAME PIECE OF MUSIC, LIKE SOME MOZART RECORDED BY DIFFERENT ORCHESTRAS OR SOLOISTS: HIS REQUIEM, THE JUPITER SYMPHONY, OR AN OPERA.

TRY TWO TAKES OF THE SAME JAZZ PIECE.

TRY A GREAT ROCK SONG PLAYED LIVE AND IN THE STUDIO. WHAT DO YOU HEAR?

BUY A CD OR GO TO A CONCERT OF A TYPE OF MUSIC YOU WOULD NORMALLY NEVER LISTEN TO. ETHNIC, CLASSICAL, JAZZ, PUNK. CAN YOU HEAR WHY PEOPLE ENJOY IT?

WHAT HAPPENS WHEN YOU DRAW AND LISTEN TO MUSIC AT THE SAME TIME? DO YOU SEE BETTER? DO YOU HEAR MORE? OR ARE YOU DISTRACTED? DO YOU FIND A DIFFERENCE BETWEEN SONGS WITH LYRICS VS. INSTRUMENTAL?

THINK ABOUT WHAT YOU HEAR.

CONSIDER THIS:

THE "CLASSICAL" PERIOD OF MUSIC LASTED FROM 1785 TO 1820 — JUST THIRTY-FIVE YEARS — AND PRODUCED HAYDN, BEETHOVEN, AND MOZART — HIP HOP MUSIC HAS BEEN AROUND ALMOST THAT LONG. DO YOU HAVE ANY SENSE OF ITS HISTORY, IMPACT, MAJOR FIGURES, ETC.? WHY OR WHY NOT?

"T" "OR TIKAR" IF YOU CAN'T PRONOUNCE IT
Tigar" that Jack's been asking for as a birthday gift for months.

Dusty CAME OVER WITH HIS TIKAR + PLAYED THE "PIRANHA" SONG.

this broke

"Any object, intensely regarded, may be a gate of access to the incorruptible eon of the gods." —James Joyce, Ulysses

See More through Contemplation.

PICK AN OBJECT TO DRAW. AS YOU DRAW, CONSIDER THE OBJECT IN NEW WAYS. MAKE UP YOUR OWN QUESTIONS, LIKE:

WHAT IS IT MADE OF? WHAT'S THE SOURCE OF THE MATERIAL? WAS IT MADE OR GROWN OR MINED? WHERE?

HOW DOES IT REACT TO LIGHT? WHY IS IT SHAPED AS IT IS? WHAT IS ITS STYLE? FUNCTION? HOW HAS TIME CHANGED IT? HOW WAS IT INVENTED? MAKE UP A STORY.

HOW AND WHEN DID YOU GET IT? WHAT WERE THE CIRCUMSTANCES?

WHAT DO YOU LIKE OR DISLIKE MOST ABOUT IT? HOW WOULD YOU CHANGE IT?

WHAT DOES OWNING THIS OBJECT SAY ABOUT YOU?

ANSWER THESE QUESTIONS ON THE SAME PAGE AS YOUR DRAWING.

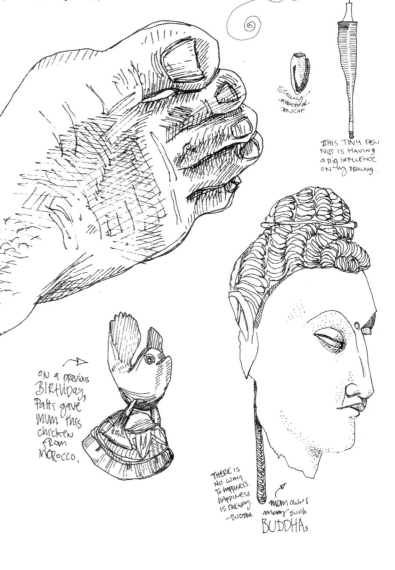

TOTALLY IMPRACTICAL PEN CAP

THIS TINY PEN NIB IS HAVING A BIG INFLUENCE ON MY DRAWING.

ON A PREVIOUS BIRTHDAY, PATTI GAVE MUM THIS CHICKEN FROM MOROCCO.

THERE IS NO WAY TO HAPPINESS. HAPPINESS IS THE WAY. —BUDDHA.

MUM OWNS MANY SUCH BUDDHAS

smith-9st. 4Av.9St. Jay St.-Borough Hall Ditmas Av.

PICK SIX THINGS IN A
CATEGORY: SPOONS, SHOES,
GARLIC CLOVES. DRAW EACH
ONE'S PARTICULARITIES.

ZOOM IN.

REMEMBER YOUR BAGEL DRAWING?
LET'S RE-VISIT THAT EXERCISE.
DRAW A PIECE OF FRUIT QUICKLY. NOW LOOK AT IT
AGAIN. DRAW MORE DETAIL. LOOK AGAIN; GO DEEPER, DEEPER.
CAN YOU CAPTURE THE TEXTURE OF THE SKIN, THE FLAWS
AND VARIATIONS, THE EFFECT OF LIGHT? RECORD THE
SURFACE QUALITY: IS IT FLAT, DOES IT HAVE LAYERS, ARE
THERE SHADOWS ON TOP OF DIMPLES ON TOP OF VARIATIONS IN
COLOR? DRAW AS MUCH AS YOU CAN. MAKE NOTES ON THE REST.

IMAGINE A SPOUSE OR FRIEND'S FACE IN YOUR MIND. STUDY
THE IMAGE IN DETAIL. CAN YOU HOLD ON TO IT? EXAMINE
THE RELATIONSHIPS BETWEEN THE FEATURES, THE CONTOURS AND
SHAPES. DRAW IT. WHAT'S RIGHT AND WRONG ABOUT YOUR
DRAWING? WHAT MAKES IT ACCURATE?

FROM MEMORY: DRAW YOUR TOOTHBRUSH,
YOUR PHONE, THE DASHBOARD OF YOUR CAR.
THEN GO AND LOOK AT THE OBJECT. WHAT
DID YOU REMEMBER? WHAT DID YOU
MISS? DRAW IT AGAIN FROM LIFE.

"I have learned that what I
have not drawn I have never
really seen, and that when
I start drawing an ordinary
thing, I realize how extraor-
dinary it is, sheer miracle."
— Frederick Franck

MY THEORY. THEORY #1.

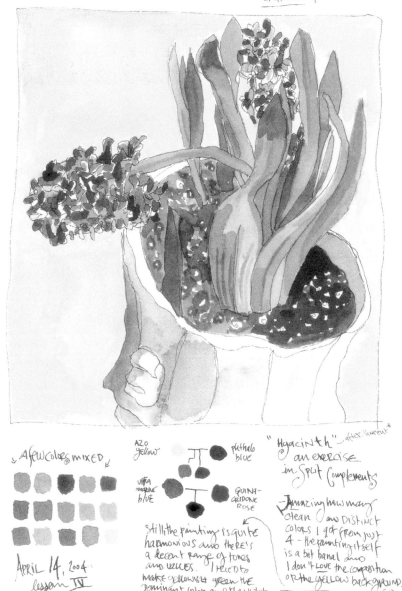

m. Graham paints

A few colors mixed

April 14, 2004
lesson IV

* I love his solid color backgrounds. F. Bacon too.

AZO Yellow

ultra marine blue

phthalo blue

QUINA- CRIDONE ROSE

Still the painting is quite harmonious and there's a decent range of tones and values. I tried to make yellow-ish green the dominant color and the violet pops pretty well.

"Hyacinth" — after Vincent *

an exercise in Split complements

Amazing how many clean and DISTINCT colors I got from just 4 — the painting itself is a bit banal and I don't love the composition or the yellow background.
(not clean enough)

— Danny

WHEN I WAS ABOUT NINE, I DEVELOPED A THEORY. WHAT IF EVERYBODY ACTUALLY SEES VERY DIFFERENT COLORS BUT CALLS THEM BY THE SAME NAMES. LIKE, I LOOK AT A TREE AND SEE ITS LEAVES AS A COLOR I CALL "GREEN." WHEN YOU LOOK AT THE TREE, YOU SEE A COLOR THAT I WOULD CALL "RED" BUT YOU CALL THAT COLOR "GREEN." THE ONLY WAY TO PROVE THE DIFFERENCE WOULD BE IF I COULD CLIMB INTO YOUR BODY AND SEE THROUGH YOUR EYES AND SAY "HOLD ON, YOU'VE GOT THE COLORS ALL BACKWARDS."

IT WASN'T A TERRIBLY USEFUL THEORY. STILL, I'VE THOUGHT ABOUT IT AGAIN QUITE OFTEN SINCE I STARTED PAINTING. WHAT I'VE BECOME INCREASINGLY AWARE OF IS HOW INACCURATE MY OBSERVATIONS OF COLOR REALLY ARE. I'M NOT COLOR-BLIND AND HAVE 20/20 VISION BUT I RARELY SEE WHAT'S REALLY IN FRONT OF ME. THE ROOT CAUSE SEEMS TO BE THE SAME THING THAT BLOCKED ME FROM DRAWING ALL THOSE YEARS: CONVERTING REALITY INTO SYMBOLS. AS I'VE

that is mine.

— ANN ELK, *MONTY PYTHON'S FLYING CIRCUS*

MENTIONED BEFORE, WHEN WE REDUCE OUR OBSERVATIONS TO SYMBOLIC SHORTHAND (THAT'S A CAR, THAT'S A BUILDING, THAT'S A PERSON) WE ARE FORCED TO DRAW ONLY SYMBOLS INSTEAD OF ACCURATE REPRESENTATIONS OF THE VERY SPECIFIC REALITY THAT LIES BEFORE US. IF WE ARE FAIRLY WELL VERSED IN CREATING DRAWN SYMBOLS, WE CAN COMMUNICATE THE GENERAL IDEAS WE PERCEIVE BUT CAN NEVER CAPTURE THE SPE-CIFIC ESSENCE OF WHAT IS THERE. WE CAN'T, IN OTHER WORDS, DRAW ACCURATELY.

AFTER A BIT OF PRAC-TICE AND SELF-DISCIPLINE, WE CAN ALL OVERCOME THIS HANDICAP AND SEE AND THEN DRAW THE SPECIFIC OUTLINES OF ANY SCENE FROM THE ANGLE WE ARE VIEWING IT. I, MORE OR LESS, HAVE DONE SO. BUT I SEE HOW MUCH I DO THE SAME OLD THING WITH COLOR. "THAT CAR IS YEL-LOW, THAT BUILDING IS GREY, HER HAIR IS BROWN." WHEN MY PAINTINGS ARE MORE THAN CARTOONS OR PAINT BY NUMBERS IT'S BECAUSE MY IDEAS ARE A LITTLE MORE COMPLEX.

"HER FACE IS IN SHADOW SO LET ME ADD BLACK OR MAYBE MIX A DARKER VERSION OF HER SKIN TONE."

"IT FEELS SORT OF COOLER OVER THERE SO LET ME PAINT THAT PART IN BLUE."

STILL, I AM DIVIDING THE WORLD UP INTO THE COLORS IN MY PAINT BOX AND THE FEW COMBINATIONS I CAN CONFIDENTLY MIX UP FROM THEM. IT'S ALL MADE-UP, A RATIONAL CON-STRUCTION BASED ON IDEAS RATHER THAN OBSERVATION.

THESE DAYS, I TRY TO FOCUS ON THE ACTUAL COLORS IN MY ENVIRONMENT. AS I WALK, I TRY TO ISOLATE A PATCH OF A WALL AND SEE WHAT COLOR IT REALLY IS. "THE WALL SEEMS BROWN, BUT THAT SECTION IN THE SHADOW IS REALLY QUITE PINK WHEREAS THAT PART ON THE CORNICE IS SILVER OR MORE ACCURATELY A COLOR I CAN'T NAME BUT SORT OF A LIGHT AND GLOWING GREY WITH A BIT OF PURPLE IN IT."

IT'S PRETTY OVER-WHELMING — SO MANY HUES AND SHADES AND VALUES, HARD TO DISCERN, DIFFICULT TO REMEMBER, IMPOSSIBLE TO REPRODUCE. BUT MY GOAL ISN'T REALLY ACCURACY. IT'S SENSITIV-ITY. TO LEARN TO SLOW MY BRAIN AND JUDGMENT DOWN ENOUGH TO ABSORB REALITY AS IT APPEARS AT THIS MOMENT, HERE. NOT TO SEE THE WORLD IN SHORT-HAND, AS A CARICATURE OR A BLUR, BUT TO LIVE LIFE FULLY, FROM MY PARTICULAR PLACE AND ANGLE. THAT, IT SEEMS TO ME, IS VERY MUCH THE POINT OF LIVING.

IF SOMEONE ELSE JUMPED INTO MY BRAIN, PERHAPS THEY'D SEE A WALL THAT'S BROWN. BUT I'D LOVE THEM TO SEE THE WHOLE RAINBOW RE-FLECTING BACK AT ME.

LeaRN to StoP.

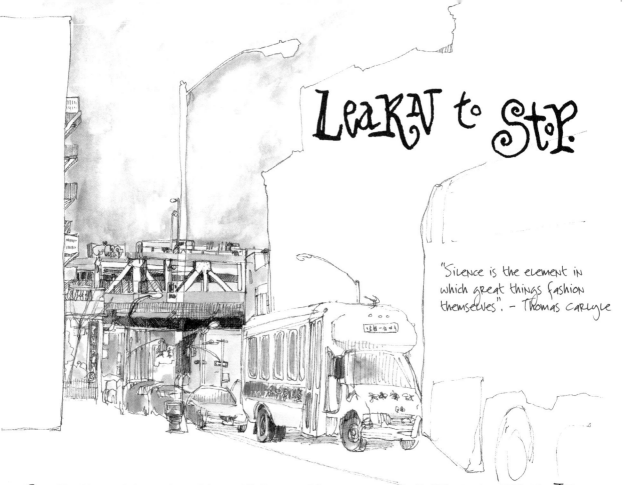

"Silence is the element in which great things fashion themselves" – Thomas Carlyle

SOMETIMES *NOTHING* IS MORE POWERFUL, MORE COMMUNICATIVE THAN *SOMETHING*. IT IS THE SPACES BETWEEN THINGS THAT DEFINE THEM. THERE WOULD BE NO DAY WITHOUT NIGHT, NO SUMMER WITHOUT WINTER, NO LIFE WITHOUT DEATH.

IN MUSIC, THE SILENCE BETWEEN NOTES CAN MATTER AS MUCH AS THE SOUNDS THEMSELVES. THESAMEISTRUEOFWRITINGWHICHISINCOMPREHENSIBLEWITHOUTBREAKSBETWEENWORDS. WHEN YOU EXERCISE, YOU MUST "REST" BETWEEN SETS. DURING THOSE BREAKS, THE MUSCLES REGENERATE AND GROW. WITHOUT THEM YOU GET ONLY STRAIN AND DAMAGE.

WHEN YOU DRAW, CONSIDER THE ROLE OF THE NEGATIVE SPACE, THE STRETCHES OF SKY BETWEEN BUILDINGS, THE BLANK CHEEKS, AS MUCH AS THE DETAILED EYES. EXPERIMENT WITH PAUSES. STOP A DRAWING WHEN YOU HAVE CAPTURED ONLY A FRACTION OF THE DETAILS YOU SEE. THIS WILL FORCE YOU TO SLOW DOWN, TO ABSORB YOUR SUBJECT IN A NEW WAY. TRY TO CAPTURE THE ESSENCE OF WHAT YOU SEE WITH AS LITTLE INFORMATION AS POSSIBLE. FILL ONE CORNER WITH INTENSE DETAIL AND SUGGEST THE REST OF THE SCENE ONLY WITH PARTIAL CONTOURS. TRY TO CAPTURE THE WORLD WITH A SINGLE LINE.

Stop to Learn.

If you could learn anything, what would you choose?
A language, an instrument, a skill, a craft, an art, a science?
Make a list. Prioritize it. What does this list really tell you about you?
What would be different about your life if you could learn X or Y?

How good would you have to be at your new skill to have
this change happen? Would simply studying it be enough? Would
you be satisfied with the basic skills? Would you have to prac-
tice for years? Could you be a happy amateur?

Research how you might learn to do these things. Look up schools. Call
experts. Send for brochures. Browse the Yellow Pages. Surf the web.

Remember: You don't have to make a career of it. Be a dabbler! Sign up!

No talent.
No money.
No time.
Play devil's advocate.
Why are these limitations?
Why are they not?

Richard's house is full of books — art books, ones on cartooning, and zillions of
reference books on nature — birds, plants, insects and critters. I think he just
traces all of his drawings out of them — I have seen most of his home and there
are no squirrels, badgers, rabbits or stoats to be found.

BRYANT PARK's lawn is almost impossibly green this year. So far no one is allowed on it. I did have a fantasy of being the only one to lie right in the center of that lush carpet and look up at the sky and the buildings around the perimeter.

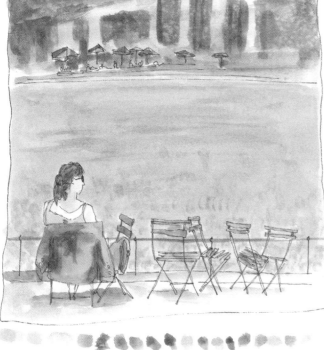

SERENDIPITY- DO-DAH.

YOU LOOK UP AND SEE STARS AND BLUEBIRDS.

THE WORLD IS ALWAYS FULL OF OPPORTUNITY, OF POSSIBILITIES, OF STIMULI, OF POTS OF GOLD. WHEN YOU FINALLY START TO LOOK AROUND, TO SEE CLEARLY, TO LIVE IN THE NOW AND DUMP YOUR BAGGAGE, YOU CAN'T HELP BUT NOTICE. WHEN YOU NOTICE THE WORLD, YOU NOTICE IT NOTICING YOU. YOU OPEN UP TO PEOPLE WHO YOU WOULD NORMALLY IGNORE, AND THEY OPEN UP TO YOU, REVEALING HOW MUCH THEY ARE LIKE YOU AND HOW MUCH THEY LIKE YOU, TOO. YOU DISCOVER NEW PAGES OF THE MENU. YOU HEAR LYRICS TO SONGS YOU USED TO FAST-FORWARD THROUGH. YOU READ POEMS CARVED IN MONUMENTS. YOU OPEN YOUR FORTUNE COOKIES.

SMALL WONDER THE WORLD SUDDENLY SEEMS TO BE FLOWING YOUR WAY. IT ALWAYS DID BUT PERHAPS YOU WERE TOO BUSY PADDLING UPSTREAM TO NOTICE.

WHEN FOLKS UNDERGO WHAT, FOR LACK OF A LESS GOOEY TERM, I'LL CALL A CREATIVE RE-AWAKENING, THEY OFTEN EXPERIENCE A SURGE OF SYNCHRONICITY. OPPORTUNITIES BOUNCE INTO THEIR LAPS. LIKE-MINDED PEOPLE JUST SHOW UP. CONNECTIONS ARE MADE, SPARKS FLY, LIGHTS BLINK ON. LIFE GETS SPICY.

SOME ATTRIBUTE THIS TO A GREATER POWER:

"GOD LOVES THOSE WHO CREATE." MAYBE SO. I HAVE A MORE DOWN-TO-EARTH HYPOTHESIS.

WHEN YOU ALLOW YOURSELF TO BE CREATIVE — TO MAKE THINGS, TO SMELL ROSES, SEE COLORS, HEAR SYMPHONIES, DANCE FANDANGOS — YOUR ANTENNA RISES. YOU START TO SCAN THROUGH NEW STATIONS, TO RE-TUNE. INSTEAD OF TRUDGING IN YOUR RUT,

"Until we accept the fact that life itself is founded in mystery, we shall learn nothing." – HENRY MILLER

Whistle while YOU WORK

JUST A THOUGHT:
WHY DO WE DO SO LITTLE TO AUGMENT OUR WORKSPACE?

ONCE I WORKED FOR A COMPANY THAT GAVE ME A DECENT SIZE OFFICE WITH A DREADFUL DESK. I LOBBIED FOR A BETTER ONE BUT ENCOUNTERED A WALL OF BUREAUCRACY. ONE WEEKEND, I FOUND A WONDERFUL DESK IN AN ANTIQUES STORE. IT WAS ONE OF A HANDFUL MADE JUST FOR EXECUTIVES AT THE WRIGLEY BUILDING IN CHICAGO, TEAK WITH IMMENSELY DEEP DRAWERS. IT WAS FAIRLY EXPENSIVE BUT I THOUGHT TO MYSELF, "LOOK, YOU'LL SPEND MOST OF EVERY DAY AT THIS DESK, WHY NOT HAVE SOMETHING BEAUTIFUL?"

AS I CLOSED THE PURCHASE, I DECIDED TO CONTACT THE PEOPLE AT MY OFFICE AND ASK THEM WHERE I SHOULD HAVE THE DESK DELIVERED. THEY WERE CONFUSED. "WHY ARE YOU BUYING YOUR OWN DESK? DIDN'T WE GIVE YOU A DESK?" MY BOSS HEARD ABOUT THE SITUATION AND BEGGED ME NOT TO BRING IN THE DESK. IT WOULD CAUSE TURMOIL AND GOSSIP, IT WOULD MAKE HER LOOK BAD. I WAS TRYING TO MANIPULATE THE COMPANY INTO REDECORATING MY OFFICE. IT JUST WASN'T DONE, TO FURNISH ONE'S OWN OFFICE. RELUCTANTLY, I SAID GOODBYE TO THE WRIGLEY DESK.

DO YOU HAVE THIS SORT OF RELATIONSHIP WITH YOUR WORKSPACE? IS IT BLANK, WITH GENERIC FURNISHINGS? DO YOU DECORATE IT AT ALL? DO YOU DECORATE IT THE WAY YOU'D DECORATE YOUR HOME?

HOW MANY HOURS A DAY DO YOU SPEND THERE? HOW MANY HOURS A DAY DO YOU SPEND IN YOUR LIVING ROOM?

THERE ARE SO MANY WAYS YOU CAN MAKE YOUR ENVIRONMENT YOUR OWN. YOU CAN FILL IT WITH DETAILS AND COMFORTS THAT ARE LIKELY TO MAKE YOU FEEL MORE PROUD, MORE RELAXED AND COMFORTABLE, MORE INSPIRED, ALL OF WHICH WILL HELP MAKE YOU MORE CREATIVE. DON'T DRINK YOUR MORNING COFFEE FROM A MUG WITH A CARTOON OR A LOGO. BUY YOURSELF A NICE CUP AND SAUCER. INDULGE YOURSELF WITH FURNITURE, LIGHTING, FLOWERS, SCENT, PICTURES, RUGS, BOOKS, MUSIC, TOYS, AN AIR PURIFIER, DESK ACCESSORIES, PAINT.

THEN GET TO WORK!

TRuSt YOuR GuT.

How often do you go with your intuition?

Can you become more receptive, more in tune? Are you so risk-averse you need enormous "factual" backup for every decision you make?

Intuition is the word we use to describe a sense that most of us don't exercise much. It's our mind's ability to accumulate little details and corner-of-the-eye observations that can add up to enormous clarity. Our conscious minds tend to learn about them in a less linear way than normal direct data input.

We call these vague sensations "hunches" or "feelings," but they are often very valid and can be the basis for creative breakthrough. Learn to heed and trust them more.

OPEN YOUR MIND.
EXPLORE HOW OTHER
PEOPLE DO AND SEE THINGS.
DON'T CATEGORIZE WITH
JUDGMENTAL TITLES.
EMBRACE THE UNUSUAL.
LOVE THE ODD.

The Reverend Otis F. Kelly, M.D.
Psychology

DoN't FEaR THE WEIRD.

- CHANGE YOUR POV IN A LOCATION AND DRAW FROM A DIFFERENT ANGLE
- DRAW THE SAME OBJECT FROM LOTS OF ANGLES, BREAKING FROM THE
 FAMILIAR. AT WHAT ANGLE DOES IT LOOK WEIRD? DRAW ITS REFLEC-
 TION IN SOMETHING DISTORTING, ITS SILHOUETTE, ITS SHADOW.

- DRAW A PIECE OF FABRIC
 AND REALLY SEE THE TEXTURE,
 THE FOLDS AS THEY ARE.

I STOLE THIS
TOWEL FROM A PUB
IN WALES about
seven years ago.
It has absorbed a
lot of ink and paint
over those years in
a stoic, reliable
fashion, befitting
an escapee from
the colliery. WHEN
I get home, it's
getting a good
wash to purge
the Road Grime.
Then, maybe
I'll give it a
little Lager.

"The first mistake of Art is
to assume that it's serious."
- Lester Bangs

SENSITIZATION - 121

Thinking on Paper.

MY MUM TAUGHT ME TO APPRECIATE PAPER EARLY, TO RIFFLE THROUGH BLANK JOURNALS AND PINCH THE SHEETS BETWEEN MY FINGER PADS. TO CONSIDER PULP AND FIBER. TO NOTICE HOW A PEN FLOWS SMOOTHLY HERE WHILE IT BUCKS AND PROTESTS THERE. SINCE THEN, I'VE MET AND FELT QUITE INTENSELY ABOUT MANY DIFFERENT PAPERS.

FRENCH TOILET PAPER — CRISP, WAXY, IMPRACTICALLY NON-ABSORBENT AND HARSH. LITTLE ITALY DELI SANDWICHES WRAPPED IN THICK WHITE PAPER, ONCE, SLICED IN HALF, THEN WRAPPED AGAIN. IN PAKISTAN, AT NINE, I CUT MY FINGER IN CLASS AND THE TEACHER BOUND IT IN GREEN CREPE PAPER, WHICH, AS I WATCHED IN HORROR, TURNED BLACK WITH MY BLOOD.

FIBROUS, MUD-COLORED HAND TOWELS IN BUS STATION BATHROOMS. HANDMADE PAPERS IN THE FLAT FILES OF TALAS, MARBLEIZED IN BRAZIL — $80 A SHEET. SMALL EDITION BOOKS WITH CREAM-COLORED PAPERS PRINTED WITH SCARLET INITIAL CAPS AND BLACK, DEBOSSED, LETTER SET TYPE. THE LOX-COLORED PAGES OF *THE FINANCIAL TIMES*. A DENTAL BIB WITH ITS LITTLE NECKLACE OF STEEL BALLS AND ALLIGATOR CLIPS. HEAVY VELLUM THAT TAKES SOFT LEAD LIKE A DREAM, THEN SMUDGES POS-TERITY. SCULPTED PAPERS AT THE DIEU DONNÉ PAPER MILL, TECTONIC LAYERS THICK AS EGG CARTONS. RIDGED PASSPORT PAGES. ANACHRONISTIC ROLLS OF BROWN PAPER IN THE BUTCHER SHOP. STATIONERY, TOO GOOD TO USE.

SILK-SCREENED BANANA LEAVES ON PRE-WAR WALLPAPERS.

FOOT-THICK STACKS OF TISSUE PAPER ON A STORE COUNTER, ENFOLDING PLATES, GLASSES, LINGERIE, SOFT AS CARNATION PETALS. THE DEHUMANIZING FEEL OF A PAPER-COVERED EXAMINATION TABLE STICKING TO MY BUTTOCKS. GRIDDED, OILY PAGES OF A CHINESE COMPOSITION BOOK. TOOTHPICK-THIN STRIPS OF HEAVY STOCK FOR SAMPLING ESSENTIAL OILS AT THE PERFUMERY. DISTANT NEWSPAPERS PACKED WITH AN EBAY PURCHASE, STALE WITH OLD CIGARETTE SMOKE.

MY GRANDMOTHER AT HER DESK, SHREDDING OLD ACCOUNTS PAY-ABLE INTO CONFETTI WITH HER ALUMINUM RULER. THE SAVAGE SHOCK OF A PAPER CUT. BOND. HOT-PRESSED BOND. THE SINFUL INDULGENCE OF ANY PAPER OVER 300 LBS. ARCHITECTS' AMBER TRACING PAPER RIPPED FROM ROLLS SCREWED TO THE DRAFTING TABLE, SOON SPIDERY WITH THE LINES OF 6H MECHANICAL LEAD AND RAPIDOGRAPH INK. DRAWING ON PAPER RESTAURANT TABLECLOTHS WITH A ROLLER-BALL PEN. COLLECT-ING SHIRT CARDBOARD. FOREIGN BANKNOTES. ANCIENT CRAFTSMEN IN FOLDED NEWSPAPER HATS. THE HEADY SMELL OF MUSTY, RARE BOOKS.

PAPER BALLS LURKING IN THE TOES OF NEW SHOES. KIDS' PAPIER MÂCHÉ OVER WITHERING BALLOONS. LOTTERY TICKETS, FRACTIONED OVER AND AGAIN, IN THE TREASURE OF SIERRA MADRE. FISH AND CHIPS IN A VINEGARY NEWSPRINT CONE. THE GRIMNESS OF MOTEL GLASSES WRAPPED AND SANI-TIZED FOR MY PROTECTION. THE SUREFIRE EXCITEMENT OF FLORIST PAPER, ENCIRCLING ROSES. RIPPING OPEN A FRESH 8 1/2 BY 11 BRICK TO FEED THE PRINTER. THE CORPSE OF A FORGOTTEN NOTE TO SELF, TRANS-FORMED AND ILLEGIBLE IN THE POCKET OF FRESHLY LAUNDERED JEANS.

THE TREMBLING PROMISE AND SNOWY EXPANSE OF A VIRGIN JOURNAL.

"Everything has its beauty but not everyone sees it." -Confucius

BELONGINGS.

SOMETIMES, I GROW SO SICK OF MATERIALISM. EVERYTHING WE ENCOUNTER, IT SEEMS, IS IN SOME INSIDIOUS WAY AIMED AT MAKING US BURN TO BUY SOMETHING, ANYTHING. (AND, YES, I'VE SPENT TWENTY YEARS IN THE BELLY OF THE ADVERTISING BEAST, STOKING THAT FLAME.)

LIKE TOO MUCH CANDY, CONSUMERISM CAN MAKE MY TEETH ACHE, MY TASTE BUDS REBEL, MY SOUL FEEL EMPTY. I REALIZE I OWN TOO MUCH AND APPRECIATE TOO LITTLE OF IT. SO I AM TRYING TO GET MORE OUT OF WHAT I HAVE. EVEN SCALE BACK, IF POSSIBLE.

I LIKE THE IDEA OF A JOURNAL DIET. DRAW EVERYTHING YOU EAT FOR A WEEK. MORE DRAWING MEANS LESS SNACKING. YOU'LL BE THINNER, CALMER, AND HAPPIER. OR DRAW EVERYTHING YOU OWN. EVERYTHING. EVERY SINGLE BOOK, EVERY STICK OF BUTTER AND SHOELACE. NOW THAT WOULD BE A HUMBLING EXPERIENCE.

MAKE LISTS:
EVERYONE YOU KNOW AND WHAT MAKES THEM SPECIAL, WHAT THEY TEACH YOU.
WHAT'S IN YOUR BAG, BRIEFCASE, BACKPACK, POCKETS.
WHAT'S IN YOUR CLOSET.
BOOKS YOU'VE READ, MOVIES YOU'VE SEEN.

STATES, COUNTRIES YOU'VE VISITED.

YOUR FAVORITE FOOD, BREAD, JELLY, SODA, FRUIT, SANDWICH, ETC.

EVERY COLOR YOU CAN SEE FROM WHERE YOU ARE SITTING.

EVERY PHONE CALL YOU MADE OR GOT THIS WEEK. ETC., ETC.

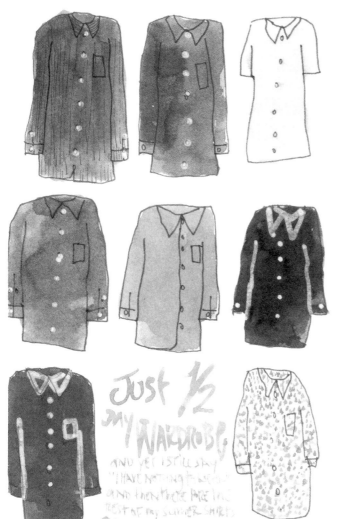

JUST ½ MY WARDROBE

AND YET I STILL SAY "I HAVE NOTHING TO WEAR" AND THEN THERE ARE THE REST OF MY SUMMER SHIRTS AND MY T-SHIRTS... WHY DO I HAVE SO MUCH STUFF?

HOW SEX and DRAWING are the SAME.

THE FIRST TIME IS USUALLY AN EMBAR-RASSING DISASTER. BUT IT ONLY IMPROVES.

SLOWER IS BETTER.

FOR THE BEST RE-SULTS, YOU MUST LET GO.

ABSTINENCE IS A SAD BUSINESS.

EVEN WHEN IT'S NOT GREAT, IT'S PRETTY GOOD.

YOU CAN DO IT FOR HOURS. OR FOR A MINUTE OR TWO.

EXPERIMENTATION IS USU-ALLY FUN, RARELY PAINFUL.

BETTER TO FOOL AROUND A LITTLE EVERY DAY OR TWO THAN TO HAVE AN ORGY ONCE A YEAR.

IF YOU SUPPRESS THE URGE IN ONE PLACE, IT'LL POP UP SOMEWHERE ELSE. AND YOU MAY NOT LIKE WHERE.

YOU CAN TAKE LESSONS, BUT YOU DON'T NEED TO.

SOME PEOPLE GET PAID TO DO IT. MOST PEOPLE DO IT EVEN WHEN THEY DON'T.

IT DOESN'T MAT-TER WHAT OTHER PEOPLE THINK OF HOW YOU DO IT.

WHEN YOU'RE DONE, YOU CHANGE SHEETS.

MEMORIES~

My grandfather in Rome, 1934.

Years ago, I went through a period of using acrylic paints. I kept them in an old gym bag, dozens of tubes, jars of gesso, brushes. Then, as I fell away from art, the bag moved deeper and deeper into the closet. Recently I pulled it out. It was now trash. All the tubes were solid, hard, unusable, unworkable.

The same can happen with technology.

Old 3-inch floppies. 8-track tapes. Betamax videos. Over time, the data on them turns to static. The outdated machines used to play them rust and decay.

I have a friend who is religious about transferring his digital photos to the newest medium (quite literally; he is a member of the Church of Latter-Day Saints and very committed to preserving memories of this world to further himself in the next). He has scanned all his old photos and moved them from diskettes to zip disks to CDs to DVDs to online storage servers.

Our bodies do the same thing. Every few years we replace all of the cells in our bodies, transferring (we hope) our memories to the new storage.

But to make sure that we retain as much of this data as possible, we need to organize our memories. It makes it a lot easier to access them. Memories are your most useful art supplies. When you leave them alone, abandoned for too long, they dry up, harden, and become unusable. You need to re-access them, use them, keep them fresh and pliable.

Drawing and journaling keep your memories available and fresh. Not overly rehearsed, like a story too polished, but raw as they were when captured. So many of my drawing friends tell me they can completely recall scenes by looking at old drawing books — the feelings, the circumstances, the smell and sounds all come flooding back as the drawing unlocks the memory vault.

The fewer memories and experiences and lived emotions you have at the ready, the more limited your palette. Drawing creates a file tab, a high-res photo, deeply detailed and uncompressed. A moment that isn't frozen. (You can't reanimate something organic once it is frozen; it is dry and flavorless and its heart will never beat again.) Instead it is stilled, like a frame on a DVD, waiting to be played again and again without decay or distortion.

Painting misty watercolors.

WHAT MEMORIES MATTER MOST TO YOU? THE TRIUMPHS, THE RAISES, THE PURCHASES?

THE TINY JOYS, THE GLIMPSED SMILE, THE SUNLIT COUNTERPANE, THE SMELL OF BAKING, THE VIEW FROM A CLIMBED TREE?

SENSE MEMORIES HAVE THE MOST TENACITY, THE MOST VALUE, THE GREATEST FEELING OF LIFE. THEY ARE MADE UP OF THE SAME SORT OF INFORMATION AS THE ORIGINAL EXPERIENCE, THE DATA FLOWING IN THROUGH YOUR SENSES.

THE MORE YOU CAN EXPERIENCE LIFE THROUGH UNCLOGGED NOSTRILS, SHARP EARS, UNCLOUDED EYES, THE MORE YOUR MEMORIES WILL MEAN, THE MORE POWER THEY WILL HAVE TO HELP YOU GENERATE IDEAS AND FRESH THOUGHTS.

Mary Louise Queenan, A.B.
Sodality · Ethuclau Club · Language Club 1,2. LPC 1 A .A

My grandfather is 94 and fairly Deaf. He probably doesn't hear the church bells at dusk or the muezzin's call at dawn or the distant gunfire during the night. Jerusalem's nightlife also consists? of many sorts of wild things: crickets, birds, owls, lizards, all boasting and bellyaching past the crack of dawn.

When we lived in Israel, thirty years ago, only doctors had phones. Now everyone has one tethered to them somewhere. I am told to speak English rather than Hebrew to the Palestinians. The young Arabs look like Israelis. The young Israelis look like Americans. The Americans all look soft and unprepared. The whole country is a lot more modernized and generic than I remember but it also has an undercurrent of paranoia and impatience that has replaced its former WORLD WEARINESS.

Just Add Water

I'M NO ARCHIMEDES, BUT I'VE HAD A DIS-
PROPORTIONATE NUMBER OF GOOD IDEAS IN THE FIVE MIN-
UTES OR SO OF THE DAY I SPEND IN THE SHOWER. I'VE
EXPLORED A NUMBER OF POSSIBLE EXPLANATIONS FOR THIS
PHENOMENON.

HYPOTHESIS #1 HAS TO DO WTH THE WATER PRESSURE IN MY
SHOWER, WHICH IS FAIRLY POWERFUL FOR A NEW YORK APARTMENT.
IT GENERALLY HITS ME RIGHT AT THE BASE OF THE SKULL, PERHAPS STIMULATING BLOOD
FLOW IN MY BRAIN. BUT THIS HITS ONLY MY MEDULLA AND MY CEREBELLUM AND THESE
ARE ALMOST CERTAINLY NOT THE SOURCE OF THE IDEAS THAT POP UP. I TEND TO KEEP
MY FRONTAL LOBES AWAY FROM THE JETS, EXCEPT FOR THE FEW SECONDS WHEN I AM
WASHING MY FACE OR SHAMPOOING MY (FEW REMAINING) HAIRS. THE ONLY THOUGHTS THAT
CROSS MY MIND AT THAT TIME RELATE TO CONDITIONER.

HYPOTHESIS #2: *I AM THE WALRUS.* MAYBE THE WATER RETURNS ME TO SOME PRIMEVAL
STATE; I READ SOMEWHERE THAT THE PATTERN OF OUR HAIR GROWTH INDICATES THAT
HUMANS WENT THROUGH SOME EXTENDED AQUATIC STAGE, LIVING ENTIRELY IN THE SEA. THIS
HYPOTHESIS SEEMS IMPROBABLE AND IN ANY CASE I DOUBT THAT IT WAS A PARTICULARLY
FECUND STAGE OF OUR HISTORY. SEALS, WHALES, AND MERMAIDS ALL LIVE FAIRLY BANAL
SORTS OF LIVES AND RARELY WIN NOBEL PRIZES OR HAVE GALLERY OPENINGS.

HYPOTHESIS #3: *THE MARINATION THEORY.* THE AFTERNOON IS GENERALLY WHEN I
GIVE MYSELF CHALLENGES AND PROBLEMS TO SOLVE. I DO RESEARCH AND KICK AROUND
A FEW PRELIMINARY IDEAS. I MAY HAVE TAPED UP SOME IDEAS ON THE WALL FROM THE
MORNING AND I'LL LOOK THEM OVER AND TRY TO PUSH FURTHER. HALF-FORMED NOTIONS
WILL RATTLE AROUND MY SKULL FOR THE REST OF THE DAY, GETTING A POLISH IN THE
CEREBRAL ROCK TUMBLER BEFORE BED.

THEN AT ELEVEN OR SO, I'LL HIT THE HAY, HOPEFULLY FOR THE WHOLE NIGHT. (SOME-
TIMES IDEAS WILL WAKE ME UP AT FOUR, JOLTED TO THE SURFACE BY A PASSING FIRE ENGINE
OR GARBAGE TRUCK. THESE IDEAS, WHILE INSISTENT IN THE DARK, TEND TO LOOK FAIRLY
UGLY BY THE LIGHT OF DAY, LIKE HALF-COOKED PORK.) BY MORNING, MY BRAIN HAS BEEN
WELL-MARINATED AND IS READY TO SERVE. I TEND TO TAKE A SHOWER 15 OR SO MINUTES
AFTER I WAKE UP, AND IN THAT CALM, CONSISTENT, NON-JUDGMENTAL ENVIRONMENT, THE
IDEAS FEEL SAFE TO POKE THEIR HEADS OUT OF MY HEAD AND PRESENT THEMSELVES.

MOST OF MY SHOWER ACTIVITIES ARE MINDLESS; MORE ACCURATELY, MY MIND IS PRESENT

BUT MY JUDGMENT IS SUSPENDED. I CAN HARDLY SEE, I CAN ONLY HEAR WHITE NOISE, I AM ALL ALONE, AND WHILE I AM DOING THINGS — WORKING UP LATHER, WASHING BETWEEN EACH TOE, GETTING AS FAR DOWN MY BACK AS I CAN REACH — I'VE DONE THEM MORE THAN 14,000 TIMES BEFORE AND THEY ARE AUTOMATIC.

SO THE TRICK IS NOT A MATTER OF SOAP AND WATER. IT'S SLOW-ING DOWN, CLEARING THE MIND, LETTING GO, GIVING MYSELF A FEW MINUTES OF NOTHINGNESS, FREE OF JUDGMENT. AND YET IN THAT RELAXED NOTHINGNESS, THERE IS BUBBLING ACTIVITY.

THE ONLY OTHER PLACE I'VE FOUND SUCH A PARADOXICAL BLEND OF TRANQUILITY AND CREATIVITY IS BETWEEN THE COVERS OF MY DRAWING JOURNAL. MAYBE I SHOULD GET A WATER-PROOF PEN AND START DRAWING ON THE TILES.

IT'S NOT EASY BEING CHARTREUSE.

I START MOST DAYS BY CHOOSING A PALETTE. IT'S OFTEN A FAIRLY SUBCONSCIOUS PROCESS AS I FLIP THROUGH MY PANTS, SHIRTS, SWEATERS, ETC. IN THE SEMI-DARKNESS OF MY CLOSET. I HAVE A LOT OF DRAB, TYPICALLY MALE COLORS: KHAKI, OLIVE, GREY, BROWN, BLACK. BUT I ALSO HAVE SOME LU-DICROUS SHADES TO PICK FROM BECAUSE I LIKE TO BUY LIGHT COLOR TROUSERS AND DYE THEM IN MY WASHING MACHINE. I HAVE BRIGHT ORANGE CORDS, RASPBERRY AND PEPTO-BISMOL JEANS, LIME GREEN, LEMON YELLOW, AND PURPLE PAISLEY CHINOS. RATHER A GHASTLY INVENTORY.

SO WHAT DETERMINES WHY I'LL END UP WEAR-ING A SAP GREEN CASHMERE SWEATER AND BURNT UMBER JEANS ONE DAY AND A BLACK TURTLENECK AND BLACK JEANS ANOTHER? IT HAS NOTHING TO DO WITH MY MOOD REALLY. I CAN BE BAD TEMPERED AND DRESS LIKE A CLOWN OR FEEL CHIPPER AND GEAR UP LIKE A MIME. AND WHEN I CHOOSE JACK'S CLOTHES, I INVARIABLY DRESS HIM IN A SIMILAR STYLE AND SPECTRUM TO WHATEVER I PICKED FOR MYSELF.

THE BIGGEST SUBCONSCIOUS FACTOR IS PROB-ABLY THE VIEW OUT THE WINDOW. IF SKIES ARE SUNNY AND BLUE, I PUT ON THE PEACOCK.

IF THE DAY LACKS COLOR, SO WILL I. THEN PATTI WILL COME IN AND SAY: "YOU'RE NOT WEARING *THAT*, ARE YOU?" AND I'LL SAY, "OF COURSE NOT," AND HEAD BACK TO MY CLOSET.

COLOR ME YELLOW.

So, how ya doin'?

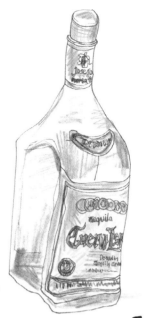

DID YOU TRY THE ELECTRON FAST? IF NOT, HOW COME? IF SO, DID YOU FIND YOURSELF WITH A LOT MORE SPARE TIME? DID YOUR MIND FEEL MORE YOUR OWN, UNINFLUENCED BY MEDIA? DID YOU FIND MANY WAYS TO PROVIDE YOUR OWN ENTERTAINMENT? DID YOU CHEAT? WAS IT WORTH IT?

KEEP EXPERIMENTING WITH YOUR LIFE. WHAT ELSE COULD YOU GO WITHOUT?

Music Alcohol Driving Comfort Electricity Guilt Sex Ego Anger

TRY OUT THESE FASTS FOR A DAY OR A WEEK AND MAKE JOURNAL PAGES ABOUT THEM.

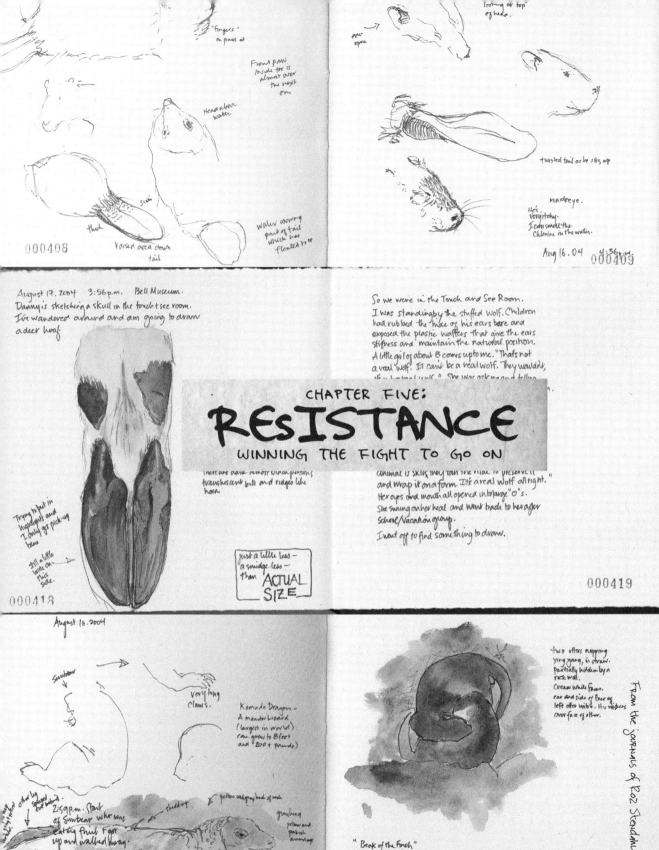

"fingers" on paws at

Front paw inside toe is almost over the next one

Head above water

Seal

Thick

raised area down tail

water covering part of tail which has floated to it

000408

looking at top of head.

ear open

twisted tail as he sits up

mind's eye.

He's very itchy. I can smell the chlorine in the water.

Aug 16. 04 4:36 p.m.
000409

August 17. 2004 3:56 p.m. Bell Museum.
Danny is sketching a skull in the touch & see room. I've wandered around and am going to draw a deer hoof.

Trying to put in highlights and I only get pick-up blue

Still little white on this side.

000418

There are almost black portions translucent bits and ridges like horn.

just a little less —
a smidge less —
than ACTUAL SIZE

So we were in the Touch and See Room. I was standing by the stuffed Wolf. Children had rubbed the hide of his ears bare and exposed the plastic waffers that give the ears stiffness and maintain the natural position. A little girl of about 8 comes up to me. "That's not a real wolf. It can't be a real wolf. They wouldn't, if a real wolf." She was asking me and telling ...

animal is skin they tan the hide to preserve it and wrap it on a form. It's a real Wolf all right." Her eyes and mouth all opened into large "O's". She swung on her heel and went back to her after school/vacation group.

I went off to find something to draw.

000419

CHAPTER FIVE:

RESISTANCE

WINNING THE FIGHT TO GO ON

August 16. 2004

Sunbear

Very long claws.

Komodo Dragon -
A monster lizard (largest in world) can grow to 8 feet and 200+ pounds)

2:59 p.m. Start of Sunbear who was eating fruit, got up and walked away.

"Does it live on human meat?"

shedding

yellow and grey band of scales

greybeard

yellow and pinkish underneath

two otters napping ying yang, is draw. partially hidden by a rock wall.
Cream white faces. ear and side of face of left otter white. His whiskers over face of other.

"Beak of the Finch"
Larry Weiner (sp?)

From the journals of Roz Stendahl

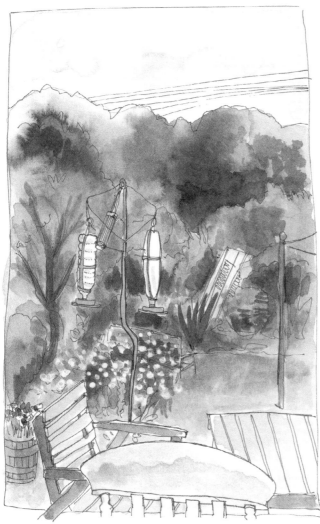

Be PrePareD.

AS YOU AWAKEN YOUR CRE-
ATIVITY, YOU STIR THE CAUL-
DRON OF YOUR LIFE. THINGS
ARE BOUND TO BUBBLE TO
THE SURFACE. SOME OF THOSE
THINGS WILL FRIGHTEN YOU,
OTHERS WILL DE-MOTIVATE YOU.

AT TIMES YOU WILL FEEL
ECSTATIC ABOUT WHAT YOU
ARE DOING AND RELEASING.
THEN YOU WILL BALK. YOU
WILL RATIONALIZE INACTIVITY
AND DEBATE THE POINT OF
CONTINUING. YOU WILL BAR-
GAIN WITH YOURSELF, LIKE A
DRUG ADDICT WHEEDLING FOR
A FIX. BREAKING HABITS IS
HARD, AND THERE ARE ALWAYS
REASONS NOT TO. STARTING
NEW HABITS TAKES DEDICA-
TION AND COMMITMENT. YOU
MUST DESCRIBE A GOAL FOR
YOURSELF. A STATE YOU'D
LIKE TO BE IN. DIMINISHED
FEAR, HEIGHTENED ENERGY,
NEW IDEAS, NEW POSSIBILITIES,
BREAKING OUT OF A RUT
— WHAT WILL IT BE LIKE?

"When the individuality of the
artist begins to express itself,
what the artist gains in the way
of liberty he loses in the way of
order." — Pablo Picasso

WARNING: We are Creations
We must Create
⤷ Creation creates
CHANGE.

EXCUSES

CAN YOU STILL NOT DRAW? WHAT PRE-
VENTS YOU? DO YOU STILL FEEL LIKE A FRAUD?
AN INCOMPETENT?

(I have no talent)

THE ABILITY TO DRAW IS NOT INHERITED,
ANY MORE THAN THE ABILITY TO SPEAK FRENCH.
CHILDREN OF "TALENTED" PARENTS ARE SIMPLY
MORE LIKELY TO BE BORN WITH PERMISSION TO
DRAW. GIVE YOURSELF THE SAME PERMISSION.

MATERIALS ARE
PRETTY IMMATERIAL
— PLAYING A FENDER
WON'T MAKE YOU PLAY LIKE HENDRIX. PLAYING A STEINWAY WON'T
MAKE YOU HOROWITZ.

WHAT OTHER CREATIVE REASONS HAVE YOU COME UP WITH TO NOT DO THIS?

"Artists Starve."

"THIS WHOLE THING
IS SELF-INDULGENT."

"MY LIFE IS TOO BORING
TO RECORD."

MAYBE YOU'RE HAVING PHYSICAL REACTIONS: HEADACHE,
CRAMP, FATIGUE. MAYBE YOU'RE FINDING ALL SORTS OF
THINGS THAT MUST BE DONE: GOTTA CALL X, GOTTA DO Y,
GOTTA BUY THIS, GOTTA WASH THAT...

"I think This guy doesn't know what he's talking about."

MAYBE YOU'VE DECIDED TO
BLAME THIS BOOK.

"THIS SEEMED LIKE A COOL IDEA WHEN I FIRST PICKED UP THIS BOOK BUT I DUNNO..."

"I CAN'T REALLY COMMIT TO THIS NOW. I'LL WAIT UNTIL..."

"IT'S EASY FOR HIM.
HE'S TALENTED."

VERY CREATIVE EXCUSES. BUT
MAYBE YOU COULD PUT THAT
CREATIVITY TO BETTER USE.

"WHAT DO I NEED TO LEARN TO DRAW FOR?!"

"MY COUSIN /NEIGHBOR/COLLEAGUE TRIED SOMETHING LIKE THIS
AND IT DIDN'T REALLY WORK FOR HIM/HER."

A demon from the mind of Prashant Miranda.

RESISTANCE ~ 133

INSPIRATION COMES to the INSPIRED

As soon as you fail to write and draw as you committed yourself to doing, you give your inner critic an opening, a chance to beat you up. Take the time and energy you'd use to abuse yourself and do something positive instead. Draw a tiny thing. Draw on anything handy — a sugar pack, a dollar bill, a boarding pass, the electric bill, a placemat. Then later paste it in your journal.

If you must, let the critic be your wake-up call. Say, "I get the message, now your job is done." Hang up. Get up. Get to work. Don't lie in bed listening to the operator yammering, the alarm ringing.

Don't wait for the muse to inspire you, to put you in the mood. That comes only with doing. So do. Momentum is a lot easier once you overcome inertia. Once your pen is moving on the paper, it's easy to fill the page. Move a little bit and the muse will get behind you and help push. But she won't help you get off your duff. Sorry. You have to take the first step.

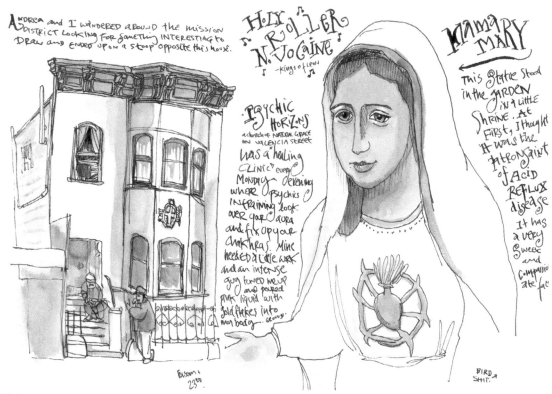

ANDREA and I wandered around the MISSION DISTRICT looking for something INTERESTING to DRAW and ended upon a stoop opposite this house.

HOLY ROLLER N. VOCAINE
—Kings of Leon

PSYCHIC HORIZONS
a church of NATURAL GRACE on VALENCIA STREET
Has a "healing clinic" every Monday evening where psychics in-training look over your aura and fix up your chakras. Mine needed a little work and an intense guy turned me up and poured PINK liquid with gold flakes into my body... Groovy!

MAMA MARY
This Statue stood in the garden in a little shrine. At first, I thought it was the Patron Saint of ACID REFLUX disease. It has a very sweet and compassionate face.

BIRD SHIT.

PR:crastination is GREAT.

IT HELPS YOU AVOID FAILURE, JUDGMENT, GROWING PAINS, TESTING.

IT ALSO STOPS YOU FROM EXPERIENCING FUN, SUCCESS, LEARNING, GROWTH, CONNECTION, AND PRIDE.

IF YOU MUST PUT SOMETHING OFF, PUT OFF FAILURE. DO *THAT* TOMORROW. GET GOING TODAY.

LITTLE DRAWINGS FILL A PAGE. COMPOSITION DRIVES YOU FORWARD. I MUST PUT SOME BLUE OVER THERE. I NEED TO FILL THIS SPACE WITH SOME WORDS, WHAT SHOULD I WRITE?

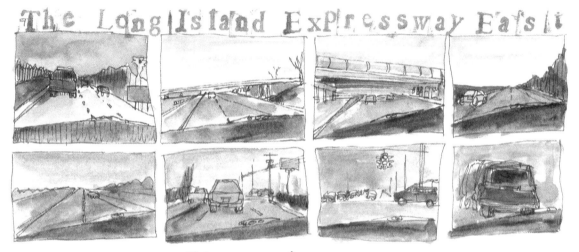

The Long Island Expressway Eats It

Think about this:

DRAWING IS A NATURAL ACTIVITY YOU DO ALL THE TIME. EVERY TIME YOU SIGN YOUR NAME YOU DRAW A SPECIAL LINE. EVERY TIME YOU STEER A CAR YOU ARE DRAWING A LINE WITH YOUR HANDS. YOUR LIFE DEPENDS ON ITS ACCURACY.

AIMING A FLASHLIGHT IS DRAWING A LINE. THROWING A BALL USES THE SAME EYE-HAND SKILLS AS DRAWING. WHEN YOU TIE YOUR SHOELACE OR MIX BATTER OR PET A DOG, YOU ARE DRAWING IN THE AIR. WE SING ALL THE TIME, TOO; TALKING IS SINGING. WE DANCE ALL THE TIME; WALKING IS DANCING. MARCHING IS JUST MOVING TO A BEAT. WE DRAW ALL THE TIME. BUT WHEN IT BECOMES *SIGNIFICANT*, WHEN IT INVOLVES *ART*, IT INTIMIDATES US INTO INCOMPETENCE.

THIS WORK CAN BE HARD.

DIFFICULTY IS NOT A REASON TO NOT DO IT. IT IS ONE OF THE MAIN REASONS YOU *MUST*.

IT'S TAKEN YOUR WHOLE ADULT LIFE TO LOSE TOUCH WITH YOUR CREATIVE ABILITIES. IT MAY TAKE MORE THAN A DAY OR TWO TO GET THEM BACK. WORK AT LEAST AS HARD AT DOING IT AS YOU HAVE AT NOT DOING IT.

"the AEROLIGHT"

DON'T TRY. DO.

TRYING MEANS STRAINING, GRUNTING, AND YET ALLOWING FOR THE POSSIBILITY OF FAILURE.

DOING MEANS ALLOWING YOURSELF TO START. IT MEANS THAT WHAT IS MOST IMPORTANT IS PRODUCTIVITY. AS THE FOLKS AT NIKE SAY, JUST DO IT. INSTEAD OF FORCING RESULTS, EMBRACE FLOW. SWING THROUGH THE BALL.

STICK TO IT. BUT IF YOU MISS A DAY, PUHLEEZE, DON'T BERATE YOURSELF.

NEED to Be YELLED at? READ THIS:

FOR GOD'S SAKE, HAVE A LITTLE BACKBONE!! STOP INDULGING YOUR WEAKEST INSTINCTS AND DO THE THING YOU KNOW YOU WANT TO DO. A LITTLE SHORT-TERM SACRIFICE OF TIME AND ENERGY (WHILE DOING SOMETHING THAT'S FUN, BY THE WAY) WILL UNFETTER YOUR LIFE AND MAKE YOU A LOT HAPPIER. YOU JUST HAVE TO STICK TO IT, SUSPEND JUDGMENT, AND KEEP PRACTICING. NOW STOP SNIFFLING AND GIVE US A HUG. GET BACK TO WORK.

Give Yourself Deadlines.

IT'S A GREAT WAY TO GET STARTED AND OVERCOME PROCRASTINATION. WHEN VAN GOGH WAS WAITING FOR GAUGUIN TO VISIT HIM IN ARLES, HE KNOCKED OUT SIX PAINTINGS OF SUNFLOWERS TO DECORATE THE JOINT. MASTERPIECES ALL. WHO'S YOUR GAUGUIN?

SAY TO YOURSELF, "I'M GOING TO DRAW UNTIL THIS CD ENDS."

"I'M GOING TO MAKE A DRAWING A DAY."

"I'M GOING TO FILL A BOOK A MONTH."

"I'M GOING TO STOP (WATCHING CSI, SLEEPING IN, PLAYING VIDEO GAMES, READING THE SPORTS PAGE, ETC.) AND DRAW INSTEAD."

"I'M GOING TO ENTER A LOCAL COMPETITION."

"I'M GOING TO GIVE EVERYONE A DRAWING FOR CHRISTMAS."

"I'M GOING TO MAKE A BOOK OF DRAWINGS FOR OUR ANNIVERSARY THIS YEAR."

"I'M GOING TO INVITE SOMEONE WHO I RESPECT TO COME SEE MY WORK. I BETTER START WORKING ON THE SHOW."

Roz Stendahl drew her dog, Dot, every single day for five years, filling four dozen hand-bound volumes. Never missed a day.

BE DISCIPLINED ABOUT WHY YOU CREATE— HAVE AN IDEA.

BE DISCIPLINED ABOUT WHAT YOU CREATE— HAVE A PLAN.

BE DISCIPLINED ABOUT WHEN YOU CREATE— HAVE A SCHEDULE.

CONTEMPLATE YOUR OWN MORTALITY — YOU DON'T HAVE THAT MUCH TIME LEFT, BETTER GET TO WORK. WRITE ABOUT THE ULTIMATE DEADLINE IN YOUR JOURNAL.

THE OLD
BANK
Horsforth, Yorkshire

WORK ON YOUR ABILITY to CONCENTRATE.

SET YOURSELF TASKS THAT WILL DRAW YOU IN.
DRAW VERY INTRICATE SUBJECTS AND PILE
ON AS MUCH DETAIL AS YOU CAN.

DRAW SUBJECTS WITH REPEATED SHAPES. BUT

Remember: FOCUS COMES WITH CONFIDENCE.
CONFIDENCE COMES WITH PRACTICE.
PRACTICE COMES with COMMITMENT.

DON'T DRAW THEM LIKE AN ASSEMBLY LINE
WORKER. EXAMINE EACH LEAF, WINDOW, HAIR
AND DRAW ITS INDIVIDUAL SHAPE.

DRAW MORE AND MORE SLOWLY. STUDY
EVERY VARIATION AS CLOSELY AS YOU CAN.
NOW DRAW MORE SLOWLY STILL.

DRAW THEMES. BOTTLES, URINALS,
CARS, CHICKENS— NOTE THEIR
SIMILARITIES AND DIFFERENCES.

TiMe SuckeRS

HAVING KIDS CAN BREAK YOUR RESOLVE. SO CAN OVERWORK. OR ILLNESS. THEY SUCK UP YOUR TIME AND ENERGY.

THE TRICK IS TO TURN THEM INTO SUBJECTS FOR YOUR ART. WRITE ABOUT THEM. DRAW BREAST PUMPS AND DIRTY DIAPERS. DRAW MEDICINE BOTTLES AND IV DRIPS.

DRAW DESKS STACKED HIGH WITH PAPERS. DRAW THE CLUTTER YOU SHOULD BE STRAIGHTENING, THE CARPETS YOU SHOULD BE VACUUMING.

WORK IN SHORT INCREMENTS. A FIVE-MINUTE DRAWING HERE, A TWO-MINUTE SKETCH THERE.

WRITE YOUR CAPTIONS HOURS AFTER YOU DRAW IF YOU MUST. JUST SLOWLY TAKE THOSE BREAKS AND FILL THOSE PAGES.

TURN YOUR OBSTACLES INTO ART.

PICK AN ART PROJECT THAT CAN BE DONE IN SHORT BURSTS—IMAGINE A MULTI-VOLUME ILLUSTRATED JOURNAL OF YOUR CHILD'S CHILDHOOD.

TURN YOUR OBSTACLES INTO SUBJECT MATTER. YOUR TRIALS ARE YOUR LESSONS.

It's horribly early of a Saturday morning but I am very awake—feeling like it is day though the streets are still and dark. I wonder if I'll ever be able to lie in bed till afternoon as I did before we reproduced—we would stay up until all hours, carousing and boozing but now we barely make it through the evening news with our eyes propped open. It's nice to be up at this hour without feeling like it's the middle of the night—more of a head start than insomnia. On the radio, the ambient music show has given way to music inspired by the mystic Rumi—"I want to hold you close like a lute so we cry out loud from the loving." I'm glad I didn't sleep through that.

DELTA

GETTIN' STARTED AND OTHER SLUMPS, DRY SPELLS & BLOCKS.

THESE SORTS OF HICCUPS ARE PART OF LIFE, PART OF NATURE. IF YOU DON'T HAVE THEM, MAYBE YOU DON'T PUSH YOURSELF HARD ENOUGH. IF YOU DO, THEN BE PATIENT AND GENTLE WITH YOURSELF. DON'T MAKE A MONSTROUS DEAL OUT OF IT. IT'S JUST FUN, NOT A TEST, NOT A TRIAL.

KEEP IT SIMPLE. DO SOMETHING SMALL AND EASY. LIGHT THE PILOT. HAVE SOME SUPPLIES HANDY. DON'T MAKE IT A BIG DEAL. JUST KEEP YOUR JOURNAL AND PEN NEARBY. WHENEVER THERE'S A MINUTE OR TWO OF DEAD TIME, PICK IT UP, DRAW SOMETHING SIMPLE.

THINK OF YOUR FIRST DRAWING AS A COPY, A TRACING. LOOK AT YOUR SUBJECT LIKE A GENTLE, ALL-KNOWING TEACHER WHO IS 100% ON YOUR SIDE. DRAW ONE LINE. THEN ANOTHER. REPEAT. EVEN IF YOU SUCK, DRAW. EVEN IF YOU'RE AN IDIOT, DRAW. EVEN IF YOU TRASH EVERYTHING YOU EVER DO, DRAW (AND RECYCLE). BEAR IN MIND THAT EVEN VERY GREAT ARTISTS TRASH 90% OF THEIR SKETCHES.

YOUR FEAR IS NOT YOU. IT IS DIMINISHING YOU, FIGHTING YOU. YOU INVENTED IT, A LITTLE SILLY FRANKENSTEIN. PUNT IT ASIDE AND DRAW THE FIRST LINE. THE TRICK IS TO GET BACK INTO IT. NEED ME TO FIRE YOUR ENGINE? HERE GOES:

CONSULT THE LIST OF 10,000 THINGS TO DRAW (PAGE 98). PICK ONE AT RANDOM. DRAW WITH A FRIEND. CHALLENGE EACH OTHER. TAKE A WORKSHOP OR CLASS. GO TO A LIFE DRAWING CLASS. TAKE A BREAK. DON'T DO ANYTHING FOR A WHILE (A FINITE WHILE).

WRITE AS MUCH AS YOU CAN ON WHY YOU CAN'T DRAW, EVERY POSSIBLE REASON AND EXCUSE. ISN'T THAT NUTS?

DRAW TEN SQUARES, SLOWLY, PERFECTLY. IF ANY ONE OF THEM IS OFF, DRAW TEN CIRCLES. THEN DRAW TEN NOSES. IF THEY ARE ALL PERFECT, THEN DRAW TEN MORE.

DIVIDE A SHEET OF PAPER INTO A GRID WITH A FEW DOZEN BOXES. DO A LITTLE DRAWING IN ONE BOX. NOW DO ANOTHER. DO A THIRD. KEEP GOING.

"You don't have to be great to start, but you have to start to be great." - Zig Ziglar

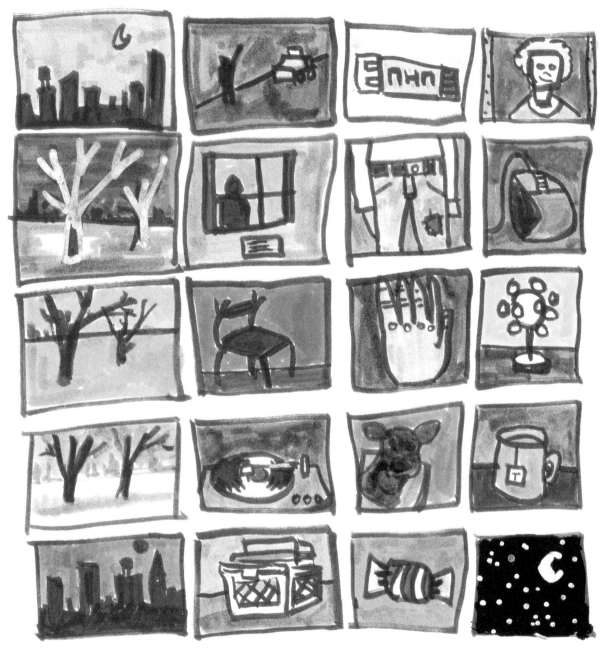

"Paintin's not important. The important thing is keepin' busy." – Grandma Moses

PATTI AND I WERE DISCUSS-
ING HER JOURNALS AND SCRAPBOOKS
RECENTLY AND, FOR ONCE, I WAS
ABLE TO GIVE HER SOME USEFUL
ADVICE. HER DILEMMA: SHE COL-
LECTS ALL SORTS OF CLIPPINGS AND
PICTURES AND CARDS AND SOUVENIRS
AND STUFFS THEM BETWEEN THE
PAGES OF HER BOOK OR INTO AN
ENVELOPE, WAITING FOR THE RAINY
DAY THAT SHE'LL STICK THEM ALL
IN AND MAKE SOMETHING BEAUTI-
FUL. BUT IT RARELY ARRIVES, SO
THE PILES OF EPHEMERA GROW
BIGGER AND MORE DAUNTING, LIKE

A CORNER OF THE COLLIER BROTH-
ERS' APARTMENT, UNTIL THE VERY
THOUGHT OF TACKLING THE PROJECT
IS MORE THAN SHE WANTS TO DEAL
WITH. WHY IS IT SO HARD TO MOVE
FROM THE *COLLECTING* PHASE TO THE
MAKING PHASE, SHE ASKED ME.

I THINK IT COMES DOWN TO
A MATTER OF PURPOSE. WHY DO YOU
WANT TO ASSEMBLE THIS STUFF?
WHAT ARE YOU GOING TO SAY WITH
IT? IS IT JUST THERE BECAUSE YOU
COLLECTED IT, BECAUSE IT SEEMED
INTERESTING OR PRETTY AT THE
TIME, BUT HAS LONG SINCE LOST ITS
SIGNIFICANCE? SOUVENIRS SHOULDN'T
GET AMNESIA. IT'S MORE IMPORTANT

TO HAVE A POINT, A VISION, A STORY
TO TELL THAN IT IS TO USE ALL
THE MATERIALS YOU HAVE. BUT MOST
IMPORTANT OF ALL IS TO JUST GET
STARTED AND MAKE SOMETHING.

I HAVE LOTS OF DIFFERENT
KINDS OF ART SUPPLIES, BUT I

UNITED STATES POSTAGE

3¢

HARVEY W. WILEY

50TH ANNIVERSARY
PURE FOOD AND DRUG LAWS

NEVER SIT DOWN AND SAY, "WELL, I'D BETTER MAKE SURE I USE EVERYTHING THAT'S IN THE BOX." I ALSO USUALLY DON'T SIT DOWN, THINKING, "I HAVEN'T USED MY BURNT UMBER CARAN D'ACHE PENCIL IN A WHILE — I REALLY OUGHT TO." No, I JUST HAVE A GLIMMER OF AN IDEA, LOOK AT MY MATERIALS, AND GRAVITATE TOWARD ONE PEN OR ANOTHER.

A VARIATION ON PATTI'S PROBLEM I ENCOUNTER IN OTHERS: "I HAVEN'T WRITTEN IN MY JOURNAL FOR SO LONG, I HAVE MONTHS OF CATCHING UP TO DO. IT'S TOO OVERWHELMING. I'LL WAIT TILL ANOTHER DAY." IT'S THE SAME IMPULSE THAT'LL MAKE YOU PUT OFF GOING BACK TO THE GYM OR BREAKING UP WITH YOUR LOUSY BOYFRIEND. THE ONLY SOLUTION IS TO EXPRESS SOMETHING, ANYTHING. TURN OVER A FRESH PAGE AND JUST DO SOMETHING ABOUT PROCRASTINATION OR DREAD OR LAZINESS OR... YOU DON'T NEED TO RECORD EVERY SINGLE MOMENT OF YOUR LIFE. JUST RECORD ONE, IN A CAREFUL AND HEARTFELT WAY. THE REST, ALL INTERLOCKING, WILL STRING ALONG WITH IT.

THESE ARE YOUR ENEMIES:

PROCRASTINATION, SELF-DOUBT, OBLIGATION, PERFECTIONISM, JUDGEMENTALISM.

NOW DEPICT THEM IN YOUR JOURNAL AND YOU'LL ALREADY HAVE THEM LICKED.

EMERGENCY INTERVENTION PEPTALK
(FOR HARD CORE RESISTERS)

DON'T WASTE TIME LOOKING FOR THE PERFECT JOURNAL, PEN, LOCATION, TIME. ADMIT THAT THIS IS ALL JUST PROCRASTINATION. LOOK BACK AT THE WHY OF DOING THIS, THE MOTIVE YOU HAVE. AND DON'T POO-POO IT NOW. DON'T MOCK YOURSELF FOR WANTING TO BE WHAT YOU REALLY ARE. WORK TO UNDERSTAND YOURSELF WELL ENOUGH TO SEE YOUR PATTERNS, YOUR SELF-DERAILING BULLSHIT, AND TAKE THAT ONE SMALL STEP IN THE RIGHT DIRECTION.

YOUR JOURNAL IS NOT A GYM MEMBERSHIP THAT GOES UNUSED, A DIET BOOK THAT GOES UNREAD, A RÉSUMÉ NEVER MAILED, A GARDEN UNWEEDED, A BED UNMADE. IT'S NOT VISITING RELA-TIVES, OR DOING TAXES.

IT IS JUST A SIMPLE LITTLE THING THAT YOU WILL DO FOR TEN OR FIF-TEEN MINUTES A DAY. IT'S FLOSSING. IT'S DEODORANT. IT'S PUTTING ON YOUR SEAT BELT. IT'S TYING YOUR SHOES. A SMALL, SIMPLE FIRST STEP. TRUST ME: EVERYONE WHO DOES THIS RESISTS INITIALLY. IF YOU CAN GET YOURSELF OVER THAT HUMP, A TINY ONE, YOU WILL START TO ROLL. VERY QUICKLY YOU WON'T WANT TO STOP. AND AS YOU GAIN MOMENTUM, YOU WILL WANT TO GO FASTER STILL; YOU WILL WANT TO HIT THE HIGHWAY, HEAD TOWARD THE HORIZON. BUT FIRST YOU MUST FIND A PEN. YES, THAT ONE WILL DO.

NOW, ARE WE ALONE? GOOD. NOBODY NEED KNOW THAT YOU ARE DOING THIS. IT'S OUR SECRET. WE BOTH KNOW THAT THE NEXT DRAWING YOU ARE ABOUT TO DO WILL SUCK. TOTALLY AND ABSOLUTELY. NO ONE NEED KNOW THAT. IN TWO DAYS, YOU WILL BE PROUD IT SUCKED BECAUSE IT WILL BE A BENCHMARK OF HOW FAR YOU HAVE COME. AND AS FOR ME, I DON'T CARE HOW MUCH IT SUCKS.

I HAVE SEEN AND MADE THOUSANDS OF DRAWINGS YOU'D BE SCARED TO WIPE YOUR BUTT WITH. IT'S A LITTLE INK ON PAPER, LIKE A SHOPPING LIST OR A MONTH-OLD NEWSPAPER.

OKAY, IF YOU'RE NOT BUYING THIS WHOLE "IT'S TRIVIAL, A MERE BAG OF SHELLS," APPROACH, LET'S FLIP IT ON ITS HEAD. YOU HAVE WAITED FOR YEARS TO MAKE SOMETHING OF YOUR LIFE, TO UNLEASH THAT CREATIVE SPIRIT, TO HAVE FUN AND PLAY, TO SHRIEK AND TO DANCE. IT SEEMS LIKE SUCH AN IMPOSSIBLY HUGE LEAP TO TAKE, SUCH A MASSIVE AND SCARY REOR-DERING OF YOUR PRIORITIES THAT YOU CAN'T FIGURE OUT WHERE TO BEGIN. WELL, NOW YOU KNOW. PICK UP YOUR PEN, STICK IT IN THE IGNITION AND LET'S GET OUTTA THIS PLACE.

HEY, IT'S YOUR LIFE. HOW MUCH MORE OF IT DO YOU WANT TO WASTE?

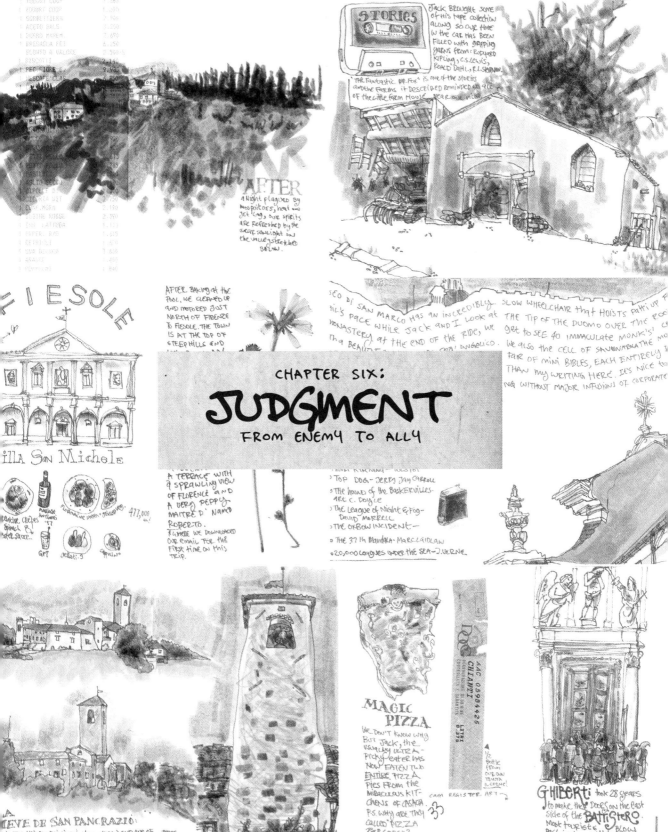

Jack brought some of his tape collection along so our time in the car has been filled with gripping yarns from: Rudyard Kipling, C.S. Lewis, Roald Dahl, R.L. Stevenson.

The Fantastic Mr. Fox is one of the stories and the farms it described reminded us all of the little farm house near our villa.

STORIES

AFTER a night plagued by mosquitoes, heat and jet lag, our spirits are refreshed by the great sunlight on the valley stretched below.

FIESOLE

Villa San Michele

AFTER baking at the pool, we cleaned up and motored just north of Firenze to Fiesole. The town is at the top of steep hills and...

...EO DI SAN MARCO has an incredibly slow wheelchair that hoists Patti up ...ill's pace while Jack and I look at ...onastery. at the end of the ride, we ...a beaut... ...fra' Angelico

...slow wheelchair that hoists Patti up ...the tip of the Duomo over the roo... get to see 40 immaculate monks... We also see the cell of Savanarola the mo... pair of mini bibles, each entirely... than my writing here. It's nice to... ...ng without major infusions of corporate...

CHAPTER SIX:
JUDGMENT
FROM ENEMY TO ALLY

477,000 L.

A TERRACE WITH A SPRAWLING VIEW OF FLORENCE AND A VERY PEPPY MAITRE D' NAMED ROBERTO. & MORE WE DOWNLOADED OUR EMAIL FOR THE FIRST TIME ON THIS TRIP.

...KIPLING - TOLSTOY
- TOP DOG - JERRY JAY CARROLL
- THE HOUND OF THE BASKERVILLES - ARC C. DOYLE
- THE LEAGUE OF NIGHT & FOG - DAVID MORRELL
- THE OXBOW INCIDENT —
- THE 37TH MANDALA - MARC LAIDLAW
- 20,000 LEAGUES UNDER THE SEA - J. VERNE

...IEVE DE SAN PANCRAZIO:
...is the notable building in town (area) and one of ...es to pray to Jesus within 500 m. of our door. It ...10th century Jesus

THREE IS FROM

MAGIC PIZZA
WE DON'T KNOW WHY BUT JACK, THE USUALLY ULTRA-PICKY EATER HAS NOW EATEN TWO ENTIRE PIZZA PIES FROM THE MIRACULOUS KITCHENS OF OSACA. P.S. WHY ARE THEY CALLED "PIZZA PARLORS"?

CHIANTI

CASH REGISTER ART

GHIBERTI took 28 years to make these doors on the east side of the BATTISTERO. Most tourists blow past in two minutes flat.

33

"As a painter I shall never really count, I can feel that absolutely." – Vincent van Gogh, 1889, Arles

BE POSITIVE: CREATIVITY RELIES ON A SPHINCTER IN YOUR BRAIN. CLAMP DOWN, NOTHING WILL EMERGE.

How to Judge:

How Do You Assess The Art You Are Making?

HOW DO YOU DEAL WITH YOUR INNER CRITIC AND DETERMINE IF IT'S VALID? SHOULD YOU BE METICULOUS OR SPONTANEOUS? HOW DO YOU DEAL WITH THE OPINIONS (STATED AND UNSTATED) OF OTHERS? HOW ARE YOU SUPPOSED TO LOOK AT THE WORK OF OTHER ARTISTS? WHAT IS THE ART WORLD ALL ABOUT AND WHERE DO YOU FIT INTO IT? WHAT MAKES GREAT ART? WHAT ROLE DOES THE ARTIST HAVE IN OUR SOCIETY? HOW DO ART AND COMMERCE CO-EXIST? DO YOU, IN FACT, SUCK? AND DOES THAT MATTER?

HOW MUCH A DRAWING LOOKS LIKE ITS SUBJECT SHOULD NOT BE THE PRIMARY STANDARD BY WHICH YOU JUDGE YOUR CREATIVITY. THESE ARE THE REALLY IMPORTANT ISSUES: DID YOU EXPRESS YOURSELF? WAS IT FUN? DID YOU LEARN SOMETHING? DID YOU SEE?

FIRST OFF, CHILL OUT. THE KEYS ARE EASE, FUN, AND PERSEVERANCE. THE FIRST TWO MAKE YOU WANT TO PERSEVERE. CREATIVITY IS NOT A BATTLE OR A COMPETITION BUT A GENTLE FLOW FORWARD. PEACEFUL, BENIGN, ORGANIC. THE POINT IS THE PROCESS, NOT THE RESULT. IF YOU MUST JUDGE SOMETHING, JUDGE THAT.

WHAT DO YOU LIKE? ABOUT OTHERS' WORK, ABOUT YOUR OWN? HOW GOOD IS YOUR OPINION? CAN YOU REALLY JUDGE WHETHER WHAT YOU ARE DOING IS

WRONG? CAN YOU TELL WHAT'S GOOD ABOUT THE WORK OF OTHER ARTISTS? ARE YOU MYSTIFIED BY THE VALUE OF CERTAIN FAMOUS WORKS OF ART? MAYBE YOU AREN'T SUCH A GREAT JUDGE AFTER ALL. GIVE YOUR OWN WORK A BREAK.

Good Questions to Ask Yourself:

AM I IMPROVING?
AM I USING THE RIGHT TOOLS IN THE RIGHT WAY?
DOES MY WORK MOVE ME?
DO I CARE ABOUT IT?
DO I LOVE IT?
IS IT HONEST?
AM I GIVING IT ENOUGH?
AM I GIVING MYSELF PERMISSION TO GET WILD? TO FAIL?
AM I DOING WHAT I SET OUT TO DO?
IF ART WAS MY RELIGION, HOW WOULD I PRACTICE IT? HOW WOULD I VIEW IT DIFFERENTLY?

THESE ARE ALL CRITERIA THAT ARE UNIQUE TO YOU SO DON'T BOTHER JUDGING YOURSELF BY OTHERS' EFFORTS.

CELEBRATE YOUR MISTAKES

IF YOUR INNER CRITIC TELLS YOU, "THIS DRAWING SUCKS. IT LOOKS NOTHING LIKE WHAT YOU WERE TRYING TO DRAW," YOU CAN RESPOND IN A NUMBER OF WAYS.

1. YOU CAN GIVE YOUR INNER CRITIC THE FULL WEIGHT OF INFLEXIBLE, DAMNING AUTHORITY AND CRUMBLE WORTHLESSLY UNDER THE CRITICISM.

2. YOU CAN DISMISS THE CRITIC OUTRIGHT AND IGNORE ITS VALUE COMPLETELY AND JUST KEEP DRAWING.

3. YOU CAN TREAT IT WITH SOME RESPECT AND TAKE ITS WORDS AS A LESSON RATHER THAN AS A PERSONAL ATTACK. START A DIALOGUE. TURN THE STATEMENTS OF CRITIQUE INTO QUESTIONS. RESPOND BY SAYING, "ALL RIGHT, HOW CAN I MAKE MY DRAWING LOOK MORE LIKE THE OBJECT? WHERE DOES IT DEVIATE?" CHECK EACH OF YOUR LINES. RE-EXAMINE YOUR SUBJECT. IF YOU FEEL RIGHT ABOUT THE DECISIONS YOU MADE ALONG THE WAY, THEN FEEL GOOD ABOUT THE RESULT.

IF YOU'D LIKE TO TAKE ANOTHER STAB, TURN TO A FRESH PAGE AND MOVE YOUR PEN MORE SLOWLY.

BAD PAGES HAPPEN. LOUSY DRAWINGS SEEM TO SOUR EVERYTHING THAT PRECEDED THEM. WHEN THE PAGES THAT FOLLOW FALL INTO PLACE, YOU CAN SEE THE ROLE OF YOUR "MISTAKE," ITS YING TO THE YANG OF THE REST.

What is "a mistake" REALLY?

ISN'T IT JUST AN OUTCOME YOU HADN'T ANTICIPATED? A VARIATION FROM YOUR EXPECTATION? AND WHAT MADE YOU RIGHT BEFORE (WHEN YOU SET UP YOUR EXPECTATIONS) BUT NOT DURING (WHEN YOU DREW YOUR LINES)?

SO THE REAL QUESTIONS ARE:

WHAT GOES INTO YOUR EXPECTATIONS? WHAT'S WRONG WITH AN UNEXPECTED OUTCOME? WHAT IF YOU HAD TRIED TO ACHIEVE IT IN THE FIRST PLACE? WHAT IF YOU ACTUALLY SET OUT TO DRAW WHATEVER LOPSIDED MESS YOU ARE CHASTISING YOURSELF FOR? COULD YOU HAVE? COULD YOU HAVE PURPOSEFULLY CREATED THIS MISTAKE?

AND BEYOND: HAVE YOU BEEN ABLE TO SURVIVE THE MOST HORRENDOUS MISTAKES OF YOUR PAST? SHOULD A MISTAKE OR FEAR OF A MISTAKE PREVENT YOU FROM REACHING YOUR GOAL? CAN YOU EXPAND YOUR MIND TO DEAL WITH THE UNEXPECTED? WHAT WOULD LIFE BE LIKE WITHOUT MISTAKES? WITHOUT GRAVITY? WITHOUT EVOLUTION?

Trust or Bust

Instead of flagellating yourself for your "errors," train yourself to be more resilient in the face of adversity. Be honest about what prevents you from being gentle with yourself. Maybe it's laziness, weakness, fear, or just ignorance.

Think about others whose mistakes you can learn from. It might be people you know personally, celebrities, or even historical figures. Consider what you can learn from them.

Finally, thank your inner critic. Each "bad" drawing is really just a chance to make the ones that follow it better.

In 1975, Keith Jarrett recorded the best-selling solo piano album ever, *The Köln Concerts*. What's even more extraordinary was that the music on the album is purely improvised. Jarrett had spent the day feeling jet-lagged and under the weather, and he had to sit down and start performing almost immediately after arriving at the concert hall. Even the provided piano slowly went out of tune as he played.

Jarrett credits the quality of his performance to all these distractions. Before every performance, he tries to make himself blank. He doesn't practice for a month beforehand. He doesn't plan, he doesn't have tricks to get over the hump — he just empties his mind, feels the silence completely, then wanders out onstage and sits down before the 88 keys. What balls.

"It's far more interesting for me than for the audience even," he said in a recent radio interview. "If you don't have total freedom, you will not make mistakes. With total freedom, you'll make mistakes you would never have dreamed of and may end up hating yourself more than ever. I aim to be completely devoid of ideas. But I'm not going to tell the music what it should be doing."

He is just a vehicle, an audience member, and his art has a life of its own.

Now, how do you get to that place? If I sat down in front of a concert hall full of Germans, we'd all thrill to 15 seconds of Chopsticks and that would be that. But Jarrett has laid down a lot of foundation. He had years of lessons, then played in cocktail lounges and Pocono resorts for years and committed all the jazz standards to memory. He played with Miles Davis and others, learning, ab-

SORBING, FILLING HIMSELF UP. BUT SO FAR THAT'S "JUST" TECHNICAL PREPARATION. MANY OTHER PEOPLE HAVE THAT.

WHEN JARRETT IMPROVISES HE ALLOWS THE PERFORMANCE TO BE A DISTILLATION OF WHO HE IS AND WHAT HE KNOWS. HE SAYS YOU HAVE TO ASSUME THAT WHAT YOU ARE DOING IS MEANINGLESS, TO BE WILLING TO TOSS IT AWAY. YOU CAN'T THINK THAT WHAT YOU ARE MAKING WILL BE RECORDED, SOLD, REVIEWED, EVEN LISTENED TO. JUST DO IT AND SEE WHAT HAPPENS.

THE BEST MOMENTS, HE SAYS, "ARE WHEN I AM PLAYING ONLY IN THE PRESENT AND NOT HEADING ANYWHERE. I ASPIRE TO NOT KNOW WHAT I AM DOING." THIS IS MINDFULNESS, LIVING IN THE PRESENT.

IN A RECENT ISSUE OF *THE NEW YORKER*, IN A REVIEW OF SAVION GLOVER'S NEW SHOW AT THE JOYCE, THERE'S THE FOLLOWING QUOTE: "I TRY TO KEEP MY CHOPS UP," GLOVER TOLD JANE GOLDBERG, FOR *DANCE MAGAZINE* "SO I CAN JUST BE." GLOVER IS THE GREATEST TAP DANCER WHO EVER LIVED, A BREATHTAKING ARTIST. HIS GOAL: TO JUST BE.

DON'T DISMISS ALL THIS BECAUSE THESE ARE INCREDIBLY ACCOMPLISHED CRAFTSPEOPLE. SURE, YOU NEED ENORMOUS AMOUNTS OF TECHNICAL EXPERTISE TO BE THE BEST IN THE WORLD. BUT TO ACCOMPLISH MINDFULNESS, YOU JUST NEED SOMETHING YOU ALREADY HAVE: THE WILLINGNESS TO QUIET DOWN, CLEAR THE CRAP, AND TRUST.

My Name is Mud.

ALFRED HITCHCOCK METICULOUSLY PLANNED OUT EVERY SHOT IN HIS FILMS LONG BEFORE HE SET FOOT ON THE SET. THEN HE WADDLED ON WITH PRECISE STORYBOARDS: HIS ANGLES, LENSES, LIGHTING DIRECTIONS ALL COMPLETELY WORKED OUT.

MOST ARTISTS AREN'T SO CONTROLLED. MANY OF US SIT DOWN TO A BLANK PAGE WITH ONLY AN INKLING OF WHAT WE WILL DO WITH IT. THEN WE LAY DOWN THE FIRST LINES, THE FIRST WORDS, THE FIRST NOTES AND BEGIN TO PLAY AROUND. WHILE SOME NOVELISTS PLOT OUT THEIR STORIES ON INDEX CARDS, OTHERS ENJOY DISCOVERING WHERE THE PLOT WILL TWIST AS MUCH AS THEIR READERS.

THERE IS A DANGER INHERENT IN EITHER APPROACH.

FOR THE PLANNER, THERE IS THE DANGER OF STALENESS, OF UNINSPIRED, MECHANICAL EXECUTION. HITCH FOUND SHOOTING A FILM TO BE QUITE A BORE—HE WAS SIMPLY EXECUTING THE COMPREHENSIVE INSTRUCTIONS HE HAD ALREADY LAID OUT FOR HIMSELF AND HIS CREW. HIS FILMS, WHILE BEAUTIFUL AND GRIPPING, ALWAYS HAVE A CERTAIN COOL, ARTIFICIAL QUALITY. BECAUSE OF HIS IRON GRIP, HE RARELY GOT THE BEST PERFORMANCES FROM HIS ACTORS.

BUT FOR THE FREE SPIRIT, THERE IS QUITE ANOTHER DANGER: THE DESCENT INTO MUD. YOU LOOK OUT THE WINDOW TO SEE THE SUN SHINING AND THE ROAD BECKONING. YOU STRIDE OUT, A SANDWICH IN YOUR POCKET AND A BREEZE IN YOUR HAIR, OFF TO LOOK FOR ADVENTURE. BUT, AT SOME POINT IN THE JOURNEY, A STORM MAY BREW. THE SKY DARKENS, THE HORIZON DISAPPEARS BEHIND CLOUDS, THE ROAD FILLS WITH POTHOLES AND PUDDLES, AND YOU, STILL DRIVEN AND UNWITTING, PLOD ON. EVENTUALLY YOU COLLAPSE — DIRTY, WET, MISERABLE, AND LOST.

WHEN ALL OF THE COLORS OF THE SPECTRUM MERGE, THEY FORM CLEAR, PURE WHITE LIGHT. BUT WHEN YOU COMBINE ALL THE COLORS IN YOUR PAINT BOX, YOU ALWAYS GET THAT SAME KHAKI BROWN.

SOMETIMES, PARTICULARLY WHEN I AM PAINTING, I WILL

GET A PICTURE TO A CERTAIN POINT AND THEN, UNHAPPY WITH THE WAY IT LOOKS, I'LL GO TOO FAR. I'LL DEEPEN THE SHADOWS, I'LL STRENGTHEN THE OUTLINES. THEN, WHEN I'M VERY DESPERATE, I'LL INTRODUCE SOME GARISHLY BRIGHT COLOR TO DISTRACT THE EYE: VERMILLION SKIES, CHARTREUSE SKIN. IT NEVER WORKS.

PAINFULLY, IT'S WHEN I AM DOING A COMMISSION OR MAKING A PRESENT FOR SOMEONE THAT I AM MOST LIKELY TO ENCOUNTER THIS PROBLEM. SOME PART OF MY BRAIN WILL NOT LET GO AND SITS IN THE BACKGROUND, WHINING AND HARPING AND FIRING SUGGESTIONS. INSTEAD OF LETTING THE PIECE TAKE ITS NATURAL COURSE, I TRY TO TWIST IT IN A DIRECTION IT DOESN'T WANT TO GO AND THE RESULT IS MUD.

I'VE SEEN THIS PHENOMENON MANY TIMES IN MY CAREER IN ADVERTISING. BECAUSE THE PROCESS REQUIRES THE APPROVAL AND OPINIONS OF MANY PEOPLE AND COMPROMISE IS OFTEN THE WATCHWORD OF THE DAY, WE SLOP A LOT OF MUD. HOW OFTEN I'VE BEEN WORKING WITH A COMPOSER ON THE SCORE OF A TV SPOT ONLY TO HAVE A CLIENT WADE IN WITH "ISSUES" AND SUGGESTIONS. SOON NEW LAYERS OF DRUMS AND STRINGS AND EFFECTS ARE THROWN OVER THE MUSIC UNTIL IT IS MUFFLED UNDER A BLANKET. THE SAME HAPPENS WITH WRITING, AS ADJECTIVES AND LEGAL CLAIMS GET INSERTED AT THE LAST MINUTE LIKE TUMORS METASTASIZING ON PARAGRAPHS THAT HAD BEEN EDITED AND POLISHED UNTIL THEY WERE ORGANIC AND EASY ON THE EAR. SO OFTEN THE REASON IS STATED: "SURE, YOU UNDERSTAND IT THE WAY YOU'VE WRITTEN IT, WE UNDERSTAND IT, BUT WILL THE CONSUMER UNDERSTAND IT? LET'S EMPHASIZE THE MAIN POINTS MORE STRONGLY."

AND SO ADDITIONAL LEGS AND WINGS AND HUMPS ARE SEWN ONTO THE MONSTER, NOT BECAUSE ANYONE'S GUT INSTINCT REQUIRES THEM BUT BECAUSE OF SECOND-GUESSING AND LACK OF VISION.

WHEN MY SON WAS IN PRESCHOOL, THERE WAS ONE TEACHER WHOSE CLASS ALWAYS DID THE MOST AMAZING PAINTINGS. EACH ONE WAS CLEAR AND SHARP AND INTELLIGENT, PICASSOS IN A SEA OF MUDDY FINGERPAINTS. I ASKED HER WHAT SHE TAUGHT HER KIDS, WHAT SHE SAID TO KEEP THEIR VISIONS SO PURE. SHE REPLIED, "I DON'T TELL THEM ANYTHING, REALLY. I JUST KNOW WHEN TO TAKE THEIR PAPER AWAY."

ARS LONGA

EVERY BIOGRAPHICAL MOVIE ABOUT AN ARTIST DEPICTS ITS SUBJECT AS SOME SORT OF DYSFUNCTIONAL WEIRDO. PICASSO: A WOMAN HATER. VAN GOGH: A PSYCHOTIC SUICIDAL. BASQUIAT: A DRUG-ADDICTED SUICIDAL. POLLOCK: A DRUNKEN SUICIDAL. WARHOL: A WEIRDO AND CON MAN IN A WIG. MICHELANGELO: A DISAGREEABLE OBSESSIVE. KAHLO: A VICTIM OF LOVE AND DISABILITY. TOULOUSE-LAUTREC: A HORNY DWARF. MOZART: A CHILD. BEETHOVEN: A DEAF CRANK.

THEIR GENIUS IS A CURSE, FED ONLY BY THEIR TORTURED SOULS.

IN AMERICA, WE LOVE ATHLETES. WE LOVE POP STARS. BUT WE LOVE TO HATE ARTISTS.

WHEN WE ARE ABOUT TEN WE ARE TAUGHT THAT BEING AN ARTIST IS IMPRACTICAL, CHILDISH, AND SELF-INDULGENT; THAT "TALENT" IS A GOD-GIVEN GIFT YOU'RE BORN WITH — OR YOU SHOULDN'T BOTHER. ARTISTS ARE ARROGANT, DISCONNECTED, ELITIST, MILLIONAIRES OR PAUPERS. THIS MYTH IS WHY

PARENTS ACCEPT ALL THE CUTS IN ART AND MUSIC EDUCATION YET WILL DO ANYTHING TO PROMOTE ATHLETICS IN SCHOOL. NO ONE WANTS THEIR KID TO GROW UP TO BE AN ARTIST.

IT WASN'T ALWAYS THIS WAY. DOING WATERCOLORS USED TO BE A STANDARD PART OF A DECENT EDUCATION; SO DID READING AND WRITING POETRY. MOZART, BEETHOVEN, BACH — THEY WERE ALL GOVERNMENT EMPLOYEES.

BUT IN 21ST-CENTURY AMERICA, THAT CRITIC IN YOUR HEAD HAS THE SUPPORT AND ENCOURAGEMENT OF THE WHOLE GANG; YOUR PARENTS, YOUR TEACHERS, YOUR NEIGHBORS, BOSSES, AND ROLE MODELS. EVEN SO-CALLED CREATIVE PEOPLE IN THE MEDIA PROMOTE THE ILLUSION THAT IT'S EITHER A FOOL'S GAME OR THE LOTTERY.

ART HAS NO SEASON, NO PLAYOFFS, NO CHAMPIONSHIPS AND WE CAN ALL PLAY, YEAR ROUND FOREVER!

Vita Brevis.

SMALL WONDER THE CRITIC'S VOICE IS SO HARD TO DROWN OUT. IT SAYS, "DON'T SING UNLESS YOU'RE GOING TO BECOME A POP STAR. DON'T PAINT UNLESS YOU KNOW YOU'LL BE A GENIUS RECOGNIZED IN YOUR OWN LIFETIME. AND IF YOU HAVE TO PRACTICE AT SOMETHING, WORK ON YOUR PITCH, YOUR SWING, YOUR KICK — SKILLS THAT'LL PAVE THE WAY FOR YOUR FUTURE."

YOU ARE FIGHTING ENOUGH OBSTACLES AS IT IS. DON'T LET YOUR OWN BRAIN JOIN THE CONSPIRACY. TELL IT TO SHUT THE HELL UP AND LET YOU GET BACK TO WORK.

BECAUSE ALL THOSE VOICES, SO RIGHT ABOUT HOW TO BUILD PROFIT, ARE FLAT WRONG ABOUT HOW TO BUILD A DECENT LIFE. WITHOUT ART, YOUR SOUL SUFFERS; YOU LACK A CHANCE TO EXPRESS WHO YOU ARE, TO HONE YOUR OWN POINT OF VIEW, TO MAKE YOUR LIFE YOUR OWN. YOU ARE LESS THAN HUMAN, NO MATTER HOW MANY SUPER BOWL RINGS YOU'RE WEARING. WHEN YOU MAKE SOMETHING AND SHARE IT WITH THE WORLD, YOUR VOICE WILL BE PROVEN WRONG AGAIN. PEOPLE WON'T SAY, "WELL, THAT DRAWING IS PATHETIC. THAT POEM IS LAME. THAT NOTE WAS SLIGHTLY FLAT. THAT DIARY REVEALS WHAT A MORON THE WRITER WAS." IF THEY STOP TO JUDGE IT AT ALL, THEY'LL ALMOST CERTAINLY SAY, "I WISH I DID THAT." WHICH WILL GIVE YOU THE CHANCE TO SAY: "WELL, WHY DON'T YOU?"

"You have to forget about what other people say, when you are supposed to die, or when you are supposed to be loving. You have to forget about all these things. You have to go on and be crazy. Craziness is like heaven."
— Jimi Hendrix

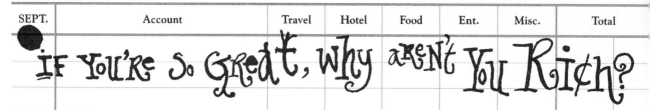

IF YOU'RE SO GREAT, WHY AREN'T YOU RICH?

THESE ARE DARK TIMES FOR THE NEXUS OF ART AND COMMERCE. EVERY INDUSTRY THAT TRIES TO MAKE A BUCK FROM OTHERS' CREATIVITY IS MORIBUND OR IN FLAMES.

THE MUSIC BUSINESS IS MORE INTENT ON SUING CHILDREN FOR DOWNLOADING MP3S THAN TRYING TO INCORPORATE INNOVATIONS IN TECHNOLOGY. THE PUBLISHING BUSINESS FOCUSES A DISPROPORTIONATE AMOUNT OF ENERGY ON THE WORKS OF TWO DOZEN BEST-SELLING BUT GENERALLY SECOND-RATE AUTHORS. THE MOVIE BUSINESS BARELY SCRAPED A TOP TEN LIST TOGETHER LAST YEAR. NETWORK TELEVISION BEMOANS THE FINAL ACT OF GERIATRIC SHOWS LIKE *FRIENDS*, UNABLE TO GENERATE ANYTHING NEW THAT MASS AUDIENCES WILL FLOCK TO. INSTEAD OF INTELLIGENT, ADULT PROGRAMMING, THEY PROGRAM SLEAZE. FASHION'S TOP DESIGNERS HAVE BECOME FACTORIES OR ELSE LEFT THE BUSINESS. ADVERTISING IS UNABLE TO COME UP WITH ANY STRATEGY TO COMBAT TIVO.

OVER THE PAST DECADE, CONGLOMERATES HAVE ENGULFED EACH OF THESE INDUSTRIES. HUGE BUSINESSES DEMAND REGULAR, INCREASING PROFITS TO FEED WALL STREET AND ARE LOATH TO BET ON ANYTHING BUT A "SUREFIRE HIT" WITH "MASS APPEAL." THEY SLATHER ON BUREAUCRACY AND CENTRALIZE DECISIONS TO MINIMIZE RISK AND SURPRISE. THEY DON'T RECOGNIZE THAT RISK AND SURPRISE ARE THE FOOD AND DRINK OF CREATIVITY.

AND YET, DESPITE THIS ARMAGEDDON, WE ARE IN THE MIDDLE OF AN ENORMOUS RENAISSANCE OF CREATIVITY. LOOK AROUND YOU. PEOPLE ARE TAKING DIGITAL PICTURES. THEY'RE RECORDING THEIR OWN SONGS. THEY'RE SHOOTING, EDITING, SCORING MOVIES. THEY'RE SCANNING ARTWORK. THEY'RE WRITING ESSAYS. THEY'RE SHARING STORIES AND RECIPES AND PATTERNS AND IDEAS. THEY'RE SUPPORTING EACH OTHER, INSPIRING EACH OTHER, FEEDING AND CHEERING AND PROMOTING EACH OTHER.

THE ONLY "PROBLEM"? OH MY GOD, NO ONE'S MAKING MONEY OFF ALL THESE BLOGS AND PERSONAL WEBSITES AND 'ZINES AND CHATS. SO THEY CAN'T BE *REAL*. THEY CAN'T *COUNT*. IF THEY WERE ANY GOOD, THEY'D TURN A PROFIT, RIGHT?

JUST LIKE CAVE PAINTERS HAD THREE PICTURE DEALS. JUST LIKE SHAKESPEARE HAD LICENSING PARTNERS. JUST LIKE MOZART WAS A MILLIONAIRE, VAN GOGH WAS PURSUED BY PAPARAZZI, NIJINSKY HAD HIS OWN MTV PILOT— FOR MOST OF HUMAN HISTORY, CREATIVE PEOPLE MADE CREATIVE THINGS BECAUSE THEY HAD TO. NOW, PERHAPS, WE'RE GETTING BACK TO AN UNDERSTANDING OF HOW ESSENTIAL AND HUMAN THAT IS.

"Where do they get off to tell me these things? What have they done, except to prove that they know how to make money?" – Henry Miller

on DRAWING IN FRONT of others:

DRAWING CAN CALM THOSE AROUND YOU. IT QUIETLY
BREAKS THE SILENCE, BUT IT'S NOT NECESSARILY INTROVERTED
OR PRIVATE. PEOPLE CAN WATCH YOUR DRAWING DEVELOP AND
FEEL A PART OF IT AND BE SOOTHED BY THE SIMPLICITY
AND THE ACT OF ITS CREATION. SEEING DRAWINGS ARRIVE
BEFORE THEIR EYES JUST MAKES PEOPLE HAPPY. IT INSPIRES
THEM TO CREATE SOMETHING AND NOT NECESSARILY ON
SOME GRANDIOSE, PROFESSIONAL LEVEL. DRAWING CAN ALSO
MAKE YOU VERY POPULAR. IT'S A DEFINITE ICEBREAKER.

YOU'D BE AMAZED AT HOW MANY OTHER PEOPLE
DRAW, TO ALL SORTS OF DEGREES. WHEN THEY SEE YOU
AT WORK, THEY'LL DROP BY AND CHANCES ARE YOU'LL
MAKE A NEW FRIEND/TEACHER/DRAWING COMPANION.

IF YOU FEEL YOU NEED TO BE PRIVATE, THEN ARRANGE
YOUR PRACTICE ACCORDINGLY. IF YOU NEED SUPPORT AND
ENCOURAGEMENT, THEN
INVITE AN AUDIENCE.
JOURNALS ARE SMALL
AND THEY CAN BE
QUICKLY SLAMMED
SHUT. BUT THERE'S
A LOT OF PLEASURE
TO BE DERIVED FROM
SHARING A BOOK FULL
OF DRAWINGS. IT'S
UP TO YOU. NOT THEM.

SEEMED
TO BE
SIMULTANEOUSLY
SAD, TIRED AND
VERY NERVOUS.

NODDING
OUT IN THE
PIZZERIA
IN SAN
CAS
CIANO
IN VAL
DI PESA!

WE WERE SCARFING
DOWN DELICIOUS
PIES WHILE THIS
GUY COULD BARELY
KEEP HIS PEEPERS
OPEN IN FRONT OF
THE GIANT SCREEN
TV. WHEN HIS
TWO PIZZAS WERE
READY, HE SLOWLY
STAGGERED OUT.

Qualità

HELL IS OTHER PEOPLE

THEY CAN INHIBIT YOU EVEN IF THEY'RE TRYING TO BE SUPPORTIVE. INTERFERENCE COMES IN MANY FORMS. PEOPLE CAN BE AGGRESSIVE AND HOSTILE: "YOU CALL THAT ART?" THEY CAN BE PASSIVE-AGGRESSIVE: "YOU AREN'T GOING TO WORK ON THAT *NOW*, ARE YOU?" THEY CAN BE JUST PLAIN IGNORANT: "SHE PAINTS BUT SHE DOESN'T HAVE A JOB."

WHY DO YOU *NEED* A CRITIQUE? WHAT'S THE OBJECTIVE?
REALLY THINK ABOUT THIS. WHY DOES IT MATTER TO YOU?
BE VERY CAREFUL BEFORE YOU ASK AN OPINION:
- DO YOU RESPECT THE PERSON YOU ARE ASKING?
- DO THEY LIKE WHAT YOU ARE TRYING TO DO?
- DO THEY HAVE YOUR BEST INTERESTS IN MIND? DO THEY WISH YOU WELL?
- ARE YOU WILLING TO REALLY LISTEN? TO LEARN? FOR HONESTY?
- IS THE RIGHT POINT TO BE CRITIQUED?

REMIND YOURSELF:
IT'S IMPOSSIBLE TO BE LIKED BY EVERYONE.
IT'S IMPOSSIBLE TO HAVE YOUR WORK LIKED BY EVERYONE.

REMEMBER WHAT THEY SAID ABOUT MICHELANGELO: THAT HE WAS STUBBORN AS A MULE.
THEY CALLED VAN GOGH A LUNATIC
PICASSO: A MISOGYNISTIC SWINE
POLLOCK: A SELF-HATING SOT
AND FOR EVERYONE WHO UNDERSTOOD AND VALUED THEIR WORK, A DOZEN THOUGHT IT WAS TRASH. ANYONE CAN THROW PAINT ON A CANVAS LIKE POLLOCK. A CHILD CAN DRAW LIKE PICASSO. BLAH BLAH.
AMERICA'S BEST-LOVED ARTIST? NORMAN ROCKWELL. BUT HE LOATHED HIS OWN CAREER, WAS PLAGUED BY DOUBT AND DISAPPOINTMENT, AND LONGED TO BREAK AWAY FROM CUTE REALISM.
SO GIVE YOURSELF A BREAK.

HOW DO YOU WANT TO SPEND YOUR DAYS?
HOW CAN YOU GET TO DO THAT, TO SPEND THE REST OF YOUR DAYS DOING WHAT YOU REALLY ENJOY, AS MUCH AS POSSIBLE?
THIS IS THE GOAL, NOT FAME OR FORTUNE OR ACCEPTANCE OR MUSEUMS, OR AWARDS OR ENDORSEMENT CONTRACTS, ETC. THIS IS SUCCESS.

"Keep away from people who try to belittle your ambitions. Small people always do that, but the really great make you feel that you, too, can become great." — MARK TWAIN

"The people who make art their business are mostly imposters." – Pablo Picasso

ART ain't FANCY or SPECIAL.

TRUE ART IS DEMOCRATIC AND HUMAN.

THE ARTS ARE ALL FANCIFIED VERSIONS OF WHAT WE ALL USED TO DO. STORYTELLING TURNED INTO NOVEL-WRITING. PAINTING GREW OUT OF DECORATION AND STORYTELLING. MAKING MUSIC WAS A PART OF EVERYONE'S PRE-ELECTRIC HOME. HAUTE CUISINE, FASHION, AND ARCHITECTURE ALL WERE ONCE EVERYONE'S DOMAIN.

THE INTERNET ALLOWS ANYONE TO EXHIBIT THEIR ART AND TO SELL IT. YOU CAN PUBLISH YOUR WRITING OR SHARE YOUR MUSIC AND GET A RESPONSE, NOT FROM CRITICS AND MONEY-MEN, BUT FROM THE PEOPLE WHO MATTER THE MOST: THOSE WHO LOVE WHAT YOU DO, YOUR AUDIENCE.

"What would art look like if artists didn't sign their names, if art became anonymous, if there were no media reporting trends? There is no doubt in my mind that art would look entirely different from the way it does today." – Audrey Flack

"Art is love." – Holman Hunt

Dealing with ART.

THERE'S THE ART WORLD. AND THERE'S THE WORLD OF ART.
KNOW THE DIFFERENCE.
DON'T LET LOOKING AT OTHERS' ART BRING YOU DOWN.

MUSEUMS AND COFFEE TABLE MONOGRAPHS ARE FULL OF SPARKS THAT WILL LIGHT YOUR PILOT. BUT TAKE THEM AT FACE VALUE. FORGET ALL THE HISTORY AND THEORETICAL MUMBO-JUMBO. IMAGINE YOU HAVE JUST PAINTED THEM.

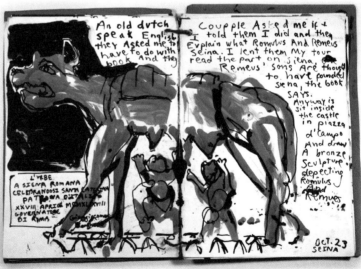

Julie Dermansky explored European monumental sculpture in her journals.

HOW to VISIT a MUSEUM

FOR SOME, NOTHING CAN BE MORE EXHAUSTING, DEPLETING, AND DEPRESSING THAN A BAD MUSEUM VISIT. AFTER HOURS SCOURING EVERY GALLERY, YOU LIMP OUT — YOUR BACK ACHES, YOUR SPIRIT EBBS, YOU FEEL JEALOUS AND OVERWHELMED AND NUMB. MAYBE YOU'RE DOING IT WRONG. TRY IT THIS WAY INSTEAD:

FIRST OFF, MAKE A PLAN. PICK A MANAGEABLE SECTION TO SEE IN NINETY MINUTES. AVOID HIGHLY PUBLICIZED SHOWS AT THEIR PEAK HOURS, UNLESS YOU ARE MORE INTERESTED IN BEING SUBJECTED TO THE OPINIONS OF OTHERS THAN IN COMMUNING WITH ART.

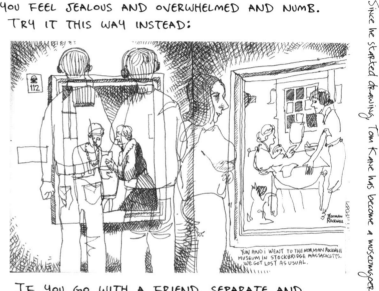

YOU AND I WENT TO THE NORMAN ROCKWELL MUSEUM IN STOCKBRIDGE MASSACHUSETTS. WE GOT LOST AS USUAL.

Since he started drawing Tom Kane has become a museumgoer.

IF YOU GO WITH A FRIEND, SEPARATE AND AGREE TO A MEETING PLACE AND TIME. MAKE SURE YOU ARE DRESSED COMFORTABLY, WITH PROPER SHOES, EMPTY BLADDER, SATISFIED STOMACH, AND ADEQUATE HYDRATION.

EXAMINE THE FIRST PIECE. NOT AS AN ART HISTORIAN OR A CRITIC BUT AS YOU — AS AN ARTIST. SHUT DOWN YOUR INNER CRITIC AND, FOR NOW, IGNORE THE LITTLE CARD WITH THE NAME OF THE PAINTING AND THE DATES.

STEP BACK, STEP FORWARD. LOOK AT THE PIECE FROM SEVERAL FOCAL LENGTHS. IF YOU CAN, GET CLOSE ENOUGH TO SMELL THE PAINTING. CANVASES THAT ARE EVEN A CENTURY OLD CAN STILL SMELL OF LINSEED OIL. THEN BACK UP SO THE WORK FILLS YOUR

PERIPHERAL VISION. BACK UP FURTHER TO SEE THE PIECE FROM AFAR.

WHAT DO YOU THINK OF THIS WORK? HOW DO YOU FEEL ABOUT IT? HOW WAS IT CREATED? WHAT WAS IT LIKE TO MAKE IT? WHY DOES IT WORK? WHY IS IT HERE IN THE MUSEUM? DRAW A QUICK SKETCH OF THE COMPOSITION IN YOUR JOURNAL AND WRITE DOWN KEY THOUGHTS.

KEEP MOVING. SKIP THE PIECES YOU WANT TO SKIP. SPEND MORE TIME WITH THOSE YOU LIKE. IGNORE OTHER PEOPLE'S

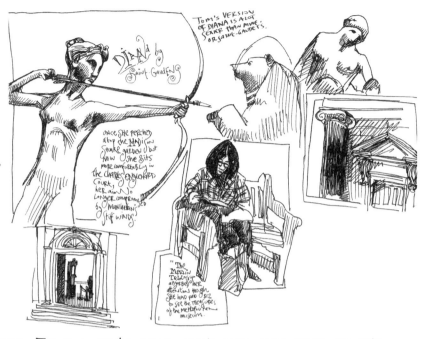

CONVERSATIONS AND ANALYSES. IF YOU CAN'T, WALK AWAY AND COME BACK TO THE PIECE LATER. THINK ABOUT WHY YOU LIKE WHAT YOU LIKE AND WHY YOU DON'T LIKE WHAT YOU DON'T LIKE. WHAT ARE THE CONNECTIONS BETWEEN YOUR FAVORITES?

WHEN YOU MEET UP WITH YOUR FRIEND, SHARE YOUR FINDINGS. DO YOUR OPINIONS AND TASTES DIFFER? WHY DO YOU THINK THAT IS? WRITE ABOUT IT.

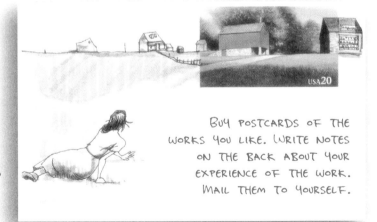

"We have imposed upon the pictures in the museums all our stupidities, our errors in the pretenses of our spirit. We have made poor ridiculous things of them. We cling to myths instead of sensing the inner lives of the men who painted them." — Pablo Picasso

BUY POSTCARDS OF THE WORKS YOU LIKE. WRITE NOTES ON THE BACK ABOUT YOUR EXPERIENCE OF THE WORK. MAIL THEM TO YOURSELF.

THE ARt of the Cinema

In the movies, artists are generally bastards, nuts, or addicts. Here are some of my favorites. Check 'em out for inspiration.

Biopics

THE AGONY & THE ECSTASY: Irving Stone boils down the Sistine Chapel with a liberal amount of artistic license. Good painting scenes. With Charlton Heston (ugh) as Mike B and Rex Harrison as Julius II.

LUST FOR LIFE: More Irving Stone. Kirk as Vincent, Tony Quinn as Gauguin, Vincente Minnelli at the helm. Beautiful and nutty and the best Vincent biopic.

AMADEUS: Nothing like the scene where Mozart dictates the Requiem to Salieri. I could watch this dozens of times. And I have.

BIRD: Clint Eastwood's version of Charlie Parker's life. Good but not as good as:

ROUND MIDNIGHT: Dexter Gordon plays Bird, Lester Young, & Bud Powell all rolled into one. It will make you love jazz.

BASQUIAT: Julian Schnabel directs this story of fame, drugs, and demise. I liked Basquiat a lot more than the film but it's still worth a gander.

ED WOOD: Proof that one of the most important things an artist needs is belief in himself.

TUCKER: Automaker as artist. A sunny metaphor for Coppola's battle with the Hollywood establishment.

HILARY AND JACKIE: The lives of classical musician sisters, one wild, one straight.

MOULIN ROUGE: The original: Toulouse-Lautrec and Zsa Zsa Gabor.

POLLOCK: Ed Harris's tribute to Action Jackson but with a little too much drunkenness and a little too little painting.

MY LEFT FOOT: Danny Day-Lewis as Christy Brown, paralyzed poet and painter. Have been meaning to see it for a decade. Will soon.

SHINE: Pianist David Helfgott has a mean dad, a breakdown, and a lot of scenery to chew. Decent but overrated.

SAVAGE MESSIAH: Ken Russell's bio of French sculptor Henri Gaudier-Brzeska and his mad affair. Tortured, weird, and romantic.

FRIDA: Great artists love, fight, paint, etc. A commercial film made by and about an artist without much compromise.

Fiction

Edward Scissorhands: A fairy tale about the artist as outsider. By one of the most creative directors in modern cinema.

The Royal Tennenbaums: The story of a creative family and the least good of the great films of Wes Anderson.

The Moderns: Alan Rudolph's story of artists in Paris in the 1920s is wildly surreal and romantic and has a wonderful soundtrack.

An American in Paris: A highly realistic story of artistic struggle. Gene Kelly, Minnelli, and my fave: Oscar Levant.

The Razor's Edge: Bill Murray (of all people) was in the good version of this story of a WWI vet discovering himself as an artist and a spiritual being.

The Hours: Virginia Woolf and all that.

Quartet: 4 stories, one of a pianist who studies for years to get a critic's approval. Also by Maugham.

The Commitments: Slightly too raucous story of an Irish soul band but a good appreciation of appreciation.

New York Stories: The first part of the trilogy is by Scorsese with Nick Nolte as a larger-than-life painter who can only work when obsessed with a woman. Some beautiful moments.

The Horse's Mouth: I loved this book as a kid — it made painting into the most heroic of acts. Alec Guinness plays Gulley, a screwup of a painter, in search of the perfect wall for his mural.

Documentaries

Rivers and Tides: Simply the best movie I've ever seen about the creative process. Documents the work of Andy Goldsworthy, the British sculptor.

Le Mystère Picasso: In 1956, Clouzot filmed Picasso painting on transparent canvases, revising the work as he goes: a chicken becomes a nude becomes a landscape, etc. Mind-blowing.

Crumb: Portrait of the great underground comix artist and illustrated journal-keeper, intense and revealing. See it even if you think you don't like him.

Wild Wheels: A tribute to art cars (covered with mirrors, grass, plastic fruit, etc.) and the people who make them.

28th Instance of June 1914, 10:50 a.m.: McDermott & McGough are a pair of artists who live as if it were pre-WWI — in their clothes, their home, their plumbing, their manner, and their photography. Beautiful and strangely compelling.

My Architect: About Louis Kahn by his son. Another "artist as bastard" movie.

PEP TALK!
(IF YA NEED ONE)

AN ARTIST IS SOMEONE WHO MAKES ART. A GREAT ARTIST MAKES GREAT ART, BUT QUALITY IS JUST THE *ADJECTIVE*, NOT THE NOUN. ACCEPT WHO YOU ARE AND JUST BEGIN TO WORK. THE MORE YOU CREATE, THE CLOSER YOU WILL COME TO FACILITY AND TO YOUR OWN VOICE, STYLE, LINE QUALITY, VISION. WORK, WORK, WORK. 1% INSPIRATION, 99% PERSPIRATION.

WHEN YOUR WORK IS JUDGED BY OTHERS, TAKE THAT JUDGMENT LESS SERIOUSLY THAN YOU DO YOUR OWN. ONLY YOU CAN MAKE WHAT YOU MAKE AND ONLY YOU CAN TRULY UNDERSTAND YOUR MOTIVATIONS AND GOALS AND THE DEGREE OF SUCCESS WITH WHICH YOU HAVE EXPRESSED THEM. BUT DON'T BE TOO HARSH IN YOUR ASSESSMENT. ENCOURAGE YOURSELF AS YOU WOULD WISH TO BE ENCOURAGED BY OUTSIDERS, AND CHERISH THAT ENCOURAGEMENT MOST OF ALL. SELF-FLAGELLATION JUST MAKES YOU TIRED, SORE, AND UNMOTIVATED.

THE ONLY WAY TO DEAL WITH SETBACK, LOSS, AND PAIN IS TO MAKE MORE. FIGHT THE CLOUDS OF NEGATIVITY WITH CREATIVE LIGHT. IT'S HARD. IT CAN BE LIKE GETTING OUT OF A WARM BED ON A FROSTY MORNING. BUT REMIND YOURSELF THAT THE BATTLE IS NOT ALL UPHILL. IT CAN BE MUCH EASIER TO FILL A CANVAS THAN TO GET YOURSELF IN FRONT OF THE EASEL.

SEEK OUT PEOPLE WHO UNDERSTAND, APPRECIATE, AND LIKE WHAT YOU DO. NOT EVERYONE WILL; THAT'S WHAT MAKES FOR HORSE RACES. NURTURE THOSE CONNECTIONS AND BUILD A FAN BASE. BE POSITIVE AND SHARE YOUR ENTHUSIASMS. DON'T PUT YOUR WORK DOWN. ESCHEW FALSE HUMILITY. IT'S A BORE.

IF YOU GET SLAPPED AROUND BY CRITICISM, REMEMBER: PRODUCTIVITY IS THE BEST REVENGE. GET BACK TO WORK AND SHOW 'EM.

NO MATTER HOW LONG YOUR JOURNEY, HOW MANY OBSTACLES, AND HOW LONG "THE ODDS," YOU CAN ONLY GET THERE BY PUTTING ON YOUR BOOTS, STANDING UP, AND HITTING THE PATH.

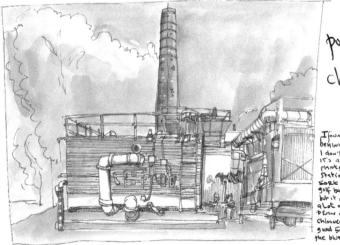

puff, puff, chug, chug.

I found this gizmo behind the hotel. I don't know if it's a cooling plant, an electrical station or some sort of elaborate golf ball washer, but it was quite a lot of fun to draw and its huge chimney soared a good 50 feet into the blue sky.

THE WORKMEN DEMOLISHING THE NYU STUDENT CENTER DO NOT STOP ON XMAS EVE.

ORANGE U GLAD IT'S XMAS?

KINDA!

BUNCHA · XMAS · EVE · TARTS

STRAWBERRY
LEMON
Citron
RASPBERRY
STRAWBERRY CHEESECAKE
CHOC + BERRY

THIS CLOVE ORANGE SMELLS FANTASTIC. I REMEMBER THEM WHEN I WAS SMALL AND I WAS FASCINATED BY THE REAL COLOR THEY WOULD EVENTUALLY TURN.

fig vi: SE 109-3 ABWEHR RADIO

fig vi: F21 CAMERA

fig: Geschäppliche RICHARD PENKOTH

SPIES

I JUST GOT A REALLY WAY COOL BOOK WITH THE HISTORY AND GIZMOS AND MACGUYS IN THE HISTORY OF ESPIONAGE SO JACK AND I ARE BUSY SPENDING THE EVENING DOING DRAWINGS OF ALL KINDSA

fig: NAGANT 7.62mm SECRET POLICE REVOLVER

fig: SECRET AGENT SCOP .25 CALIBRE PISTOL

fig: KGB PAGE

fig: SECRET MATCH CAMERA

fig: PETER ARTEMON, KGB

COUNT Johann Heinrich von Bernstorff, 1917

I am about halfway through Neal Stephenson's novel, CRYPTOMNICON. Alan Turing, who helped break the Enigma code and invented Colossus, the first electronic computer, is one of ...

TOP SECRET!

BODY BUTTS
FRONT MOUNTING
CENTERING COVER
CENTRIFUGAL SWITCH
STATOR

SPLIT-PHASE INDUCTION motor

CLUTCH RING
PRIMARY FRAME ASSEMBLY
REAR BRACKET
DRIVE SHAFT
NON ELECTRIC STEAM IRON

this common is more common is more are. 24 18 81

SPARES

JOHN BROWN SUITCASE RADIO INVENTOR

CRISPY DUCK

Lunch at EVERGREEN SHANGHAI Restaurant with Cynthia + David + PL + Jack Tea

CHAPTER SEVEN:

IDENTITY

WHO YOU ARE AND WHY THAT'S FINE

MICHIGAN AVENUE IS LINED WITH ALL SORTS OF ORIGINAL ARCHITECTURE—MOST OF IT NOT BOXED IN BY OTHER BUILDINGS SO ONE CAN STUDY EACH ONE UNOBSCURED.

CHICAGO WATER TOWER, 1869

THIS CHURCH-LIKE STRUCTURE WAS ONE OF THE ONLY LANDMARKS LEFT UNSCATHED IN THE GREAT FIRE NOW

ALLERTON HOTEL TIP TOP TAP

THIS NEON SIGN SEEMED TO PROMISE SOME SORT OF COOL OLD BAR WITHIN. BUT WHEN WE NEARED AS FOOT I SAW THAT IT WAS NOW A CROWN PLAZA + WENT NO FURTHER.

HOUSE OF BLUES

REDFISH

COME TO THE CONCLUSION THAT THE SOUTH HAS BEEN STRIPPED OF PARAPHERNALIA TO DECORATE CHICAGO THEME RESTAURANTS

What Does it Feel Like to Be an Artist?

MAINSTREAM CULTURE SERVES UP ALL SORTS OF BLEAK CLICHÉS TO KEEP ARTISTS DOWN.

THE SUFFERING ARTIST
THE DRUG-ADDICTED MUSICIAN
THE SPOILED ACTOR
THE DRUNKEN AUTHOR
THE ANOREXIC DANCER

THEY MAKE IT SEEM LIKE YOU MUST BE TORTURED TO CREATE. THE MYTH INVOLVES ALL THE TRAPPINGS OF A TENNESSEE WILLIAMS PLAY:

BROKEN HEARTS-FAMILY ANGST-POVERTY-DISLOCATION- REPRESSION-TORTURED SOULS...

THE REALITY: ART is FUN!

PEOPLE WHO ALLOW THEMSELVES TO CREATE, WHO WAKE UP EACH DAY WITH SONGS IN THEIR HEARTS, PRIMED CANVASES IN THEIR STUDIOS, FRESH PAGES IN THEIR JOURNALS, KNOW THAT ART IS TRULY ABOUT: JOY-CELEBRATION- BEAUTY-LOVE-HUMOR- REAL LIFE...

Prashant Miranda's journals are filled with his love of life.

Pathum by moonlight.

Butterfly island by day

"Enough of Art. It's Art that kills us. People no longer want to do painting: they make art."
- Pablo Picasso

DOES ART HAVE TO BE YOUR JOB FOR YOU TO BE AN ARTIST?

YOU CAN, AND PROBABLY WILL BE, A CREATIVE PERSON, AN ARTIST, WITHOUT MAKING SCADS OF MONEY FROM IT. AS SO MANY PROFESSIONAL ARTISTS HAVE TOLD ME, MAKING MONEY IS PARTLY HARD WORK, PARTLY LUCK. TALENT IS OFTEN INCIDENTAL.

THAT DOESN'T MAKE PEOPLE WHO MAKE BREAD OTHER WAYS NECESSARILY ANY LESS ARTISTIC THAN THOSE LUCKY ENOUGH TO BE ABLE TO DEVOTE EVERY WAKING HOUR TO ART.

CONSTABLE WORKED IN A MILL
DAVID SMITH WORKED IN A FACTORY
DEGAS AND MATISSE WERE LAWYERS
VAN GOGH WAS A PREACHER
GAUGUIN STARTED PAINTING IN HIS 30s
R. CRUMB STARTED BY DRAWING GREETING CARDS
SALMAN RUSHDIE BEGAN AS A COPYWRITER
ROUSSEAU BEGAN AS A CUSTOMS AGENT
WALLACE STEVENS WAS AN INSURANCE AGENT
SO WAS RAYMOND CHANDLER
JESUS WORKED AS A CARPENTER
T.S. ELIOT WAS A BANKER
CHURCHILL WAS A PRIME MINISTER

DIANNE STILL HAS A QUARTER OUNCE OF "CHARLIE" PERFUME IN HER MEDICINE CABINET.

"ARTIST" IS JUST another LABEL.

PRECISELY THE THING THAT DRAWING IS TEACHING US TO GET AWAY FROM.

WHAT'S THE DIFFERENCE BETWEEN SAYING, "I'M WRITING A SCREENPLAY" AND "I'M A SCREENWRITER," "I PAINT" AND "I'M A PAINTER"? I THINK IT'S SIMPLY INSECURITY.

CALL YOURSELF WHATEVER THE HELL YOU WANT. OR DON'T. JUST KEEP WORKING.

TALK LESS ABOUT YOUR IDENTITY AND DO MORE TO DEFINE, LIVE, AND BELIEVE IT.

"If the art world begins to destroy your life, give it up. Don't give up art." - Audrey Flack

Pigeonholes.

MAN, THE NAME-GIVING ANIMAL, IS IN RARE FORM THESE DAYS. WE'RE JUST STALKING THE PLANET, HELL-BENT ON SLAPPING LABELS ON OTHERS, STUFFING THEM INTO COMPARTMENTS, AND SPEWING VAST GENERALITIES ABOUT THINGS WE DON'T UNDERSTAND WELL ENOUGH.

FOR A WHILE, IT SEEMED LIKE THE FORCES OF GLOBALIZATION WOULD PUSH DOWN THE WALLS THAT SUBDIVIDE THE PLANET, PROVIDING A GLOBAL CULTURE OF INCLUSION, ONE HUGE BENETTON AD. INSTEAD, WE'VE BEEN GIVEN TOO MANY MCDONALD'S FRANCHISES, TOO MANY NIKE LOGOS. INSTEAD OF RELIGIONS AND NATION-STATES, THE FOLKS IN THE BOARDROOMS WANTED TO GIVE US ALL SKUS, COMPARTMENTALIZING EVERYTHING TO FIT NEATLY INTO WALMART'S INVENTORY.

THE INTERNET SEEMED LIKE ANOTHER BEACON OF HOPE, CONNECTING US ALL, ONE TO ONE, ALLOWING US TO FOUND AND FIND OUR OWN COMMUNITIES OF INTEREST. WE'D HAVE LABELS BUT AT LEAST WE GOT TO PUT THEM ON OURSELVES BY SIGNING UP FOR THIS CHAT GROUP OR THE OTHER. BUT THE ANONYMITY AND LACK OF ACCOUNTABILITY THAT RULES THE ETHER HAS MADE IT HARD FOR PEOPLE TO TRANSLATE THEIR KEYSTROKES INTO ACTION. WE CAN CONNECT AND AGREE, SLAPPING ONE ANOTHER ON THE BACK AND EXCHANGING WILD EMOTICONS, BUT THE RESULTS ARE AMORPHOUS AND HARD TO TURN INTO ANYTHING CONCRETE AND ENDURING.

AMONG CREATIVE PEOPLE WE FIND SIMILAR DIVIDES, SO MANY OF WHICH ARE SELF-IMPOSED. AESTHETICS ARE RULED BY PROFESSIONALISM. YOU CAN BE AN ACTOR BUT YOU CAN'T THEN BE A WRITER, TOO. YOU CAN ACT ON TV BUT NOT IN MOVIES. YOU CAN WRITE COMEDY BUT CAN'T PAINT MURALS. YOU CAN BE A ROCKER BUT DON'T EXPECT TO BE TAKEN SERIOUSLY AS A COMPOSER.

SURE, SOME PEOPLE CLIMB OVER A WALL HERE OR THERE, THE SEAN JEAN/P DIDDYS, THE WILL SMITH/FRESH PRINCES, THE CARRIE FISHERS, THE J-LOS.

BUT WE MUCH PREFER TO KNOW WHICH SECTION OF THE BOOKSTORE TO FIND OUR FAVORITE AUTHORS AND THE MORE THEY REPEAT THEMSELVES — THE JOHN GRISHAMS, THE TOM CLANCYS, THE JAMES PATTERSONS — THE MORE WE WILL REWARD THEM. THE SAME GOES FOR BANDS AND MOVIE STARS AND FASHION DESIGNERS AND CHEFS. "BE CONSISTENT. LET PEOPLE KNOW WHAT TO EXPECT. BE A BRAND."

AND HOW WE DRAW THOSE BARRIERS THROUGH OUR OWN LIVES, TOO, IMPOSING RESTRICTIONS OFTEN THROUGH SHEER INERTIA. "I DON'T EAT INDIAN FOOD. I DON'T READ MYSTERIES. I HATE FRENCH WINE. I'M NOT INTO DOCUMENTARIES.

I DON'T LOOK GOOD IN RED. I HATE HISTORY. I NEVER GO TO THE OPERA. BLAH, BLAH, BLAH."

AND THEN, DEEPER STILL, WE CARVE LABELS ON OUR VERY SELVES: "I'M NOT TALENTED. I'M AN AMATEUR. I CAN'T DRAW. I'VE GOT TWO LEFT FEET. I'LL NEVER MAKE IT. I DON'T HAVE A DEGREE. MY WHOLE FAMILY IS TONE-DEAF. I NEVER READ. I'M A WOMAN. I'M TOO OLD. I HAVE TO MAKE A LIVING. I NEVER FINISH THINGS. BLAH, BLAH, BLECH."

SPARE ME.

CAN'T WE ALL BE A LITTLE MORE SUBTLE, A LITTLE MORE AWARE, A LITTLE MORE *CREATIVE*? CAN'T WE START SEEING THE WORLD IN ALL ITS SHADES OF GREY, AND ALL THE HUES OF THE SPECTRUM?

WE DON'T LIVE IN A BOX. WE LIVE ON A BALL, ALWAYS REVOLVING, ALWAYS CHANGING, MOVING AHEAD, NEVER IN THE SAME PLACE FOR MORE THAN A MOMENT. THAT'S THE NATURE OF THE UNIVERSE. THAT'S THE TRUE NATURE OF MAN. AND THAT, MY LABEL-HUNGRY FRIENDS, IS WHAT ART IS ALL ABOUT.

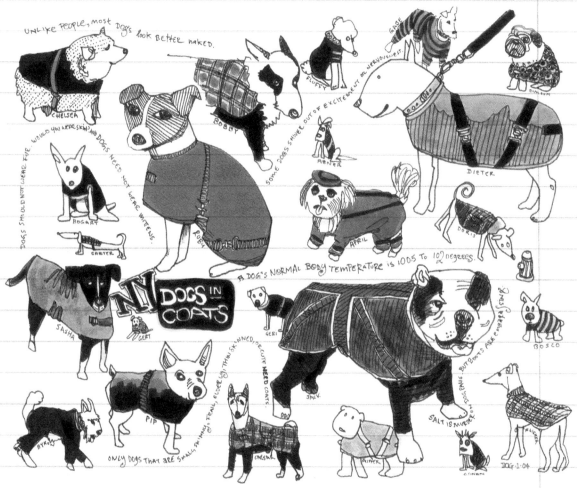

I AM.

I LIVE ON THE EARTH. I AM AN EARTHLING.

I EAT MEAT AND VEGETABLES. I AM AN OMNIVORE.

I HAVE A WIFE. I AM A HUSBAND.

I HAVE A SON. I AM A DAD.

I SCRATCH MY ASS. I AM AN ASS-SCRATCHER.

I WALK. I AM A WALKER.

I GO TO MOVIES. I AM A MOVIEGOER.

I READ. I AM A READER.

I TAKE PHOTOS. I AM A PHOTOGRAPHER.

I PLAY THE GUITAR. I AM A GUITARIST.

I WRITE. I AM A WRITER.

I DRAW. I AM A DRAW-ER.

I MAKE ART. I AM AN ARTIST.

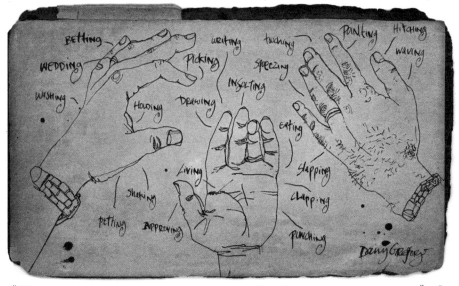

"Each morning we are born again. What we do today is what matters most." —Buddha

Miles ahead

I'VE BEEN READING ABOUT JAZZ RECENTLY, SPECIFICALLY ABOUT MILES AND HIS SEMINAL ALBUM, *KIND OF BLUE*. MILES WAS INTENSELY COMMITTED TO WHAT HE DID, BRAVE IN A WAY I WONDER IF I CAN EVER BE. HE SEEMED TO LIVE WITHOUT DOUBT. AT ONE POINT, HE AND THE AUTHOR HAD AN ARGUMENT ABOUT WHAT DAY IT WAS. WHEN HE WAS SHOWN A COPY OF THAT DAY'S PAPER THAT PROVED HE WAS MISTAKEN, HE SAID, "SEE THAT WALL OF AWARDS? I GOT THEM FOR HAVING A LOUSY MEMORY." HE DIDN'T DWELL ON THE PAST, DIDN'T REPEAT HIMSELF, DID WHAT HE DID AND KEPT ON FORGING AHEAD.

WHAT KEEPS ONE SO RESOLUTE? MILES WAS SUCCESSFUL, RICH BY JAZZ STANDARDS, BUT HE WAS DERIDED FOR HOW HE BEHAVED. PEOPLE THOUGHT HIM ARROGANT, RACIST, MISOGYNISTIC, AND UNCOMMUNICATIVE. HE WOULD OFTEN PLAY WITH HIS BACK TO THE AUDIENCE AND NEVER SPOKE ONSTAGE. I DON'T BELIEVE HE BEHAVED THIS WAY BECAUSE HE COULD. I THINK HE WAS JUST BEING UNCOMPROMISINGLY HIMSELF. THAT WAS THE KEY TO HIS ART. HE WAS AN ASSHOLE, BUT THAT WAS OKAY WITH MILES.

HOW DO YOU LEARN FROM A PERSON LIKE THIS? HOW DO YOU FOLLOW HIS EXAMPLE IN ORDER TO BECOME PURELY YOURSELF? DOES IT MEAN BEING UNRESPONSIVE TO ANY INPUT, BEING PIGHEADED, SELFISH, AND RUDE? OF COURSE NOT.

MILES BELIEVED IN HIS ART. HIS COMMITMENT WAS COMPLETE AND HE WORKED ENORMOUSLY HARD ON HIS TECHNIQUE AND IDEAS. EVEN IF HE WASN'T RIGHT (AND BY AND LARGE HE WAS), HE COULD TELL HIS INNER AND OUTER CRITICS THAT HE DID HIS VERY BEST AND THAT HE HAD FAITH IN THAT. PERHAPS THAT'S THE POINT OF ONE'S LIFE. TO DISCOVER WHAT ONE LOVES, TO PURSUE IT TO THE UTMOST OF ONE'S ABILITY, AND THEN TO GAUGE THE SUCCESS OF ONE'S LIFE BY HOW PURELY ONE HAS DONE THAT, RATHER THAN BY THE CRITERIA OTHERS SET.

IT CAN BE A ROUGH ROAD. ONE CAN STRUGGLE TO MAKE A LIVING. ONE CAN FAIL TO GET ACCOLADES OR EVEN SUPPORT FROM OTHERS. PERSONALLY, I WOULDN'T BE SATISFIED WITH A LIFE THAT OFFENDED AND ALIENATED THE REST OF THE WORLD BUT MAYBE I AM JUST A WIMP. STILL, I THINK IF YOU CAN SUSTAIN MILES-LIKE FOCUS ON YOUR ART, YOUR CHANCES OF SUCCESS ARE GOOD. VAN GOGH SPENT A DECADE DRAWING CRAP, BUT HE KEPT AT IT, AND THEN SUDDENLY HE BLOSSOMED.

I'M SURE MANY PEOPLE WILL SAY:

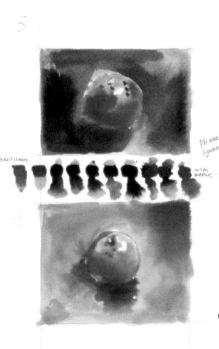

burnt sienna

ph martins synchromatic

ultra marine

- "ARE YOU TELLING ME THAT IF I WORK HARD ENOUGH, I WILL SUCCEED? AND CONVERSELY, IF I DON'T ACHIEVE THE HEIGHTS, IT WILL BE DUE TO MY LACK OF SUSTAINED EFFORT?" I DON'T KNOW. I DON'T WANT TO PAINT SUCH A BLACK-AND-WHITE PICTURE. BUT I

- THINK FOCUS AND PERSEVERANCE ARE CRITICAL. THE THUNDERSTRUCK ARTIST WHO GETS WHACKED BY THE MUSE AND SUDDENLY BECOMES A HUGE HIT IS A MYTH. YOU'VE GOTTA PRACTICE AND PRACTICE AND PRACTICE TO BORE TO YOUR CORE. THEN YOU'VE GOT TO HAVE THE BRAVERY TO BE UNFLINCHING ABOUT EXPOSING THAT CORE. YOU'VE GOT TO BE SMART, FIGURING OUT

- WAYS TO SHARE YOUR WORK WITH DIFFERENT PEOPLE WHO WILL GIVE PRODUCTIVE ADVICE AND HELP SHARE YOUR STUFF WITH OTHERS. IT ALSO

HELPS TO BE LUCKY (WHATEVER THAT MEANS).

I BELIEVE THAT A POSITIVE OUTLOOK IS ESSENTIAL, TOO. THAT TAKES WORK AS WELL. I AM OFTEN MY OWN WORST ENEMY, MY INNER CRITIC BAYING AT EVERY SHADOW. I CAN WAKE UP AT 4 A.M. AND KEEP MYSELF AWAKE WITH HORRIBLE IMAGES OF MY "INEVITABLE" FALL FROM GRACE. IN MY CHURNING MIND, MY

FOOLISH WAYS DESTROY MY FAMILY, MY SAVINGS, MY HEALTH, MY PROMISE. INSTEAD OF BEING A GROWN-UP, I AM DABBLING IN FEEBLE, ARTSY THINGS. UNWILLING TO SUCK IT UP AND JUST DO MY JOB AS A MAN AND A PROVIDER, I AM INDULGING MYSELF IN CRAP LIKE DRAWING PICTURES OF MY LUNCH.

BUT, WHEN I WAKE UP, EXHAUSTED FROM THE ASSAULT, I TRY TO GET TO WORK TO PAINT A SUNNIER PICTURE. THE FACT IS, I HAVE DEALT WITH HARDER THINGS THAN NIGHTMARES AND NAGGING INTERNAL VOICES. AND I HAVE DONE THAT BY BEING POSITIVE AND PROACTIVE.

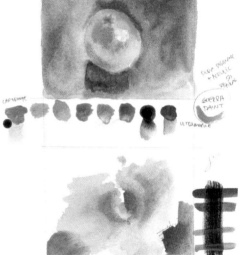

THE FUTURE IS A BLANK SHEET. I CAN TRY TO CATAPULT TURDS AT IT BUT THAT'S JUST MAKING THE PRESENT UGLIER. AND A LONG SUCCESSION OF UGLY TODAYS WILL LEAD TO AN UGLY TOMORROW. ON THE OTHER HAND, I CAN IMPACT THE FUTURE BY BELIEVING IN MYSELF, BY WORKING HARD, BY STAYING THE COURSE, BY CONFIRMING MY DIRECTIONS WITH THOSE WHO HAVE ALREADY TRAVELED IT, BY PURIFYING MY EXPECTATIONS AND INTENTIONS, BY KEEPING MY CHIN UP.

MAYBE MILES WASN'T ACTUALLY ALL THAT CONFIDENT. MAYBE THAT'S WHY HE PUT JUNK IN HIS ARM AND UP HIS NOSE, WHY HE RAGED AND SULKED. BUT I KNOW HE WAS POSITIVE ABOUT HIS ART. IF HE HADN'T BEEN, HE WOULD STILL HAVE HAD ALL THAT DOUBT AND STRESS. BUT HE WOULDN'T HAVE *BLUES FOR PABLO* AND *BYE BYE BLACKBIRD*.

AND NOR WOULD WE.

"You are not here merely to make a living. You are here in order to enable the world to live more amply, with greater vision, with a finer spirit of hope and achievement". – Woodrow Wilson

I contain multitudes.

I AM A WIRY COWBOY OR MAYBE AN EX-CON; SIDEBURNED, SUNBURNED, SHEATHED IN JAILHOUSE TATS, WEARING DICKIES, VITALIS, AND A DASH OF OLD SPICE, A HAND-ROLL DANGLING BELOW MY FU-MANCHU, STONILY SILENT; A SOLID PECKER-WOOD WHO'S 1000-YARD-STARING THROUGH GLACIAL BLUE EYES.

I AM ROBERT DE NIRO AS VITO CORLEONE IN *GODFATHER II*; POISED, DETERMINED, RESOURCEFUL, LETHAL.

I AM AIMEE MANN: THIN, BLONDE, BEAUTIFUL; CYNICAL, HILARIOUS, PROFANE; PART ANGEL, PART CONSTRUCTION WORKER.

I AM EMINEM.

I AM MILES.

I AM TYSON.

I AM THE DALAI LAMA.

I AM JIMI HENDRIX: MY FINGERS SCRABBLING AND SINGING ACROSS THE STRINGS, MY CHEEKS SUCKED IN, MY EYES CLOSED, MY SHIRT A RIOT OF PSYCHEDELIC PAISLEY.

I AM STEVE McQUEEN, LEAPING THE BARBED-WIRE FENCE INTO SWITZERLAND ON THE BACK OF A STOLEN GERMAN MOTORBIKE.

I AM FRANCIS BACON.

I AM WARREN BUFFETT.

I AM KEITH RICHARDS: KOHL EYES, TURTLE SKIN, BROWN BONY ARMS GRIPPING MY AXE.

I AM CURTIS, HOLDING A PIECE OF CARDBOARD AND A CUP ON SIXTH AVENUE.

I AM VINCENT IN THE WHEAT FIELD.

I AM ARNOLD, WINNING MR. OLYMPIA YET AGAIN.

I AM HENRY MILLER, FINGERING IN CLICHY, SCRIBBLING IN BROOKLYN.

I AM DY THOMAS, BLOWING A FAG END INTO A BBC MIKE.

I AM A SPOTTY FOURTEEN-YEAR-OLD WITH A MEAGER MUSTACHE.

I AM A BLOATED, MIDDLE-AGED, BALDING MAN.

I AM A CORPSE.

LAST NIGHT I WAS THINKING ABOUT HOW HARD IT IS TO STAY IN MY OWN SKIN. MAYBE THAT'S THE WAY ART IS SUPPOSED TO MAKE YOU FEEL, TO CATAPULT YOU INTO ANOTHER ASPECT OF YOURSELF AND LET YOU DWELL THERE A WHILE. OR MAYBE THAT'S JUST WHAT IT IS TO BE HUMAN

AND TO TRY TO LIVE AN EXAMINED LIFE.

I'M REACTING INTENSELY TO ALL OF THE THINGS I AM GOING THROUGH RIGHT NOW, ALL OF THE DIFFERENT AUDIENCES I SEEM TO BE STRUTTING PAST. I WANT TO "BE ME," TO EXPRESS THAT ME-NESS, AND YET IT IS SO VARIED, SO CONTRADICTORY. THERE'S ME AS HUSBAND, FATHER, SON, AND BROTHER. ILLUSTRATOR, AUTHOR, BLOGGER, COPYWRITER, PROFESSIONAL, AND NOVICE. TEACHER, STUDENT, KNOW-IT-ALL, AND IDIOT. AD GUY, ART GUY, UGLY AMERICAN GUY, AND REGISTERED ALIEN. JEW, CHRISTIAN, BUDDHIST, AND ATHEIST. HERMIT, TIRELESS SELF-PROMOTER, SUCCESS, AND FAILURE.

IT'S NOT REALLY THAT I'M SEEKING THE ANSWER ANYMORE. MY ADOLESCENCE IS SO FAR BEHIND ME, AND I HAVE WORN OUT MY ALLOTMENT OF MID-LIFE CRISES. IT'S MORE THAT I'M PERPETUALLY RESTLESS, ONLY TEMPORARILY SATISFIED WITH ANY CONCLUSION.

PERHAPS THIS IS THE BIOLOGICAL IMPERATIVE THAT MOVES SUCCESSFUL ORGANISMS TOWARD ADAPTATION AND EVOLUTION. THOSE WHO ARE CONTENT TO KEEP CHOWING DOWN ON A CERTAIN KIND OF LEAF OR TO HANG OUT BY A CERTAIN WATERHOLE ARE SECURE ... UNTIL THE CRAP COMES DOWN. THEN IT'S ONLY THOSE SHIFTY, SCUTTLING RODENTS IN THE UNDERGROWTH THAT MAKE IT TO THE NEXT LEVEL. WE ARE THE DESCENDANTS OF EVERY SUCCESSFUL SHAPE-SHIFTER THERE'S BEEN TILL NOW, THE FREAKIEST OF ALL MUTATED FREAKS, AND THESE DAYS, AS THE BROWN COMES DOWN MORE HEAVILY THAN EVER, ONLY THE UNSATISFIABLE WILL SURVIVE. SO PERHAPS I'M WORKING MY WAY UP TO MISSING LINKHOOD.

OR MAYBE I'LL JUST BE THE FIRST LEMMING OFF THE CLIFF. OR WORSE YET, SOMEWHERE LOST IN THE MIDDLE OF THE HERD.

TALKING TO D.PRICE ON THE PHONE ABOUT HIS "SITUATION"

INFLUENCES.

ELEVEN ann

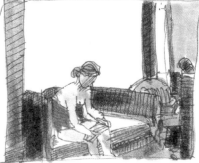

HOTEL ROOM.

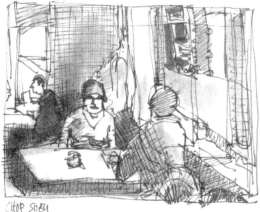

CHOP SUEY

HOPPED UP ON HOPPER

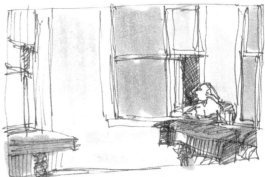

City sunlight.

ED'S IN MY HEAD

DO YOU KNOW WHAT YOU LIKE? WHAT IS IT YOU LIKE ABOUT IT? CAN YOU INCORPORATE IT INTO YOUR OWN WORK, MAKE YOUR OWN? CONSIDER THE DIFFERENCE BETWEEN INFLUENCE AND IMITATION. WHEN YOU LOOK AT SOMEONE ELSE'S WORK YOU SHOULD ABSORB THE ENERGY, NOT COPY THE TECHNIQUE.

"I have a horror of copying myself, but I have no hesitation, when I am shown for example a portfolio of old drawings, in taking from them whatever I want."
– Pablo Picasso

DON'T BE OBSESSED WITH ORIGINALITY. BE YOURSELF AND YOU WILL BE ORIGINAL. ACKNOWLEDGE AND CELEBRATE YOUR UNIQUENESS. KEEP BURROWING DEEPER AND SHAKING UP YOUR PERCEPTIONS.

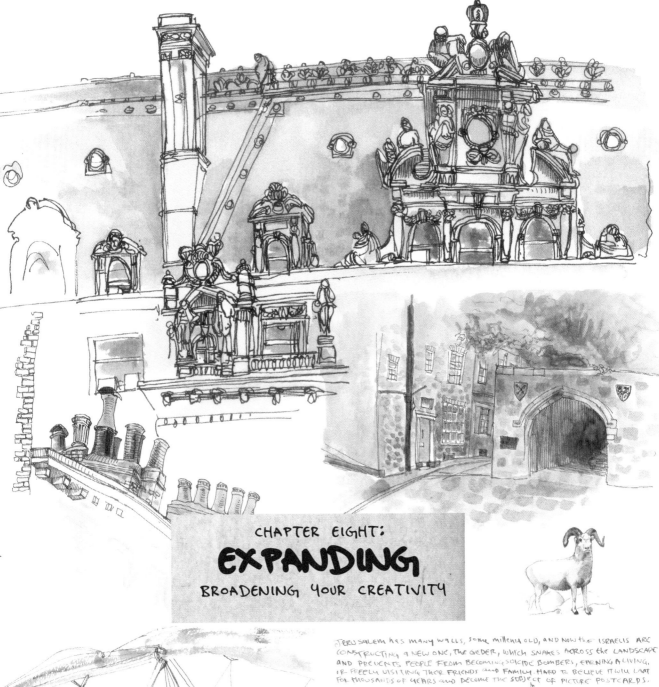

CHAPTER EIGHT:
EXPANDING
BROADENING YOUR CREATIVITY

JERUSALEM HAS MANY WALLS, SOME MILLENIA OLD, AND NOW THE ISRAELIS ARE CONSTRUCTING A NEW ONE, THE GIEDER, WHICH SNAKES ACROSS THE LANDSCAPE AND PREVENTS PEOPLE FROM BECOMING SUICIDE BOMBERS, EARNING A LIVING, IR FREELY VISITING THEIR FRIENDS AND FAMILY. HARD TO BELIEVE IT WILL LAST FOR THOUSANDS OF YEARS AND BECOME THE SUBJECT OF PICTURE POSTCARDS.

DAVE'S
ultra-light at
his hangar at the
Joseph "airport."

art is what you call it.

I LOVE TO SEE ART THAT DOESN'T KNOW IT IS ART. WOMEN WITH INCREDIBLE HAIRSTYLES OR FANTASTICALLY ELABORATE MANICURES WITH AIRBRUSHING AND DECALS AND GLUED-ON GEMS AND INITIALS. MEN WITH CUSTOMIZED CARS AND MOTORBIKES. I LOVE GETTING MAIL COVERED IN DRAWINGS AND STAMPS AND LABELS, TOO.

BAGGING ART.

PACKING LUNCH FOR YOUR KID CAN BE ART, TOO. JACK TAKES A LUNCH BOX TO SCHOOL BUT WHEN HE GOES TO SUMMER DAY CAMP, HIS CARROT STICKS, COOKIE, AND SANDWICHES (UNVARYINGLY: ONE SALAMI, ONE PB&J)

TRAVEL ALONG IN A BROWN PAPER BAG. AT ONE POINT, MAYBE IT WAS LAST SUMMER OR THE SUMMER BEFORE, PATTI ASKED ME TO WRITE HIS NAME ON THE BAG. SOON THIS BECAME A RITUAL AND EACH MORNING AFTER BREAKFAST I WOULD DO MORE AND MORE ELABORATE CALLIGRAPHY TO

IDENTIFY HIS BAG. THEN I STARTED MAKING UP PANELS FROM SUPERHERO COMICS AND PRINTING THEM ON THE BAG WITH MY INK-JET. THIS YEAR I ALTERNATE BETWEEN DIP PEN HIEROGLYPHICS AND WATERCOLORS AND GOUACHE (WHICH LOOK GREAT ON THE BISCUIT BROWN PAPER).

WHEN I FIRST CAME TO AMERICA AT THIRTEEN, I GOT MY FIRST LUNCH BOX. I THINK I PICKED IT OUT MYSELF, A SCOOBY-DOO MODEL. IT WASN'T LONG BEFORE MY CLASSMATES STARTED TO SNICKER AND THEN OPENLY DERIDE ME FOR MY CLUELESSNESS.

BEFORE LONG, I'D GOTTEN THE MESSAGE AND BEGAN TO BROWN-BAG IT. NO NAME OR WATERCOLORS.

AFTER YEARS OF DRAWING, I DECIDED TO LEARN TO PLAY A MUSICAL INSTRUMENT, SOMETHING I HAD ALWAYS WANTED TO DO BUT FELT I COULDN'T, AS IF I WAS MISSING SOME ESSENTIAL MUSICAL CHROMOSOME OR SOMETHING.

RECENTLY, JACK, MY BOY, 10 YEARS OLD, GOOD, HANDSOME, SMART, GOT INTO HIS SKULL THAT HE JUST HAD TO BECOME A ROCK 'N' ROLL DRUMMER. DESPITE MY ATTEMPTS TO DISSUADE HIM, HE BEGAN TAKING LESSONS AND HAMMERING AWAY ON MOST HORIZONTAL SURFACES WITH HIS DRUMSTICKS WHENEVER POSSIBLE.

A COUPLE OF WEEKS LATER, HIS PAL, LUKAS, DECIDED THAT HE NO LONGER WANTED TO TAKE GUITAR LESSONS, THOUGH HIS TWIN, EDITH, HAS BEEN EXCELLING ON SAID INSTRUMENT AND, IN FACT, ONE FRIDAY, PLAYED "I'M A BELIEVER" TO A SOLD-OUT CROWD

IN THE PS41 TALENT SHOW, AND A GOOD TIME WAS HAD BY ALL, EXCEPT PERHAPS FOR LUKAS. ANYWAY, AROUND THE SAME TIME THAT LUKAS GAVE UP ON THE GUITAR, JACK STARTED FOOLING AROUND ON THAT SAME AXE, AND MENTIONED CASUALLY TO ME THAT MAYBE PLAYING THE GUITAR WAS COOL AND THAT MAYBE HE'D LIKE TO PLAY IT SOMEDAY. MY EARS PRICKED UP AND I SUGGESTED THAT MAYBE WE COULD BOTH TAKE LESSONS TOGETHER, HOPING AGAINST HOPE THAT THIS MIGHT OBVIATE THE NEED FOR ME TO FILL OUR PEACEFUL APARTMENT WITH A GIGANTIC DRUM KIT ONE OF THESE DAYS.

WE WENT TO THE GUITAR STORE AND BOUGHT OURSELVES A PAIR OF FENDER GUITARS — JACK'S BLACK, MINE CADMIUM RED — AND THE ATTENDANT AMPS AND STOOLS AND STANDS AND STUFF. (I WAS QUITE SURPRISED HOW AF-FORDABLE GUITARS ARE; NOT AS CHEAP AS, SAY, TOMBOW BRUSH MARKERS OR GLUE STICKS, BUT NOT NEARLY AS EXPEN-SIVE AS THE TITANIUM COMPUTER I WRITE ON.

Jack's First Drum Lesson

February 2

JAMMING GOD WITH WEIRD GILLY

I WAS ALWAYS SO IMPRESSED WHEN PETE TOWNSHEND SMASHED A PERFECTLY GOOD GUITAR ONTO THE UNFORGIVING FLOOR-BOARDS OR WHEN, IN ABOUT 1980 AND AT CBGB, I WATCHED THE PLASMATICS BISECT A PLUGGED-IN GUITAR WITH A CHAINSAW AND IT BUCKED AND SCREAMED AND FINALLY FELL IN TWO, ITS STRINGS GEYSERING. I WAS MOST IMPRESSED NOT BY THE NOISE OR THE GESTURE BUT THE SHEER WASTE OF MONEY. ANYWAY, IT TURNS OUT IT WASN'T THAT MUCH MONEY AFTER ALL.)

So NOW OUR APARTMENT LOOKS LIKE BACKSTAGE AT MADISON SQUARE GARDEN, WHAT WITH ALL THIS GEAR AND AMPS AND HALF-EMPTY BOTTLES OF JACK DANIEL'S STANDING AROUND. FIRST THING THIS MORNING, JACK WALKS INTO OUR BEDROOM WEARING ONLY A BATHROBE AND HIS GUITAR, READY TO ROCK AND ROLL. I HAD TAUGHT HIM THE ONE SONG I KNOW, THE ONE I LEARNED WHEN I WAS 15, THE SAME SONG EVERY BOY OF MY GENERATION LEARNED TO IMPRESS GIRLS: THE OPENING CHORDS OF "SMOKE ON THE WATER" BY DEEP PURPLE. DUM, DUM, DUM. DUM DUM DE DUM. DUM, DUM, DUM, DUM DE DUM. SO, JACK WALKS AROUND, IN HIS ROBE, HAMMERING OUT THE SONG AND SOUNDING MUCH LIKE THE PLAS-MATICS WITH A GOOD BILLY IDOL CURL TO HIS LIP.

THE FIRST EVENING, WHEN I GOT HOME FROM WORK, RUSSELL, OUR TEACHER, WAS HALFWAY THROUGH JACK'S LESSON. THEN IT WAS MY TURN TO LEARN HOW TO SIT, HOW TO HOLD THE GUITAR, HOW TO CURL MY FINGERS INTO IMPOSSIBLE CONTORTIONS AND PRESS MY DELICATE FINGER PADS INTO THE EGG-SLICER STRINGS. RUSSELL DECIDED THAT I WAS TO BE THE FIRST ONE TO LEARN HOW TO TUNE THE "MACHINE," AS HE CALLS IT. HE SHOWED ME THE FIRST STEPS AND THEN LAUNCHED INTO AN ERUDITE MONOLOGUE ABOUT THE PHYSICS OF SOUND. MY INNOCENT QUESTIONS RICOCHETED OFF HIS AMPLE BRAIN IN ALL SORTS OF DIRECTIONS, INCORPORAT-ING ARISTOTLE, EUCLIDEAN GE-OMETRY, MILES DAVIS'S EARLY INEPTNESS, THE WELL-TEMPERED CLAVIER, ELEC-TRICAL ENGI-NEERING, AND THE REAL DIF-FERENCE BE-

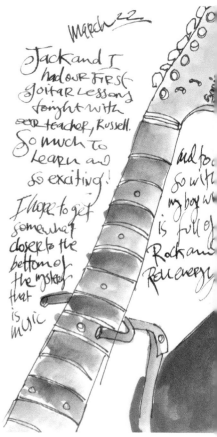

March 22
Jack and I had our first guitar lessons tonight with our teacher, Russell. So much to learn and so exciting!
I hope to get somewhat closer to the bottom of the mystery that is music

...and too so with my boy w... is full of Rock and Roll energy

TWEEN SINATRA AND TORMÉ. IT WAS THE SORT OF RICH BROTH I LOVE BUT, AFTER AN HOUR OR SO AND WITH A SIGH, WE WENT BACK TO FILLETING MY FINGER PADS.

I HAVE ALWAYS LOVED MUSIC OF ALL SORTS, BUT IT HAS ALWAYS MYSTIFIED ME.

I HAVE HALFHEARTEDLY STUDIED OTHER INSTRUMENTS BEFORE BUT THE HARMONICA IS THE ONLY ONE I HAVE BEEN AT ALL FLUID WITH AND THEN, ONLY IN THE SHOWER. SO MUSIC AND THE PEOPLE WHO PLAY IT HAVE ALL BEEN SUFFUSED WITH MAGIC. MUSICIANS, PARTICULARLY IMPROVISATIONAL JAZZ CATS, SEEM LIKE ANOTHER SPECIES — WITH SOME SORT OF EXTRATERRESTRIAL KNOWLEDGE THAT I CAN NEVER BEGIN TO COMPREHEND. IT'S A FOOLISH SORT OF OBSTACLE THAT I SET UP FOR MYSELF SO LONG AGO, THIS ABSOLUTE SENSE THAT I COULD NEVER HOPE TO PLAY AN INSTRUMENT, EVEN ON AN AMATEUR LEVEL.

AND YET, IN MY ONE LESSON, I ALREADY BEGAN TO FEEL THE DOOR INCHING OPEN. ONE OF THE POINTS THAT RUSSELL EMPHASIZED TO ME WAS TAKING THE TIME TO LISTEN AND SAVOR THE NOTE. WHILE MY BODY WAS LEARNING AND STRETCHING, MY TENDONS LENGTHENING, MY BONES SHIFTING, I SHOULD GIVE MY MIND THE TIME TO FEEL THE MUSIC, TO HEAR THE DECAY OF A NOTE, TO SEE HOW THE SOUND EMERGES AND THEN HOW THE HARMONICS FALL AWAY. WHAT I FIND FASCINATING IS THAT, YET AGAIN, THE LESSONS I LEARNED IN DRAWING ARE AT THE CORE OF ALL CREATIVE EFFORT.

TO SUSPEND TIME AND TO APPRECIATE THE MOMENT.

TO BE GENTLE WITH MYSELF AND FEEL COMFORTABLE WITH "ERRORS."

TO REALIZE THAT NO MATTER HOW FEW HAIRS I HAVE AND HOW GREY THEY MAY BE, I CAN ALWAYS LEARN NEW THINGS.

THAT ONCE I OPEN MY MIND TO LEARNING, EVERYTHING BECOMES A FRESH LESSON.

FINALLY, I AM ALSO SO EXCITED TO BE LEARNING SOMETHING RIGHT ALONG WITH JACK, AS HE DOES. IN MANY WAYS, HE IS A MUCH BETTER ARTIST THAN I AM — FREER, BOLDER, AND CLEARER. I HOPE HE NEVER LOSES THAT WAY HE HAS WITH MAKING THINGS. I AM ALSO INTERESTED TO SEE WHAT IT IS LIKE TO BE AS NEW TO SOMETHING AS HE IS, TO LEARN ALONGSIDE HIM, TO SEE HOW WE TACKLE OUR FRUSTRATIONS DIFFERENTLY. I THINK THIS GUITAR THING IS GOING TO BE QUITE AN ADVENTURE AND A GOOD INVESTMENT OF WHAT LITTLE FREE TIME I HAVE LEFT. MY TRUE GOAL: TO PLAY "THE MILKMAN OF HUMAN KINDNESS" OR ANYTHING ELSE BY BILLY BRAGG.

"FREEBIRD," ANYONE?

SHARING.

UNLIKE SOME, I'M A JOURNAL-KEEPER WHO FEELS OKAY ABOUT SHARING (MOST OF) HIS JOURNALS WITH OTHER PEOPLE. BUT MANY PEOPLE ARE LESS PROMISCUOUS. THE TWO KEY REASONS WHY PEOPLE SEEM RELUCTANT TO SHARE WHAT THEY MAKE IN PRIVATE ARE A) THEIR SENSE OF PRIVACY AND B) EMBARRASSMENT AT THEIR MORE HUMBLE EFFORTS.

I AM A RESERVED AND PRIVATE PERSON BY NATURE SO PERHAPS MY JOURNALS ARE A WAY TO LET IT OUT.

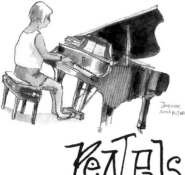

Jaquine AND MOZART

MY JOURNALS HAVE NEVER STRUCK ME AS TERRIBLY PRIVATE. TRUE, I TALK ABOUT THE DAILY ASPECTS OF MY LIFE, BUT FRANKLY THEY ARE NO MORE INTIMATE THAN THE THINGS I SHARE IN SMALL TALK WITH THE PEOPLE AT WORK. FOR ME, MY JOURNAL IS NOT A CONFESSIONAL BUT A HISTORIAN IN THE BEST SENSE OF THE WORD. SOMEONE WHO NOT ONLY RECORDS THE FACTS BUT DEVELOPS THEMES AND MEANING THAT WEAVE THEM TOGETHER, EXPLICATING MY LIFE AND SHOWING ME WHAT'S IMPORTANT, LENDING DEEPER VALUE TO THINGS OTH-ERWISE TOO EASY TO TAKE FOR GRANTED. GENERALLY, I FIND THAT THESE THEMES AND LESSONS ARE UNIVERSAL AND BY SHARING THEM I GET A CHANCE FOR A SOUNDING BOARD.

PENPALS

I AM REALLY LUCKY TO HAVE A FRIEND WHO HAS TAUGHT ME AN AWFUL LOT ABOUT JOURNALING. D. PRICE IS THE AUTHOR OF A WONDERFUL 'ZINE CALLED *MOONLIGHT CHRONICLES* (SUBSCRIBE AND YOU WILL BE VERY HAPPY) AND HE AND I HAVE BEEN SHARING OUR WORK FOR YEARS. WE COPY THE PAGES FROM OUR JOURNALS AND SEND THEM TO EACH OTHER AND, WHENEVER POSSIBLE, WE GET TOGETHER FOR JOURNALING TRIPS IN DIFFERENT PARTS OF THE COUNTRY (HE LIVES IN RURAL EASTERN OREGON WHILE I LIVE IN THE HEART OF MANHATTAN).

IT'S A GREAT EXPERI-ENCE TO SIT DOWN AND CREATE A PAGE IN YOUR JOURNAL, CHRONICLING YOUR CURRENT EXPERIENCE AND THEN SHARING IT WITH A TRUSTED FRIEND WHO IS DOING THE SAME THING AT THE SAME MOMENT. SOMETIMES, WHEN WE SHARE THE SAME VANTAGE POINT, THE SAME SIZE JOURNALS, AND THE SAME PAINT BOX, DAN AND I DISCOVER OUR PAGES ARE VERY SIMILAR.

BUT WHEN WE REALLY TAKE OUR TIME, WE SEE THINGS QUITE DIFFERENTLY. I TEND TO SEE LIGHT AND SHADE, WHEREAS DAN TENDS TO FOCUS ON SHAPES. I CAN GET QUITE LOST IN A

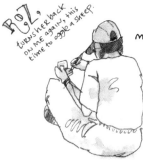

ROZ, turns her back on me again, this time to ogle a sheep.

As to embarrassment at my experimentations — I'd rather not share lame drawings, failed experiments, and inattention, but that doesn't prevent me from sharing my unedited pages. I find that by having a sense that what I am making will be seen by someone, sometime, I am actually driven to take more care with what I am doing, to polish my words and drawings and make sure my observations ring true. As to really experimental things — pen wipes, color combinations, etc. — well, I usually do those on a piece of scrap paper and chuck 'em out. They would be meaningless even to me in a few hours.

The one really solid reason to not share your journal is because, frankly, most people don't care. They're not interested in what you had for breakfast, whether it's raining, how the cat is, whether your hair's turning grey. Most people are interested only in themselves. Even if you cram your book with intimate revelations, chances are most readers will flip through, say, "Very nice," and hand it back to you. None of us is that important! But I find sharing is an enriching experience. It connects me to others and makes me see how universal my concerns and experiences are. It drives me to make my pages less sloppy, my writing more terse. It is a gift of myself that often leads to wonderful conversations and gifts of all sorts in return.

Diaries with locks on them are things of girlhood. Open your life, I say. Be brave and share yourself.

muddy mess of paints or cross-hatching while his colors are bright and sharp. Our writing is quite different, too. I'm the city mouse, he's the country mouse. We are impressed by very different stuff.

When we are done, we swap books and discuss why we did what we did. It's a great way to learn and grow.

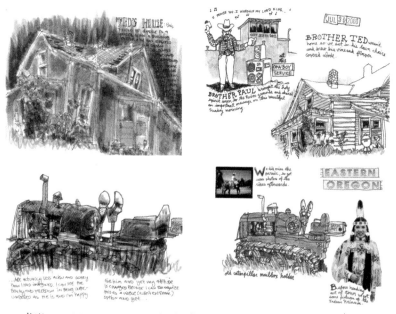

MY IMPRESSIONS OF THE DAY ... AND MY BUDDY DAN'S

Did Ya Ever...

TRY THESE OUTLETS FOR YOUR CREATIVITY.
WHEN YOU'VE WORKED THROUGH THE WHOLE LIST, TAKE THE REST OF THE DAY OFF.

ACCOUNTING
ACTING
ANIMATION
BAKING
BALLET
BANJO
BASKET-WEAVING
BASS
BEADING
BLOGGING
BONSAI
BOOKBINDING
BREAKDANCING
CALLIGRAPHY
CANDLE-MAKING
CAR-CUSTOMIZING
CARD-MAKING
CELLO
CERAMICS (HAND-
BUILT, WHEEL-THROWN)
CHINESE KNOTTING
CLOISONNÉ
COLLAGE
COOKING (CZECH,
ISRAELI, INDONESIAN,
DIM SUM, TAPAS,
FILIPINO, VENETIAN,
AFRICAN, ETC.)

CROCHETING
DECOUPAGE
DESKTOP PUBLISHING
DRUMS
EMBROIDERY
FABRIC PAINTING
FILMMAKING
FINE CABINETRY
FLASH ANIMATION
GARDENING
GIFT-WRAPPING
GLASS-ETCHING
GLAZING
GOUACHE
GRAPHIC DESIGN
GUITAR
HANDBAG DESIGN
HARMONICA
IKEBANA
INTERIOR DESIGN
JEWELRY-MAKING
KITE-MAKING
KNITTING
LETTER-WRITING
MACRAMÉ
MIXOLOGY
MODEL-MAKING

MOSAICS
NOVEL-WRITING
ORIGAMI
PAINTING
PAPERMAKING
PAPIER MÂCHÉ
PASTELS
PHOTOGRAPHY
PIANO
PLAYWRITING
POETRY
POTTERY
PRINTING (WOODCUTS,
SCREEN, ENGRAVING,
ETCHING, MONO, ETC.)
PUPPETRY
QUILTING
RAPPING
SAXOPHONE
SCRAPBOOKING
SCROLLWORK
SCULPTURE
SEWING
SHORT STORIES
SILVERSMITHING
SINGING
SOAP-MAKING

STAINED GLASS
STAMPING
TAP DANCING
TATTOOING
TAXIDERMY
TIE-DYEING
TOY-MAKING
TRUMPET
TYPOGRAPHY
UKULELE
UPHOLSTERY
VENTRILOQUISM
VIBRAPHONE
VIOLIN
WEAVING
WEB DESIGN
WELDING
WHITTLING
WINE-MAKING
WOOD BURNING
WOODWORKING
XEROX ART
XYLOPHONE
YARD WORK
'ZINE PUBLISHING

CHAPTER NINE:

NEXT

CREATIVITY IN THE REAL WORLD

calligraphic experiments from Nancy Hopwell

The qu... *nancy* ...jumps

NANCY GREW UP IN THE SOUTHWEST, I THINK IT WAS ALBUQUERQUE. SHE WAS
ALWAYS A CREATIVE PERSON AND, OVER DAD'S OBJECTIONS, SHE MAJORED IN ART AT
U OF NM BECAUSE SHE LOVED TO DRAW. THIS WAS IN THE '70S WHEN, FRANKLY,
DRAWING WAS NOT THE THING. INSTEAD HER INSTRUCTORS WERE PUSHING PERFORMANCE
ART, CONCEPTUAL ART, EARTHWORKS, THAT SORT OF THING. BEFORE THE FIRST
SEMESTER WAS OVER, NANCY, BEATEN, CHANGED HER MAJOR. SHE DECIDED TO BECOME
A PHYSICAL EDUCATION INSTRUCTOR. SHE FIGURED ART AND PE BOTH HAD SOMETHING
TO DO WITH ANATOMY, SO SHE'D STILL BE IN A RELATED FIELD. WHEN SHE GRADUATED,

over the lazy dog. 1234567890

SHE GOT A JOB AS A SUBSTITUTE GYM TEACHER. SHE WOULD LIE IN BED EACH MORNING
WITH THE PILLOW OVER HER HEAD, HOPING NOT TO HEAR THE PHONE RING AND CALL
HER IN. SHE HATED BEING A GYM TEACHER.
 NANCY LOVED PLAYING MUSIC. SHE WAS IN BAND AFTER BAND, PLAYING THE CLUBS AND
BARS AROUND TOWN, MAKING A LITTLE CASH HERE AND THERE. NOT ENOUGH CASH, HOWEVER, SO
SHE GOT A JOB IN A BANK. SHE WAS THE TELLER IN THE DRIVE-THROUGH, SENDING DEPOSITS
BACK TO THE BRANCH OVER A PNEUMATIC TUBE. SHE HATED THIS JOB, TOO, AND SUCKED AT IT.
 ONE DAY, NANCY WAS ON HER LUNCH BREAK AT THE TGI FRIDAY'S ACROSS THE

The quick brown fox jumps

ROAD. IT WAS DECORATED IN THAT NOSTALGIC STYLE THAT BLOSSOMED IN THE '60S,
FULL OF MUSTACHE CUPS AND BARBER POLES AND MERRY-GO-ROUND HORSES AMIDST
THE SPIDER PLANTS. HANGING OVER EACH TABLE WAS AN ERSATZ TIFFANY LAMP.
NANCY DECIDED THERE AND THEN THAT WHAT SHE WANTED TO DO WAS TO WORK
PROFESSIONALLY IN STAINED GLASS. SHE FOUND OUT THAT ONE OF THE COUNTRY'S
LARGEST COMMERCIAL WORKSHOPS FOR STAINED GLASS WAS RIGHT THERE IN ALBUQUER-
QUE AND SHE SOON HAD A JOB THERE.
 NANCY'S FRIENDS WERE ENVIOUS. SHE'D QUIT HER STRAIGHT JOB AND WAS MAKING

over the lazy dog. 1234567890

MONEY ENTIRELY THROUGH CREATIVE ENDEAVORS — GLASS IN THE DAY, MUSIC AT NIGHT.
 NONETHELESS, NANCY STILL WASN'T HAPPY. SHE REALIZED THAT DESPITE HER
FIELD, SHE DIDN'T REALLY FEEL LIKE AN ARTIST. THE GLASSWORK SHE DID WAS NOT
ORIGINAL; SHE WAS JUST WORKING FROM PATTERN BOOKS, FILLING ORDERS FROM

MARKS
STUDENT | TEACHER

TEMPLATES. AND HER BAND, GOOD AS IT WAS, WAS REALLY JUST A COVER BAND. IF THEY EVER PLAYED ORIGINAL COMPOSITIONS, THE AUDIENCES SQUIRMED AND THE BAR OWNER WOULD COMPLAIN. ALBUQUERQUE AIN'T NO CBGB AND THERE WAS LITTLE APPETITE FOR TRUE ORIGINALITY.

SO NANCY SHED HER JOB, HER HOME-TOWN, AND HER HUSBAND, AND CAME TO NEW YORK CITY. SOON SHE HAD A JOB WITH THE PREMIER STAINED-GLASS WORK-SHOP IN THE COUNTRY. SHE WORKED ON CHURCHES, ON SYNAGOGUES, ON CORPO-RATE HEADQUARTERS. SHE EVEN REPAIRED THE GLASS IN THE STATUE OF LIBERTY'S TORCH. FOR THE NEXT FIFTEEN YEARS OR SO, SHE WAS AT THE TOP OF HER GAME. SHE HAD A NEW BAND WITH HER NEW HUSBAND AND THEY PLAYED THE CUTTING-EDGE CLUBS OF THE CITY. SHE HAD TWO KIDS. SHE SEEMED FULFILLED.

THEN NANCY REACHED THE NEXT CRI-SIS. SHE WAS THE #2 PERSON IN THE #1 FIRM. IF SHE BECAME #1 SHE WOULD SIT IN AN OFFICE AT A COMPUTER ALL DAY AND CEASE PLYING HER CRAFT. SHE'D TOPPED OUT. SHE ALSO FELT PAST THE AGE WHEN SHE REALLY ENJOYED CAR-RYING ENORMOUS PANES OF GLASS INTO THE GRIMY TOPS OF OLD BUILDINGS. THE WORK WAS MORE PHYSICAL THAN SHE WANTED. TIME FOR A NEW PAGE.

THE PART OF GLASSWORK NANCY HAD ALWAYS ENJOYED THE MOST WAS RESTORING OR CREATING THE HAND-LETTERED LEGENDS THAT ADORN BIG WINDOWS, NAMING THE SAINTS, THE DATES, THE GREATS OF THE CHURCH OR THE CORPORATION. SO SHE DECIDED TO TRY HER HAND AT SOMETHING

BRAND-NEW TO HER. DURING HER LAST YEAR AS A STAINED-GLASS ARTISAN, SHE SPENT EACH NIGHT TAKING CLASSES AND PRACTICING CALLIGRAPHY. SHE WENT TO WORKSHOPS, SHE LEARNED MATERIALS, AND SHE WORKED HARD AT HER CRAFT. WHEN THE YEAR WAS UP, SHE OPENED HER FIRST BUSINESS. SHE SENT OUT A SMALL ANNOUNCEMENT TO EDITORS AND ART DIRECTORS AND SHE WAS OFF DOING WORK FOR WEDDINGS, FOR PUBLISHERS, FOR ALL SORTS OF EXCITING AND GLAMOROUS CLIENTS.

WITHIN THREE YEARS, NANCY WENT FROM A NOVICE TO ONE OF NEW YORK'S TOP CALLIGRAPHERS. WHENEVER YOU SEE SOME LOVELY ORNATE PENMANSHIP IN *MARTHA STEWART WEDDINGS* MAGAZINE, CHANCES ARE NANCY DID IT.

IS SHE FULFILLED NOW? MORE SO THAN EVER. BUT SHE TELLS ME SHE'D STILL LIKE TO PUSH FURTHER, TO CREATE PIECES THAT SHE WRITES HERSELF, WORKS OF PURE ART THAT ARE NOT COMMERCIAL BUT EXPRESS HERSELF AT THE DEEPEST. SHE'S WORK-ING ON THAT NOW. NANCY AND MARK AND THEIR KIDS JUST MOVED OUT OF THE CITY TO CONCENTRATE COMPLETELY ON THEIR ART, TO PLAY MORE MUSIC, AND TO BREATHE FRESH COUNTRY AIR.

NANCY IS A CONSTANT REMINDER TO ME THAT YOU CAN GET WHAT YOU WANT, NO MATTER HOW FAR-FETCHED IT MIGHT SEEM. FIRST OFF, KNOW WHAT IT IS YOU ACTUALLY WANT. THEN BE WILLING TO WORK HARD, TO TAKE RISKS, AND, MOST IMPORTANTLY, TO LISTEN ONLY TO THE LITTLE VOICE IN YOUR HEAD THAT FIRST SPOKE THE DREAM.

JAKARTA, Indonesia (TK) - MEITY HAFID AT HER HOUSE IN JAKARTA, HOLDS A PICTURE OF HER DAUGHTER MEUTYA WHO'S REPORTEDLY MISSING IN IRAQ. FOR THOSE OF YOU OUT TO LUNCH, THAT MEANS KIDNAPPED. ANOTHER THIRTY THREE PEOPLE KILLED IN BAGHDAD TODAY. YOU CAN DEFINATELY GET IMMUNE TO THIS CRAP, IT'S LIKE DID I READ THAT YESTERDAY? OH NO, THAT WAS A DIFFERENT THIRTY THREE PEOPLE KILLED AND KIDNAPPED. THE ARTICLE I WAS READING HAD ANOTHER FIVE PARAGRAPHS OF KILLINGS AND BOMBINGS. IT WAS TOO MUCH SO I JUST FOCUSED ON A FEW. ALSO TODAY THE ACLU OBTAINED A COURT ORDER TO SEE HUNDREDS OF PAGES OF DOCUMENTS ABOUT THE U.S. TREATMENT OF DETAINEES AROUND THE WORLD. GET THIS, THE ARMY DESTROYED TONS OF DOCUMENTS AND PHOTOGRAPHS SHOWING U.S. SOLDIERS ABUSING PRISONERS IN AFGHANISTAN. SEEMS AFTER THE ABU GARAIB THING WENT DOWN EVERY ONE WAS SCRAMBLING TO COVER UP THE WIDESPREAD ABUSE. I WONDER HOW ALBERTO GONZALEZ AND JUDGE MICHAEL CHERTOFF FEEL ABOUT ALL THIS. THEY WERE THE ONES WHO ADVISED THE WHITE HOUSE THAT THEY COULD TORTURE DETAINEES. I WONDER WHAT THEIR PUNISHMENT WILL BE. OH THAT'S RIGHT THEY WERE MADE HEAD OF HOMELAND SECURITY AND ATTORNEY GENERAL.

TEHRAN, Iran (TK) - GEORGE W. BUSH WANTS TO BOMB IRAN. HE'S NOT REAL GOOD AT NEGOTIATIONS. IN FACT ANY TIME ANY OF HIS CABINET PEOPLE HAVE BEEN IN CHARGE IN WASHINGTON THERE HAS BEEN WAR, BOMBINGS, KILLINGS AND WHAT NOT. WHEN THESE GUYS HAVE BEEN OUT OF POWER THEY MAKE THEIR DOUGH SELLING WEAPONS. THE BUSINESS OF WAR. IRAN FOREIGN MINISTRY SPOKESMAN, HAMID REZA ASEFI IS WARNING AMERICA IT WILL SHOOT DOWN OUR SPY DRONES FLYING OVER IRAN. THIS IS LIKE OUR OLD GULF OF TONKIN PLAY. THAT'S WHERE WE LIED ABOUT A BOAT BEING FIRED ON TO START THE VIETNAM WAR. WHEN WE SAY IRAN SHOT DOWN ONE OF OUR DRONES, THAT'S WHEN THE FUN BEGINS FOR CHENEY, BUSH, WOLFOWITZ AND RUMSFELD. LET THE WARS AND MONEY BEGIN TO FLOW, ALL THEIR BUDDIES CAN GET THOSE BANK ACCOUNTS READY FOR A REFILL. IT'S GETTING HARDER AND HARDER TO BELIEVE WHAT OUR GOVERNMENT SAYS. THIS ADMINISTRATION LOVES TO CRY WOLF. YOU SEE ALL THE NUCLEAR BOMBS AND CHEMICAL WEAPONS WE FOUND IN IRAQ. NOW WE'RE MAKING THE SAME CLAIM. EVEN PRIME MINISTER TONY BLAIR IS RUNNING FOR THE HILLS. HE HAS AN ELECTION COMING UP IN MAY.

HAPPY LIKES TO LAY IN THE SUN.

WHEN I WAS DONE WITH THIS DRAWING HAPPY ACTUALLY CAME OVER AND STARED AT IT FOR A WHILE.

CALIFORNIA, Santa Barbara (TK) - PETER PAN IS ABOUT TO GO ON TRIAL SOON. HE'S ACCUSED OF MOLESTING A 13 YEAR OLD BOY. HE LIKED TO SHOW THE BOYS NUDIE PICTURES AND SERVE THEM WINE IN SODA CANS (JESUS JUICE HE CALLED IT.) RIGHT NOW THEY ARE SELECTING A JURY. ONE POTENTIAL JUROR WAS ASKED IF HE RECOGNIZED THE NAMES OF CELEBRITY WITNESSES WHO MAY TESTIFY IN THE CASE, INCLUDING SELF-HELP GURU DEEPAK CHOPRA. "I THINK HE'S A RAPPER," THE JUROR SAID. THAT DUDE MARTIN BASHIR DID ANOTHER MICHAEL JACKSON SPECIAL ON TV. JACKO IS WAY WEIRDER THAN I THOUGHT. HE BEFRIENDS LITTLE BOYS AND THEN GOES AND STAYS AT THEIR HOUSE FOR THE WEEKEND. THE PARENTS ACTUALLY LET THIS WIERD 43 YEAR OLD STAY ALONE IN THE KIDS ROOM WITHOUT PARENTAL SUPERVISION. THESE PARENTS SHOULD BE ON TRIAL ALSO. MY FAVORITE THING ABOUT JACKSON IS THAT A GUY ALWAYS FOLLOWS HIM HOLDING A GIANT UMBRELLA OVER HIS HEAD. TOO BAD THAT GUY WON'T BE IN PRISON WITH HIM.

IRAQ, Baghdad (TK) - INTERIM IS AN INTERESTING WORD. INTERIM. IT MEANS BETWEEN. IRAQI INTERIM PRIME MINISTER AYAD ALLAWI WANTS TO GET RID OF THE INTERIM PART IN THE WORST WAY. BUT IT JUST ISN'T GOING TO HAPPEN. HE TRIED TO USE AND ABUSE HIS INTERIM POWER TO COMMANDEER THE TELEVISION AIRWAVES TO RUN COMMERCIALS ABOUT HIMSELF 24 HOURS A DAY BEFORE THE ELECTION. BUT IT DIDN'T REALLY WORK. BUT YOU CAN'T BLAME HIM FOR TRYING. ANYWAY HE WILL HAVE LITTLE POWER IN THE NEW GOVERNMENT. NO ONE SEEMS TO HAVE ANY POWER OVER THE INSURGENTS. A ROADSIDE BOMB KILLED 3 U.S. SOLDIERS AND WOUNDED SIX IN AN EXPLOSION IN TANMIYA. A SUICIDE BOMBER WEARING A POLICE UNIFORM BLEW UP IN A CAR AT A POLICE HEADQUARTERS IN TIKRIT. HE KILLED FIFTEEN. TWO OTHER U.S. SOLDIERS WERE KILLED IN QUAYAT. YOUNG PEOPLE IN AMERICA SEEM TO NOT CARE SO MUCH ABOUT WHAT IS HAPPENING. THERE'S NOT ONE SINGLE WAR PROTEST SONG OR PRO WAR SONG FOR THAT MATTER. IT'S AS IF IT'S NOT REALLY HAPPENING. I'M READING BOB DYLAN'S BIOGRAPHY. HE USED TO WRITE SONGS ABOUT WHAT HE SAW HAPPENING IN THE WORLD. MAYBE ASHLEY SIMPSON WILL COME THROUGH AND WRITE ONE.

ST.MONICA

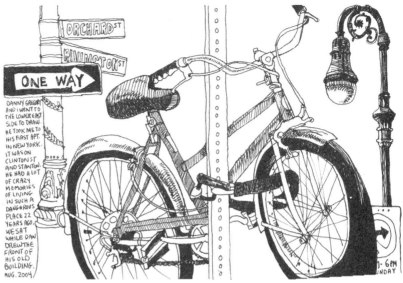

DANNY GREGORY AND I WENT TO THE LOWER EAST SIDE TO DRAW. HE TOOK ME TO HIS FIRST APT. IN NEW YORK. IT WAS ON CLINTON ST AND STANTON. HE HAD A LOT OF CRAZY MEMORIES OF LIVING IN SUCH A DANGEROUS PLACE 22 YEARS AGO. WE SAT WHILE DAN DREW THE FRONT OF HIS OLD BUILDING. AUG. 2004

ONE DAY, WALKING THROUGH THE EAST VIL-LAGE IN NEW YORK, I SAW A MAN IN A FA-MILIAR POSE: SITTING ON THE CURB, HUNCHED OVER A LITTLE BOOK, THE CLASSIC POSE OF THE ILLUSTRATED JOURNAL-KEEPER. AS I APPROACHED, I REALIZED I KNEW THE ARTIST.

Tom KANE AND I HAD WORKED TOGETHER WHEN WE WERE BOTH IN OUR MID-TWENTIES. AND HERE HE WAS, DECADES LATER, ON THE SAME PATH AS ME. AS WE TALKED, HE TOLD ME HE'D JUST TAKEN UP DRAWING AGAIN AFTER A LONG HIATUS. HE'D READ SOME OF MY STUFF AND DECIDED TO TRY HIS HAND AT IT AGAIN. NOW HE WAS HOOKED.

Tom WENT FROM ART SCHOOL RIGHT INTO THE BULLPEN AT AN ADVERTISING AGENCY. OVER THE NEXT TWENTY-FIVE YEARS, HE CARVED OUT A SUCCESSFUL CAREER. YOU'VE PROBABLY SEEN HIS WORK: BIG-HEADED GIRL CAMPAIGN FOR STEVE MADDEN SHOES, STARTLING GRAPHICS FOR YELLOWTAIL WINE, OR SLEEK TV SPOTS FOR BASF. THOUGH HE WAS ALWAYS VERY CREATIVE, Tom NEVER THOUGHT OF HIMSELF AS AN ARTIST. HE WAS AN ADMAN. A PROFESSIONAL, WORKING ON BEHALF OF OTHERS.

ILLUSTRATED JOURNALING HAS CHANGED HIS LIFE. AS SOON AS HE GETS INTO HIS OFFICE, HE SCANS THE NEWS, THEN CRACKS HIS JOURNAL AND WRITES AND DRAWS ABOUT THE CURRENT EVENTS THAT IMPACT HIM. WHEN LUNCH ROLLS AROUND, HE TAKES A SANDWICH OUTSIDE AND DRAWS IN HIS JOURNAL. EACH EVENING HE DRAWS, HE PAINTS, HE READS ABOUT ART. ON WEEKENDS, HE GOES TO MUSEUMS AND GALLERIES, PLACES HE HAD PREVIOUSLY IGNORED IN HIS MANY YEARS IN THE CITY. Tom IS NOW GETTING READY TO ENTER A SHOW SHARING HIS FANTASTIC CREATIVITY WITH THE WORLD. HE HAS LESS AND LESS TIME AND INTEREST FOR THE INDUSTRY THAT ENWRAPPED HIM ALL THESE YEARS. HE KNOWS HE'S AN ARTIST. FINALLY.

DAN PRICE

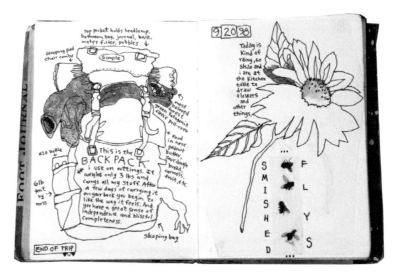

DAN PRICE GREW UP IN THE ROUGH TIMBERLAND OF EASTERN OREGON. HIS DAD, HIS UNCLES, HIS GRANDPA WERE ALL LOGGERS AND RANCHERS. DAN SQUEAKED OUT OF HIGH SCHOOL AND INTO CONSTRUCTION WORK. HE GOT MARRIED TOO YOUNG, STARTED HAVING KIDS, MOVING RIGHT ALONG IN THE GROOVE LAID OUT FOR HIM. THEN HE DISCOVERED PHOTOGRAPHY. DAN BECAME A NEWSPAPERMAN, COVERING LOCAL EVENTS FOR ONE SMALL-TOWN PAPER AFTER ANOTHER. HIS TASTE IN PHOTOGRAPHY WAS FOR THE SPONTANEOUS, THE UNREHEARSED, THE RAW AND DISTRESSED. HE LIKED TAKING PICTURES WITH THE CHEAPEST, CRUDEST PLASTIC CAMERAS AND HE STARTED CORRESPONDING WITH PHOTOGRAPHERS HE ADMIRED AND ASKING FOR PRINTS OF THEIR PERSONAL PICTURES, THEIR LOOSE AND UNPOLISHED WORK. DAN DECIDED TO SHARE THOSE PICTURES IN A LITTLE MAGAZINE AND SOON HE

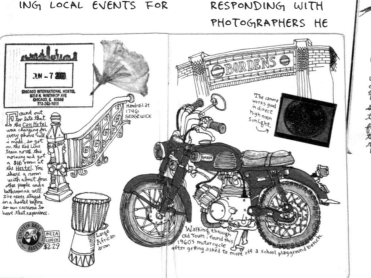

WAS THE PUBLISHER OF A CULT-Y LITTLE MONTHLY, CHERISHED BY PHOTOGRAPHERS' PHOTOGRAPHERS.

AFTER A FEW YEARS, DAN STILL LIKED TAKING

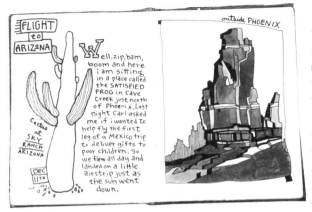

FLIGHT to ARIZONA

Well, zip, bam, boom and here i am sitting in a place called the SATISFIED FROG in Cave Creek just north of Phoenix. Last night Carl asked me if i wanted to help fly the first leg of a Mexico trip to deliver gifts to poor children. So we flew all day and landed on a little airstrip just as the sun went down.

Cactus at SKY RANCH ARIZONA

DEC 11th

outside PHOENIX

SUBSCRIBERS. HE'S BEEN AT IT FOR A DECADE NOW, EKING OUT A LIVING FROM SUBSCRIPTIONS TO HIS XEROXED LITTLE 'ZINE, TRAVELING THE BACK ROADS OF OREGON, THE BLUE HIGHWAYS OF AMERICA, EVEN VENTURING ABROAD AND SHARING HIS FEELINGS, THOUGHTS, AND ADVENTURES WITH A LOYAL AND GROWING BUNCH OF READERS.

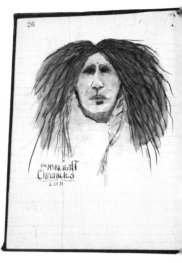

26

the MOONLIGHT Chronicles

PICTURES BUT HE STARTED TO EXPERIMENT WITH A NEW FORM: DRAWING. HE STARTED DOING A LITTLE SKETCH JOURNAL IN HIS MAGAZINE, A WEIRD LITTLE IDIOSYNCRATIC COLUMN CALLED "MOONLIGHT CHRONICLES." SOON, DRAWING TOOK OVER. HE SOLD THE MAGAZINE, LEFT THE PAPER, AND JUST DREW AND DREW. THE CHRONICLES BECAME THEIR OWN LITTLE THING, FIVE BUCKS A POP, WITH A FEW HUNDRED

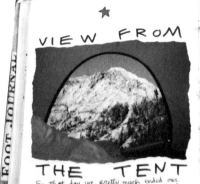

FOOT JOURNAL

★

VIEW FROM THE TENT

So that day we pretty much ended our hike there and played in the mud for hours then we hatched a plan to return the next night with a bunch of friends, camping gear and a boom box, to have a rave dance

SHILO

down there by the cold river on the mud flats. And that very next night that's what we did. We ate and danced and hollered till late under a million stars. Lynne even walked in

IF IT WEREN'T FOR ART, DAN'D BE POUNDING NAILS SOMEWHERE, ANOTHER CLOSED-IN, BROODING AMERICAN MALE.

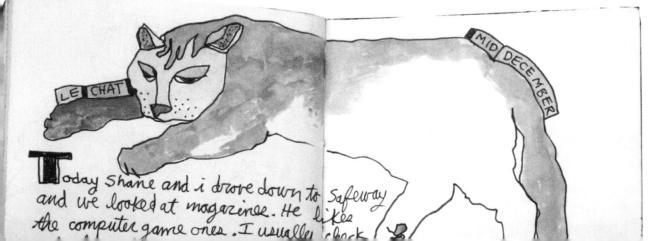

LE CHAT

MID DECEMBER

Today Shane and i drove down to Safeway and we looked at magazines. He likes the computer game ones. I usually check

Chillin' with DYLAN

RECENTLY, I RECOVERED FROM THE FLU IN BED WITH TEA AND BOB DYLAN'S NEW MEMOIR, *CHRONICLES, VOL. 1.* BY THE NEXT MORNING, I'D BOUNCED BACK AND FINISHED READING THE BOOK.

FOR MOST OF MY LIFE, I REALLY HAD NO INTEREST IN DYLAN, UNTIL ABOUT SEVEN YEARS AGO WHEN MY FRIEND, BOB DYE, MORE OR LESS FORCED ME TO LISTEN TO *THE FREEWHEELIN'* AND *HIGHWAY 61.* THE MUSIC SOFTENED MY RESISTANCE BUT PENNEBAKER'S MOVIE *DON'T LOOK BACK* TRIGGERED THE SORT OF INSTANT CONVERSION USUALLY LIMITED TO EVANGELICALS. I HAVEN'T PAID MUCH ATTENTION TO THE ALBUMS FROM THE MID-1970S TO THE MID-1990S BUT OWN AND PLAY MOST OF THE EARLY AND LATE RECORDS FAIRLY REGULARLY.

DESPITE ALL THIS ENTHUSIASM, NOTHING PREPARED ME FOR THIS MEMOIR. I HAD LONG ASSUMED THAT, THOUGH I ADMIRED THE MUSIC, THE MAN WAS ARROGANT AND WITHDRAWN, THE SORT OF PERSON ONE WOULD NEVER WANT TO SPEND TEN MINUTES WITH. INSTEAD, I DISCOVERED THAT BOB DYLAN HAS ALL THE HALLMARKS OF THE QUINTESSENTIAL CREATIVE PERSON (AND I'M SURPRISED THAT THIS SURPRISED ME).

FIRST, I WAS STRUCK BY HOW MUCH HE KNOWS ABOUT MUSIC, ALL SORTS OF MUSIC, FROM CLASSICAL TO BEBOP TO RAP TO DOO-WOP TO THE CHEESIEST SORT OF POP, AND IS ABLE TO EXTRACT SOMETHING USEFUL AND INSPIRING FROM ALL OF IT. LIKE PICASSO, HE BELIEVED IN BORROWING FROM EVERYWHERE ... BUT HIMSELF.

SECOND, HE HAS ALWAYS CHALLENGED HIMSELF — NOT TO BE SUCCESSFUL FINANCIALLY

AND CRITICALLY — BUT TO CONSTANTLY GROW AND BRANCH OUT IN NEW DIRECTIONS. EXCEPT FOR A PERIOD WHERE HE ADMITS HE WAS IN SOME SORT OF CREATIVE STUPOR, HE HAS ALWAYS BEEN MOTIVATED BY SOME FLICKERING NOTION IN THE BACK OF HIS HEAD THAT SLOWLY GROWS AND BLOOMS AS HE FEEDS IT. IT'S NOT TO "SHOW THE WORLD" OR PROVOKE THE INDUSTRY, BUT BECAUSE HE IS ALWAYS FEEDING HIMSELF WITH NEW INFLUENCES THAT SPARK FRESH IDEAS AND DIRECTIONS.

THIRD, DESPITE THE FACT THAT HE IS SUCH AN IMPORTANT MAVERICK, HE HAS DEEP ROOTS IN THOSE THAT CAME BEFORE. HIS LOVE FOR AND APPRECIATION OF ROOTS BLUES AND FOLK MUSIC HAS ALWAYS BEEN THE CORE OF HIS ART. HE HAS SOLID FOUNDATIONS, ONES HE FORGED HIMSELF, AND HE HAS BEEN LAYERING ON TOP OF THEM FOR FIFTY YEARS. READING ABOUT HIS EARLY RECORD COLLECTION HAD ME REVISITING MINE, PULLING OUT SLEEPY JOHN ESTES, DAVE VAN RONK, AND HARRY SMITH'S *AMERICAN FOLK MUSIC* ONCE AGAIN.

NEXT, I WAS STRUCK BY HIS ENORMOUS GENEROSITY. HE IS LAVISH IN HIS ACKNOWLEDGMENT OF ALL THE INFLUENCES ON HIS ART. HE TALKS ABOUT WHAT HE LEARNED FROM ALL SORTS OF SURPRISING INFLUENCES, EVERYONE FROM FRANK SINATRA JR. TO DANIEL LANOIS.

IT WAS FASCINATING TO HEAR HOW HE FIRST CAME TO WRITE MUSIC, HOW CONTENT HE HAD BEEN TO SIMPLY PLAY OTHERS' COMPOSITIONS, AND HOW HESITANT HE WAS TO COMPROMISE THE BODY OF FOLK MUSIC, SORT OF LIKE IF HOROWITZ BEGAN PLAYING HIS OWN PIANO SONATAS RATHER THAN BEETHOVEN'S. SLOWLY, DYLAN BEGAN TO INTRODUCE HIS OWN ADDITIONAL LYRICS TO FOLK STANDARDS AND THEN EVENTUALLY TO CREATE HIS OWN FROM THE MUSIC STAFF UP.

WHILE HE WAS COMMITTED AND HARDWORKING, DYLAN NEVER COMES OFF AS TERRIBLY AMBITIOUS. HE WANTS TO KEEP MOVING FORWARD, TO PLAY FOR LARGER AUDIENCES SO HE CAN HAVE NEW CREATIVE OPPORTUNITIES BUT HE NEVER SET OUT TO BE A SUPERSTAR.

ONE FIFTH AVENUE

IN FACT, IN HIS ADMIRATION FOR POP SINGERS AND TIN PAN ALLEY COMPOSERS, HE ACKNOWLEDGES THAT PLAYING WOODY GUTHRIE SONGS HARDLY SEEMED THE ROAD TO FAME AND FORTUNE, EVEN IN THE FOLK-MAD DAYS OF THE EARLY 1960s. EVEN RECENTLY, WHEN HE HAS BEEN TOURING A LOT, IT'S TO STRETCH HIMSELF CREATIVELY, TO PLAY MUSIC PUBLICLY THAT SHOULD BE PLAYED, TO SHED THE NOSTALGIC CLASSIC ROCK TRAPPINGS AND TALK TO NEW AUDIENCES IN NEW WAYS. MILES WAS MUCH THE SAME WAY. THE STILL-TOURING MEMBERS OF THE STONES, THE BEATLES, THE WHO, ETC. HAVE NO SUCH CREATIVE AMBITIONS.

A NUMBER OF PEOPLE HAVE WRITTEN TO ME FOR A CERTAIN KIND OF ADVICE. TYPICALLY, THEY'LL ASK HOW THEY CAN BECOME PROFESSIONAL ILLUSTRATORS OR, EVEN MORE FREQUENTLY, HOW THEY CAN GET BOOKS PUBLISHED. I TEND TO ANSWER SUCH LETTERS LESS OFTEN THAN I USED TO BECAUSE I REALIZE THAT I DON'T HAVE THE ANSWERS. BUT I THINK DYLAN DOES. HERE ARE A FEW LANDMARKS:

1. FIGURE OUT WHAT YOU'RE ABOUT. WHAT DO YOU LIKE TO DO, WHAT IS YOUR MEDIUM, YOUR SUBJECT MATTER, YOUR STYLE?

2. EXPLORE. GETTING TO #1 REQUIRES FLEXIBILITY, OPENNESS, A WILLINGNESS TO EXPLORE AND TO TRY ON LOTS OF COSTUMES.

3. FOCUS. SPEND LESS TIME ON SUCCESS AND MORE ON ART. THE MORE YOU WORK, THE BETTER YOUR ART, THE MORE LIKELY THINGS ARE GOING TO HAPPEN. AND FIGURE OUT WHAT YOU REALLY WANT. AT ONE POINT, I JUST WANTED MY NAME ON A BOOK JACKET, ANY BOOK. NOW I HAVE A CLEARER SENSE OF WHAT I AM WILLING TO SPEND MY TIME ON. AND CONSIDER YOUR WORK FROM THE POINT OF VIEW OF THOSE WHO YOU WANT TO WANT IT. LEARN ABOUT THE INDUSTRY YOU ARE TRYING TO BREAK INTO AND THE AUDIENCE YOU ARE TALKING TO. DON'T JUST SEND OFF STUFF TO INAPPROPRIATE AND UNINTERESTED PUBLISHERS. UNDERSTAND THE MARKET.

4. SPEND SOME TIME IN A CREATIVE MECCA: NEW YORK, LA, LONDON, PARIS. YOU MAY HAVE TO MAKE SOME SACRIFICES TO DO SO. BUT IF YOU'RE NOT WHERE IT'S AT, YOU'RE NOT WHERE IT'S AT. THIS ESPECIALLY APPLIES TO THOSE HELL-BENT ON COMMERCIAL SUCCESS (BUT, OF COURSE, THERE ARE MANY OTHER WAYS TO BE SUCCESSFUL). BUT MOST IMPORTANTLY, WHEN YOU ARE IN THE DEEP END OF THE CREATIVE POOL SURROUNDED BY OTHERS FULL OF ENERGY AND IDEAS AND EXAMPLES, YOU LEARN TO SWIM A LOT BETTER.

5. BE GENEROUS. SEIZE EVERY OPPORTUNITY TO THANK PEOPLE AND INCLUDE THEM IN WHAT YOU'RE DOING. GIVE YOUR WORK AWAY THEN MAKE MORE.

6. THERE ARE NO SMALL PARTS. PLAY THE COFFEE SHOPS,

PASS THE BASKET, DON'T JUST HOLD OUT FOR THE GARDEN. BE WILLING TO ILLUS-
TRATE SCHOOL PLAY PROGRAMS OR DINER MENUS, PUBLISH A 'ZINE, START A BLOG, ETC.
WHATEVER WILL GET YOUR WORK OUT INTO THE WORLD.

7. MEET LIKE-MINDED FOLKS AND BE ACTIVELY INVOLVED WITH THEM. MEET OTHER
ARTISTS AND CREATIVE PEOPLE. DON'T JUST TALK ABOUT THE BUSINESS OF ART (GOD, HOW
DULL) BUT SHARE YOUR PASSION FOR MAKING THINGS AND INFECT ONE ANOTHER.

8. NEVER COMPLAIN, NEVER EXPLAIN. BE YOURSELF AND BE GLAD OF IT. CRE-
ATIVITY NEEDS LIGHT AND NOURISHMENT.

9. ABOVE ALL, DO WHAT YOU LOVE AND LOVE WHAT YOU DO. DON'T TRY TO FIGURE
OUT WHAT YOU SHOULD DO TO BE SUCCESSFUL BUT HOW TO SUCCESSFULLY EXPRESS WHAT
MAKES YOU YOU. THERE'S NOTHING MORE PATHETIC AND BORING THAN THOSE WHO HAVE
DONE EVERYTHING THEY CAN TO MOLD THEMSELVES TO THE PREVAILING NOTIONS OF
WHAT IS POPULAR. THAT ALREADY EXISTS (IT'S ON FOX AND IT'S CALLED *AMERICAN
IDOL*). YOU NEED TO BLAZE NEW PATHS, YOUR OWN PATHS. NO ONE DOES WHAT YOU DO.
KEEP IT THAT WAY BY EXPRESSING THE TRUE YOU, THE INNER YOU.

REMEMBER, ART'S MOST IMPORTANT JOB IS TO LIGHT THE VIEWER'S FUSE, TO
CREATE NEW FEELINGS AND INSIGHTS, TO CREATE BY SHARING. BY SHARING YOURSELF,
YOU MAKE THE WORLD A BETTER PLACE. THE IMPORTANT GOAL IS NOT TO WIN GOLD
RECORDS OR HUMMERS OR GROUPIES. IT'S THE SAME AS THE GOAL OF EVERY SHARE-
CROPPER WHO PICKED UP A SEARS GUITAR AND WAILED THE BLUES. TO BE AUTHENTIC,
TO EXPRESS YOURSELF. THAT MAY LEAD YOU TO CLEVELAND AND THE HALL OF FAME
OR, EVEN BETTER, TO AN ENRICHED FEELING OF WHAT IT IS TO BE HUMAN.

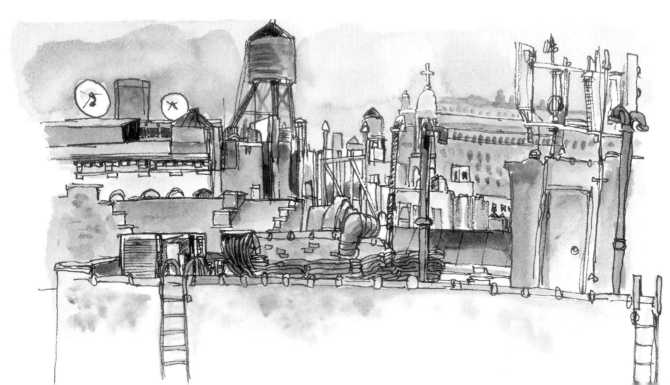

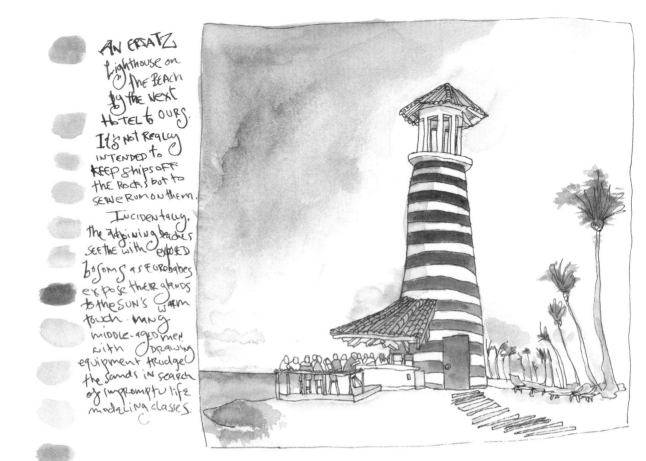

AN ERSATZ lighthouse on the beach by the next hotel to ours. It's not really intended to keep ships off the rocks but to serve rum on them.

Incidentally, the adjoining beaches seethe with exposed bosoms as Eurobabes expose their glands to the sun's warm touch. Many middle-aged men with drawing equipment trudge the sands in search of impromptu life modeling classes.

Nancy, Tom, Pan, and Bob

AND THOUSANDS OF OTHER PEOPLE HAVE ALL ALLOWED CREATIVITY TO TRANSFORM THEIR LIVES.

MANY BEGAN IN THE SAME PLACE I DID: FEELING INADEQUATE, INEPT, AND INTIMI-DATED. THEY WORRIED THAT THEY LACKED TALENT. THEY FELT THE ART WORLD WAS TOO INTELLECTUAL FOR THEM. THEY FEARED THAT THEY COULDN'T MAKE A LIVING THROUGH ART. THEY HAD LITTLE SUPPORT FOR THEIR EFFORTS FROM PEOPLE AROUND THEM.

FOR DIFFERENT REASONS, THEY DECIDED TO JUST CONTINUE MAKING THINGS ANYWAY. THEY LOOKED AROUND FOR EXAMPLES TO FOLLOW. ENCOUNTERING OBSTACLES, THEY WERE OCCASIONALLY DERAILED; BUT BECAUSE THEY LOVED THE FEELING OF EXPRESSING THEIR CREATIVITY SO MUCH, THEY CAME BACK TIME AND AGAIN, PROGRESSIVELY STRONGER.

IT WAS HARD FOR THEM BUT AS THEY FOUND OTHERS WHO SHARED THEIR STRUG-GLES, IT BECAME EASIER.

KEEP ON GROWING

I HOPE THAT BY NOW, AFTER WORKING THROUGH THE IDEAS AND EXERCISES IN THIS BOOK, YOU HAVE BEGUN TO FEEL EMPOWERED TO FOLLOW YOUR OWN CREATIVE PATH. PERHAPS YOU'LL JUST KEEP DEVELOPING YOUR ILLUSTRATED JOURNALS. OR MAYBE YOU'LL SEE THAT, JUST AS YOU LEARNED TO DRAW, YOU HAVE PERMISSION TO LEARN TO PLAY MUSIC, TO DANCE, TO ACT, TO WRITE A NOVEL.

AND IF YOU CHOOSE TO, YOU'LL TAKE THIS CREATIVITY TO A DIFFERENT PLACE, ONE WHERE YOU SHARE YOUR WORK WITH A BROADER AUDIENCE. MAYBE YOU'LL TRY OUT FOR THE LOCAL COMMUNITY THEATER. PERHAPS YOU'LL PLAY IN A BAND IN YOUR GARAGE. OR, WHO KNOWS, YOU COULD DECIDE YOU BELONG SOMEWHERE ELSE— *THE NEW YORK TIMES'* BESTSELLER LIST, THE STAGE OF THE GRAMMYS, THE PERMANENT COLLECTION OF THE MUSEUM OF MODERN ART, THE SHELF OF YOUR LOCAL BLOCKBUSTER— AND YOU'LL TAKE THE MANY STEPS IT TAKES TO GET THERE.

REGARDLESS OF WHERE AND HOW YOU SHOW YOUR CREATIVITY, THE MOST IMPORTANT AND REWARDING THING IS TO LET IT FLOW. INSERT CREATIVITY IN ALL ASPECTS OF YOUR LIFE FROM HOW YOU DRESS IN THE MORNING TO WHAT YOU DREAM OF AT NIGHT. AND REMIND YOURSELF OVER AND AGAIN THAT CREATIVITY IS YOUR BIRTHRIGHT, A NATURAL PART OF WHO YOU ARE: A LIVING ENTITY ON THIS EARTH. YOU DON'T NEED PERMISSION FROM YOUR FAMILY, FROM CRITICS, FROM BANKERS, TO BE AN ARTIST. YOU WERE BORN ONE.

AND OF COURSE, NOW THAT YOU HAVE YOUR CREATIVE LICENSE, DON'T LEAVE YOUR ABILITIES MOLDERING IN LONG-TERM PARKING. HIT THE ROAD. KEEP GOING. EXPERIMENT, DREAM, DARE TO FAIL. GO DOWN DEAD ENDS, THEN PULL A U-TURN AND HEAD FOR ANOTHER CORNER OF THE MAP. TRAVEL THE MAIN HIGHWAYS AND THE PARTS UNCHARTED.

WHEN I SEE YOU OUT THERE, I'LL HONK TWICE.

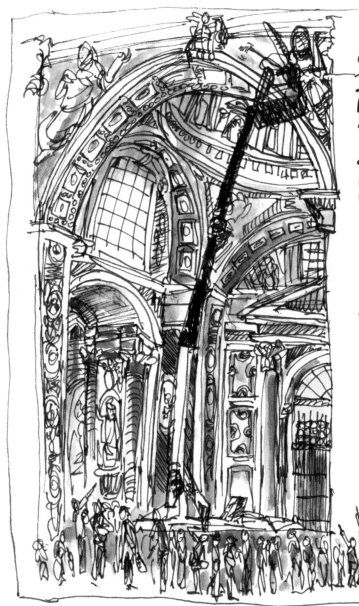

AN UNFOLDING ROBOTIC GIZMO IS USED FOR **DUSTING.** A MAN WENT UP ON THIS SLENDER CHERRY PICKER TO VACUUM THE STATUES A HUNDRED FEET OR SO ABOVE. St. PETER'S IS MAD WITH DETAILS AND MIXED MEDIA — METAL, MARBLE, FRESCO OVER EVERY SQUARE INCH OF IT — A COUPLE OF FOOTBALL FIELDS LONG — NOT THAT I HAVE MUCH OF A SENSE OF HOW BIG A FOOTBALL FIELD IS — AND I GET THE FEELING THAT I AM SEEING THE OTHER HALF OF THE COLISEUM TOUR — THE PLUNDERED SKIN AND EMBELLISHMENTS RE-PURPOSED FOR THE GREATER GLORY OF MONOTHEISM. I COULD SPEND WEEKS DRAWING THIS PLACE. I WONDER IF I CAN GO UP IN THE CHERRY PICKER FOR A SKETCH OR TWO?

THANK YOU, thANk YOu!

You have taken the first step. I urge you to take more and to consult with other, wiser experts on all things creative. The ones who influenced me most include Dan Price, Julia Cameron, Dr. Betty Edwards, Dr. Eric Maisel, and Frederick Franck. I recommend you buy and read their books.

Many people helped me write this book. First, my always inspiring wife, Patti, and my favorite artist, Jack Tea Gregory. My endlessly creative and persevering agent, PJ Mark. If he hadn't bought me a cup of coffee on a rainy day in Tribeca, this book would still be a tree. My wonderful editor, Kelly Notaras, who saw the potential in my ideas and helped me turn them from a bunch of drawings and chicken scratchings into something sane people would fork over good money to own. Thanks also to all the production folk at Hyperion who have made this book as beautiful as I'd only dreamed it could be. And, without the Millers, Bob and Steve, I would never have dared to write this book or imagined that many people would be terribly interested.

My many talented friends were endlessly supportive and inspiring as I struggled to assemble and organize these thoughts: D. Price, Richard Bell, Roz Stendahl, Tom Kane, Hazel Kahan, Rosecrans Baldwin, Andrew Womack, Julie Dermansky, Andrea Scher, Prashant Miranda, Nancy Howell, Todd van Rigby, Tom Pratt, and all my pals at the Everyday Matters site and group.

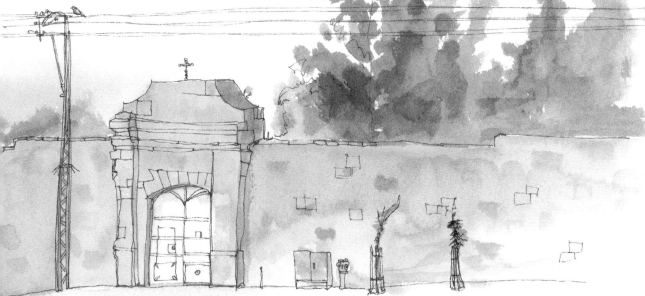

The convent at the end of the street. Over thirty years, I've never seen a soul emerge or enter. I guess those girls must be very busy praying in there.

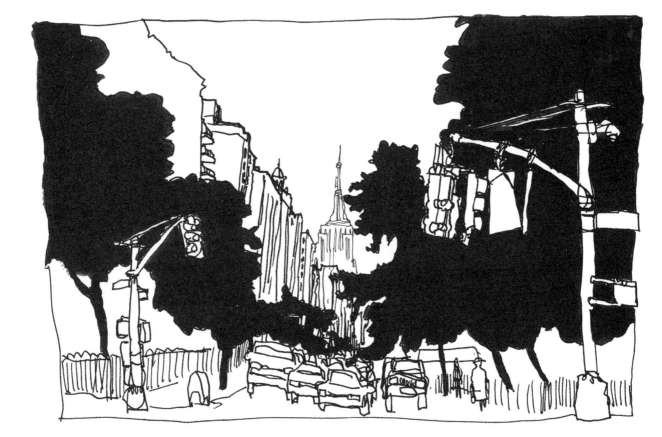

WWW.DANNYGREGORY.COM